LEONARDO DA VINCI

'The human race in its marvellous and varied works
seems to reveal itself as a second nature in this world.'

(B.L.151v)

LEONARDO DA VINCI
The Marvellous Works of Nature and Man

Martin Kemp

James Prendergast Library Association
509 Cherry Street
Jamestown, New York 14701

Harvard University Press
Cambridge, Massachusetts
1981

Library of Congress Cataloging in Publication Data

Kemp, Martin.
 Leonardo da Vinci, the marvellous works of nature and man.
 Bibliography: p.
 Includes index.
 1. Leonardo da Vinci, 1452–1519. I. Title.
N6923.L33K45 709′.2′4 81–279
ISBN 0-674-52460-8 AACR1

Printed in Singapore

Contents

List of Plates 7
List of Figures 12

Photographic Acknowledgments 16
Preface 17
Abbreviations and References 21

I 'Leonardo da Firenze' 23
II The Microcosm 91
III The Exercise of Fantasia 152
IV The Republic: New Battles and Old Problems 213
V The Prime Mover 278

Bibliography 350
Index 367

Dedicated to J.K. x3

List of plates

All the illustrated works are by Leonardo unless otherwise indicated.

1 Giotto, *Christ before the High Priest* (c. 1305), Padua, Arena Chapel (Capella Scrovegni)

2 Masaccio, *The Trinity with the Virgin, St John and Donors* (c. 1426-7), Florence, S. Maria Novella

3 Antonio Pollaiuolo, *Battle of the Nude Men* (c. 1475?), engraving, London, British Museum

4 Verrocchio (and workshop?), *Madonna and Child in front of a Ruined Basilica (The 'Ruskin Madonna')* (c. 1470-3), Edinburgh, National Gallery of Scotland

5 *Studies of Heads and Machines* (1478), pen and ink, Florence, Uffizi

6 *Study of a Warrior in Profile* (c. 1476), metalpoint, London, British Museum

7 Verrocchio, *Study of a Lady's Head with Elaborate Coiffure* (c. 1474), black chalk, bistre and white, London, British Museum

8 *Study of a Lily (Lilium candidum)* (c. 1473), black chalk, pen and ink and wash, Windsor, Royal Library (12418)

9 *Annunciation* (c. 1473), Florence, Uffizi

10 *Ginevra de' Benci* (1474?), Washington, National Gallery of Art

11 *Study of a Tuscan Landscape* (1473), pen and ink, Florence, Uffizi

12 *Study for a Madonna's (?) Head* (c. 1481), metalpoint, Louvre, Paris

13 *Madonna and Child with a Vase of Flowers* (c. 1475), Munich, Alte Pinakothek

14 *The 'Benois Madonna'* (c. 1480), Leningrad, Hermitage Museum

15 *Study for the Madonna and Child with a Cat* (c. 1480-1), pen and ink, London, British Museum

16 *Study for the Madonna and Child with a Cat* (c. 1480-1), pen and ink and wash, London, British Museum (reverse of Plate 15)

17 Verrocchio and workshop, *Baptism of Christ* (c. 1476), Florence, Uffizi

18 Verrocchio, *Putto with a Dolphin* (c. 1470), Florence, Palazzo Vecchio

19 *Studies for the Bust of an Infant* (c. 1495), red chalk, Windsor, Royal Library (12519 and 12567)

20 *Four Studies of a Horse's Foreleg* (c. 1490), metalpoint, Budapest, Museum of Fine Arts

21 *Studies of a Woman's Head and Shoulders* (c. 1478), metalpoint, Windsor, Royal Library (12513)

22 *Adoration of the Magi* (1481), Florence, Uffizi

23 Filippo Lippi (and Fra Angelico?), *Adoration of the Magi* (*c.* 1455), Washington, National Gallery of Art, Samuel H. Kress Collection

24 *Compositional Study for the Adoration* (1481), metalpoint, pen and ink, Paris, Louvre

25 *Studies of Figures in Conversation and Movement, a Madonna and Child, a Last Supper and a Hygrometer* (1481), metalpoint, pen and ink, Paris, Louvre

26 *Perspective Study for the Adoration* (1481), metalpoint, pen and ink and wash, Florence, Uffizi

27 *Studies of Hands for the Adoration* (*c.* 1481), metalpoint, Windsor, Royal Library (12616)

28 *Mechanical Studies* (1478), pen and ink, Florence, Uffizi (reverse of Plate 5)

29 *Mechanical Studies* (*c.* 1478), pen and ink, Milan, Biblioteca Ambrosiana (C.A. 379ra)

30 *Design for a Mechanism for Repelling Ladders* (*c.* 1481), pen and ink, Milan, Biblioteca Ambrosiana (C.A. 49vb)

31 *Devices for Raising Water and Other Studies* (*c.* 1480), pen and ink and wash, Milan, Biblioteca Ambrosiana (C.A. 386rb)

32 *Design for an Automatic File Engraver* (*c.* 1481), pen and ink and wash, Milan, Biblioteca Ambrosiana (C.A.6rb)

33 *Waterclock, Sundial, Geometrical Studies, etc.* (*c.* 1481), pen and ink, Milan, Biblioteca Ambrosiana (C.A.12va)

34 *Madonna of the Rocks* (1483—*c.* 1486), Paris, Louvre

35 *Study for the Tiburio of Milan Cathedral* (*c.* 1487), pen and ink, Milan, Biblioteca Ambrosiana (C.A.310rb)

36 *Design for a Centralized 'Temple'* (*c.* 1488), black chalk, pen and ink and wash, Paris, Bibliothèque de l'Institut de France (Ash. I, 5v)

37 *Cross Sections of the Human Skull* (1489), pen and ink, Windsor, Royal Library (19057r)

38 *Proportional Study of a Man in the Manner of Vitruvius* (*c.* 1487), pen and ink, Venice, Accademia

39 *Design for Multi-level Town* (*c.* 1488), pen and ink, Paris, Bibliothèque de l'Institut de France (B.16r)

40 *Design for Canals, Tunnels and Arcades* (*c.* 1488), pen and ink, Paris, Bibliothèque de l'Institut de France (B.37v)

41 *Design for an Equalizing Device for a Barrel Spring* (*c.* 1499) Madrid, Biblioteca Nacional (I, 45r)

42 *Study of Five Characters* (*c.* 1494), pen and ink, Windsor, Royal Library (12495r)

43 *Study for an Allegory of Justice and Prudence* (*c.* 1494), pen and ink, Oxford, Christ Church

44 Unknown Architect, *Piazza Ducale and Entrance Tower of the Castello at Vigevano* (early 1490s)

45 *Design for a Napping Machine* (*c.* 1497), pen and ink, Milan, Biblioteca Ambrosiana (C.A.397ra)

46 *Designs for a Scythed Chariot, Armoured Vehicle and Partisan* (*c.* 1487), pen and ink and wash, London, British Museum

47 *Men Struggling to Move a Huge Cannon* (*c.* 1488), pen and ink, Windsor, Royal Library (12647)

48 Leonardo and workshop, *Sala delle Asse, detail of Vault Decoration showing the Central Oculus* (1498-), Milan, Castello Sforzesco

49 *Sala delle Asse, detail of Decoration above North-East Window*

50 *Sala delle Asse, detail of Decoration in Southern Corner*

51 Leonardo workshop, *Sala delle Asse, Roots, Rocks and Plants on the North-Eastern Wall*

52 *Last Supper* (*c.* 1495-7), Milan, Refectory of S. Maria delle Grazie

53 *Study for the Last Supper, with Method of Constructing an Octagon and Arithmetical Calculation* (*c.* 1495-6), pen and ink, Windsor, Royal Library (12542)

54 *Study for the Head of St James the Greater in the Last Supper and a Domed Corner Pavilion for the Castello Sforzesco (?)* (*c.* 1496), red chalk, pen and ink, Windsor, Royal Library (12552)

55 *North-Western Corner of the Refectory of S. Maria delle Grazie* (with the outlines of the tapestries within the Last Supper emphasized)

56 *Lady with an Ermine (Cecilia Gallerani)* (*c.* 1485), Cracow, Czartoryski Museum

57 *Study of a Horseman on a Rearing Horse above a Fallen Enemy* (*c.* 1485-9), silverpoint, Windsor, Royal Library (12358r)

58 *Study of a Horse in Profile and from the Front* (*c.* 1490), silverpoint, Windsor, Royal Library (12321)

59 *Design for a Casting Hood for a Horse's Head* (*c.* 1491-3), red chalk, Biblioteca Nacional, Madrid (II, 157r)

60 Leonardo (?) and workshop, *Madonna and Child with a Yarnwinder* (*c.* 1501), Collection of the Duke of Buccleuch and Queensberry

61 *Madonna, Child, St Anne and a Lamb* (*c.* 1508 onwards), Paris, Louvre

62 *Cartoon for the Madonna, Child, St Anne(?) and St John* (*c.* 1508), London, National Gallery.

63 *Study for the Cartoon of the Madonna, Child, St Anne (?) and St John* (*c.* 1508), black chalk, pen and ink and wash, London, British Museum

64 *Map of Imola* (1502), pen and ink with watercolour, Windsor, Royal Library (12284)

65 Peter Paul Rubens, *Copy of Leonardo's Battle of Anghiari* (based on the engraving by Lorenzo Zacchia), Paris, Louvre

66 *Studies for the Battle of Anghiari, showing the Fight for the Standard and Other Incidents* (1503), pen and ink, Venice, Accademia

67 *Studies of Warriors' Heads for the Battle of Anghiari* (1503), red chalk, Budapest, Museum of Fine Arts

68 *Study for a Cavalcade* (for the right hand side of the *Battle of Anghiari?*) (*c.* 1504), black chalk, Windsor, Royal Library (12339)

69 *The Trachea and Bronchii Studied in Isolation and a Study of Thoracic and Abdominal Organs* (*c.* 1508), black chalk, pen and ink, Windsor, Royal Library (19054v)

70 *Composite Study of the Respiratory, Circulatory and Urino-genital Systems in a Female Body* (*c.* 1508), black chalk, pen and ink and wash, Windsor, Royal Library (12281)

71 *Portrait of a Lady on a Balcony (the 'Mona Lisa')* (*c.* 1505-14), Paris, Louvre

72 After Leonardo, *Leda and the Swan*, Collection of the Earl of Pembroke, Wilton House, Wiltshire.

73 *Study for the Kneeling Leda* (*c.* 1506), black chalk, pen and ink and wash, Chatsworth, Devonshire Collection

74 *Study of the Star of Bethlehem (Ornithogalum umbellatum) and Other Plants* (*c.* 1506), red chalk, pen and ink, Windsor, Royal Library (12424)

75 *Study for Leda's Coiffure* (*c.* 1507-8), black chalk, pen and ink, Windsor, Royal Library (12516)

76 *Madonna of the Rocks* (*c.* 1495-1508), London, National Gallery

77 *Geometrical Studies of Squaring a Circle and Studies for an Allegory of Truth and Falsehood* (*c.* 1509), pen and ink, Windsor, Royal Library (12700v)

78 *Study for the Trivulzio Monument* (*c.* 1508-9), red chalk, pen and ink, Windsor, Royal Library (12356r)

79 *Study of the Superficial Anatomy of the Foot and Lower Leg* (1510), pen and ink, Windsor, Royal Library (19017r)

80 *Four Sequential Studies of the Superficial Anatomy of the Arm, Shoulder and Breast* (*c.* 1510-11), pen and ink and wash, Windsor, Royal Library (19008v)

81 *Studies of a Dissected Shoulder, Bones of the Foot and Lower Leg, and Thoracic Musculature* (*c.* 1510), pen and ink and wash, Windsor, Royal Library (19013v)

82 *Studies of the Heart (of an Ox or Bull?)* (1513-14), pen and ink, Windsor, Royal Library (19073v-4v)

83 *Geometrical Studies of Related Areas* (*c.* 1513), pen and ink, Milan Biblioteca Ambrosiana (C.A.167ra-b)

84 *Studies of Hydrodynamic Turbulence* (*c.* 1508-9), pen and ink, Windsor, Royal Library (12660v)

85 *A Deluge, with a Falling Mountain and Collapsing Town* (*c.* 1515), black chalk, Windsor, Royal Library (12378)

86 *A Deluge, Formalized* (*c.* 1515), black chalk, pen and ink, Windsor, Royal Library (12380)

87 *Study of Light and Shade on a Tree (Robinia)* (*c.* 1508), red chalk, Windsor, Royal Library (12431v)

88 *St John the Baptist* (*c.* 1509), Paris, Louvre

List of figures

All figures are based upon drawings by Leonardo unless otherwise indicated. The figures should not be regarded as reproductions of the original drawings but as diagrammatic transcriptions made for the purpose of illustrating a specific point or points. In some cases, where it seemed appropriate, the lines of the original drawings have been closely followed, while in others (particularly those of a geometrical nature) the diagrammatic intentions of the sketches have been clarified.

1 *Diagrammatic Ground Plan of Brunelleschi's Perspective Demonstration of the Florentine Baptistery*

2 *Diagrammatic Reconstruction of the Appeareance of Brunelleschi's Perspective Demonstration of the Florentine Baptistery*

3 *Ground Plan of Masaccio's Trinity*

4 *The Visual Pyramid According to Alberti*

5 *Alberti's Perspective Construction*

6 *Ground Plan of S. Maria in Pertica, Pavia*, based on B.55r

7 *Ground Plan of a Centralized Church*, based on Ash.I, 4r

8 *Ground Plan of a Centralized Church*, based on B.35r

9 *Diagram of Musical 'Proportions'*, based on F. Gaffurio, *De Harmonia*, 1518, H8b

10 *Ground Plan of a Centralized Church*, based on B.57v

11 *Proportions of a Column Base*, based on Forster III, 45r

12 *Design for a Worm Gear*, based on Madrid I, 17v

13 *Design for an Axle Bearing*, based on Madrid I, 119r

14 *Design for the Wing of a Flying Machine*, based on B.74r

15 *Vertical and Horizontal Sections of the Head to Show the Ventricles*, based on W.12603r

16 *Horizontal Section of the Head to Show the Ventricles*, based on W.12627r

17 *The Visual Pyramid and the Eye*, based on C.A.85va

18 *Radiant Pyramids Arising from a Circular Object*, based on Ash. II, 6v

19 *Circular Diffusion of Waves from Two Centres*, based on A.61r

20 *Pyramids of Visual Diminution*, based on A.37r

21 *Diagram Illustrating the Pyramidal Law*, based on M.44r

22 *Grades of Primary and Secondary Shadows on and behind a Sphere illuminated from a Window*, based on Ash.II, 13v

23 *Angular Impacts of Light on a Face*, based on W.12604r

24 *Nerves of the Neck and Shoulders*, based on W.19040r

25 *Diagram of the Human Figure in a Crouched Position*, based on L.28v

26 *Comparison between the Paths of a Freely Thrown and Bouncing Ball*, based on A.24r

27 *Analysis of Water Flow in a River*, based on C.26v

28 *Comparison between a Bouncing Ball and Waves of Water*, based on I.115v

29 *Turbulent Flow caused by Circular and Triangular Obstructions*, based on H.64

30 *Studies of the Trajectory of a Ball from a Mortar*, based on I.128v

31 *Pyramidal Law of Force in a Bow String*, based on Madrid I, 15r

32 *Studies of Hammers of Different Weights*, based on M.83v

33 *Studies of Balances*, based on Madrid I, 129v, 157r, 167v, and C.A.86rb

34 *Compound Balance and Pulley System*, based on M.38r

35 *Pulley System with a Ratio of 1:33*, based on Madrid I, 36v

36 *System of Pivots for Raising a Load*, based on I.58r and 114r

37 *System of Pulleys in Equilibrium*, based on C.A.321ra

38 *Analysis of the Statics of an Arch*, based on Madrid I, 142v

39 *Dodecahedron Absiscus Solidus*, based on C.A.263rc

40 *Dodecahedron Absiscus Vacuus*, based on C.A.263rb

41 *Sketch of the Five 'Platonic Solids'*, based on M.80v

42 *Analysis of a Water Droplet on a Progressively Inclined Plane*, based on I. 90r

43 *Mechanism for 'Pluto's Paradise'*, based on B.L.231v

44 *Sala delle Asse, diagram of Vault and Wall Decoration*

45 *Design for a Decorative Lattice with the Initials of Ludovico and Beatrice*, based on I.14r

46 *Sforza Emblem of a Tree*, based on a roundel in the Piazza Ducale at Vigevano

47 *Analysis of the Perspectival and Modular Structure of the Last Supper*

48 *Study of the Proportions of the Foreleg of a Horse owned by Galeazzo Sanseverino*, based on W.12319

49 *Outline of a Walking Horse from a Casting Diagram for the Sforza Monument*, based on Madrid II, 149r

50 *Lines of Fire from Gun Placements*, based on L.45v

51 *Sketch of Bramante's Capella del Perdono in the Ducal Palace at Urbino*, based on L.73v

52 *Sketch of the Staircase of the Ducal Palace at Urbino*, based on L.19v

53 *Design for a Circular Fortress displayed in Solid Section*, reconstructed from designs on C.A.48ra-b

54 *Reconstruction of the Locations of the Main Elements in the Pictorial and Sculptural Decoration of the Sala del Consiglio*, based on Wilde and Pedretti

55 *Number Square transcribed from Luca Pacioli's Summa de Arithmetica...,* based on Madrid II, 48v

56 *Tree of Arithmetical Proportions transcribed from Luca Pacioli's Summa de Arithmetica...,* based on Madrid II, 78r

57 *Studies of Lunulae and related Constructions,* based on C.A.142vb, 96va, 233ra and 134va

58 *Technique for Cubing a Dodecahedron,* based upon Forster I, 7r

59 *Study of Pyramids arising from the Same Base,* based on Forster I, 28r

60 *Technique for Squaring a Circle,* based on K.80r

61 *Study of the Centre of Gravity of a Tetrahedron,* based on F.51r

62 *Alternative Technique for Determining the Centre of Gravity of a Tetrahedron,* based on Madrid II, 66r

63 *Comparison between Blood Vessels in the Old and Young,* based on W.19027r

64 *Comparison between the Heart as the Origin of the Vascular System and a Seed as the Origin of a Plant,* based on W.19028r

65 *Study of a 'Captive' for the Trivulzio Monument,* based on W.12355

66 *Pulmonary/Aortic Valve in Isolation,* based on W.19073v

67 *Six Views of the Pulmonary/Aortic Valve in Isolation,* based on W.19079v

68 *Geometrical Analysis of the Pulmonary/Aortic Valve,* based on W.19116v

69 *Geometrical Study of Circles and Triangles,* based on G.17v

70 *Geometrical Analysis of the Tricuspid Valve,* based on W.19074r

71 *Geometrical Studies of Incomplete Circles,* based on G.56r

72 *Study of the Area of a Curved Triangle (1509),* based on W.19145

73 *Geometrical Rosette Pattern,* based on W.19145

74 *Geometrical Studies of Related Areas,* based on C.A.221vb

75 *Technique for Squaring the Surface of a Sphere,* based on E.24v

76 *Study of the Triangular Technique of Squaring a Circle,* based on W.12280r

77 *Stereometric Studies of Archimedean Volumes,* based on G.61v, E.1v/G.62r and E.56r

78 *Construction of a Spiral,* based on G.54v

79 *Spiral Path of a Rolling Hemisphere,* based on E.34v

80 *Mechanical Analysis of the Operation of the Ventricular Valve,* based on W.19074v

81 *Vortices of Blood within the Neck of the Pulmonary Aorta,* based on W.19117v

82 *Analysis of the Effects of a Balance Arm,* based on E.58r

83 *Hydrodynamic Design of Boats and Fishes,* based on G.50v

84 *Four Varieties of Spiral,* based on E.42r

85 *Spiral Erosion of the Rock of Mugnone,* based on B.L.29v

86 *The Platonic Configuration of the Elements and the True Configuration*, based on F.27r

87 *Cross Section of the Earth with the Sphere of Water*, based on Leic.31r

88 *Diagram of a Pyramid Partially Surrounded by a Sphere of Water*, based on Leic.35v

89 *Subterranean Water Course arising from the Bed of a Lake*, based on G.48r

90 *Compression Waves below a Bird's Wings*, based on E.47v

91 *Analysis of the Sun's Reflection from Waves in Water*, based on B.L.27r

92 *Optical Demonstration of the 'Transparency' of a Small Object close to the Eye*, based on D.6v

93 *Optical Demonstration of the Blurred Edge Effect of an Object close to the Eye*, based on D.10v

94 *Optical Demonstration of the Moving Needle Illusion*, based on D.2v

95 *Double Intersection of the Rays within the Eye*, based on D.10v

96 *Diagram of the 'Camera Obscura' Phenomenon*, based on D.8r

97 *Analysis of the Reflection of Rays in a Parallel Beam striking a Concave Mirror*, based on B.L.87v

98 *Lateral Recession of a Wide Object Perpendicular to the Line of Sight*, based on E.4r

99 *Demonstration of the Relationship between the Skin and Underlying Muscles*, based on G.26r

100 *Linear Pattern produced by 'Mistioni'*, based on F.95v

Photographic acknowledgments

The following sources for photographs are gratefully acknowledged: Budapest, Szépmüvészeti Museum (Museum of Fine Arts), Plates 20 and 27; Cracow, Muzeum Nardowe (Czartoryski Museum), Plate 56; Edinburgh, National Gallery of Scotland, Plate 4; Edinburgh, Tom Scott, Plate 60 (reproduced by kind permission of the Duke of Buccleuch); Leningrad, Hermitage Museum, Plate 14 (by permission of the Direction of the Hermitage Museum); London, A.C. Cooper, Plate 72 (by kind permission of the Earl of Pembroke); London, Courtauld Institute, Plate 73 (by permission of the Trustees of the Chatsworth Settlement); London, British Museum, Plates 3, 6, 7, 15, 16, 46 and 63 (by permission of the Trustees); London, Mansell Collection (Anderson-Alinari), Plates 5, 11, 17, 18, 26, 52 and 66; London, National Gallery, Plates 62 and 76; Madrid, Biblioteca Nacional, Plates 41 and 59; Milan, Biblioteca Ambrosiana, Plates 29, 30, 31, 32, 33, 35, 45 and 83; Munich, Alte Pinakothek, Plate 13; Oxford, Christ Church, Plate 43 (by permission of the Governing Body); Padua, Museo Civico, Plate 1: Paris, Bibliothèque Nationale, Plates 36, 39 and 40; Paris, Service de documentation photographique de la Réunion des Musées Nationaux, Plates 12, 24, 25 and 65; Washington, National Gallery of Art, Plates 10 and 23; Windsor, Royal Library, Plates 8, 19, 21, 27, 37, 42, 47, 53, 54, 57, 58, 64, 68, 69, 70, 74, 75, 77, 78, 79, 80, 81, 82, 84, 85, 86 and 87 (by gracious permission of Her Majesty the Queen).

Preface

This is intended to be a book about Leonardo as a whole. I have endeavoured to capture the unity of his creative intellect, not I hope at the expense of his variousness, but in such a way as to illustrate the main trunk from which the ramifications of his work grew. I have attempted to come to terms with the principles, style and development of his thought, rather than enumerating his artistic and scientific achievements. I have been concerned to characterize the shape of his vision of the world, to assess the relationship between this vision and his works of art, and to show how each major facet of his activity relates to the whole and how his outlook developed during the full span of his career.

This approach inevitably places an emphasis upon those aspects of his work which possess the clearest philosophical implications, and militates against an extended consideration of his technical work in all its inventive variety. I have, in other words, been concerned with the principles of his mechanics rather than with a list of the machines he invented. I have been concerned with the reasons why his anatomies took the form they did, rather than running him beside Vesalius and Harvey in a historical race towards 'observational accuracy'. I have been concerned to understand his theory of vision and its implications rather than trying to mould him into an ancestor of Kepler. I have been concerned to illustrate the personal flavour which he brought to a broadly Aristotelian range of physical sciences rather than to draw up an historical balance sheet of scientific credits and debits. And ultimately I have been concerned to show how his art profoundly reciprocates his scientific vision but is not identical to it.

Just as it would be idiotic to claim that this or any other volume was *the* comprehensive Leonardo book, so it would be misleading to think that the internal balance of this necessarily selective study reflects the actual balance of the various activities in his own career. There are a number of reasons why such a balance remains elusive. The most unavoidable is that the surviving historical record is incomplete in a lopsided manner, as we will have repeated cause to see. Furthermore, any selection of material from his legacy is inevitably conditioned by the author's personal attitude to what he considers important, interesting and relevant to his theme. Finally, it is doubtful if anyone could achieve the required level of understanding across the whole range of Leonardo's work to treat every aspect with equal authority. Leonardo himself did not achieve an even level of success in all the fields he tackled. Perhaps the best the author can hope is that his strengths and weaknesses may correspond in some measure and on a minor plane to Leonardo's own.

In attempting to resolve a certain number of the historical problems arising from Leonardo's career, any author inevitably finds himself having to provide answers to questions without the necessary evidence to make his answers anything other than hypothetical. Wherever this has been the case, I have endeavoured to make it as clear as possible to the reader — at the risk of sounding equivocal and saturating the text with maybe's, perhapses, possibly's, if's and but's. A few of the recurrent problems have looked different to me almost every time I have considered them. Chapter IV contains two notable examples: the dating of the *Mona Lisa* ; and the reading of the *Battle of Anghiari* narrative. I would like to claim certainty on such matters, but it would be foolish and dishonest to do so. The best I can say is that I have tried to present the evidence in such a way as to allow the reader to make his own judgments.

That I have written this book at all is obviously an indication that I thought it needed writing. The existing literature on Leonardo is so vast that it has embraced almost all the extremes of historical writing: from poetic insight to novelettish sloppiness; from myopic scholarship to insupportable generalization; from brilliance to stupidity. But unified visions of Leonardo's achievements have been few and far between. Only a few hardy souls have made the attempt. Seailles and Valéry spring most especially to mind from the nineteenth century. In this century Heydenreich represents one kind of attempt, a sequential analysis of different aspects of Leonardo's work, while Zubov represents a more inherently rewarding one. Zubov's learned analysis of Leonardo's intellectual foundations irons out the chronological wrinkles in what for me is an ultimately misleading manner, and even more seriously leaves the art largely out of the equation. But Zubov's book is full of insights and rewards. An aquaintance to whom I outlined the scheme of my book said that it sounded like 'Zubov with art history'. In a way that is not an unpleasing assessment. If my writing on Leonardo's thought has approached Zubov's level of learning and my attempts to understand his art have shared even a little of Kenneth Clark's perception, I should be well satisfied — providing that the final effect is more unified than this eclectic ideal might seem to promise.

Important aspects of this book are coloured by my admiration for the late nineteenth-century generation of scholars who strove to characterize Leonardo through the documentation of his career and environment. I am thinking of writers like Müntz, Solmi and Malaguzzi-Valeri. During the preparation of this study I found myself returning again and again, as any student of Leonardo must, to certain crucial sources: the anthologies of Leonardo's writings by MacCurdy and Richter, the latter now available with Pedretti's invaluably detailed commentaries; the corpus of Windsor drawings catalogued by Clark, and the selection of drawings published by Popham; McMahon's two volumes on the *Treatise on Painting*, which include a facsimile of the Codex Urbinas; and, of course, the facsimiles

and transcriptions of all the original manuscripts as listed in the Bibliography. The collections of documentation by Beltrami and Poggi require revision and amplification, but meanwhile remain essential, while Calvi's work on the chronology of the manuscripts continues to provide the foundation for any sequential assessment of the written legacy. It is also right that I should acknowledge my debt to O'Malley and Saunders' commentary on the anatomical drawings, which some years ago provided my first guide to a non-artistic area of Leonardo's work. The pioneer work by Solmi on the sources for Leonardo's opinions has not been superseded, and ultimately remains more useful than Duhem's suggestive discussions of Leonardo's relationship to various medieval authors. Other more specific debts in particular sections of the text are acknowledged in the Bibliography.

I would wish in this, my first book worthy of the name, to acknowledge my indebtedness to those who have inculcated in me whatever grasp of the subject I now possess: to Professor Michael Jaffé of Cambridge who never allowed one to lose sight of the fact that art history is about works of art; to Professor John Shearman, formerly of the Courtauld Institute, who cajoled all his students to adopt more rigorous standards of historical analysis; to Professor Sir Ernst Gombrich of the Warburg Institute, who taught me directly only on one or two brief occasions, but whose example and encouragement have been a source of inspiration. It was Sir Ernst Gombrich's generous loan of a preliminary typescript of his paper on Leonardo's studies of water which was responsible for my embarking upon Leonardo studies in earnest. My earlier education in science was shaped at school by Dennis Clark, a remarkable teacher. That I subsequently failed to learn as much as I should from my scientific instructors at Cambridge was largely my fault not theirs. In my immediate post-student days I owed the foundation of my career to Professor Anthony Blunt and to the late Professor Andrew McLaren Young. Professor McLaren Young of Glasgow University appointed me to my first established post and encouraged me in every way possible. His successor at Glasgow, Professor Ronald Pickvance, generously promoted and facilitated the sabbatical year without which this book would not have been completed when it was, if at all.

Warm thanks are due to the staff of those institutions in which I have pursued my studies over a number of years. The unique nature of the library of the Warburg Institute gave feasibility to my programme of research, and the unrivalled accessibility of its holdings saved more hours than I care to think of wasting. The Milanese libraries each made significant contributions in their different ways: the Biblioteca Ambrosiana, with its determinedly archaic air of punctiliousness; the Biblioteca Trivulziana within the efficient and friendly Archivio di Stato; and the Raccolta Vinciana, a working collection for students. Nearer home I have benefited enormously from the collection of Leonardo literature in the National Library of Scotland, presented in memory of the Rev. Alexander

MacCurdy. Numerous individuals have made contributions to the furtherance of my research and publications on Leonardo and related topics in the Renaissance. If I specifically mention Professor James Ackerman, Michael Baxandall, Allan Braham, Cecil Clough, Caroline Elam, Robert Gibbs, Richard Greenwood, Anne Harrison, Dr Kenneth Keele, Daniel King, Paul Hills, Professor Alastair Smart, David Summers, Professor John White and Peter Wright, this is not to suggest that the assistance of others has been forgotten. I shall remain unreservedly grateful to successive generations of Glasgow students for their patient attention and intermittent scepticism. In the final preparation of the typescript Mrs Tannia McLaren provided quick and careful assistance. The compilation of the index was undertaken by Margaret Walker, to whom warmest thanks are due, no less than to Kay Nichols for her sympathetic editorial guidance.

No research can be undertaken without finance, and the grant-awarding organizations made vital contributions. A succession of grants over a number of years from the University of Glasgow have made a cumulative contribution to the book's progress, while the final burst of study during my sabbatical year was generously financed by the Carnegie Trust for the Scottish Universities and the British Academy. The sabbatical itself was dependent upon the good will of my colleagues in the Fine Art Department at Glasgow and upon the cheerful willingness of Evelyn Silber who shouldered a term of heavy teaching. To friends at the University of Melbourne I would wish to send my thanks and regrets — they will know what I mean.

My last expressions of gratitude — last in a chronological but not quantitative sense — go to Sandra Vittorini in Florence, who has tenaciously endeavoured to keep me abreast of developments in the search for the *Battle of Anghiari*, and to Cecil Gould, who has provided valuable assistance with respect to the newly discovered documents for the *Madonna of the Rocks*.

Abbreviations and references

A heavy dose of footnotes would be inimical to the kind of text I have wished to write. However, it is obviously essential that the sources of my extensive quotations from Leonardo's manuscripts should be properly acknowledged, and I have used a series of abbreviations for this purpose. These abbreviations correspond to those used in much of the Leonardo literature, with the exception that 'Br.M.' for British Museum has been updated to 'B.L.' for British Library. Any reader wishing to trace the sources for the other evidence I have adduced and to pursue further reading on particular topics should be able to do so quite readily by means of the classified and annotated Bibliography at the end of the text.

The names and reference letters given here as elsewhere to Leonardo's surviving manuscripts are the result of historical accidents. For the history of the manuscripts, see the Bibliography.

Abbreviation	Location etc.	Date
A.	Paris, Institut de France	in and around 1492
Ash. I (Ashburnham)	also known as B.N.2037, formerly part of MS.B., Paris, Institut de France	late 1480s–1490
Ash. II (Ashburnham)	also known as B.N.2038, formerly part of MS.A, Paris, Institut de France	in and around 1492
B.	Paris, Institut de France	late 1480s–1490
B.L. (British Library)	also known as Arundel MS. and Br.M., London, British Library	compiled from material from various periods
C.	Paris, Institut de France	1490–1
C.A. (*Codice atlantico*)	Milan, Biblioteca Ambrosiana	compiled from material from various periods
D.	Paris, Institut de France	probably 1508

E.	Paris, Institut de France	1513-14
F.	Paris, Institut de France	1508
Forster I, II and III (including I¹, I², II¹ and II²)	formerly known as S.K.M.I, II and III, London, Victoria and Albert Museum	I — late 1480s; II — mid 1490s; III — *c.* 1493-4
G.	Paris, Institut de France	1510-15
H. (including H¹, H² and H³)	Paris, Institut de France	1493-4
I. (including I¹ and I²)	Paris, Institut de France	late 1490s
K. (including K¹, K² and K³)	Paris, Institut de France	K¹ and K² (folios 1-80) — *c.* 1503-5; K³ (folios 81-128) — *c.* 1506-8
L.	Paris, Institut de France	*c.* 1497-1502
Leic. (Leicester)	formerly Holkham Hall (Norfolk), Library of Lord Leicester	*c.* 1507-10
M.	Paris, Institut de France	late 1490s-1500
Madrid I	Madrid, Biblioteca Nacional MS. no. 8937	1490s
Madrid II	Madrid Biblioteca Nacional MS. no. 8936	folios 1-140 — *c.* 1503-5; folios 141-57 — 1490-3
Triv. (Trivulzio)	Milan, Castello Sforzesco, Biblioteca Trivulziana	mid 1480s-1490
Turin	Turin, Biblioteca Reale	1505
Urb. (Codex Urbinas) and L°A. (*libro* A)	Rome, Vatican	compiled by Melzi (?) from various MSS, including L°A of *c.* 1508
W.	Windsor Castle, Royal Library	a collection of MSS material from various periods

I 'Leonardo da Firenze'

'Leonardo from Florence'?

I am not seriously suggesting that henceforth we should actually abandon his time-honoured name. Indeed, such a radical recasting is unwarranted in strictly biographical terms. Even at the end of his life in his will he retained the surname 'da Vinci', denoting that he came from Vinci, the Tuscan hilltown near which he was born in 1452 and in which he probably spent most of his childhood. Not only is his name biographically accurate, but it also provided a nice opportunity for puns on the theme of *vincere* (to conquer) which those poets who sang his praises were quick to exploit. Italian court humanists of the Renaissance could rarely resist an elegant word manipulation and inevitably worked their variations on the theme of the painter who 'conquers nature' (*vince la natura*) — a theme which was more than a mere pun in view of Leonardo's supreme achievements in capturing natural effects.

His legal name in the Italian usage of the time was alternatively Leonardo di Ser Piero da Vinci — as such he was listed when he first became due to pay his subscription to the painters' Company of St Luke in 1472 — an acknowledgment that he was the first son, albeit illegitimate, of Ser Piero da Vinci and a woman from a lower class called Caterina. Ser Piero, following the family profession, was a notary, a kind of official solicitor who drafted and interpreted legal documents in Latin. He established a prestigious practice in Florence during the 1450s and 1460s, rising to a prominent place in civic employment, and he was probably responsible for introducing his son to the city when the time came for Leonardo, who had apparently been raised in the family home in Vinci, to acquire a profession. This is unlikely to have occurred before 1464, and may have been considerably later.

In no sense, therefore, was Leonardo literally from Florence, and he was to live there for less than twenty of his sixty-seven years. But if intellectual and artistic ancestry are to count for anything, then he may legitimately be called a child of Florence. The basis for the aspirations which dominated his career had been conceived there by earlier generations of painters, sculptors, architects and engineers, and were generated in his own mind by direct contact with the Florentine masters of his own day, most notably Andrea del Verrocchio, with whom he lived until at least 1476. His debt to the great sculptor, probably personal as well as artistic, was such that he could in the fashion of the time have well been called after his master; that is 'Leonardo d'Andrea' or 'Leonardo del Verrocchio'.

The Florentine Legacy

In a paragraph written about 1490, Leonardo himself composed a laconic history of art, in which the pre-eminent roles of two great Florentine painters were emphasized to the exclusion of all others:

> The painters after the Romans...always imitated each other, and from age to age continually brought their art into decline. After these came Giotto the Florentine, who (not content to imitate the works of Cimabue, his master) being born in the solitary mountains inhabited only by goats and similar animals, and being guided by nature towards this art, began to draw upon the rocks the actions of the goats of which he was the keeper; and thus began to draw in this manner all the animals found in this countryside; after much study he surpassed not only the masters of his own age but all those of many centuries past. After this, art receded because all imitated existing paintings, and thus it went on from one century to the next until Tomaso the Florentine, nicknamed Masaccio, showed by perfect works how those who take for their guide anything other than nature — mistress of the masters — exhaust themselves in vain (C.A.141rb).

From the time of Giotto in the early fourteenth century, Florentine artists and the increasing number of writers who paid attention to Giotto's outstanding achievements had placed special importance upon the painter's ability to imitate nature in a consistent manner. To do this, Giotto developed a rational understanding of certain principles. In rendering architectural space, for example, his paintings established the principle that 'the mouldings which you make at the top of the building should slant downward from the edge next to the roof; the moulding in the middle of the building, half-way up the face, must be quite level and even; the moulding at the base of the building must slant upwards in the opposite direction to the upper moulding which slants downwards'. The words are those of Cennino Cennini, writing at the end of the fourteenth century (or the beginning of the fifteenth), who regarded himself as a direct heir of the Giotto tradition, a kind of artistic grandson. Cennini was describing, in a rather awkward manner, a system of defining space which is elegantly exemplified in Giotto's *Christ before the High Priest* (Plate 1).

This fresco, painted about 1305, is one of an astonishingly brilliant series of what can justifiably be called 'experiments' in creating illusory space behind two-dimensional wall surfaces within the Arena Chapel in Padua. By setting forms in his paintings at an angle to the viewer or, as here, opening up a view into a separate box of illusory space, Giotto was able to weave the psychological webs of his biblical narratives both across and *into* the wall surface. Corresponding to Cennini's description, the upper margins of the side walls slope downwards, and the edge of the lowest forms (in this case the base of the High Priest's throne) are inclined upwards, while the line at head level barely deviates from a pure horizon-

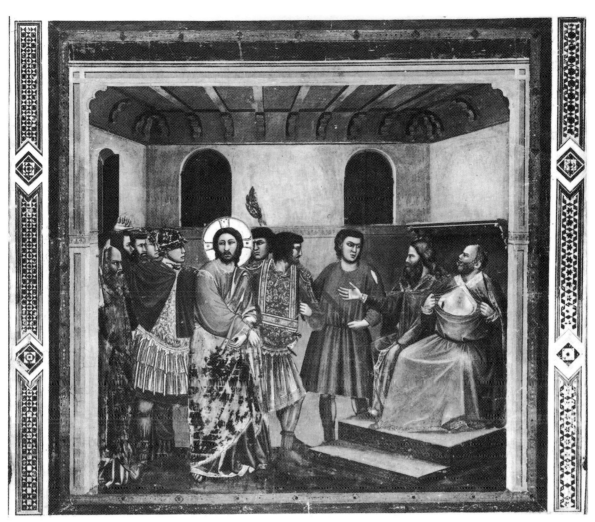

Pl.1 Giotto, *Christ before the High Priest* (*c.* 1305), Padua, Arena Chapel (Capella Scrovegni)

tal. Perfectly in tune with this carefully described space was Giotto's ability to model his figures sculpturally by means of directional light and shade, an effect which is nowhere more effective than in the uncompromising knees of the High Priest.

It was for this apparent command of nature, coupled with what was called 'a full knowledge of the stories', that Giotto was praised in his own century for his *'ingegno'* ('innate brilliance'), a form of contemporary praise which had been almost unthinkable for any painter during the preceding ages. Leonardo was echoing a widely held opinion when he wrote that Giotto 'after much study, surpassed not only those artists of his own era, but also those of many past centuries' (C.A.141rb), and Leonardo's *Last Supper* is a direct descendant of the kind of interior spaces first excavated by his great predecessor in Florence.

Giotto's method was not precisely optical. The receding beams of the ceiling converge to a reasonably convincing focus but it is only approximate and it does not coincide with the horizon line as it should, according to the later rules of linear perspective. This method is, however, systematic and rational, factors which no doubt provided a powerful stimulus for the more fully scientific rule-seekers of the subsequent century. Priority among those who preceded Leonardo in searching for precise optical laws in picture-making must go the great architect and erstwhile sculptor, Filippo Brunelleschi. At some time before 1413, Brunelleschi constructed two (lost) paintings which showed how buildings could be represented in 'what painters today call perspective; for it is part of that science which is in effect to set down well and with reason the diminutions and enlargements which appear to the eyes of man from things far away and close at hand' — to quote Brunelleschi's first biographer and friend, Antonio Manetti. The two paintings showed, respectively, the octagonal Baptistery (S. Giovanni) as seen from the door of the Cathedral (Figures 1 and 2), and the Palazzo Vecchio (the seat of the Florentine government) at an angle from the corner of the Piazza della Signoria. Both these buildings were such focuses of popular attention for contemporary Florentines (as they have become for generations of modern tourists) that the accuracy of Brunelleschi's demonstrations would have been subjected to the most rigorous scrutiny. In fact the designer himself set up controlled viewing conditions for the first painting so that its optical truth could be verified absolutely. In the Baptistery panel he drilled a small hole. The spectator was intended to pick up the panel and press his eye to the hole on the unpainted side. With his other hand, he was then required to hold a mirror in such a way that the painted surface was visible in reflection through the hole. By this means, Brunelleschi established precisely the perpendicular axis along which his representation should be viewed. Standing within the door of the Cathedral, in the position from which the representation was made, and peering through the peep-hole, the spectator could raise and lower the mirror at will, checking and rechecking the correspondences between the painted miracle of illusion and the actual scene in front of his eye. Such precise matching of visual experience and painted representation was to become the foundation for Leonardo's theory of art and, indeed, his whole theory of knowledge.

The procedure used by Brunelleschi in his demonstrations is not recorded, but Manetti's account does make it clear that he had formulated some kind of scientifically exact system for recording the appearance of a three-dimensional form on a two-dimensional surface. His system was probably founded upon the well-established techniques of late medieval surveying, including the use of mirrors, which he may himself have exploited in taking his measurements of ancient Roman buildings. Relying upon the geometrical principles of similar triangles, this technique would have necessitated a laborious series of scaled measurements from pre-

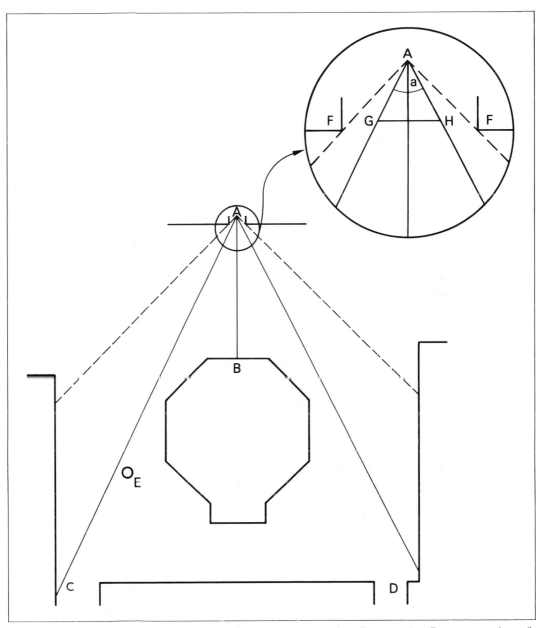

Fig.1 *Diagrammatic Ground Plan of Brunelleschi's Perspective Demonstration of the Florentine Baptistery*

A viewpoint within the porch of the Cathedral

a visual angle: minimum of *c.* 53° (solid lines); maximum of *c.* 90° (broken lines)

B Baptistery

C Canto alla Paglia

D Volta de' Pecori

E Column of S. Zenobio

F, F edges of Cathedral porch

G H intersection made by panel (not to scale in the diagram)

Fig.2 *Diagrammatic Reconstruction of the Appearance of Brunelleschi's Perspective Demonstration of the Florentine Baptistery*

L largest feasible size for the panel in relation to the image of the Baptistery (corresponding to a visual angle of *c.* 90°)
S smallest feasible size for the panel in relation to the image of the Baptistery (corresponding to a visual angle of *c.* 53°)
H peep-hole for viewing with a mirror

existing structures. His method probably did not provide painters with a ready and rapid means of constructing an *imagined* space for their narratives, and could only be used in a given work of art if real buildings were to be incorporated or if the painter in some way assumed the role of architect, drawing in scale an 'actual' building from which he could take his optical measurements. On the one hand, the use of a pre-existing building or scene is unlikely to have been considered expedient in a

religious narrative at this time, either on grounds of decorum or formal suitability, while, on the other, the precise design of a new building and the subsequent plane projection might appear to promise labours far in excess of the likely rewards. Moreover, it is doubtful whether an established technique for measured architectural drawings of the requisite kind was known even to professional architects at the time — other, perhaps, than to Brunelleschi himself. But the use of such drawings and subsequent projection is precisely what seems to have happened in just one outstanding and innovatory instance.

It would require a painter of quite exceptional vision to understand fully the visual potential for religious art of Brunelleschi's innovation and one of exceptional talent to put it into appropriate action. Both these qualities were perfectly realized in the person of Masaccio and manifested with astonishing maturity in his *Trinity with the Virgin, St John and Donors* (Plate 2), probably painted a year or two before Masaccio's tragically early death in 1428 at the age of twenty-seven. The architectural space is described in perspective with such lucidity by the young artist that its basic architectural plan can be deduced with almost complete certainty (Figure 3). The way in which we can translate the two-dimensional surface of Masaccio's fresco into an 'actual' structure in three dimensions surely suggests that the painter had adopted exactly the reverse procedure, that is, he started with a design which was fully conceived as a credible building and then meticulously projected it on to the flat surface.

The perspective of the *Trinity* defines not only the space in depth, behind the plane of the wall, but also a series of forms which seem to project forward into the actual space in which the spectator stands. By these means — a stroke of real genius — Masaccio has visually and intellectually differentiated between the divine realm which exists behind the wall surface, like Alice's world through the looking glass, and the real world shared by the donors, the skeleton and ourselves. The transitory nature of our worldly realm is ominously and incontrovertibly stressed by the message written above the skeleton: 'I was once that which you are; and that which I am, you will yet become.' The donors' prayers to the intercessory Virgin were thus no mere gestures of conventional piety but urgent pleas for the eternal life of their souls. This was the first true perspective painting of the Renaissance, yet it shows no trace of uncertainty as to how the new discovery can be exploited in relation to either form or content; there is a total integration of technical innovation and spiritual meaning. Illusion is placed in the service of allusion in just the same way as Leonardo was later to do. For Leonardo, the perfection of Masaccio's illusion contained the most important moral of all; 'Masaccio showed with perfect works how those who take for their guide anything other than nature — mistress of the masters — exhaust themselves in vain' (C.A.141rb).

Pl.2 Masaccio, *The Trinity with the Virgin, St John and Donors* (*c.* 1426-7), Florence, S. Maria Novella

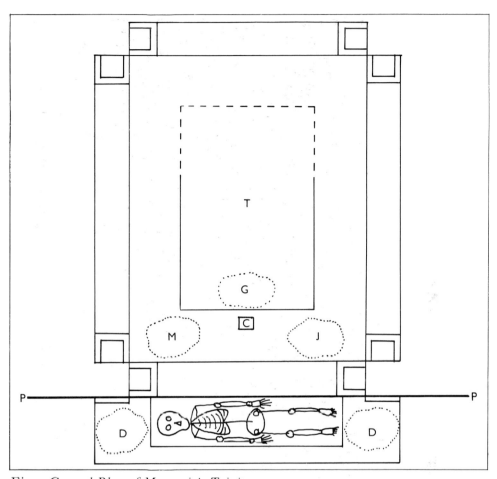

Fig. 3 *Ground Plan of Masaccio's Trinity*

T tomb of Christ (?) on which God the Father stands
G position of God the Father
C position of the base of the cross
M position of Mary
J position of St John
P, P plane of wall
D, D position of donors

The superb harmonization of forms and content in the *Trinity* can only be the product of Masaccio's own mind, but the technical means were those of Brunelleschi. Indeed, none of his other paintings contains anything like the same complexity of geometrical projection or sophistication of architectural detail, and we may be justified in believing that Brunelleschi was involved in the actual design of the structure which his friend was to paint. The vocabulary of architectural forms, based upon a measured study of Roman buildings, is precisely that which Brunelleschi had been the first to exploit in his architecture. Even the figure style strongly reflects Brunelleschi's artistry; the anatomy of Christ is closely related to

Brunelleschi's wooden crucifix for the church of S. Maria Novella. The presence of the great architect's ideas in the *Trinity* appears to go beyond the question of mere influence; his active collaboration seems to be involved.

This, however, was an exceptional result in an exceptional case. What was required before perspective could be readily utilized in the general run of picture-making was a simplified system for constructing whatever spatial setting might be required in any instance. Both Masaccio and his older colleague, Masolino, managed to extract an abbreviated method of describing depth from Brunelleschi's technique, using the principle of the apparent convergence of parallel lines to what is now called the vanishing point, but their paintings constructed along those lines show that this abbreviated method did not allow them to make a completely consistent distribution of forms at every point in a controlled 'box' of space. A simple system which established complete spatial control of the requisite kind was provided by Leon Battista Alberti in his revolutionary little book in Latin, *'On Painting'* (1435), a treatise which provided directly or indirectly the foundation for Leonardo's theory of art.

Alberti, the son of an exiled Florentine, was a humanist author of distinction and a dilettante artist who was later to become the most archaeologically minded architect of his generation. Returning to Florence in 1434, he was astonished by the achievements of the Florentine artists, his friend Brunelleschi, the late Masaccio, and the sculptors, Donatello, Ghiberti and Luca della Robbia. His dedication of the Italian version of *'On Painting'* in 1436 bears eloquent witness to this admiration: 'In you ... there is a brilliance for every praiseworthy thing in no way inferior to any of the ancients [Greeks and Romans] who gained fame in these arts.'

As his first priority, Alberti laid down the visual foundations for the painter's art—and these foundations were the optical truths of perspective. He described how the eye 'sees' by means of a visual pyramid, a converging system of rays which acts like a set of geometrical dividers, measuring the shape and position of forms in front of the eye (Figure 4). His exposition of the geometry of vision is followed (not without a certain discontinuity in the logic of his presentation) by his method of constructing the illusion of space on a two-dimensional surface. He began by determining the height of a standing man according to the scale of his picture. The proportional division of this man into three equal parts (three scale *braccia* in terms of contemporary measures) then provided the module for his construction. His subsequent procedure can best be described diagrammatically (Figure 5).

What Alberti was doing in his description of the visual pyramid was to provide a simplified version of optical science as it was known in classical antiquity and the Middle Ages. Many medieval philosophers had devoted what seems to be an extraordinary amount of intellectual effort to the study of optics, but we must take into account the reasons for the power

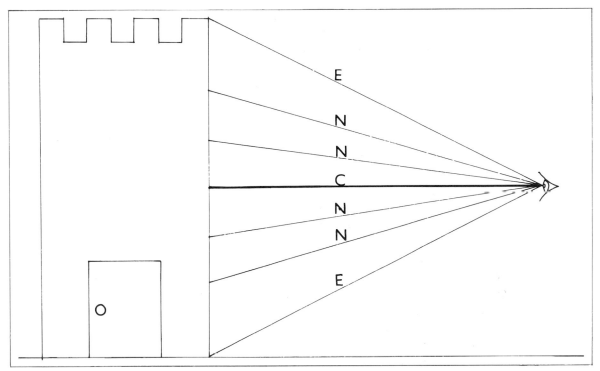

Fig.4 *The Visual Pyramid According to Alberti*

E extrinsic rays 'measuring' the dimensions of an object
N intrinsic rays conveying information relating to the surface
C centric ray certifying vision and confirming distance

which light held over their minds. Light was, traditionally, the manifestation of divine power and glory; few self-respecting Christian visions were complete without a grand display of miraculous radiance. Light was regarded by a group of influential philosophers during the thirteenth century as the primary metaphysical component of all being. And in their resulting studies of optical forces they found that the exalted absolutes of classical geometry moved into uniquely close conjunction with the actual processes of the natural world. Light, travelling in straight lines, appeared to obey geometrical laws in such a way as to reflect the divine order of God's creation. Thus it was that such major intelligences as Alhazen, Roger Bacon, John Pecham, and Witelo raised the science of optics to a revered place in medieval natural philosophy. And thus it was that light, at once rigorously geometrical and incomprehensibly transcendent, came to provide the supreme manifestation of divinity in Dante's *Paradiso*.

The pattern of scientific exploration of optics was set in the eleventh century by Alhazen, whose book on the science of *perspectiva* (embracing what we would now call ophthalmology as well as optics) was originally written in Arabic but had been known in Latin translation to medieval philosophers from the thirteenth century onwards. In eight sections (or

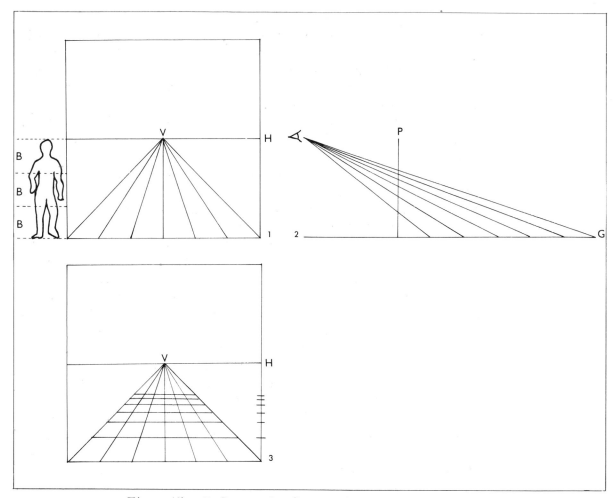

Fig.5 *Alberti's Perspective Construction*

First Stage:

B scale divisions equivalent to one *braccio*. A man three *braccia* tall provides the scale for the painting. The lower edge is divided into units equivalent to one *braccio* each

H horizon line taken from the height of the man

V vanishing point, upon which converge the parallel lines from the *braccio* units

Second Stage:

G ground plane viewed at right angles to the first stage and also divided into *braccio* units

P picture plane intersecting the visual pyramid. The intersection points provide the horizontal divisions for the third stage

Third Stage:

the horizontal divisions from stage two are added to the construction in the first stage, providing a fore-shortened checkerboard floor. Any object can now be drawn according to its appropriate scale in the depth of the painting

'books') the great Arabian scientist provided an incredibly detailed and massive account of vision, dealing successively with the geometrical principles of the eye's anatomy, the reception of light rays within the eye, the perception of size and distance, the notion of beauty, visual illusions, binocular vision, reflection and refraction. The intellectual science of optics was held up to the spectator as the greatest of the empirical sciences, that is to say based upon an observation of the natural world's effects and extraction of its underlying order. This compelling vision inspired a number of major followers during the thirteenth century in Europe. Witelo, a Polish philosopher, produced an edited paraphrase with an introduction which stressed that light was the divine substance which linked the superior world of God with the inferior materials of nature; John Pecham in England compiled a neat epitome or *précis*, his *Perspectiva communis*, which became the standard text-book for at least three centuries; and Roger Bacon was moved to devote a quarter of his *Opus majus*, his all-round compendium of divine knowledge, to the science of *perspectiva*. The way in which the science was harmonized with the mystical vision of medieval theology can be seen in a series of typically medieval analogies drawn up by Bacon: direct vision of light was equated with knowledge of God; refracted (i.e. weaker) vision was equivalent to the angels; reflected (i.e. least direct) corresponded to the position of man. The theological significance of medieval perspective science was as profound as its scientific qualities were rigorous.

This medieval science had been drawn most firmly into the artist's orbit in the third of Lorenzo Ghiberti's *Commentaries*, probably composed in the 1450s. Ghiberti, famed as a sculptor not least for the brilliant perspective reliefs on his second set of doors for the Florence Baptistery, compiled an intelligent anthology of relevant sections from the books of Alhazen, Bacon, Pecham and Witelo in such a way as to stress that the painter's perspective was founded upon a science of considerable intellectual complexity and philosophical respectability. When Leonardo began to extend Albertian perspective into the realm of scientific optics half a century later he was to turn to these very same authorities.

Ghiberti ended his account by quoting the only surviving Roman treatise on architecture, the *Ten Books* of Vitruvius (first century BC):

> Agatharcus in Athens, when Aeschylus was producing a tragedy, painted the scenery and left a commentary about it. This lead Democritus and Anaxagorus to write on the same subject, seeing how, given a centre in a definite place, the lines should naturally correspond with due regard to the point of sight and the extension of the visual rays, so that by this deception a faithful representation of the appearance of buildings might be given in painted scenery, so although all is drawn on a vertically flat surface, some parts may seem to be receding into the background, and others to be projecting out in front.

Although the meaning of the passage is not altogether clear, it pro-

vided Ghiberti with evidence enough that painters in classical Greece possessed a system of perspective and had written treatises upon it. These classical sanctions for both his practice and his theory were of inestimable importance for a man of Renaissance — for such Ghiberti considered himself to be. The intellectuals of the Renaissance, the literary men in particular, the 'humanists', aimed to provide a stylish revival of Greek and Roman learning, and during the fifteenth century the visual artists laid an increasing claim to participate in what had hitherto been a largely literary movement of 'rebirth'. Vitruvius had been 'rediscovered', for the second time within a hundred years, by the humanist Poggio Bracciolini in 1416, and Ghiberti could hardly have quoted a more topical source. Leonardo later knew Vitruvius' writings well, and one of his colleagues in Milan, Giacomo Andrea da Ferrara, was a specialist interpreter of the *Ten Books*.

In the minds of Renaissance authors, the whole idea of art imitating nature found decisive support in Greek and Roman writings about art, notably the section on painters and sculptors in Pliny's *Natural History*. Writing in the first century AD, Pliny described with admiration the achievements of the long dead Greek artists who had taken painting and sculpture from the stylized angularity of the Egyptians to the great mastery of classical naturalism. The great artists, such as Pheidias and Praxiteles in sculpture, and painters such as Zeuxis and Apelles were seen within the framework of a step-by-step progress to which a number of artists each contributed vital discoveries. Kimon, for example, was said to have invented the three-quarter view in painting, while Myron, creator of the famous *Discobolus*, showed how to represent complex poses and anatomical details in sculpture. This pattern of progress towards naturalism provided a model for the Italian Renaissance writers on art, not only in their interpretation of ancient art, but also in their assessment of the 'progress' of art in their own day. Nowhere is this more apparent than in Ghiberti's *Commentaries*, where a history of ancient art culled largely from Pliny is followed by a parallel account of modern Italian art during the century and a half between the advent of Giotto and the climax of his own career. Like Pliny, he described the development as a series of contributions made by such artists as Giotto, the Lorenzetti brothers, the Pisano family of sculptors, and culminating with characteristic immodesty in Ghiberti himself, whose autobiography occupies a quarter of his section on modern art. Even his actual ambition to write about the visual arts, a far from standard practice at this time, followed ancient precedents; certain Greek artists were recorded by Pliny as having composed treatises, not least the great Apelles.

Given this sometimes obsessive attention to classical precedent, the highest praise which a Renaissance man of letters could accord to a painter of his own generation was to term him a 'second' (or 'new') Apelles or Zeuxis, or hail a sculptor as the equal of Pheidias and Praxiteles. Simone Martini, for example, was greeted as the successor to Apelles by no less a

poet than Petrarch, while Leonardo was automatically seen by contemporaries as 'the Apelles of Florence' or the new 'Praxiteles'. His *Last Supper* was said (by no less a writer than the famous mathematician, Luca Pacioli) to equal the eye-deceiving illusions of Apelles as described by Pliny, while his full-size model for the huge equestrian statue of the Duke of Milan was estimated by one contemporary poet to have actually surpassed all the sculptures of antiquity, including those by Myron.

Having praised the artist as a Grecian genius reincarnate, a Renaissance author would commonly proceed to say, using another formula from Pliny, that a figure sculpted or painted by the artist was so life-like that 'it seemed to lack only speech'. In the case of the most supremely communicative artist of the century, Donatello, even this deficiency seemed to be transcended. And the narrative brilliance of Masaccio was such that new dimensions seemed to be given to Simonides' ancient formulation that 'painting is mute poetry' — an idea quoted more than once by Leonardo. The command of the human figure which was essential to achieve this degree of communicative power, the sense of a moving and speaking being, was the supreme achievement of antique art as it was known in the Renaissance, and when Alberti explained how the painter should populate his perspective space, he advocated a close study of the structure and functioning of the human figure. In representing the proportions of the human body, he recommended that the painter should build up his figures in three stages: the bones, which are the least variable part of the structure; the nerves and muscles; and finally the flesh and skin. Ghiberti equally considered that 'Anatomy must be studied, so that the sculptor may know the arrangement of bones, muscles, nerves and tendons in the body and so construct statues accordingly.'

Alberti placed at least as great an emphasis upon the expression of narrative (*istoria* as he called it) as upon correct spatial representation. Indeed, it could be claimed that the latter was the servant of the former. The significance of the narrative should be made explicit by the representation of the 'almost infinite motions of the mind' apparent in facial expressions and bodily gestures. The study of the bodily vehicle which was driven by these mental motions became an absorbing passion for many Florentine artists, just as it had been for their Greek predecessors. From Giotto, through Masaccio and Donatello, to Antonio Pollaiuolo and Andrea del Verrocchio, so there seemed to be a truly Plinian progress in the mastery of the human figure. By the time (during the 1470s?), Pollaiuolo made his seminal engraving, the *Battle of the Nude Men* (Plate 3), the demonstration of anatomical prowess had sometimes become something of an end in itself. Pollaiuolo's muscular ballet pays simultaneous homage to nature and antique sculpture, in a truly Renaissance manner and in such a way that his sheer delight in anatomical achievement appears to override its obscure subject-matter. Vasari's account, written almost a century later, certainly exaggerated in reporting that Pollaiuolo had flayed 'many

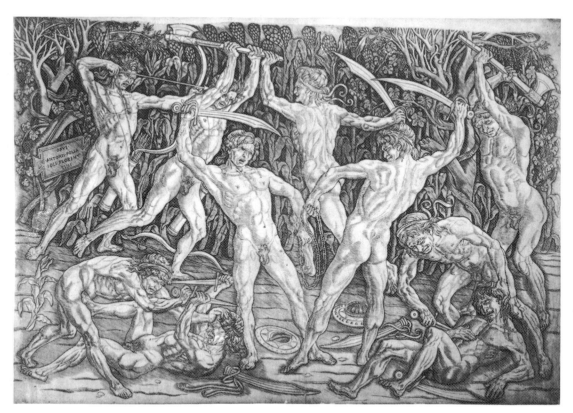

Pl.3 Antonio Pollaiuolo, *Battle of the Nude Men* (*c.* 1475?), engraving, London, British Museum

corpses'. It is unlikely that any fifteenth-century artist before Leonardo had the opportunity to carry out dissections of the human figure. However, other methods of anatomical study were available, in addition to surface inspection, most notably the taking of casts from parts or whole live figures. Cennino Cennini outlined the technique required, noting that it 'is very useful and gets you a great reputation in drawing for copying and imitating things from nature ... just as in ancient times'. The artist himself, Cennini recommends, should be prepared for the sake of his art to submit himself to the not inconsiderable discomforts of life casting, which involved being dropped into a shallow bath of wet plaster and then being 'pulled out neatly'.

A number of drawings from the Florentine studios testify to the practice of copying from casts and it may have become a standard procedure in the training of pupils. Verrocchio's studio is reported to have contained casts of torsos and limbs 'for the purpose of copying' (Vasari), and Leonardo's earliest list of his own works includes 'several whole nude figures, arms, legs, feet and postures' (C.A.324r), which may consist at least in part of studies made in this manner. Judging from his surviving works, Verrocchio's delight in anatomy seems to have been little less

pronounced than that of Pollaiuolo and would probably have seemed as great had we not lost his two most deliberate works of anatomical demonstration: a cartoon of a *Battle of the Nude Gods*, presumably close in type to Pollaiuolo's engraving; and a restoration of an antique sculpture of a flayed Marsyas for Lorenzo de' Medici in which he utilized the natural white veins in a red block of stone to imitate the appearance of sinews.

Even if the scientific importance of the fifteenth-century artist-anatomist has been overrated by some modern historians in their desire to denigrate the medieval tradition of professional medicine, there can be no doubting the intensity of the artists' ambition to portray the structure of the human body as correctly as possible — with obligatory homage to the ancients — and there is no gainsaying their substantial successes in this direction.

Armed with a classical ability to portray the eloquent anatomy of the human figure and with the theoretical science of geometrical perspective, a few of the more intellectually self-conscious of the fifteenth-century artists began to press forward from the throng of artisans (saddlers, tailors, jewellers, weavers, etc.) to be recognized as the equal of the musician, who claimed the cerebral benefits of Pythagorean harmonies, and of the poet, the narrator of great moral tales. Poetry, it should be stressed, performed a very different role from its normal function today. In the hands of Dante and his followers, poetry dealt not only with imaginative 'fictions' and the emotions of the poet, but could also expound great philosophical ideas and even express scientific truth. Leonardo Bruni, probably as great a scholar as has ever been a head of state — he was Chancellor of Florence from 1427 to 1444 — interpreted Dante's poetry as the fruit of universal learning: 'He acquired the knowledge which he was to adorn and exemplify in his verses through attentive and laborious study of philosophy, theology, astrology, arithmetic, through the reading of history and through the turning over of many different books.' Ghiberti, taking his cue from the Roman writings of Vitruvius, laid down a set of comparable requirements for the artist, who should not only master the principles of draughtsmanship but also be conversant with grammar, geometry, philosophy, medicine, astrology, optics, history, anatomy and arithmetic. Only by bearing such a heavy burden of intellectual responsibility could the practitioner of the visual arts claim to rival the traditional 'liberal arts' and most especially poetry. Much of Leonardo's career was devoted to demonstrating just this.

We would be mistaken in thinking that all artists of the fifteenth century, even all the major figures, fully shared in this cerebral vision of painting and sculpture as learned knowledge. But a sufficient number had been captivated by the new ideal to ensure that an ambitious young artist of naturally intellectual proclivities, like Leonardo, was inevitably fired by comparable aspirations. Some artists undoubtedly preferred to get on with the job of painting and forget about theoretical discussions. One of

Leonardo's 'adversaries' claimed that 'He does not want so much science, that practice is enough for him to draw the things in nature' (Urb.222r). More than a few may have agreed with Leonardo's contemporary, Mariotto Albertinelli, who was reputed to have been fed up with all the 'muscles, foreshortening and perspective', though none of Albertinelli's colleagues appear to have taken his extreme step of abandoning painting (temporarily) to run two hostels. Verrocchio does not appear to have been an author-artist in the Ghibertian mould, but we can be certain that his great professional skills were accompanied by a highly developed sense of the principles of his art; his surviving works show as much.

Verrocchio's aspirations in anatomical representation have already been stressed. He was also admired in his own day as a master of perspective. His sculptural relief in silver for the altar of Florence Baptistery shows a solid grasp of basic perspective in an Albertian manner, and one painting which emanated from his workshop, the *Madonna in Front of a Ruined Basilica* (Plate 4), exhibits a perspective scheme of such complexity that it rivals any contemporary product. Verrocchio himself seems to have devoted most of his own executant powers to the production of sculpture, but as the head of a large workshop he made designs for and oversaw production of works in almost all the available media, including metalwork, terracotta and painting, in addition to the statues and tombs in bronze and marble which provide the basis for his enduring fame. Much of the work of his studio was carried out in response to commissions from the all-powerful Medici family. He was also responsible for the most notable engineering feat of his day, the construction and erection of the huge copper orb on top of the lantern of Brunelleschi's Cathedral dome. Years later, Leonardo still vividly recalled his master's achievement: 'Remember how the ball of S. Maria del Fiore was soldered together' (G.84v).

Nothing is known of Leonardo's education before he entered Verrocchio's studio. As the, albeit illegitimate, son of a notary, he might have been expected to receive a good basic schooling, but we know from his later struggles that he either had received no sustained instruction in Latin or had failed to benefit substantially from his teachers. His education was probably restricted to the basics of numeracy and literacy, as would have been useful in the commercial world. All that is known for certain about his subsequent apprenticeship is that it seems to have officially ended in 1472, at the age of twenty, when he was first debited his enrolment fee in the Company of St Luke. Although historical facts relating to his early career are scarce, the environment he entered in his master's workshop can be reconstructed reasonably fully.

In successful studios at that time, it was customary for a master to use assistants as executants to a greater or lesser degree. These assistants would range from the youngest pupils, aged twelve or so, who would perform the most menial of tasks, to senior 'foreman' pupils who could play a major part in the actual making of finished works. Verrocchio seems

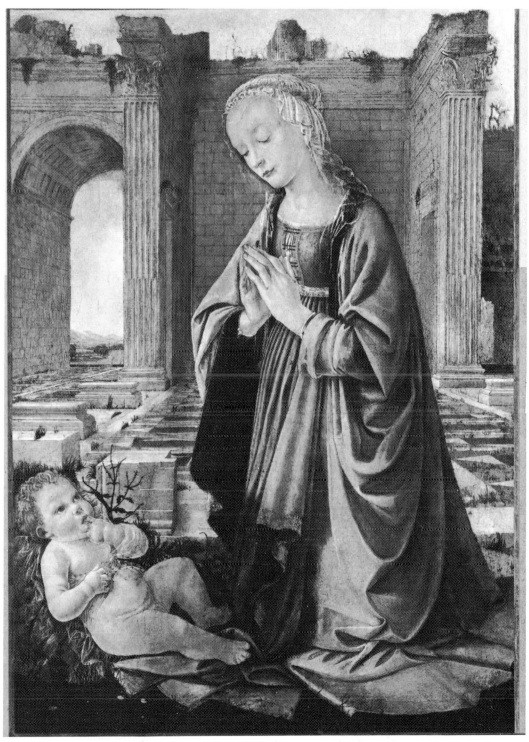

Pl.4 Verrocchio (and workshop?), *Madonna and Child in front of a Ruined Basilica* (*The 'Ruskin Madonna'*) (*c.* 1470-3), Edinburgh, National Gallery of Scotland

to have placed an unusually heavy reliance upon assistants in the sphere of painting; we cannot be certain that any of the products of his workshop were painted wholly by the master himself. During the 1470s the studio was uniquely fortunate in being able to call upon the services of such a remarkably gifted group of young painters as Perugino, Leonardo himself and Verrocchio's most pliable *amanuensis,* the skilled but limited Lorenzo di Credi. Domenico Ghirlandaio, Botticini and Cosimo Rosselli may also have been employed there for short periods. The studio rivalled that of the Pollaiuolo brothers as *the* place to be in the 1470s, for its range of media, the opportunities it presented to bright pupils, the nature of the commissions it received, and above all for the presence of the master himself. The firm of Verrocchio and Co. was finely geared to the steady production of high quality artefacts — in an age which did not expect its artists to be solitary geniuses working erratically upon the unique products of their individual creativity.

Leonardo obviously found in Verrocchio's active workshop a sympathetic environment. Although he could have set up shop independently in 1472, he nevertheless remained with Verrocchio for at least four more years. In 1476, together with various members of the studio, he was accused and acquitted of sodomy. Notwithstanding the acquittal, it cannot be reasonably doubted that his dominant sexual impulse was homosexual, and throughout his life he attracted around him a group of handsome young men of like spirit. Two imperfectly legible lines of writing on a torn sheet from 1478 (Plate 5) suggest the kind of affectionate relationships he established: 'Fioravante di Domenico . . . in Florence is my most cherished companion, as though he were my' It may have been that a special bond of friendship also existed at one stage between the brilliantly attractive student and his unmarried master. If this emotional bond cannot be proved (and it is ultimately of little lasting consequence), his intellectual and artistic affinity with Verrocchio can be more convincingly inferred.

Leonardo's Florentine Products

When Leonardo compiled an inventory of his works early in his career, probably in 1482, shortly after arriving in Milan, not one of the many items would have been out of place in the workshop of Verrocchio (or, for that matter, that of the Pollaiuolo brothers) and many of them show a more than superficial relationship to his master's practice. The list is worth quoting in full for the insights it provides into his early interests:

> Many flowers copied from nature; a head, full face, with curly hair; certain St Jeromes; measurements of a figure; designs of furnaces; a head of the Duke [the late Francesco Sforza of Milan?]; many designs of knots; 4 drawings for the picture of the Holy Angel; a little narrative of Girolamo da Fegline; a head of Christ done in pen; 8 St Sebastians;

Pl.5 *Studies of Heads and Machines* (1478), pen and ink, Florence, Uffizi

many compositions of angels; a chalcedony; a head in profile with beautiful hair style; certain forms in perspective; certain gadgets for ships; certain gadgets for water; a head portrayed from Atalante, who raises his face; the head of Girolamo da Fegline; the head of Gian Francesco Boso; many necks of old women; many heads of old men; many complete nudes; many arms, legs, feet and postures; a Madonna finished; another, almost finished, which is in profile; the head of Our Lady who ascends to heaven; a head of an old man with an enormous chin; a head of a gipsy; a head wearing a hat; a narrative of the passion made in relief; a head of a young girl with plaited tresses; a head with a head-dress (C.A.324r).

The parallels with Verrocchio's practice in particular and the 'scientific' aspects of the Florentine tradition are very clear. The 'forms in perspective' were surely the kind of elaborate studies in the foreshortening of objects which Paolo Uccello and Piero della Francesca are known to have made. The possibility that the 'arms, legs', etc. were based upon life casts has already been mentioned, and the list indicates that he unexceptionally

made studies from the living model, focusing with characteristic intensity upon a particular subject until it was literally treated from every angle. In an Albertian vein, his investigation of anatomy was associated with the doctrine of proportions as recorded in the 'measurements of a figure'. He already showed a physiognomic fascination with the heads of old people, and the 'many necks of old women' were probably occasioned by the clarity with which tendons are visible in scrawny people of advanced age. Studies of heads, which play a prominent role in the list, may have been especially popular in the Verrocchio shop, since we know that the great sculptor made two bronze relief heads in profile of the ancient leaders, Alexander and Darius. These heads are reflected in a number of workshop versions in marble and terracotta. The belligerent, leonine warrior *all' antica*, displayed in profile like an Emperor on a Roman coin, is the subject of the most highly finished of all Leonardo's early drawings (Plate 6), a drawing which pays homage to Verrocchio on every level, from the superb vitality of classical detail to the marvellous vigour of characterization. A variant of this 'nutcracker man' (to quote Clark's inspired epithet) appears on the damaged sheet on which he had recorded his affection for Fioravante, juxtaposed with a gentle youth of similarly Verrocchian pedigree (see Plate 5). The gruff warrior, sometimes parodied, sometimes enobled, became a leitmotif of Leonardo's drawings, regularly set in sharp counterpoint to the Grecian youth who haunted his creator with equal persistence. The physiognomic types invented by Verrocchio had struck a note of deep and continuing resonance within his pupil's psychology.

Another of Leonardo's obsessions, his love of intertwined curves in knots and plaited coiffures, emerges strongly from the inventory, and is no less directly related to motifs in his master's work. Such patterns seem to have been all the rage in the late fifteenth century — and not only in Florence. Domenico Ghirlandaio, who may have worked with Leonardo in the workshop for a time, had acquired his family name from his father's design for a woven garland (*ghirlanda*) worn as a head decoration by young ladies. Verrocchio's own virtuosity in this field is displayed most notably in a beautiful drawing of a woman's head with elaborately dressed hair (Plate 7), which is alone an eloquent testimony to the quality of his draughtsmanship and to the lessons he could teach his gifted pupils.

The first entry in the inventory, 'many flowers copied from nature', suggests a comparably detailed devotion to the world of nature. Such devotion stands in contrast to the dominant aspirations of the pioneers of Florentine painting, Giotto and Masaccio. Rather, it was a major feature of the persistent late Gothic tradition, represented most brilliantly in fifteenth-century Italy by Gentile da Fabriano and Pisanello, whose animal draughtsmanship certainly influenced Leonardo. Moreover, in the last quarter of the century in Florence, detailed naturalism had been given an irresistible stimulus by imports of Netherlandish painting, most spec-

Pl.6 *Study of a Warrior in Profile* (*c.* 1476), metalpoint, London, British Museum

Pl.7 Verrocchio, *Study of a Lady's Head with Elaborate Coiffure* (c. 1474),
black chalk, bistre and white, London, British Museum

tacularly represented by the magnificent altarpiece by Hugo van der Goes,
ordered for S. Maria Nuova by a somewhat unreliable agent of the Medici
bank in Bruges, Tommaso Portinari. The most impressive of Leonardo's
'flowers copied from nature' surviving from this early period is the beauti-
ful pen and wash drawing of a lily (Plate 8), which may actually have been
used in the preparation of a painting, since its outlines are pricked through
for precise transfer. We can even guess what kind of painting it would have
been; it would almost certainly have featured the Virgin, since the lily was
symbolic of her purity, and would probably have been an *Annunciation* in

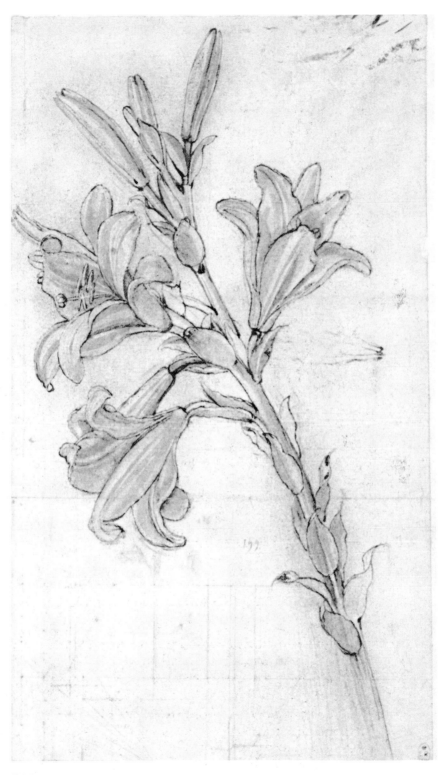

Pl.8 *Study of a Lily (Lilium candidum)* (*c.* 1473), black chalk, pen and ink and wash, Windsor, Royal Library (12418)

which the Angel would have held the flower in the manner usual in Florentine pictures of this event.

An *Annunciation* by Leonardo of just this kind has survived (Plate 9), and was originally housed in the Convent of Monte Oliveto. We can be sure that Leonardo participated in the design of this picture in view of his characteristically rhythmic drawing for the angel's flouncy sleeve bound by a spiralling ribbon (Oxford, Christ Church). The painted lily can also be recognized from Leonardo's drawing, though it differs tantalizingly in its precise details. The *Annunciation* as a whole is undeniably gauche in its failure to achieve a fluent integration of the main compositional components. Some of the individual elements are transparently derivative — the fine but distracting reading desk is an assembly of motifs from Verrocchio's repertoire, and the Angel's delicately precious profile exudes a distinct air of Fra Filippo Lippi — but other of the separate parts breathe a unique quality of originality and intensity of visual challenge. Many of the components are minor triumphs in isolation: the crisp, Netherlandish conviction of white oil paint in the waxy petals of the lily, worthy of Hugo van der Goes; the lush carpet of plants rippling with a superabundance of natural vitality within the *hortus conclusus*, the 'enclosed garden' symbolic of Mary's virginity; the remorselessly sculptural rendering of the Angel's and Virgin's outer garments; the neatly precise perspective of the Virgin's house and tiled pavement, constructed with scrupulous care in a series of lines inscribed into the gesso priming of the panel; and the sharp profiles of the middleground trees set against the misty glimmer of the distant harbour scene. But the parts do not add up to a convincing whole. It is the picture of a young man striving to impress, just a little too hard, and losing sight of the wood for the trees. Its bittiness is strangely akin to the effect of reading the inventory itself. Yet for all its awkwardness it is a highly

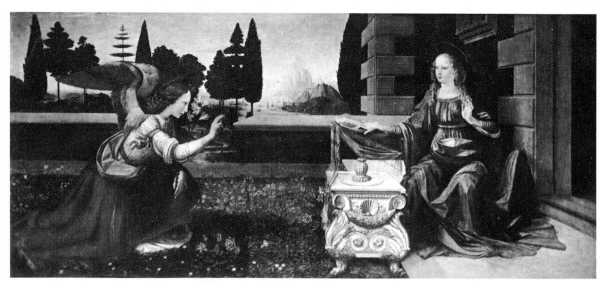

Pl.9 *Annunciation* (*c.* 1473), Florence, Uffizi

individual not to say eccentric picture, conveying a strange sense of originality.

The inventory also records Leonardo's early involvement with portraiture and although none of the items on the list can now be identified, there is one surviving portrait which evinces the same remorseless, unblinking attention to natural effects apparent in the *Annunciation*, namely the *Ginevra de' Benci* (Plate 10). Here, a major focus of his intense depiction is the telling textural contrast between the sensual sheen of her silky hair, releasing its groomed tidiness into a series of springy vortices, and the spiky screen of juniper — the bush which provides a punning reference (Italian: *ginepro*) to her name. The portrait is almost oppressively direct, verging upon the obsessive, in the manner of a young artist who is prepared to make no concessions in his desire to describe natural surfaces. He is saying, almost shouting, 'This is how it is', although this is not to say there are no references to established formulae. The unrelaxed intensity of visual concentration is in itself strongly reminiscent of Netherlandish art, above all the manner of Jan van Eyck's meticulous follower, Petrus Christus.

The presentation of the figure is hieratically similar to the kind of sculpted portrait bust which Verrocchio produced. We know from the way in which the heraldic motif on the reverse has been severed that the panel has been cut at the bottom, with a resulting loss of up to a third of its original height. The lost portion may well have permitted the inclusion of the sitter's hands, perhaps holding some attribute such as a ring. The figure would originally have borne an even closer resemblance to Verrocchio's bust of a *Lady holding Flowers* (Florence, Museo Nazionale del Bargello) than it does in its truncated state. There is a certain incongruity in the way in which the sculptural severity of the composition and the incisive linear curves of her garments are combined with the optical effects of intangible light and soft texture which only oil paint can suggest. Later, Leonardo devoted much effort to debating the *paragone*, the comparison of painting with the other arts, in which he repeatedly advocated the superiority of painting over sculpture; here some of the arguments appear to be precociously rehearsed and left unresolved within a single painting. Like the *Annunciation* it is an awkwardly original picture, leaving the spectator with something of that creeping sense of subcutaneous unease which permeates his later attempts to evoke the inner spirit of nature.

Clearly both paintings originate from the early part of his career; but when? If we are fortunate enough to know the circumstances of the commissioning of a Renaissance portrait, we often find that it was occasioned by a special event in the sitter's life. Ginevra, daughter of Amerigo de' Benci, was born into one of the richest banking families in Florence, and mixed in the highest circles. A poetess herself, she was the subject of two sonnets by Lorenzo de' Medici, and featured from 1475

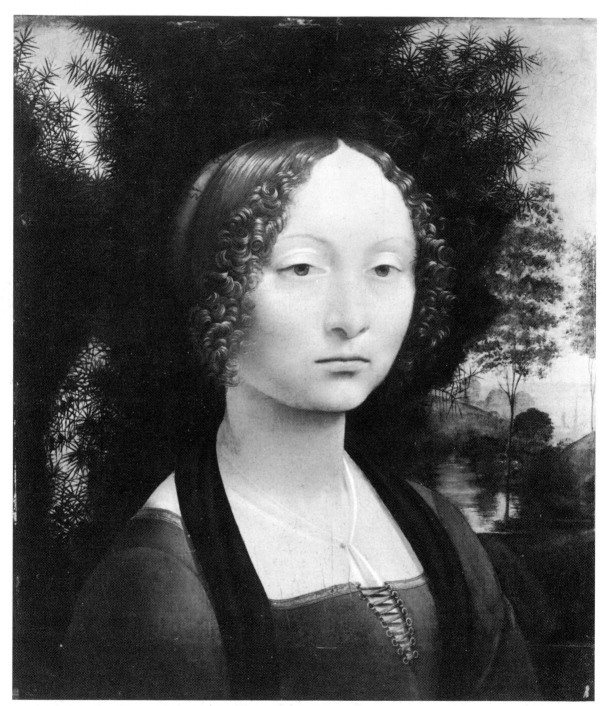

Pl.10 *Ginevra de' Benci* (1474?), Washington, National Gallery of Art

onwards as the chaste but responsive recipient of the Venetian ambassador's love in a series of poems composed in the Medicean circle. The tone of these panegyrics is similar to that of the motto on the reverse of the panel: *'Virtutem forma decorat'* ('Beauty adorns virtue'). She had been married to Luigi di Bernardo Niccolini in 1474, at the age of sixteen. Perhaps the strain of her enforced maturity is reflected in the taut (and taught) self-composure of her bearing. Her marriage or betrothal seems the most likely occasion for the portrait, and in the absence of other information about Leonardo's early paintings, 1474 will serve as its hypothetical date. It would thus have been painted within Verrocchio's studio, but by a master whose St Luke registration two years earlier indicated that he was in a position to accept independent commissions. This fits with the style.

We do in fact have some definite idea of what Leonardo was capable of in his early twenties. He inscribed the date, 'day of Holy Mary of the Snows on the 5th August 1473' on a remarkable pen drawing of a Tuscan panorama (Plate 11). It is a record unique up to that time. It means quite simply (if simply is not the wrong word for such an innovation) that this is what the artist saw on this particular day.

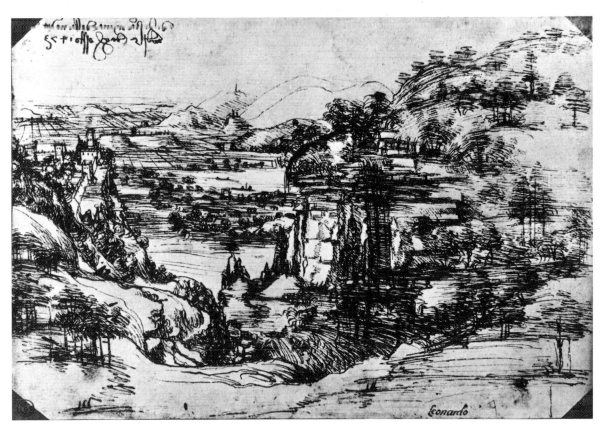

Pl.11 *Study of a Tuscan Landscape* (1473), pen and ink, Florence, Uffizi

Anyone with a knowledge of the countryside around Vinci can readily understand the spirit in which this drawing was made. The precipitous hillsides in the dated view are altogether comparable to the steep slopes around Vinci, which plunge down to a similarly distanceless plain. Whether or not the drawing was actually made on an excursion in the hills around Vinci, he was clearly responding to effects which recalled his earliest experiences of nature's magnificence. Throughout his life Leonardo appears to have retreated periodically from the cities, seeking inner nourishment from the unadorned vitality of nature. In this vein, he later told a heart-felt parable of a stone which was 'perched on the edge of a delightful grove ... surrounded by plants and flowers of diverse colours' and which foolishly wished to join its companions on a stony road:

> ...letting itself fall, it ended its rapid descent amongst those desired companions. When it had been there for some time, it found itself in continual distress from the wheels of the carts, the iron hooves of the horses, and the feet of passers by. One rolled it over; another trod on it; sometimes it raised itself up a little as it lay covered with mud or the dung of some animal, but it was in vain that it looked up at the spot whence it had come as a place of solitude and tranquil peace. So it happens to those who leaving a life of solitary contemplation choose to dwell in cities among people of infinite evil (C.A.175va).

Unlike the inert stone, Leonardo could still exercise his option to climb again into his native hills. The drawing reads like a visual sigh of relief on escaping from the Florentine cauldron in August.

The shimmering transience of the landscape is achieved in a graphic technique adapted only slightly from an existing style in Florence, and the bird's-eye view is akin to the landscapes which Pollaiuolo had developed from Netherlandish precedents. But these conventions are revitalized. The drawing breathes an unrivalled sense of vital flux: everything stirs, rustles and flickers under the suggestive touch of his pen.

This unique suggestiveness is shared by the glimpse of a lakeland landscape behind Ginevra, its fluid radiance counterpointed by the barbed sharpness of the overhanging juniper sprigs. To achieve this effect in the oil medium of the portrait, which is of a quite different order of suggestiveness from the graded softenings of distance in Netherlandish oil painting, he has resorted to what appears to have been a new technique for Florence: he pressed his fingers into the wet paint to blur the precision of his brush-drawn shapes. This seems to have been the instinctive gesture of an artist seeking a new means to create an effect which had hitherto eluded brush technique. One is reminded of Pliny's story of Protogenes, a contemporary of Apelles, who was so frustrated at his inability to paint the foam on a dog's mouth that he hurled a paint-filled sponge at his picture, inadvertently achieving the desired effect. There is evidence that Giovanni Bellini in Venice some years earlier had used rags soaked in paint to

capture the variegated effects of marble in his paintings but there is nothing comparable in previous Florentine art.

Returning to the inventory, we may note that the only two items which definitely refer to paintings rather than drawings are the two Madonnas: 'one finished' and the other 'almost'. Perhaps these were the two Madonnas which he recorded on the page dedicated to Fioravante and containing the 'nutcracker man'/ Grecian youth confrontation: 'D[ecem]ber 1478, I started the two Virgin Marys' (see Plate 5). We also know that in January of that year he received an important commission from the Florentine government for an altarpiece depicting the Madonna and Saints, to be placed in the Chapel of St Bernard in the Palazzo Vecchio. However, after receiving a first payment, the project seems to have lapsed, until the commission was taken over by Filippino Lippi and completed seven years later. At least five Madonna projects from this period are traceable in his drawings and surviving paintings: drawings for a Madonna and Child with a cat, and for a Madonna and Child with the infant St John; the paintings of the *Madonna with a Vase of Flowers* (Munich) and the so-called *Benois Madonna* (Leningrad); and a beautiful study of a woman's head (Paris) (Plate 12) which relates closely to a painting of the Child suckling, the *Madonna Litta* (Leningrad,

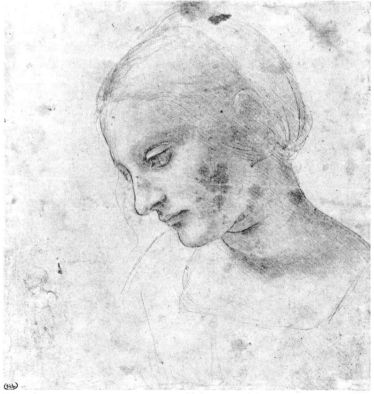

Pl.12 *Study for a Madonna's (?) Head* (c. 1481), metalpoint, Louvre, Paris

Hermitage). The painting of the *Madonna Litta* is so awkward that it can hardly have been executed by Leonardo himself — even allowing for the oddness of his early works — but it is reasonable to suppose that its general format contains a reflection of the 'almost finished' Madonna 'in profile' of the inventory.

In contrast to the laboured painting of the *Madonna Litta*, the drawing shows that rare combination of strength and delicacy which only a few of the greatest draughtsmen have achieved. The subtle nuances of modelling and contour which Verrocchio achieved in sculpture, and for which Leonardo could have found further inspiration in the work of the underrated Desiderio da Settignano, have here been translated with apparently effortless ease on to the two-dimensional surface of the paper. And, at a far remove from the mute head of the Virgin in the *Annunciation*, there emerges that double sense of implied communication with another being and inner emotional life which characterizes all his later Madonnas.

The increasing fluency with which he was able to treat emotional relationships is perfectly illustrated by the two surviving Madonna paintings of this period. The earlier of the two, the *Madonna with a Vase of Flowers* (Plate 13), shares something of the *Annunciation's* myopic focus upon unremitting detail, as in the preternaturally crisp posy of blossoms. It also bears more clearly than any other painting by Leonardo the stamp of 'Verrocchio and Co.'. The master's drawing of a woman's head (see Plate 7), already noticed in connection with her knotted coiffure, could almost be seen as a preparatory study for Leonardo's picture. This may provide some insight into the effective pooling of creative resources which occurred in the greatest workshops — of which Verocchio's was certainly one. By contrast, the *Benois Madonna* (Plate 14) represents the stage when he was beginning to separate himself from the workshop, certainly in the artistic sense and probably in the material as well. Everything, even in the present damaged state of the painting, is now more unified: the emotional focus is a more positive vortex for lines of compositional force; the light has a directional flow which emphasizes the forms in space rather than catching upon objects scattered across the picture surface; the draperies have gained a consistently rhythmic quality; and the figures respond with their whole being to their intense relationship.

These unified effects are the result of one single cause — a revolution in drawing style. This revolution is most vividly exemplified in the series of drawings for a *Madonna, Child and a Cat* (Plates 15 and 16), probably dating from shortly after the *Benois Madonna*. The ostensible reason for the cat's presence is a legend which told of a cat giving birth at the time of the Nativity. Leonardo relieved the cat of its purely accessory function and literally wove it into the emotional interplay of the holy figures. He did this in a series of brilliant drawings, scribbled in a frenzy of creative impatience. The cat is in turn seized, cuddled, stroked and half-choked,

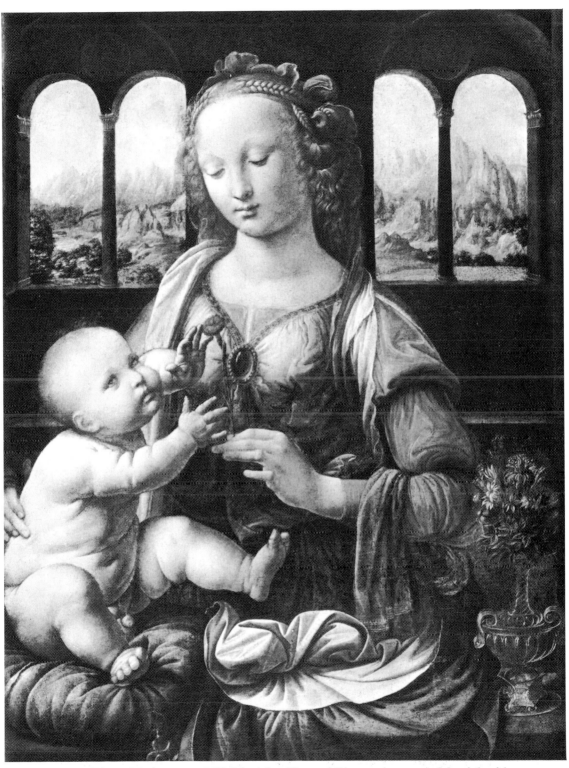

Pl.13 *Madonna and Child with a Vase of Flowers* (*c.* 1475), Munich, Alte Pinakothek

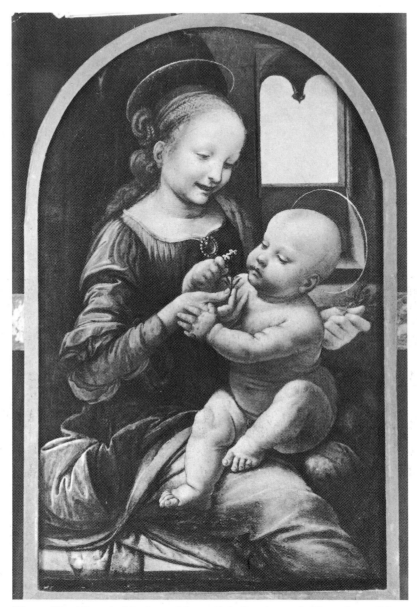

Pl.14 *The 'Benois Madonna'* (*c.* 1480), Leningrad, Hermitage Museum

reacting to each experience with perfectly characterized, feline agility. What appears to be the final stage in the composition is represented on the sheet in the British Museum (Plate 15), and is the most remarkable of all. Never before had any artist worked out his compositions in such a welter of alternative lines. The pattern-book drawing techniques of the fourteenth and fifteenth centuries, which Verrocchio had relaxed in some measure, have here been overthrown in a 'brain storm' of dynamic sketching. Such flexibility of preparatory sketching became the norm for later centuries; it was introduced almost single-handedly by Leonardo.

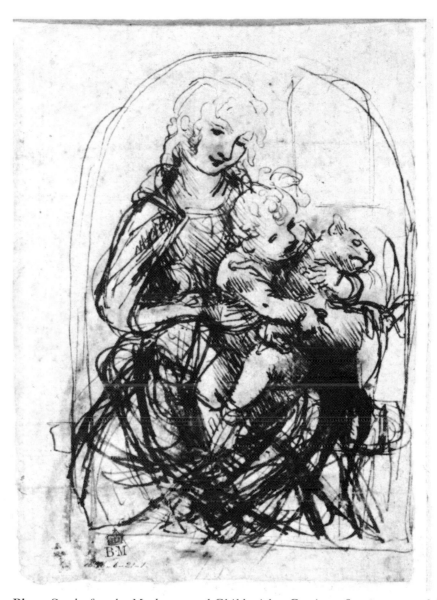

Pl.15 *Study for the Madonna and Child with a Cat* (*c.* 1480-1), pen and ink, London, British Museum

This pen drawing in fact became so confused that he used a stylus to press its salient points through to the other side of the paper (Plate 16), where the brain storming began all over again. Finally he resorted to a dark wash to clarify whatever was emerging most satisfactorily from the maelstrom. The significance of this new drawing style cannot be exaggerated; its effect upon the emotional and formal dynamics of a finished painting is immense. Just turn for a moment from the supple interplay of the *Benois Madonna* to the mechanical gestures of the Virgin in the *Annunciation*, and the revolution will be immediately apparent.

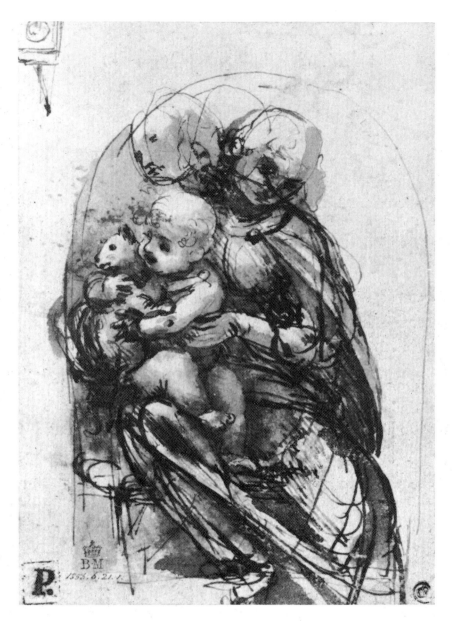

Pl.16 *Study for the Madonna and Child with a Cat* (*c.* 1480-1), pen and ink and wash, London, British Museum (reverse of Plate 15)

In looking at this series of drawings we have taken Leonardo to a point just outside the immediate ambience of Verrocchio. But we have not even mentioned the Verrocchio painting which generally provides the starting-point for discussions of the relationship between master and pupil, the *Baptism of Christ* (Plate 17). This omission is deliberate. Although the left-hand angel was convincingly attributed to Leonardo at an early date, and might seem to represent the *first* instance of his individual skill

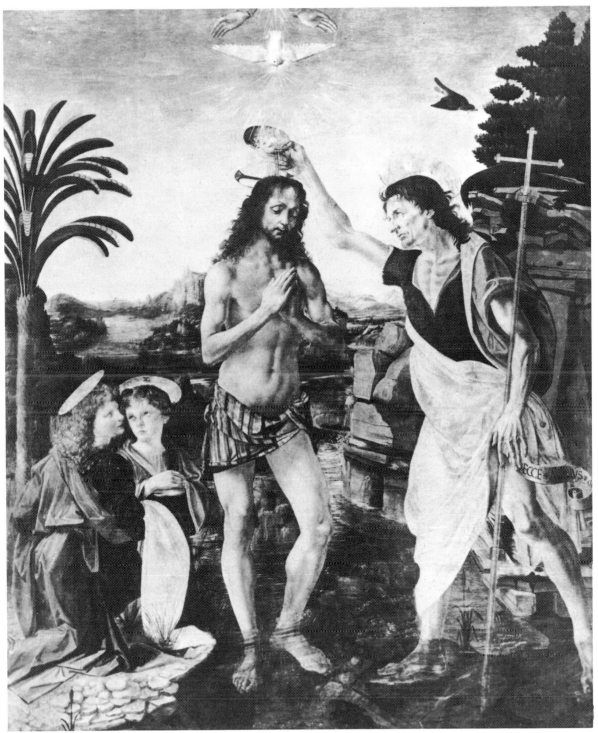

Pl.17 Verrocchio and workshop, *Baptism of Christ* (*c.* 1476), Florence, Uffizi

emerging from his master's workshop about 1472, I am not at all sure that matters are as simple as that. If what I have said so far is reasonably correct, his style about 1474 in the *Ginevra* and (earlier?) *Annunciation* was characterized by formal stiffness and vital detail. I do not find this combination in the *Baptism* angel. The detail is vital, to be sure, but the movement of the figure displays a perceptible loosening of the mechanistic rigidity which typifies the other two paintings. The turn of the head on the shoulders, the *profile* barely *perdu*, and the intensity of upward gaze are features of his drawings in the later 1470s — the youth in the Fioravante drawing of 1478 is a good example (Plate 5) — and can be paralleled in the 1482 (?) inventory by 'a head portrayed from Atalante, who raises his face'. Moreover, the almost imperceptible softening of the pure profile is similar to the drawing for the *Madonna Litta*. The underlying complexity of the angel's pose, with the left knee thrust forward as a counterweight to the right shoulder, is of a quite different order from anything in the *Annunciation*.

The treatment of detail in the angel of the *Baptism* shows a comparable progression from the *Ginevra*. More and more attention is paid to the evocation of the impression of light upon objects and less to the linear description of their actual form. The hair is less a series of gleaming filaments and more a sparkling cascade of radiant curls in which suggestion and definition are inextricably mingled. The glass hemispheres on the band across the shoulder are described entirely in terms of reflected and refracted light in a manner which would do credit to Jan van Eyck. And the side of the face is depicted in nuances of melting tone. This is not to overlook some continued awkwardness in the relationship between the fluid elements of bodily posture and the stiffly angular folds of drapery — the drapery surely studied from cloth set in plaster-of-Paris in the way described by Vasari. But the overall effect is more developed than the *Annunciation*.

As a whole, the *Baptism* is a brilliant but uneven picture. The main protagonists are constructed in Verrocchio's best, 'anatomical' manner and are undeniably impressive, but the middle ground vegetation is unrelievedly routine in conception and the palm tree is horribly lumpen. However, the distant view of lakes with tumbling cascades and pointed mountains shrouded in atmosphere can only be the highly individual product of the artist of the 1473 landscape drawing, Leonardo himself. It is also possible that his distinctive touch in the oil finish of the tempera picture may be present in the final surface of Christ's body and in the foreground water which eddies so convincingly round Christ's ankles. The distant landscape suggests that Leonardo's contribution to the *Baptism* occurred about 1473, but the angel seems to require a later date, probably about 1476, towards the end of his prolonged stay in the workshop. The evidence relating to the angel is the more substantial and I am inclined to take 1476 as a feasible if approximate date for Leonardo's work on the

picture. There can be no definite conclusions on this question.

The picture of Leonardo's early paintings which has emerged from this brief survey would be thrown into much clearer perspective if we possessed a better idea of the history of painting within Verrocchio's studio as a whole. At present, it appears probable that the *Annunciation* was painted in the early 1470s, at a time when there was no definitive painting style in the studio, in spite of Verrocchio's maturity as a sculptor. What Leonardo has done is to adapt sculptural motifs from his master's style for the basic construction of his work and then to cast around among a variety of fifteenth-century painting styles, Florentine and Netherlandish, for a means of representing the colours and details. The *Ginevra* stands in a slightly more mature position, and the Munich *Madonna* more so again. We may surmise that as the volume of paintings emanating from the studio increased, so Verrocchio's own style as a designer of paintings matured and a more consistent workshop style began to emerge; the Munich *Madonna* is a product of this phase. This would explain why the relationship between Verrocchio's drawings and Leonardo's paintings is closer about 1475 than it had been a few years earlier.

If Leonardo's early development as a painter is hard to define with precision, his role as a sculptor within the studio is even more obscure. The 'designs for furnaces' in the inventory may indicate an early interest in the technology of bronze casting and one item specifically refers to a piece of sculpture: the 'story of the passion, made in relief', presumably modelled in terracotta. In his letter of self-introduction to Ludovico Sforza he claimed mastery over marble sculpture as well. No pieces of sculpture by Leonardo appear to have survived, but this should not lead us to underestimate the importance of sculpture in his early practice of art or in generally forming his artistic vision. Few of the items in the list concern pursuits outside a sculptor's range. That he considered himself to be proficient as a sculptor at this time, and expected to be so considered by others, is quite clear. And what is really important is that his whole vision of form in space was fundamentally conditioned by his training and early practice in the workshop of a master-sculptor. Verrocchio's role in pioneering spatial freedom in sculpture has rarely been adequately acknowledged by historians and probably never received its full due from his immediate successors, with the avid exception of Leonardo himself who paid visual homage to his master's talent again and again, not merely borrowing specific motifs from Verrocchio (in the manner we have seen), but adopting Andrea's sense of spatial movement in a profound manner.

When the opportunity presented itself, as in his design for the bronze *Putto with a Dolphin* on a fountain in the garden of the Medici villa at Careggi (Plate 18), Verrocchio was prepared to repudiate the automatic expectation that a statue would possess a clearly defined main viewpoint

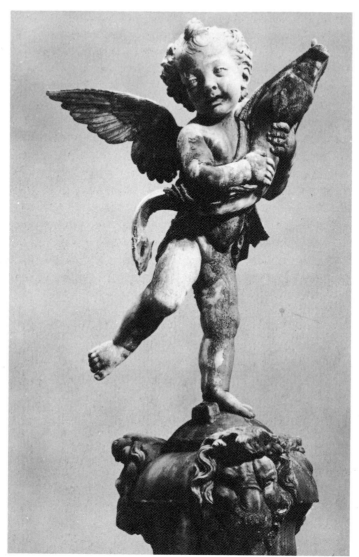

Pl.18 Verrocchio, *Putto with a Dolphin* (*c.* 1470), Florence, Palazzo Vecchio

from which it should be most satisfactorily seen. Verrocchio has turned the putto's head away from the axis of the torso, setting up a turning motion which is strongly amplified by the right leg and superbly underlined by the serpentine spiral of the fish's tail. The spectator is thus invited to move around the sculpture, or rather around the bowl of the fountain at the centre of which it originally stood. A sequence of captivating patterns of form in space are continuously presented. The spout of water which the sculptor intended the putto to 'squeeze' out of the mouth of the squirming fish would have rounded off this fluid symphony of movement, as the water trickled over the plump limbs gleaming in the sun. The effect must have been sparkling, both visually and intellectually.

The first sculptural projects by Leonardo for which drawings survive date from after his first period in Florence, but they show very definite signs of lessons of spatial control well learned in Verrocchio's workshop. Among the most popular motifs in Florence during Leonardo's youth were busts of young children in marble and terracotta, sometimes identifiable as the young St John the Baptist (the patron saint of the city). Vasari records casts of 'children's heads, executed like a master' by Leonardo, and, although no such pieces are now known, studies have survived for what was probably a 'Giovannino' ('little John'). The drawings on two sheets at Windsor (Plate 19), dateable to the 1490s, if not earlier, show the complete bust from the side — the sharp cut-off at the bottom confirms the purpose of the drawing — and the torso from back and front. Compared to Verrocchio's exuberant fountain piece, this sober bust is necessarily less fluent in its rhythmic transitions from one viewpoint to another, but the essential axiality of Leonardo's image has not prevented him from sharing his master's keen concern with the appearance of a piece of sculpture from more than one aspect.

By this system of 'architectural' surveying from three viewpoints, he could control and describe every nuance of three-dimensional form. Its earliest known application occurs in a drawing of a horse's head at Windsor (W.12285), dating at the latest from about 1481, which appears to have been drawn from a sculptural model, probably ancient Roman, rather than a living animal. This rather rigid system of two or three right-angle views, entirely appropriate for a static bust with frontal gaze, could be relaxed when the occasion demanded, as when he was designing the great equestrian statue of Francesco Sforza in Milan — if I may be allowed to anticipate evidence from a later period. In general, the horses for this sculpture were studied in profile from their most characteristic aspect (i.e. from either side) in keeping with his belief that 'the infinite boundaries of a figure in the round can be reduced to two half-figures'. But his instinctive absorption of Verrocchio's fluid system of design led him on a number of occasions to move irresistibly around the form, either as if looking at it from diverse viewpoints, or as if the object is turning in his hands to present a 'cinematographic' sequence of views. Four studies of the raised foreleg of a horse in the Budapest Museum (Plate 20) describe from right to left (as a left-hander Leonardo invariably arranged sequential drawings in this manner) the continuous turning of the limb from outer profile to inner profile. How little this amazing vision of form in space was understood even by his close followers is shown by a copy at Windsor (W.12299) in which three of the legs have been rearranged in the wrong sequence. In his late anatomies, this instinctive technique was to be intellectually developed into a system in which eight regularly spaced views were to be displayed in complete continuity (Plate 80).

There is no evidence to suggest that Verrocchio made multi-viewpoint drawings. In the absence of such studies we can only conclude

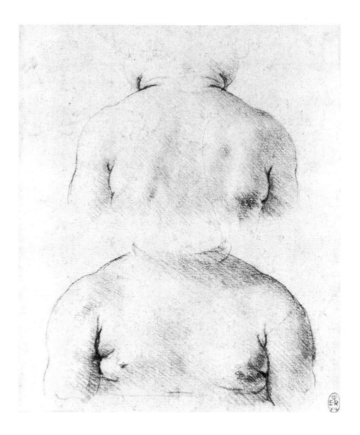

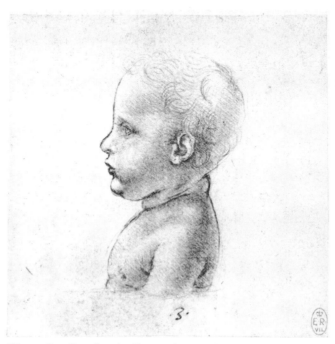

Pl.19 *Studies for the Bust of an Infant* (*c.* 1495), red chalk, Windsor; Royal Library (12519 and 12567)

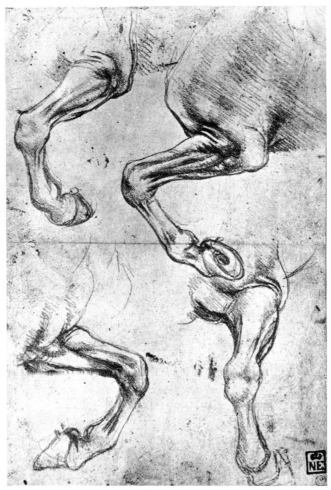

Pl.20 *Four Studies of a Horse's Foreleg* (*c.* 1490), metalpoint, Budapest, Museum of Fine Arts

that when Leonardo came to make *drawings* of figures he formulated the graphic equivalent of his master's *sculpture*. Probably the most comprehensive instance of Verrocchio's sense of spatial fluidity re-emerging in his pupil's drawings occurs in a set of eighteen or so studies of a woman's head and shoulders on a single page at Windsor (Plate 21), composed about 1478 at the time of his 'two Virgin Marys' and probably associated with the project for one of them. The cast of the head and neck on the shoulders is transformed mellifluously while the viewpoint moves around the subject continually exploring fresh combinations of form, starting with the more or less frontal aspects suitable for the Madonna and ending with back views which do not possess any directly preparatory function. The whole page conveys an impression of sheer delight in the infinite possibilities of contour and rhythm in the movement of the human form in space. This delight was obviously shared by master and pupil alike.

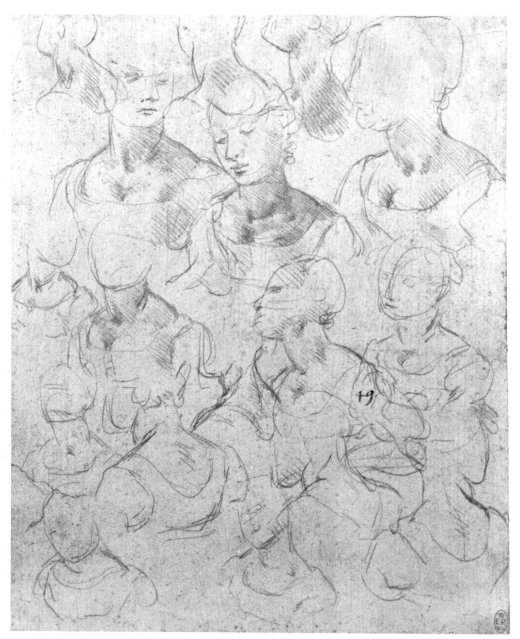

Pl21 *Studies of a Woman's Head and Shoulders* (*c.* 1478), metalpoint, Windsor, Royal Library (12513)

All the various elements we have seen contributing to the formation of 'Leonardo da Firenze' (or 'Leonardo del Verrocchio') are gathered together and transcended in the great climax of the period, the *Adoration of the Magi* (Plate 22). The unfinished *Adoration* is the only surviving painting before his move to Milan which can be associated with a known commission.

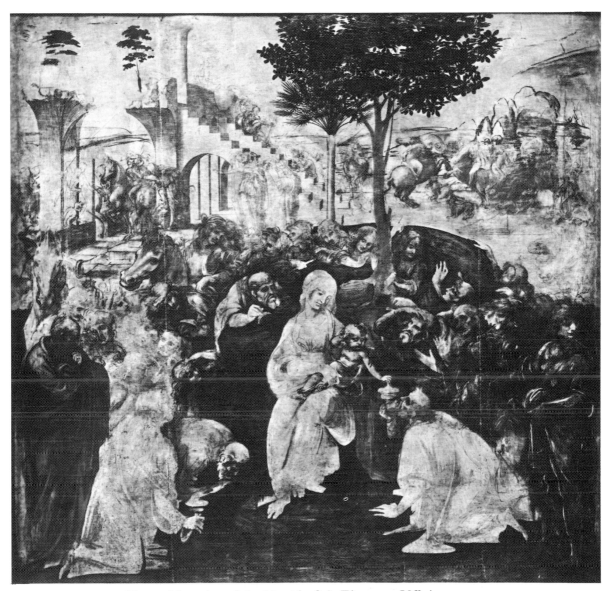

Pl.22 *Adoration of the Magi* (1481), Florence, Uffizi

In 1479 a saddle manufacturer's endowment for the monastery of S. Donato a Scopeto, just outside the city walls, provided for the commissioning of a painting for the High Altar and a dowry for his granddaughter. Leonardo's father was the notary for S. Donato and may have played an important role in arranging for Leonardo to assume responsibility for painting the altarpiece — and responsibility for the provision of the young lady's dowry! The general contract (the specified subject is not recorded) was drawn up in March 1481, with a 24–30 months delivery date. Four months later we learn that unhappily he had defaulted in respect of his obligations to ensure payment of the dowry, pleading inadequate funds,

and the unfinished state of the painting testifies to his failure to fulfil the other part of the contract. Interim payments were made up to 28 September 1481, after which we hear no more of his work on the painting. The monks were not to receive their altarpiece until Filippino Lippi painted an *Adoration of the Magi* for them some fifteen years later.

The story of the Magi had gained special popularity in Florence, not least through the coincidence of Christ's Adoration by the Kings and his Baptism on the same day in the Ecclesiastical calendar — 6 January — and the Baptism, of course, was *the* event in the life of St John, the city's patron saint. The *Compagnia de' Magi,* a religious association of laymen favoured particularly by the Medici family, regularly organized a spectacular procession on the joint feast day of the Epiphany and Baptism, descriptions of which bring vividly to mind the richly processional qualities of painted *Adorations* in Renaissance Florence, most notably the gorgeous pageant of Gentile da Fabriano's 1423 version and also the parade of adorers teeming through the archway in Fra Filippo Lippi's *tondo* (Plate 23). Such a supporting cast of 'thousands' is nowhere justified by the Biblical account, although a Franciscan theologian in the fourteenth century (known as the pseudo-Bonaventura) had envisaged the 'three kings arriving with a great crowd and a noble retinue'. Leonardo's earliest drawings specifically on the theme of the Magi — he was also devising schemes for an *Adoration of the Shepherds* in connection with this or a slightly earlier project — show his attachment to this populous type of presentation.

Of the preparatory drawings which survive for the *Epiphany* only one relates to the whole composition (Plate 24), and this is certainly preparatory in a very preliminary sense, representing an early stage within his inventive processes. The frieze of figures, already animated by an unusual intensity of reaction, is reasonably coherent in itself (if somewhat overweighted to the right), but the complex background has been arbitrarily inserted at a disconcerting angle and with an awkwardly high viewpoint. His intention in adding the background scene is clear; he was aiming for that combination of classical ruins and processional clamour familiar from Filippo's *Adoration.* The sketchy trumpeters on the right contribute an additional noise, probably on Botticelli's precedent. The surviving series of subsequent studies is obviously only a fraction of the original number, but it does provide a good insight into the extreme fluidity of his creative methods, as he moulded this ill-integrated composition into an image of surging coherence. They show that the painting's format never settled in his mind into a fixed pattern which could be systematically realized in a series of orderly steps in the normal manner. The flow of his thought cascaded onwards in a rough and tumble of ideas, sometimes splashing off in unexpected directions — unexpected, we may suspect, even to Leonardo himself. As he manipulated a series of conversing figures, extracted from the main group, so the image of an argumentative *Last Supper* floated prematurely into his vision (Plate 25), while the equestrian activities of the

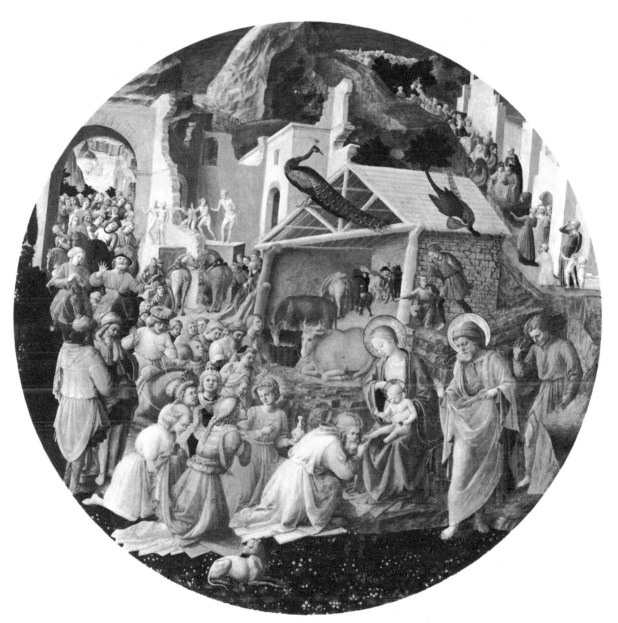

Pl.23 Filippo Lippi (and Fra Angelico?), *Adoration of the Magi* (*c.* 1455), Washington, National Gallery of Art, Samuel H. Kress Collection

background were momentarily transformed into St Georges or dragon fights.

This fluency not only affected the formal business of arranging a composition; it involved meaning as well. The bewildered figure holding a staff at the right of the compositional study is recognizable as Joseph — portrayed in the kind of unflattering role which was then his lot — but as Leonardo manipulated the pose in separate drawings so he became first a

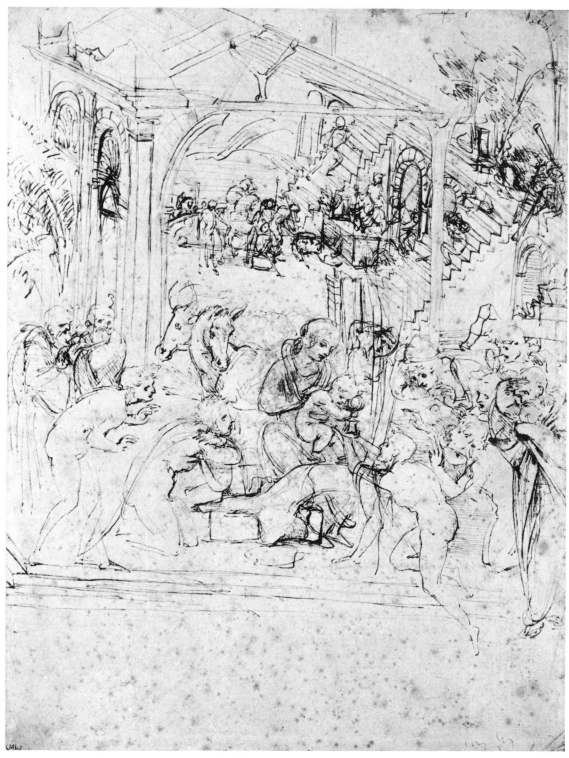

Pl.24 *Compositional Study for the Adoration* (1481), metalpoint, pen and ink, Paris, Louvre

Pl.25 *Studies of Figures in Conversation and Movement, a Madonna and Child, a Last Supper and a Hygrometer* (1481), metalpoint, pen and ink, Paris, Louvre

contemplative Joseph of unusual profundity and was finally abstracted into the 'philosopher-prophet' flanking the painted composition, who is certainly not identifiable as Mary's husband. The intermediate drawing containing the thoughtful Joseph (Paris, Ecole des Beaux Arts) also shows how the secondary spectators have become increasingly animated by their inner dynamos, assuming a dramatic significance as urgent witnesses far beyond their ostensible role as members of the Kings' entourage. This dynamism of form, meaning and expression in his inventive process, placed in the service of his dominant striving for communicative intensity, should be borne in mind when we attempt to identify the individual figures and elements in the panel as it has come down to us. Perhaps the youths above Mary are angels. Perhaps the group pressing in from the right are shepherds. Leonardo's inventive flexibility prevents absolute certainty in such matters.

Two themes, however, are of such centrality that they not only persist but are amplified at every stage in the process of communicative improvisation. The first of these is the obvious one — the devotional reverence of the Kings — but it is more than this. From the first in his mind it assumed something of that centralized, ritual quality of the painting itself, the Virgin becoming a sacred 'altar' at which the Magi worship Christ. The second 'constant', at least from the time of the compositional study, is the deliberately paganizing quality of the background. Neither theme is unprecedented, but both are explored with an emotional potency which makes them seem entirely new.

Fra Filippo's *tondo* is one of a number of *Adorations* which exploit ruined Roman architecture for symbolic purposes — the fall of the old order and the birth of the new — a symbolism which is underlined by the almost naked and unbaptized 'natives' inhabiting Filippo's ruins. In Biblical terms the ruins relate to Simeon's prophecy on the presentation of the infant Christ in the temple: 'Behold this child is set for the fall [*ruinam*] and rising again of many in Israel' (Luke 2:34). A further relevant text is Numbers 24:17 (in the reading favoured at the time): 'A virgin [*virgo* or 'sceptre', *virga*] shall rise out of from Israel and shall strike the corners of Moab, and destroy all the children of Seth.' This theme of destruction had become associated with an 'archaeological' legend which purported to explain the ruin of an actual building in Rome much admired in the Renaissance and then known as the Temple of Peace — 'which it is said was a temple of idols and which, the Romans asserted, would endure until a virgin gave birth, and it was split and ruined exactly on the night when Our Saviour Jesus Christ was born'. This account of the fall of what we now call the Basilica of Maxentius was written by Giovanni Rucellai, now remembered particularly as Alberti's patron. The legend accounts for the representation of the Temple of Peace in conjunction with the Nativity on the eleventh float of the *Festa di S. Giovanni* on 24 June 1454. The use of this story in painted images of the Virgin was probably pioneered in

Pl.26 *Perspective Study for the Adoration* (1481), metalpoint, pen and ink and wash, Florence, Uffizi

Verrocchio's studio; the background of the Edinburgh *Madonna* (Plate 4) appears to depict the three remaining bays of the ruin on the basis of verbal accounts. Leonardo's vaulted structure does not make such a direct reference to the same 'Temple', but the general significance of his pagan ruin is certainly the same.

In the compositional drawing, so as to emphasize the building of the new from the ruins of the old, a large stable is actually erected within the pagan ruins, and the same is true in the meticulous perspective study in the Uffizi for the whole background (Plate 26). Architecturally the perspective drawing exploits many of the same elements, but Leonardo has now resolved its spatial and dynamic relationships, working towards a complex series of asymmetrical balances which prevent the eye from settling definitively upon the central point. The focus of the perspective scheme is placed to the right of centre in such a way that the ratio of the distances between the two edges and the vanishing point is very close to the golden mean; that is to say in geometrical terms the ratio made when a line AB is divided at C in such a way that $CB: AC = AC: AB$. There is no way of telling whether this placement is calculated or instinctive, although we do know that the mathematics of such 'divine' ratios were later to hold considerable fascination for him.

A number of vertical lines on the drawing, forming a kind of 'ghost colonnade', have only the most tenuous connection with the actual

architecture and seem to be part of his search for axes of visual gravity. One of the 'ghost columns', immediately to the left of the central support of the stable, marks the geometrical centre of the composition.

The perspective construction of the tiled floor, seen necessarily from a distant viewpoint which compresses the horizontal divisions almost unmanageably, is among the most rigorous of all Renaissance demonstrations of Alberti's visual science. The drawing's overall proportions have been carefully geared to the actual dimensions of the upper half of the panel, but, almost needless to say, even such a laborious effort of controlled definition was not actually definitive for Leonardo's restless intelligence, as a comparision with the final painting will show; not only were details changed, but even the relative proportions of major elements were adjusted.

The ruins in themselves are not different in kind from Filippo Lippi's, whatever their greater formal rigour, but what happens in and around them conveys a very different impression. The conventional hustle-bustle of servants, horses and trumpeters in the compositional drawing has sprung into violent life. The attractively domesticated animals which had first appeared in his study for an *Adoration of the Shepherds* — animals whose pedigree of detailed naturalism is by Pisanello out of Benozzo Gozzoli — acquired a rubbery vigour in the intermediate drawings and have finally been galvanized into 'beastly madness' (as Leonardo was later to call war). The intellectual geometry of the structure has unexpectedly become the setting for an orgy of organic frenzy in which the shadowy inhabitants of the ancient world have plunged themselves into a chaos of self-destructive conflict — watched by a justifiably alarmed camel. It is as if Filippo's naked natives have run amok in a world of unbridled licence.

In the painted panel some important adjustments continued characteristically to be made to both form and content. The stable, now with its apocryphal ox and ass, has been limited to the extreme right, probably in response to the intrusion of the two trees, and the Roman vaults are more conspicuously ruined. Thematically the most important additions are the female observers who have taken the place of the camel in front of the steps. In contrast to the wild men, they exhibit an angelic mien, and one of their number actually appears to be restraining the agitated horseman below the fractured vault. Her action in apparently trying to control animal passion is reminiscent of the narratives in the two *all'antica* reliefs beside the Virgin in Mantegna's S. Zeno altarpiece, in which a rearing horse is restrained, and a centaur (an obvious symbol of animal tendencies) is led in tame submission. Perhaps the virtuous ladies of the ancient world in Leonardo's painting are the sibyls, the legendary prophetesses of Christ's coming. They were certainly represented as such in the theatrical processions of the *Festa di S. Giovanni* in Florence.

Just as the background was subject to Leonardo's uniquely fluid

manipulation of meaning and structure, so the loosely grouped frieze of figures in the foreground of the compositional study has undergone a no less remarkable if less well-documented transformation. The row of urgently attentive worshippers has been transformed into a dense crowd scene of magnificent turbulence. The key to both emotion and religious content lies in the relationship between Christ and the bearded Magus on the right. The presentation of the gift to Christ and the King's receipt of the Child's precocious blessing have the devotional air of a pious rite, particularly when compared to the undecorous way in which Jesus snatches the gift in the compositional drawing. The ceremonial quality which he has introduced may have been intended to echo the deeply familiar ritual of the Eucharist. Medieval techniques of Biblical exegesis relied heavily upon an elaborate system of analogies, and in the case of the Magi an analogy was drawn between the Kings' worship of Christ's bodily arrival on earth and the ritual act of the faithful at the altar in worshipping the presence of Christ's body in the host. In these terms, the old King can be seen to make his oblation in the form of a gift, to signify his adoration by kneeling (and perhaps by kissing the precious flask), and to receive unction in the form of Christ's blessing.

If this analogy sounds excessively arcane, we know that it found expression at a popular level in the well-known play of the *Three Kings*, which came over the centuries to centre upon the Magi's presentation of gifts at an altar where a manger had been constructed. This identification of the manger as an altar was not uncommon in painting, but its Eucharistic connotations were rarely underlined in art. The most spectacular and relevant exception for Leonardo was Botticelli's *Adoration of the Magi* in S.Maria Novella, painted about 1473. The standard of his colleague's work was enough in itself to commend it to Leonardo but he had also had good reason to have become especially aware of Botticelli's altarpiece at this time; during the month following the commission of his *Adoration* in 1481, his father acted as the notary who drew up a revised agreement between the monastery of S. Maria Novella and the patron's widow for the continued endowment of the altar which housed Botticelli's work. Emotionally, however, the two paintings are poles apart. Botticelli's clever Medicean ceremony — he has included members of the family not only as spectators but also as two of the Magi themselves — has been given a darker sense of excitement by Leonardo.

Leonardo has shown the arrival of Christ's physical presence on earth as unsettling at the profoundest level, unsettling not only as an awesome event in itself but probably also in anticipation of Christ's passion. One of the sermons presented to the *Compagnia de' Magi* envisaged that the Magi had seen the cross prefigured in the guiding star. All the variety of reactions — awe, incredulity, bewilderment, devotion, contemplation and even plain inquisitiveness — centre upon these supreme mysteries. The display of emotion is, therefore, in no sense expression for the sake of art, a

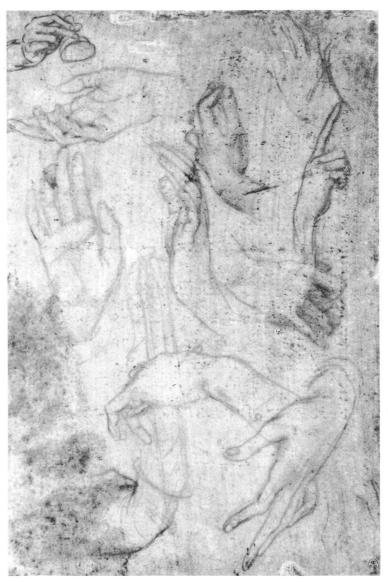

Pl.27 *Studies of Hands for the Adoration* (*c.* 1481), metalpoint, Windsor, Royal Library (12616)

display of physiognomic pyrotechnics to demonstrate pure artistry. However, the means to achieve this apparently spontaneous expression involve an almost academic technique of rhetorical calculation. The facial expressions could only be the fruit of prolonged study of human features in action, and the care with which the gestures have been orchestrated can be beautifully documented by a series of disembodied hands in a Windsor drawing (Plate 27). These 'speaking hands' are eloquent witnesses both to the feelings of their owners in the context of the *Adoration* and to Leonardo's development of the spatial fluency pioneered by Verrocchio.

The overall disposition of the foreground groups, generally analysed in dispiritingly dry terms as a pyramid set within a semi-circle and hailed as the first great structure of the High Renaissance, is not some kind of abstract system which happens to use figures, but a dynamic response to the relationship between form and content at the deepest level. Somehow it combines the balanced symmetry suitable for the ritual of worship with a tangled turbulence which expresses extremes of spiritual agitation. The underlying disposition is as firm as an architectural structure in formal terms, and symbolically it may allude to the high altar and curved apse of a church. We have already noted the tradition of the Magi presenting their gifts at an altar, and one of them bends low apparently to kiss the soil as if to acknowledge that the ground is consecrated; a similar act of reverence occurs in Pol de Limbourg's *Adoration* in that most refined of Burgundian manuscripts, the *Très Riches Heures du Duc de Berry*.

The underlying formality is subtly drawn away from absolute symmetry at almost every point. Just as the background designs embodied a search for dynamic balance rather than fixed regularity around the absolute centre, so the foreground relies upon a complex resolution of contrary forces in such a way that movement is orchestrated rather than frozen. In contrast to the ruins, which build towards the left, the bias of the foreground is clearly to the right of centre, emphasizing the crucial relationship between Christ and the King. This bias is carried through to the two figures who flank the composition, like the lateral figures on a classical sarcophagus, the 'prophet-philosopher' closing the left while the right is opened by the elegant youth who turns as if to introduce late arrivals. Neither figure seems to have a specific identity, though the elder man developed out of early thoughts for Joseph; they appear to perform the important functions of meditation and mediation on behalf of the spectator.

The two trees, a palm and an ilex (?), also play a significant role in the series of compositional checks and balances. They translate the leftward ascent of the architecture into the rightward descent of the main action, marking centres of gravity in the same way as the 'ghost columns' in the perspective drawing. Their conspicuous presence is, however, unlikely to have been justified solely on formal grounds. The palm is a common symbol of victory and had gained Marian associations through the *Song of Songs*: 'Thy stature is like unto a palm tree' (7:7). The more prominent tree may prove to possess some precise symbolism in relation to its type — if it is an ilex it may allude to the legend that Christ's cross was manufactured from that tree — or it may make a more general allusion to Isaiah's famous prophecy as recited at Christmas and Epiphany; 'And there shall come forth a rod [*virga*] out of the tree of Jesse and a Branch shall grow out of its roots' (Isaiah 11:1). The *radix sancta* ('holy root') was one of the many metaphors which had come to be applied to the Virgin in the Middle Ages, and the emphasis upon the roots above Christ's head favours this interpretation.

The impression which emerges from a study of the drawings and resulting underpainting is a complex picture of interaction between form and content, each adjustment in one reciprocally affecting the other in such a way as to elude rigid techniques of analysis. The fluency in developments of meaning and design is part and parcel of the 'brain storm' drawing technique we saw at its most spontaneous in the *Madonna, Child and Cat* studies. Indeed, the emotional and compositional flow in the relationship between the Virgin, Child and King in the *Adoration* is closely related to the dynamism of the independent Madonna sketches. Even the underpainting on the wooden panel still conveys the impression of emergent ideas rather than predetermined solutions.

The figures are also emergent in another sense, in that the most highly modelled forms loom out of a dark substratum of shadow. The way in which Leonardo has created tonal modelling in the *terraverde* (green earth) pigment, brown bitumen and white lead, before the application of the major colours, shows that he already placed great value upon the establishment of a unified scheme of light and shade as the sculptural foundation for his descriptions of forms in space. He continued throughout his life to emphasize the primacy of tonal relationships: 'The scientific and true principles of painting first establish what is a shaded body, and what is direct shadow, and what is light; what is darkness, light, colour, body, shape, position, distance, nearness, motion and rest' (Urb.19v). The depiction of light and shade, called *chiaroscuro*, possessed such importance for him that a painting 'may be adorned with ugly colours and yet astonish those who contemplate it through the appearance of relief' (Urb.48r). We cannot, however, fully judge the intended relationship between *chiaroscuro* and colour in this painting, because the colours were never laid on top of the tonal foundation, which is itself incomplete; but we can at least say that the density of light and shade in the *Adoration* is quite unmatched by any previous underpaintings or drawings known to us and is unlikely to have played a secondary role in whatever final effects he envisaged.

And, though these final effects were not to be realized, the *Adoration* in its present state remains an artistic experience of the highest order.

The immediate cause of his abandonment of the *Adoration* was his departure for Milan, probably in 1482, to enter the service of Duke Ludovico Sforza. To introduce himself, the artist from Florence drafted his own testimonial. The text, apparently written by someone else from Leonardo's draft or at his dictation, makes remarkable reading and gives a markedly different impression of his interests from that conveyed by most of the other documents from this time. It begins:

> Most illustrious Lord, having sufficiently seen and considered the works of all those who are reputed to be masters and contrivers of war machines, and that the invention and operation of the aforesaid instruments are none other than those in common use, I will strive, without

disparaging anyone else, to show my intentions to your Excellency, showing my secrets to you, and then offering all of them for your approbation, to work effectively at opportune times on all those things which are briefly noted in part below (C.A.391ra).

He then proceeded to list nine rather loose categories of military engineering in which he claimed special power: portable bridges and 'methods of destroying and burning those of the enemy'; draining trenches and making 'infinite numbers of bridges, covered ways, ladders', etc.; 'methods of ruining every castle or fortress , even if it is founded on rock etc.'; bombarding machines which hurl small stones 'almost like a tempest'; methods of tunnelling; new types of chariot; various kinds of guns 'of beautiful and useful forms outside the common usage'; catapults etc. 'of marvellous efficacy and outside the common usage'; 'and if it should occur at sea, I have many types of devices most effective for offence and defence'. The last item was originally written as fifth on the list, but was re-numbered ninth, presumably because he considered that naval warfare would occupy a relatively low place in the Duke's military priorities. Finally, as the tenth item, he reminded Ludovico that he could 'carry out sculpture, in marble, bronze and clay; similarly in painting also that which can be done to bear comparison with any other, name who you will'.

The list of attainments is impressive. But how far was Leonardo spinning a yarn to gain the favour of the ruler of the most consistently bellicose state in Renaissance Italy? An element of exaggeration, almost of naïve over-confidence, may be present in the letter, but it is impossible to believe that he would have dared to present entirely false credentials in a city which was a major centre of arms manufacture and where the profession of war was an esteemed art. In fact there are a number of pieces of evidence to show that he could at least begin to substantiate his claims: his inventory of works, already cited in connection with his works of art, contains 'certain devices for ships' and 'some devices for water'; the sheet on which he both described his love for Fioravante and recorded his commencement of two Madonnas in 1478, also contains studies of a rat-chet, various mechanical devices and a crossbow; and the page of *Adoration* studies which contains the *Last Supper* drawing also includes a technical sketch (see Plate 25). A series of drawings in the *Codice atlantico* can be related to these, and together help to build up a picture of his engineering abilities during the years immediately preceding his departure.

The mechanical drawings on the inscribed side of the 1478 sheet are too slight and fragmentary to provide much information, other than to indicate an interest in ratchets, gears and wooden joints, but the sketches overleaf (Plate 28) give a more substantial idea of his accomplishments at this time. Most informative is a complete study of a machine for bending a bow using a screw shaft, either a testing machine to determine the breaking strain of the bow or a shaping device. Just below it is drawn a winch

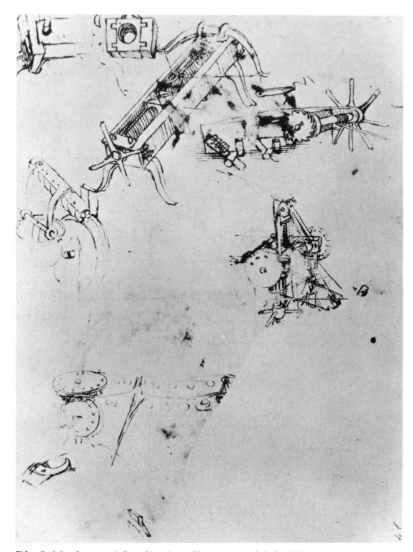

Pl.28 *Mechanical Studies* (1478), pen and ink, Florence, Uffizi
(reverse of Plate 5)

with a ratchet escapement of an entirely feasible kind. The other two main
drawings on the page are less definite, but appear to show a relatively
complex lifting mechanism involving gears, and a kind of conveyor belt.
Probably none of these are very remarkable in contemporary terms, but
they do show a knowledge and understanding of some mechanical systems
together with a remarkable ability to visualize their action in three dimen-
sions. Throughout his life he was to delight in the three-dimensional
transmission of one motion into another in a different plane, such as here
in the transmission of the turning of the screw shaft into the powerful
longitudinal force which pulls the bowstring.

Similar applications of screw systems are scattered in erratic pro-

fusion across a further page of designs from this early period (Plate 29), including a mechanism which uses two bows to provide spring tension for what may be a lathe (upper left), a die-stamping machine with crank handle (centre), and some rough sketches for a cranking device for a crossbow. Already there is an impression of superabundant fertility. Whether or not the drawings represent original inventions — this is always difficult to tell, given the almost inevitable scarcity of evidence — they help substantiate the tone of his letter, teeming almost impatiently with an endless variety of inventions. On this crowded sheet he has written with a flourish: 'I, Leonardo' and 'In God's name amen: year of our Lord: amen Francesco d'Antonio' (Francesco d'Antonio was an uncle who was to leave Leonardo a disputed legacy). These read like a reflex-action re-minder of the inventor's identity in conjunction with a sense of something done and witnessed, as on the legal documents which were his father's stock in trade. The phrase 'in God's name amen' recurs elsewhere in his notebooks as one of his verbal doodles, perhaps as an echo of the legal phraseology which would have been so familiar in his family background and which he would re-encounter himself on the receiving end of a notary's contract for a work of art.

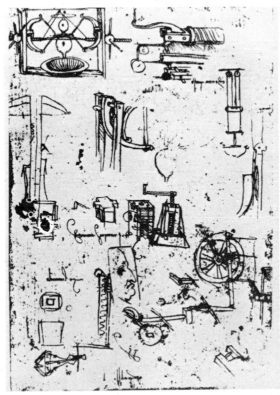

Pl.29 *Mechanical Studies* (*c.* 1478), pen and ink, Milan, Biblioteca Ambrosiana (C.A.379ra)

In addition to detailed improvements, like the cocking mechanism for the crossbow, there are also a few surviving schemes for grander implements of war from this early period. One such is a neatly definitive drawing of a section of fortified wall (Plate 30). As the attackers lean their scaling ladders against the outside, so the defenders activate a horizontal bar by means of a simple lever and three push-rods, which cunningly flips over the ladders, sending the assailants crashing to the ground. The detailed drawings demonstrate secure methods of wall fastening in a thoroughly convincing manner. No one had ever drawn such a mechanism with comparable spatial conviction. And it is characteristic of Leonardo that he has instinctively added the busy little figures who provide the source of energy behind his defence machine.

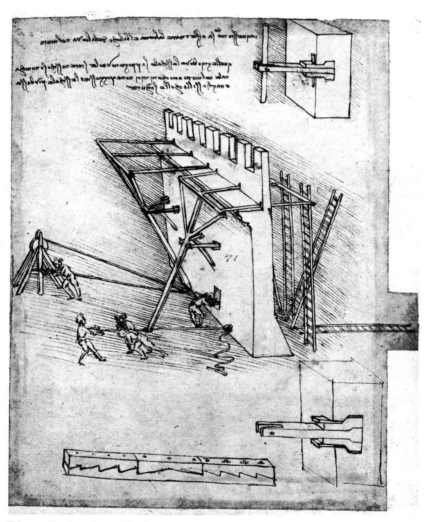

Pl.30 *Design for a Mechanism for Repelling Ladders* (*c.*1481), pen and ink, Milan, Biblioteca Ambrosiana (C.A.49vb)

Human motive power was still the readiest form of available energy in the fifteenth century, even in the wake of the technical revolution of the late Middle Ages, but in certain industries, particularly in textile manufacture which provided the foundation of Florence's wealth, water power had assumed increasing importance. The 'gadgets of water' in Leonardo's inventory would therefore have been directly relevant to the economic needs of his adopted city. The most spectacular of such early devices are to be found on either side of a page in the *Codice atlantico* (Plate 31). They are concerned with the raising of water to a higher level so that, in the case of the tower, its potential energy may be used to subsequent advantage. In addition to systems of pumps and buckets, he exploited that most delightfully improbable of all hydraulic devices, the Archimedes screw, which

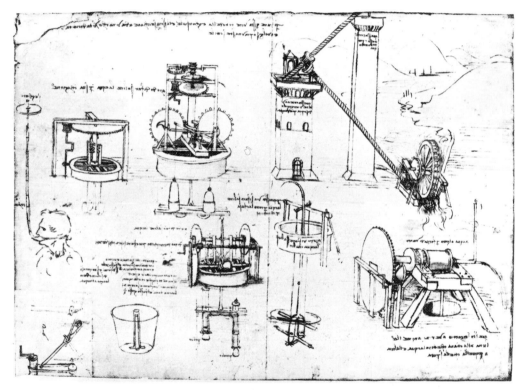

Pl.31 *Devices for Raising Water and Other Studies* (c. 1480), pen and ink and wash, Milan, Biblioteca Ambrosiana (C.A.386rb)

has the net effect of making water flow uphill. A continuous tube arranged in spiral around a central core is set with its lower end in the supply of water at a particular angle, so that when the whole device is revolved the water runs 'down' the turning spirals of the tube in such a way as to emerge eventually at a higher level from its open top. As its name suggests, this hydraulic screw possessed the kind of classical pedigree which would have

especially commended it during the Renaissance. One version had been published in the first edition of Roberto Valturio's *De re militari* (1472), an ingenious anthology of classical military science with modern implications. We know that Leonardo was to make a close study of Valturio's treatise after its publication in Italian translation in 1483, and he was undoubtedly aware of the Latin version soon after its first appearance in print. Even if he would have found it difficult to make full sense of the Latin text, the illustrations provided a lively source of inspiration and its topics were no doubt the subject of lively discussion in the artist-engineer's studios. The engineering achievements listed in his letter are classified into categories in a manner which clearly indicates his knowledge of Valturio's system of exposition.

The water towers fed by screws were drawn by Leonardo in a spatially insecure manner strongly reminiscent of the illustrations in late medieval and Renaissance treatises, and the arrangement of the screws themselves exhibits an unstable, ramshackle quality in marked contrast to the compact strength of his later designs. The Archimedean screws are inadequately supported and it is impossible to believe that their gearing would have been operative. In general, his early designs for machines are characterized by a 'strung-out' quality in which the motive power is transmitted at some distance to the load by a series of shafts and gears. Many of the drawings display diffuse, delicate and almost flimsy constructions, which would generally correspond in mechanical terms to systems wasteful of effort. To some extent this is even true of the most charmingly convincing of the machines which he designed either shortly before or after his move to Milan, an automated file-maker (Plate 32). As the wound-up weight descends so a screw shaft, operated by lantern and crown gears, steadily moves the block holding the file forward, while a sharp-ended hammer linked to the drive shaft by sprocket wheel and lug remorselessly pecks a series of evenly spaced grooves on to the blank surface of the file.

Almost all the early designs have one quality in common — an innate feeling for coordinated, syncopated and reciprocal movements, often operating in close conjunction with the living forces of nature. It is utterly typical of him to sketch the mountainous source for the river which rushes turbulently under the water wheel driving his Archimedean screw system. The combination of liquid flow and spiral movement found in the screws was to prove an irresistible attraction for Leonardo throughout his later hydrodynamic researches. The onrushing forces of nature are overtly present in many of his early designs: in a lock system water tumbles over weirs in a manner comparable to the small cascades in the *Baptism* landscape (C.A.33va); and in a scheme for an automatic spit he exploited the rising action of hot air upon a horizontal 'wind-mill' to turn a geared shaft. In this latter instance the naturally driven system ingeniously contained a built-in regulator — 'the roast will turn slow or fast depending upon

whether the fire is small or strong' (C.A.5va) — in contrast to a clockwork mechanism which would grind along at the same pace regardless of the cooking temperature.

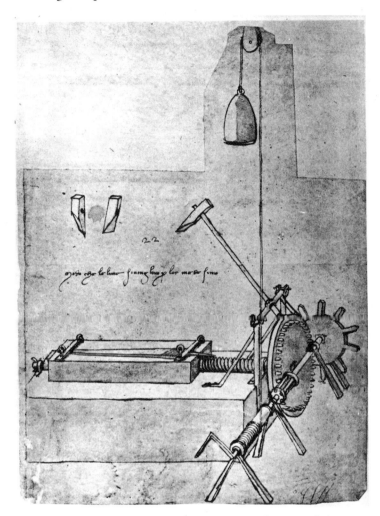

Pl.32 *Design for an Automatic File Engraver* (*c.* 1481), pen and ink and wash, Milan, Biblioteca Ambrosiana (C.A.6rb)

With the mechanical spit we are entering the world of gadgetry, in which utility and delight are inextricably combined. Much the same is true of the hygrometer on the *Adoration/Last Supper* drawing (Plate 25). A sponge is placed at one end of a balance arm on a disc, and when the humidity of the air increases the sponge will absorb water, becoming heavier. The change in weight will be registered by a greater inclination of the balance arm. Although it does have a practical function — Leonardo's note tells us that it is a 'method of weighing the air and of knowing when

the weather will break' — it is obviously a source of fascination in its own right, like a more scientific version of a child's weather house or piece of dry seaweed. It would certainly be too pretentious to call it an experiment in meteorology and it is not an original invention — Alberti, among others, had used a comparable instrument — but it undoubtedly does possess a clearer potential for 'pure' scientific research than the applied science of his water engineering.

Sketches for engineering projects greatly outweigh those which may be said to pertain to pure science at this time, but there are certainly some slight hints in Leonardo's early drawings and notes of an interest in the rules of nature for their own sake. One drawing (C.A.320va), produced accurately with geometrical instruments, contains the germ of a geared system which betrays an interest in the precise ratios of motion and may be related to an astronomical instrument such as an astrolabe, while another (Plate 33) displays a sundial in the shape of a quadrant and some simple diagrams of pure geometry. This second sheet is one of the most revealing of all those which may be dated shortly before his departure to Milan. In what is probably his last addition to the page, he has written a list, one of those *aide-memoire* which appear not infrequently among his later notes:

> The quadrant of Carlo Marmocchi [astronomer and geographer]; Messer Francesco Araldo [a Florentine Herald?]; Ser Benedetto Cieperello [a notary]; Benedetto on arithmetic [a text-book by the noted mathematician?]; Maestro Paolo, physician [Toscanelli, leader of Florentine science and friend of Brunelleschi]; Domenico di Michelino [painter]; el Calvo of the Alberti [the bald man of the Alberti family?]; Messer Giovanni Argiropolo [a celebrated authority on Greek philosophy in fifteenth-century Florence].

This list appears to comprise a series of things to do — authorities to consult, either first hand or through their writings, and people to see. Perhaps he hoped that the herald, the notary and fellow artist would be helpful to him in some aspect of his career, which was already showing uneasy symptoms of his constitutional inability to fulfill his obligations in a businesslike manner.

A certain unease in this respect may already be present in a carefully drafted discourse on the nature of time which he wrote on the same page as the list. It was unexpectedly occasioned by an objective drawing of a water clock: 'We do not lack ways nor devices of dividing and measuring these miserable days of ours, wherein it should be our pleasure that they be not frittered away or passed over in vain and without leaving behind any memory of ourselves in the mind of men.' This note is not isolated in feeling at this time. About 1480 he wrote: 'O time, devourer of all things, and O envious age, you destroy all things and devour all things with the hard teeth of old age, little by little with lingering death. Helen, when looking in a mirror, seeing the shrivelled wrinkles of her face made by old age, wept and contemplated bitterly that she had twice been ravished'

(C.A.71ra). This is in one sense thoroughly literary in tone — it is in fact a freely recast translation of a passage from Ovid's *Metamorphoses* (XV, 1, 232-6) — but its force of expression leaves little doubt that he was expressing a genuinely personal sentiment.

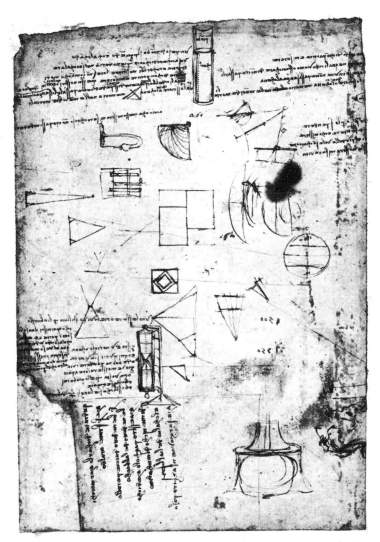

Pl.33 *Waterclock, Sundial, Geometrical Studies, etc.* (*c.* 1481), pen and ink, Milan, Biblioteca Ambrosiana (C.A.12va)

Already these notes suggest a powerful feeling for the inexorable progress of time, as it strides remorselessly forward, ever in advance of the 'immortal' achievements with which his mind was so impatiently filled. A comparable sense of impatience also seems to pervade the most common of his verbal doodles at this time, '*dimmi semmai fu fatto chose*' ('tell me if anything was ever done'). Written often in abbreviated form, *dimmi sem-*

mai, or with occasional variations, it is the phrase which sprang most readily to mind when he had to try a new pen, or during moments of abstraction from the immediate business in hand.

These suggestions of unrepressed pessimism temper the extravagantly confident tone conveyed by his letter to Ludovico. Both are integral facets of his personality, existing in a strange state of harmonic tension. We can also observe that about 1480 the expansive flourishes of his youthful writing style have generally been tempered by a new sobriety, in keeping with the growing maturity and deepening of his mind, accompanied by a concomitant loss of innocence. Perhaps the emphasis he placed upon engineering in his letter to Ludovico reflected not only a wish to appeal most appropriately to his patron but also a feeling that a new direction in a new city might put right what had gone wrong before.

Coming from someone trained as an artist, the claims which Leonardo made in his letter and the kind of technical drawings we have studied from this period would not have seemed as exceptional to a Renaissance patron as they might seem to us today, with our greater sense of professional specialization and compartmentalization. The extension of an artist's activities to embrace engineering, both domestic and military, found many important precedents in the Renaissance. Giotto, the painter, had designed the bell-tower for Florence Cathedral in the fourteenth century. Brunelleschi, the greatest architectural technician of the fifteenth century, had in fact been trained as a goldsmith and first gained notice in Florence as a sculptor. Brunelleschi's range of skills provides an almost precise precedent for the kind of claims which Leonardo was making in his letter. Revered by posterity as the pioneer of the Renaissance architectural style *all'antica* and as the inventor of linear perspective, Brunelleschi impressed his contemporaries above all for his inventive genius as an engineer, gadgeteer and solver of all technical conundrums: his supreme act of technical ingenuity was the hitherto impossible construction of the Cathedral dome between 1420 and 1436; in 1421 he was granted a three-year patent for a new type of load-carrying boat, the secret of which he was guarding with characteristic jealousy; during 1430 he acted as military engineer in the siege of Lucca; he was involved in new defensive schemes at Pisa during the 1440s; and he had earlier worked upon a new bridge in the same city. The precedent he set for Leonardo was more than a question of general similarity. Leonardo proclaimed his specific indebtedness in drawings of two of Brunelleschi's renowned lifting devices (C.A.391vb and 349ra), and he also later sketched the ground plans of Brunelleschi's churches of S. Spirito and S. Maria degli Angeli in Manuscript B.

A considerable if underrated artist of Leonardo's own generation, Francesco di Giorgio, provides an even closer parallel. The author of treatises on civil and military architecture and engineering, Francesco practised as a painter, sculptor, architect, engineer and designer of clever devices. His crowded pages of designs convey an impression of almost

infinite inventiveness, a quality which he greatly valued in artists, and are closely similar in spirit to Leonardo's drawings. Leonardo later owned one of Francesco's treatises, making marginal annotations, and he was to be professionally associated with him in Milan.

Verrocchio himself exhibited a versatility which his pupils would have accepted as something of a norm. His most important engineering achievement, the making and erection (1471) of the 'golden' ball on top of the lantern of the Cathedral was not only a major accomplishment in its own right but also brought the studio into directly physical contact with the genius of the late Brunelleschi. We have already noticed Leonardo's *aide-mémoire*, written about forty years later: 'Remember how the ball of S. Maria del Fiore was soldered together.'

This Italian Renaissance tradition of artist-engineers provides the historical base for Leonardo's activities as expounded in the letter. He boasted no practical experience, and there is no way of knowing if any of his inventions had been put into practical operation, but they were not merely the eccentric fantasies of a man out of touch with the realities of contemporary technology. His earliest inventions, military and domestic, appear to be practical expressions of an amazingly inventive mind in the Brunelleschian mould, and they already reflect that individual feeling for natural processes in action which is apparent in his first works of art, but they probably do not at this stage depend upon an extensive knowledge of scientific principles in dynamics and statics. There are, however, clear hints that he had begun to extend the inventor's question 'how' into the realm of the natural philosopher's 'why'. And the *Codice atlantico* list of names appears to reflect early steps in the process of self-education in the classical and medieval heritage which was to bulk so large in his Milanese notebooks. But he did not possess any systematic knowledge of natural law at this time. Just as his grasp of painter's perspective had not yet expanded into full-scale optical research in its own right, so most of his inventions remained tied to practical problems of making and doing. Thus any knowledge of levers which he might have possessed would have largely been the lay science of the practical operative — the man who knew how to amplify man's muscle-power in transporting blocks of marble and raising heavy weights, who understood how a ratchet worked and could visualize improvements, and who knew that the extreme end of a long catapult arm hurled missiles further than points nearer the axis. That obsessive search for inner causes, which came to dominate his mind in Milan, is barely if at all apparent in the surviving record of his Florentine activities, whatever his instinctive feel for underlying processes.

Leonardo's Florentine experiences had, therefore, provided him with a vision of art as a rational pursuit based upon certain principles and with a background in practical design. And Verrocchio had provided a repertoire of compelling motifs, together with a sophisticated conception of fluid movement in space. To these Leonardo contributed his own special sense

of natural energy at work — the swirling of water, the growth of plants, the movement of faces, the scintillating passage of light — and developed creative procedures which gave the established formulas of Florentine art a new expressive and formal flexibility. The same inherent feeling for energy, movement and spatial geometry is apparent in his engineering. He was already a great if unfulfilled artist and a clever engineer, in the Florentine tradition.

It was not unnatural, therefore, when he was doodling verbally on a piece of paper, perhaps to try out a new pen, that the phrase 'Maestro Leonardo Fiorentino' should emerge from his mind (C.A. 191vb). However, while it is true to say that the foundations of his intellect and art were established in Florence, I believe that the particular form taken by the edifice of knowledge which he later erected upon these foundations is as much Milanese in appearance as Florentine. And throughout the preceding and subsequent discussions, we must always remember that the actual products of his mind are greater than the sum total of the influences. As he signed himself in his letters, he was ultimately not 'Leonardo da Firenze', 'Leonardo del Verrocchio' or even 'Leonardo Milanese', but the supremely individual Leonardo da Vinci.

II The Microcosm

Man is all symmetrie,
Full of proportions, one limbe to another,
And all to the world besides.
Each part may call the furthest, brother:
For head with foot hath private amitie,
And both with moons and tides.
(George Herbert, *Man*)

Why did Leonardo go to Milan and, more important, why did he stay? Early sources indicate that he was sent by Lorenzo de' Medici as an artistic emissary, accompanied by a sixteen-year-old musician. The musician's name is given as Atalante Migliorotti, and Leonardo's inclusion of an 'Atalante who raises his face' among the works in his inventory at this time lends some credence to this otherwise undocumented story. Whatever his reasons for visiting Milan, he settled there presumably because he considered that it offered a better arena for his talents than the city in which he had been trained. The major reason probably lies within the nature of the patronage he could expect to receive in Milan, always bearing in mind that decisions to 'emigrate' are rarely occasioned by a single, definitive cause, but rather by a complex compound of present dissatisfactions and future expectations. Much has been made of his intellectual affinity with the climate of Aristotelian thought in Northern Italy and his antipathy to the rarefied philosophizing of Neoplatonic Florence, but these polarities are too crudely drawn. It is doubtful if any identifiable philosophical stance can be credited to the Milanese thinkers as a group — if a 'group' as such can be said to have existed at all — while Leonardo himself showed a more than passive sympathy with certain aspects of the Platonic philosophy which coloured intellectual life in the Medici circle. His motives were probably social and material.

In Florence, not even the Medici family as *de facto* rulers could be said to support an autocratic court on the scale of the tyrants of Italy, such as the Sforza of Milan, the Gonzaga of Mantua, the d'Este of Ferrara and the Aragonese rulers of Naples (or even the Pope himself). The Medici certainly provided support for humanist authors, such as Marsilio Ficino, the Neoplatonic philosopher who was enabled to establish an 'Academy' in the Medici villa at Careggi. Lorenzo de' Medici seems to have taken the sculptor Bertoldo (Michelangelo's teacher) into his household as custodian of antiquities and as an active recreator of an ambience *all'antica*. Also, Verrocchio could count upon a steady flow of Medicean commis-

sions, even if regular payment was less reliable. And Leonardo may have relied either directly or indirectly upon a certain measure of Medici support. But the Medici palace in the city and the out-of-town villas never provided a court equivalent to that of the great Castle of Milan. The Milanese *Castello* and other ducal properties formed the business centre and in some cases the residences of a large body of officials, secretaries, military men, masters of the hunt, writers, musicians, singers, dancing masters, artists, artisans, buffoons, dwarfs and servants. In the Sforza court, the actions of a secular prince, the activities of state government, the administration of business and a large measure of influence over the Church were all overtly combined in a way which would have been unthinkable in fifteenth-century Florence.

Florence was still nominally a republic, and the majority of artists operated on the time-honoured basis of remuneration for goods provided or services rendered. Artists received money in advance to purchase materials, and interim payments, but the commissioners of paintings were not philanthropically aiming to support 'Art' or 'Artists' as such and would expect delivery of finished products just as they would expect a completed suit from a tailor before parting with the remainder of the fee.

There were already clear and worrying signs that Leonardo was not well suited for survival in the business atmosphere of Florence. He had produced very little in the way of saleable commodities during the nine years after his registration in the Company of St Luke. Most notably he had apparently done little or nothing in connection with the important civic commission in 1478 for an altarpiece in the Palazzo Vecchio. And the *Adoration* remained unfinished, in marked contrast to the sounder business practice of Mantegna who postponed his entry into the service of the Gonzaga in Mantua until he had completed his altarpiece for the church of S. Zeno in Verona. Leonardo's inventory of works already suggests the expansion and proliferation of studies which devoured so much of the time which a more orthodox painter would use for making finished works. What he needed was a degree of financial support with a wide variety of activities and as few strings attached as possible. He required a salaried appointment which would give him scope for intellectual improvisation; as far as such a position existed at all in the Renaissance, he seemed to have found it in Milan. The exact nature of the original business agreement between him and his 'Illustrious Lord' is not known, but we can be sure he was granted a regular salary as one of the *stipendiati* of the court, at least until the late 1490s, when he had to petition the Duke for two years' back pay to cover himself and 'the two masters who are continually in my pay and at my expense' (C.A.335va). Ludovico, hard pressed for cash at the beleaguered end of his reign, seems to have responded in kind by giving his painter a vineyard outside the city walls (presumably a money-making property) which Leonardo still owned at his death.

Clearly, Ludovico would not have supported Leonardo's gracious

life-style without expecting some tangible results in the form of effective weapons, clever festival designs, fine frescoes or beautiful paintings of court favourites, but the pressure of hand-to-mouth existence dependent upon the fruits of his labours had been removed by his court appointment. How quickly he achieved this secure position in the Sforza circle we cannot tell. Certainly during the 1490s he was regarded as an ornament of the court, a man who could discourse on an astonishing variety of things, a wit with a ready fable for every occasion and a master chef of visual treats for sophisticated palates. He was also granted the liberty, like Mantegna at the Gonzaga court, to accept outside commissions on a straightforward business basis (if any business with Leonardo could ever be termed 'straightforward'). The earliest of these outside commissions provides our first notice of Leonardo in Milan.

In 1483 the Milanese Confraternity of the Immaculate Conception commissioned him to provide the painted decorations for their large altarpiece in the church of S. Francesco Grande. To judge from surviving examples, the whole altarpiece would have resembled a miniature temple compressed against the wall and decorated with polychromed sculpture and paintings. The terms of the commission were laid down in a contract on 25 April 1483: in company with the da Predis brothers, Evangelista and Ambrogio, he was to supply in seven months the painted adornments for a complex structure which had been carved in wood by Giacomo del Maino during the preceding three years. This meant not only providing paintings on flat panels to be set into the carved framework, most notably 'the picture in the middle to be painted on a flat panel of Our Lady with Her Son', but also the gilding and colouring of the sculpted sections, including statues and reliefs of the Virgin and God the Father. Work began, but what happened subsequently is not at all clear.

An incomplete series of records survives in Milan which shows that a protracted dispute developed between the Confraternity and the artists. The first signs of trouble appear in an appeal composed by Leonardo and Ambrogio at some time after Evangelista's death in 1490 and seemingly addressed to Duke Ludovico. The artists rejected the Confraternity's valuation of twenty-five ducats for 'the said Our Lady done in oils' and claimed that alternative clients had already offered a hundred ducats. Even by 1496, matters were still unresolved, and a certain Ambrogio de' Gaffuri, as the Confraternity's Procurator, was given responsibility for settling the dispute. The next we hear is in June 1503, when a notary recorded the existing position at length, including a renewed appeal from Ambrogio da Predis, in terms which suggest that he was endeavouring to look after his personal interests, and a summons served on Leonardo who had left Milan some three-and-a-half years earlier. On 4 April 1506, two arbiters were appointed who went to see with their own eyes the state of the altarpiece and ruled that Leonardo was legally obliged to finish 'well and diligently the aforementioned panel or altarpiece on which is portrayed

the image of the most glorious Virgin Mary and this must be completed within the next two years by the hand of the said master Leonardo'. According to very recently discovered documents, the painting was complete and in place by 18 August 1508, when Leonardo — who had returned to Milan and apparently resolved a disagreement between himself and Ambrogio da Predis — was granted permission to remove it temporarily from the altar to make a copy which had been commissioned jointly from the two painters by an unknown patron. The final payment for the altarpiece was made to Ambrogio and ratified by Leonardo on 23 October 1508.

What is not clear is the precise stage reached by the altarpiece at each point in the saga, but a series of provisional conclusions can be drawn: (i) a first version of the painting was finished by the early 1490s, when the artists' appeal was apparently made; (ii) the artists did sell this painting, as they threatened by implication to do; (iii) they began a second version for the Confraternity but did not complete it before Leonardo left Milan in 1499 or 1500; (iv) this version was finished after 1506 on Leonardo's return to Milan; (v) it was a copy of this second painting which was ordered in August 1508, shortly before the final payment for the altarpiece was received; (vi) this further copy may be one of the known versions of lesser quality, or it may have been lost or never executed. This outline is far from certain, but it is at least consistent with the fact that two major variants of the *Madonna* are known, one of which belongs stylistically to the 1480s, while the other betrays later characteristics and is known to have come from the Milanese church of S. Francesco. The first is in the Louvre (Plate 34) and the second is in the National Gallery, London. It is the first version which concerns us at this stage of our study.

The cult of the Virgin, such a shadowy figure in the Bible, was never stronger than during this period and the particular doctrine of her Immaculate Conception (birth without stain of sin) became especially popular in late fifteenth-century Milan. It was a Milanese theologian, Bernardino de' Busti, who formulated the office for the Feast of the Immaculate Conception which was approved by Sixtus IV in 1480. The Milanese Confraternity was founded in 1478 and their new chapel in S. Francesco Grande was built during 1479. Their splendid altarpiece would naturally have reflected their doctrinal views, and major images of the Virgin featured prominently. A carved image, placed at a point of high eminence, may have carried the main burden of Immaculist imagery, leaving the central panel with a freer role in its portrayal of 'Our Lady with Her Son'. In the event, Leonardo's painting did not conform to the terms of the contract; he has unexpectedly included St John and only one of the required 'angels'. In fact, he has not simply painted a devotional image of the Virgin and Child but illustrated a popular story from the early lives of Christ and John, whose childhoods had long been the sentimental subjects of apocryphal gospels and imaginative biographies. One of these tales, popularized in fourteenth-century Italy by Pietro Cavalca, told of a pro-

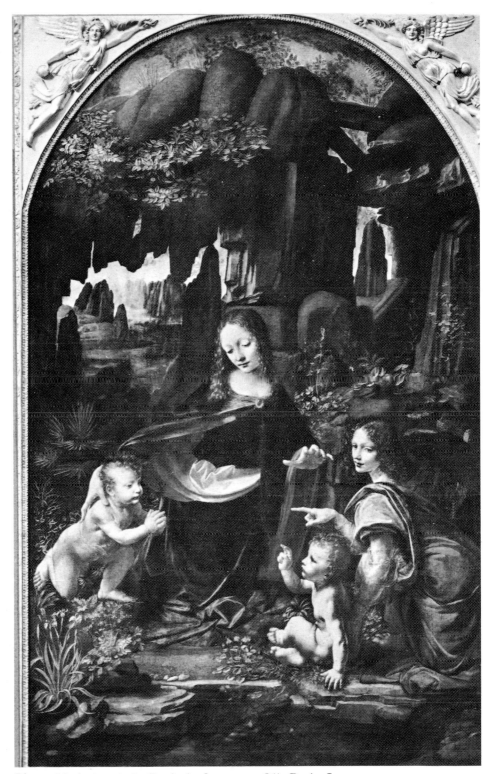

Pl.34 *Madonna of the Rocks* (1483 — *c.* 1486), Paris, Louvre

phetic meeting between Christ and John long before the Baptism. Living precociously as an infant hermit under the tutelage of the Angel Uriel, St John met Christ during the Holy Family's flight into Egypt — both having evaded Herod's massacre of the innocents. John paid homage to Jesus who in turn blessed his precursor and prophesied the Baptism. The story is embroidered with secondary symbolism in the painting; the foreground pool (as it appears to be) prefigures the Baptism; the sword-shaped leaves of the iris represent the sword of sorrow which was to pierce the Virgin's heart; and the palm leaves are a Marian emblem and symbol of victory as in the *Adoration*. Other similar examples of botanical symbolism can undoubtedly be adduced.

The novel setting of the scene in front of a rocky grotto may simply be intended to convey an imaginative impression of exotic wildness suitable for John's mountain lair — one story tells how 'a mountain cleaved asunder' to shelter him and his mother on their flight — but this would be to read the picture too predominantly as an illustration of the life of St John, rather than as an image of the Virgin for the Milanese Confraternity. Mary is the supreme figure in this picture, tenderly sheltering the children and knowingly sanctioning their spiritual dialogue. It is thus more satisfactory to see the cleaved rocks as an illustration of yet another metaphor from the *Song of Songs*, the quarry of Marian imagery especially beloved of Immaculists: 'My dove in the clefts of rock [*in foraminibus petrae*], in the cavities of walls [*in caverna maceriae*], reveal your countenance to me' (2:14). The sense of miraculous revelation, as the light picks out the faces of the Virgin and the other protagonists, is precisely in keeping with the spirit of this metaphor.

Leonardo has orchestrated the relationships between the figures with an almost painful care for narratively explicit gesture. The interlocutor, Uriel, pointedly directs our attention to the Baptist; he kneels devotionally in front of Jesus, receiving a blessing and being drawn into the Holy circle by Mary's embracing arm; her other hand, brilliantly foreshortened, hovers over the pointing hand of Uriel, whom we may also notice is lending support for Christ on the rocky ledge above the pool. We are literally meant to *read* the story, as it weaves its cat's cradle of relationships within the pyramidal space of the group.

This flow and counterflow of feeling is perfectly amplified by the fluid pools of light which provide the painting's dominant visual effect. Indeed, nowhere is the novelty of this picture more pronounced than in the system of light which he has employed. It is fully apparent in no work by his Italian predecessors and is only incompletely anticipated in his own earlier paintings. The *Madonna of the Rocks* provides the clearest visual evidence that he had totally rethought the traditional techniques of depicting light and shade, formulating a system in which tonal unity provides one of the foundations for its pictorial structure.

The earliest surviving writings which record Leonardo's rules for

tonal description (in Manuscripts C and Ashburnham II) date from a few years after the probable execution of the *Madonna of the Rocks* but the painting shows that the basic concepts had been formulated at least by 1483-6. His insistent aim in his use of light and shade was to give irresistible three-dimensionality to his depiction of form: 'Relief is . . . the soul of painting' (Ash.II,1r). To achieve relief he relied upon the potency of darkness over light: 'Shadow is of greater power than light, in that it can impede and entirely deprive bodies of light and the light can never chase away all the shadows of bodies' (Ash.II,22r). Shadow ultimately dominates colour, subordinating all hues to its darkness: 'Different colours with a common shadow appear to be transformed into the colour of that shadow' (Urb.66r); 'Do not in the ultimate shadows make it a practice that colours which adjoin each other can be identified' (Urb.206v). The artist must show the murky areas of mutual shadow as they really are: 'When you represent in your work shadows which you discern with difficulty, whose edges cannot be known without confusion and without imperfect judgment, do not make definite or sharp boundaries because your work will have a wooden quality' (Ash.II,14v). From this soft substratum of velvety shadow emerge the colours, revealed only by the presence of light: 'The quality of colours will be ascertained by means of light and it is to be judged that where there is more light the true quality of the illuminated colour will be seen' (Urb.67v). The 'true quality' to which he referred was what we would call the most saturated colour, that area in which the hue is most fully seen.

Leonardo has here formulated the essential ingredients of tonal painting: a unity of shadow, progressively veiling the boundaries of different colour areas; and the most brilliantly saturated colour reserved for the most directly illuminated parts. Within this basic unity of shadow an infinitely subtle series of adjustments are made to accommodate the inherent tonal values of different colours, from the lightest yellow to the deepest of blues. These qualities of tone and colour are richly manifest, for example, in the Virgin's garments: the different colours shade mutually though not identically into soft darkness, in which individual hue is gradually veiled; while at the same time each hue, such as the brilliant yellow-gold of the drapery across her body, radiates under the strongest light with full brilliance, to reveal its 'true quality'.

In Italy only Masaccio and Piero della Francesca had achieved anything like this tonal consistency, and neither approached Leonardo's forceful depth of shadow coupled with his selective brilliance of saturated colour. It shares more in common with the richness of tone achieved by Netherlandish artists in the oil medium, but no northern painting exhibits Leonardo's remorselessly systematic quality of radiant forms emerging from obscure darkness. Perhaps Netherlandish night scenes come closest to his approach, but the *Madonna of the Rocks* is not a night scene and it retains a fuller sense of colour values.

This tonal system undergoes modification in Leonardo's painting as it evolves into depth. More and more the atmosphere takes its effect, draining objects of their individual colour (according to what he called the 'perspective of colour') and blurring the definition of forms (his 'perspective of disappearance'). The atmosphere, blue because it is compounded of its own whiteness and the 'blackness of the void' above, can be seen here taking its effect on the distant pinnacles of rock in a carefully graded manner. The moist atmosphere is itself graded in colour, from a strong blue at the top, nearest the void, to a more brilliant lightness near the horizon, where the rays of the sun are increasingly caught by the denser quality of the airs and vapours.

Within these basic systems of tonal control and atmospheric progression there are numerous signs of his incredibly detailed perception of secondary light effects, recorded in such profusion in his later notebooks and already part of his armoury as a painter. He repeatedly noted the way in which a bright object was enhanced by a dark background and vice versa. Examples of this occur throughout the painting, but look especially at the dark teeth of the overhanging rocks as they bite into the bleached radiance of the distant haze. He was also fascinated by the different optical qualities of 'light' and 'lustre' (shiny highlight), the latter gleaming most conspicuously on the clasp of the Virgin's cloak, and by the inter-reflection of coloured surfaces, one on the other. The painting is full of passages where the already subtle modulations of tone are further complicated by secondary radiance of light from bright to shaded surfaces. As examples: the reflected sheen at the junction of Jesus' chin and neck; the sense of diffused light under Mary's foreshortened hand; the colour reflections of yellow on the underside of her right arm; and the reddish glow in the area of Christ's back and the Angel's hand. No one until the nineteenth century was to achieve a comparable level of intensity in depicting the elusive complexities of visual phenomena.

I do not wish to suggest that Leonardo was illustrating an optical system like a kind of Renaissance Seurat, but I do insist that he is already aiming to remake nature in his paintings on the foundations of visual principles — what he called 'causes' or *ragioni.* The rules of tone, colour, reflection and shine provide the visual structure for his manipulation of light as an expressive force in his painting. The balance between optical description and intuitive expression is miraculously struck with such subtlety that at one moment the system seems to dominate; at another an ineffable magic appears to rule.

It is this latter tone, the sense of nature's mystery, which certainly rules in an ostensibly 'geological' description of a rocky landscape written about 1480:

> Drawn by my eager desire, wishing to see the great manifestation of the various and strange shapes made by formative nature, I wandered some way among gloomy rocks, coming to the entrance of a great

cavern, in front of which I stood for some time, stupefied and incomprehending such a thing. . . Suddenly two things arose in me, fear and desire: fear of the menacing darkness of the cavern; desire to see if there was any marvellous thing within (B.L.115r).

If we visualize the *Madonna of the Rocks* in its original setting, we may well imagine that it would have resembled a mysteriously penumbral cavern in the glittering cliff of gilded wood, in such a way that its aura of spiritual mystery would have finally subsumed the science of its visual structure.

One suspects that the painting would have seemed formidably odd to the Milanese, who had seen nothing like it before, and it still exudes a sense of strangeness among the Renaissance paintings in the Louvre. The Milanese, however, may have had little chance to see this first version. It certainly was not the painting which finally occupied the central aperture in the Confraternity's altarpiece after 1508; we know that the second painting fulfilled that role. What actually happened to the finished painting in the 1490s is not at all clear. We have surmised that it was sold; but to whom? One attractive possibility is that it was purchased by none other than Ludovico himself for presentation to his nephew-in-law, Maximilian. One early source refers to such a presentation of a Leonardo painting — 'which was said by those able to judge to be one of the most beautiful and rare works that have been seen in painting' — probably on the occasion of Maximilian's marriage to Bianca Maria Sforza in 1493. It would have been a nicely characteristic piece of opportunism on the part of Ludovico to have taken advantage of the contractual dispute to 'acquire' a painting by his own court artist. Finished Leonardos were certainly rare enough to justify such an irregular procedure.

The chequered history of his first Milanese contract confirms what had already been apparent in Florence — that he was constitutionally ill-fitted for making a good living by fulfilling commitments in a businesslike manner. Regular financial support from a sympathetic patron was not so much a luxury for him as a near necessity.

When Leonardo arrived in Milan, his future patron had only recently mastered his dynastic rivals to assume complete control of the Milanese empire in North Italy. Even so, Ludovico was still not Duke of Milan; that title belonged to Gian Galeazzo Sforza after the death of Duke Galeazzo Maria in 1476. Gian Galeazzo had succeeded his father at the age of seven under the Regency of his mother, Bona di Savoia, but was never destined to rule in any real sense before his early death in 1494. By 1480 Ludovico had negotiated a period in exile, inherited the title Duke of Bari from a dead brother (Sforza) and manoeuvred himself into Bona's place as Regent. Although he was not formally invested with the title of Duke of Milan until 1495, taking precedent over Gian Galeazzo's infant son, he rapidly established himself as *de facto* Duke in the eyes of most of Europe. His legitimacy as Duke of Milan was never possible to establish on strictly

genealogical grounds — he was only the fourth son of old Duke Francesco — but it was undeniable in terms of the power structure of Italy. And the Sforzas, who had risen through the profession of arms, knew that power meant what existed in reality and not in the legal rights of dynastic succession.

The city into which Ludovico had insinuated himself as supreme master was exceeded in size only by London and Paris. A colossus by late medieval standards, approaching 200,000 inhabitants, it had more than once threatened to overpower most of Italy, including that self-styled bastion of anti-tyrannical freedom, Florence. Ludovico never mounted a sustained campaign of territorial acquisition in central Italy as his Visconti predecessors had done, and was more disposed to the slippery skills of diplomacy than towards the military valour of his father, Francesco. But as master of a huge territory and overlord of an extensive network of regional castles — most prominently the castle of Pavia which rated little below Milan in grandeur, and also chains of fortifications on the River Ticino to the west and the Adda to the east — he would have considered military matters to be of great importance in his administration. The efficacy of his fortifications would require review as would the state of his armed forces. The prestigious captain of the Milanese army, Galeazzo Sanseverino, became Ludovico's son-in-law and was a significant patron in his own right as Luca Pacioli was to testify. Leonardo's written appeal in his capacity as a military engineer was therefore shrewdly slanted, particularly in the context of events in 1482 when the Milanese became embroiled in the War of Ferrara.

As a centre of economic power, exporting armaments, wool and silk, and as an area of agricultural riches, Milan possessed a wealth which attracted envious and ultimately fatal attention from European monarchs. The lavish reconstruction by the Medici of the palace given to them by Duke Francesco as a base for their banking activities symbolized the city's economic significance. Strategically, no set of shifting allegiances in the fickle world of Italian politics could leave Milan out of the equation, and Ludovico was often active himself in the promotion of new alignments in the balance of European power. Artistically, however, this powerhouse of Italian politics contained disproportionately little in the way of Renaissance art which would have won Florentine admiration. The scale of the city was impressive and the Gothic Cathedral rivalled the largest in Europe, but the Renaissance style *all'antica* was only intermittently expressed in visual terms. The decoration of the Medici bank was an exception, as was the Portinari Chapel in S. Eustorgio, but these were Florentine establishments; and the Ospedale Maggiore owed the origins of its Renaissance qualities to a Florentine architect, Antonio Filarete. Generally, Milan would have seemed deficient in appreciation of the 'true rules' of ancient art, and worst of all the Cathedral was 'barbarically' constructed 'in the German style, on account of which it contains many

errors' (Marcantonio Michiel).

Duke Francesco had taken pains to ensure that his sons and daughters were exposed to the fashionable learning of the Renaissance scholars he had invited to Milan, most notably the brilliant if difficult Francesco Filelfo (at least two of whose works were later owned by Leonardo). Young Ludovico learnt his lessons with sufficient intelligence to be able, at the age of seventeen, to compose a Latin oration in honour of his father, which is handsomely recorded in a presentation manuscript. On achieving power, he furthered his Renaissance ideals by attracting an accomplished group of courtier-authors, antiquarians, historians, musicians and artists, modelling his aspirations on the autocratic courts of North and Central Italy, the Gonzaga at Mantua, the house of Montefeltro at Urbino and, most directly, on the d'Este at Ferrara.

There was a considerable interchange of artistic personnel between the courts as well as a traffic in well-connected brides. A series of carefully planned marriages, aimed predominantly at cementing Milan's political allegiances, also served the social function of exchanging courtly fashions. Ludovico's marriage in 1491 to Beatrice d'Este established a sisterly link with the aesthetically avaricious Isabella d'Este, who herself married into the accomplished Mantuan court of the Gonzaga. Like modern day Joneses, the Sforzas certainly would not wish to be outshone by their neighbours and relations.

If permanent or semi-permanent members of Ludovico's group of authors — including a respected representative of the Tuscan tradition, Bernardo Bellincioni and three knightly poets, Gaspare Visconti, Niccolò da Correggio and Antonio Fregoso — contained no writer of genius, that was not the patron's fault. If the names of the Milanese scholars, such as Constantino Lascaris, Giorgio Merula and Jacopo Antiquario, are unlikely to figure in anything other than the most academically specialized halls of fame, that is not to say that they were not minds of considerable distinction in their day. Like other Italian courts, the Sforza could boast the services of a number of leading musicians from France and the Netherlands (then the source for many of the top performers and composers) and it provided continuous employment for Franchino Gaffurio, a fine musician and the most productive theorist of his generation in Europe. Mathematicians and 'pure' scientists do not figure prominently among the Sforza *stipendiati,* until the notable arrival of Luca Pacioli in 1496 — unless we count Leonardo in this respect. Men of medicine figure more conspicuously, not least for practical reasons, and the Ospedale Maggiore (founded in 1456) was unrivalled for its scale of medical activity. In 1488 Ludovico founded the *Lazzaretto,* a hospital specifically devoted to combating the always imminent scourge of the plague. Milanese and Pavian natural philosophers included some notable authorities on the science of the human body, some of whom are known to have played an important role in Leonardo's scientific education: the Marliani, members of an

illustrious family of physicians; Stefano Caponi, in whose possession Leonardo recorded a Euclid manuscript; and not least, Fazio Cardano, by profession a jurist but by avocation a natural philosopher, who was editor of John Pecham's *Perspectiva communis.* Ludovico's patronage reached its summit, in our eyes at least, with his artist-engineers, among whom Leonardo, Bramante and Francesco di Giorgio represent an unrivalled peak of excellence. A host of lesser artists worked during the second half of the century on a wide range of projects in Milan and her subject towns. Of these, the Mantegazza brothers, Amadeo, Foppa, Borgognone, Butinone, Montorfano, Zenale, Bramantino, the da Predis brothers, the various Solari, Briosco, Gian Cristoforo Romano and the Florentine medallist-sculptor, Caradosso, are recognizable talents.

The effects of Leonardo's association with this court were of two kinds: one was physical, in terms of works executed and projects under-taken; the other was intellectual, in the prodigious development of his natural philosophy in contact with the resources of learning available in Milan and Pavia. His activities as the *maestro* of visual effects in the context of the court's artistic life is the subject of the next chapter; for the moment I intend to concentrate upon his development from a practising artist and engineer, who could lay claims to a theoretical base, into a court intellectual who indulged in 'subtle speculation concerning the nature of all things' (Urb.4v). Aware of his lack of traditional learning to achieve this elevated aspiration, Leonardo tried to circumvent the bookish sources of knowledge:

> I well know that, not being a literary man, certain presumptuous persons will think that they may reasonably deride me with the allegation that I am a man without letters. Stupid fellows! Do they not know that I might reply as Marius did in answering the Roman patricians, by saying that they who adorn themselves with the labours of others, will not concede to me my very own: they will say that, not having learning, I will not properly speak of that which I wish to elucidate. But do they not know that my subjects are to be better illustrated from experience than by yet more words? — experience which has been the mistress of all those who wrote well, and, thus as mistress, I will cite her in all cases (C.A.119va).

This disparagement of book learning was obviously a form of self-defence against the kind of court intellectual who could blind his audience with borrowed science, regurgitating segments of text from the classical authorities, taking ancient authors as the absolute arbiters in all things. However, to survive in such a context, he was forced to comply with at least some of the rules of the game — in denying that he was a *literato* he learnedly cited Marius from Sallust's somewhat obscure *Bellum Iugurthinum* (first century BC), perhaps through the intermediary of an earlier fifteenth-century treatise, the *Dispute Concerning Nobility* of Bonacorso da Montemagno the Younger, which contains passages in praise of the self-

raised man which Leonardo would have found thoroughly sympathetic. Leonardo as an artist may have felt a special affinity with Marius, the *novus homo* ('new man') who forced his way to the front in spite of the traditionalist opposition of the hereditary nobles. In a very real sense, the visual arts as a whole could be regarded as the *novus homo* in the Renaissance, fighting for rank among the venerable nobility of the established liberal arts (grammar, dialectic, rhetoric, arithmetic, geometry, astronomy and music). He was also too intelligent to dismiss all the fruits of earlier learning, whether classical or medieval. And, as we shall see, even his reliance upon 'experience' was related closely to a respectable philosophical tradition of which he was well aware.

His position with regard to written authority in natural studies was broadly comparable to his attitude towards his artistic predecessors. Ideally, nature was the only guide: 'The painter's works will have little merit if he takes for his guide other pictures, but if he will learn from natural things he will bear good fruit... those who take for their guide anything other than nature — mistress of the masters — exhaust themselves in vain' (C.A.141rb). However, as in artistic practice we have seen him building upon the solid foundations of the Florentine traditions, so in his science he endeavoured by consulting medieval precedessors to obtain a firm base from which to study nature. His actual position is most accurately represented by his advice for the young painter: 'The youth should first learn perspective, then the proportions of objects, then he may copy from some good master, to accustom himself to fine forms. Then from nature, to confirm by practice the rules he has learned' (Ash.II, 17v). In art, Leonardo well knew all the rules by the age of thirty (and had made some new ones of his own); in science he had probably not even seen many of the games played, let alone learnt all the basic rules.

In coming to terms with the basic principles of existing science, Leonardo faced immense problems in understanding the basic texts, because they were almost all written in Latin, a language which he partially understood at best. Whereas all the men of letters and science with whom he associated in Milan would have been able to move with ease in the world of Latin literature, as could his patron, Leonardo himself never gained the kind of fluency in the ancient tongue which his intellectual inferiors took for granted. By the late 1480s, whatever schoolboy Latin he may have acquired was probably about as efficient as the schoolboy French of an English tourist in Paris for the first time at about the age of thirty-five. Leonardo's Milanese notebooks from 1487 show that he attempted to rectify this situation. His teach-yourself sources were the standard textbooks, including Perotti's *Rudimenta grammatices*, from which he transcribed conjugations of verbs (H.3v-4r), and the *Grammatica di Donato* (Triv.2r). A version of this latter text was to be used as a schoolbook for Ludovico's son, Massimiliano, in the form of a personalized and richly illuminated manuscript. It is rather humbling to think of Leonardo in his

late thirties secretly schooling himself in the rhythmic rotes of 'amo, amas, amat...', like one of the children of the court. In spite of these efforts his occasional translations from Latin texts remain very laboured and it is clear that he turned to Latin sources only as a last resort.

The body of literature available in Italian was extremely limited and could in no way convey the full scope of classical and medieval learning. Medicine was relatively well served, no doubt because its instructions on the maintenance of health were of more than scholarly concern, and at the University of Pavia Niccolo Sillacio specialized in medical translations. This may help to account for the prominent role which medical science played in Leonardo's thought before 1500. Translations of natural philosophy tended to be concerned with popular and 'magic' science of the kind least useful to him, like the *Secrets* attributed to Albertus Magnus, while the brilliant complexities of the Aristotelian corpus (with medieval commentaries) was still largely available only in Latin. Original writings in the vernacular on science or any learned subject were uncommon. Only exceptionally in the fifteenth century were major treatises actually composed and first published in Italian, as were Alberti's *De familia* and Matteo Palmieri's *Della vita civile*. In the Middle Ages, Ristoro d'Arezzo's *Della composizione del mondo* (1282) stands out as an exception, and provided a welcome source for Leonardo.

To supplement these meagre resources there was also a vernacular tradition of poetry which carried a considerable burden of philosophical learning, either with supremely integrated ease, as in Dante's works, or in a more laboured fashion, like Cecco d'Ascoli's *Acerba* and Federigo Frezzi's *Quadrerigio*. Leonardo undoubtedly absorbed implicit elements of natural philosophy from Dante's *Divina commedia*, and consciously harvested ideas from Dante's more contrived feast of knowledge, the *Convivio*. We will also see him making extensive use of Cecco d'Ascoli in the compilation of his bestiary. Nuggets of knowledge were similarly derived from Valturio's *De re militari* in Ramusio's translation; an apparently learned quotation from the Roman medical authority, Cornelius Celsus (Triv.2v), comes not from the original source but from Valturio's eclectic compilation. None of the vernacular sources provided a coherent body of scientific and philosophical knowledge — that was not their aim — but they did provide hints and suggestions upon which a mind as fertile as Leonardo's could act.

His Milanese notebooks show that he worked hard to fill out his meagre knowledge of specialized writings, often having of necessity to grapple with texts in Latin. He built up his own library, listing on a number of occasions some of the books in his possession. About 1495 he recorded some forty volumes (C.A.210ra), mostly printed books, ranging from the Bible to the scandalously misogynist satire, *Il Manganello*, and from a work by Albertus Magnus to a translation of Ovid's letters. He was able to supplement his own stock of books by study in the Lombard

libraries, not only the monastic collections in Milan like that at S. Ambrogio but also the major holdings in the University of Pavia: 'Try to get Vitolone [Witelo's treatise on perspective] which is in the library of Pavia' (C.A.225rb, written about 1490). This instruction is just one item in a long memorandum which vividly conveys the way in which he used his Milanese contacts to acquire the raw material for his natural philosophy and applied science. In addition to listing written works he intended to consult, often with a note of their owners' names — e.g. 'the *proportions* by Alkindi, with notes by Marliano, from Messer Fazio [Cardano]' — he also reminded himself of questions and problems which he hoped his acquaintances would resolve:

> Memorandum.
> From Giannino Bombardieri, regarding the means by which the tower of Ferrara is walled without loopholes; Ask maestro Antonio how mortars are positioned on bastions by day or night; Ask Benedetto Portinari [an agent of the Medici bank] by what means they go on ice in Flanders; Get the master of mathematics to show you how to square a triangle; Find a master of hydraulics and get him to tell you how to repair, and the costs of repair of a lock, canal and mill in the Lombard manner.

Similar memoranda in his notebooks convey the impression of Leonardo constantly pestering his friends for knowledge, asking why this, why that, always asking and asking, with the persistence of a five-year-old and the penetration of a maturing genius. We may well imagine that when he went to supper with his fellow engineer, Giacomo Andrea da Ferrara on 24 July 1490 (C.15v) the conversation would have turned to discussions of Vitruvius, on whom his host was an acknowledged authority. His continued interest in Giacomo's speciality is confirmed twenty years later when he recorded that 'Messer Vincento Aliprando, who lives near the Inn of the Bear, has the Vitruvius of Giacomo Andrea' (K.109v). Giacomo had been executed by the French invaders in 1500.

In theory, Leonardo's expressed reliance upon empirical observation alone should have rendered Latin learning irrelevant. In practice, of course, it is not as simple as this. As Aristotle stated in the opening sentence of Book 1 in his *Posterior Analytics*, 'All instruction and learning through discussion proceed from what is known already'. Observation requires a structured context to acquire any meaning, and exposition of its significance can only take place within a system of shared reference for ideas. Leonardo was probably the first major intellect since antiquity to use the vernacular as the primary means of structuring his investigations and the sole means of articulating his exposition in natural philosophy. The problems he faced were two-fold: we have already seen his difficulty in acquiring adequate knowledge through predominantly Italian sources; and in expressing the fruits of his endeavours he would have found his

native language deficient in suitable terminology. The poetic Italian of
Dante, Petrarch and Boccaccio, for all its lyrical beauty, was not primarily
designed to expound scientific ideas. The reformation of Italian, or more
specifically Tuscan Italian, into a language capable of the same kind of
crystalline precision as Latin had occupied the attention of a number of
Renaissance authors, including Alberti and not least Cristoforo Landino,
the great authority on Dante in Medicean Florence. This reformation was
to be accomplished by the introduction of latinizing vocabulary and lin-
guistics into Italian, and Luigi Pulci had compiled his *Vocaboli latini* for
just this purpose. Before 1490, in the Trivulzio manuscript, Leonardo
used Pulci's dictionary to assemble a list of latinisms from Ramusio's
rather heavy-handed translation of *De re militari*. Whatever the intention
behind his lists — they certainly do not seem to have developed to a point
at which we can say that he was planning his own treatise on language — he
certainly achieved an enrichment of his native tongue, particularly in the
abstract terms necessary for scientific discussion.

In addition to his language studies, the Trivulzio manuscript also
bears witness to other aspects of his campaign of self-education. Not
unnaturally he did more than use Valturio's mililtary anthology as a source
for latinisms; he also drew upon its range of classical citations, as we have
seen in his quotation from Celsus. Alongside passages drawn from *De re
militari* concerning such things as a 'trick used by the Gauls against the
Romans', he made punning fun of Petrarch's beloved Laura as a seasoning
for food (i.e. laurel), noted philosophical maxims, jotted down moral
precepts and aphoristic sayings, discussed rudiments of statics, optics,
acoustics and ballistics, outlined procedures for casting canons and de-
veloped architectural ideas.

At the head of a number of pages in the *Codice trivulziano* he recorded
philosophical aphorisms, sometimes credited to named (classical) sources
but more often left in bald isolation. One 'family' of statements scattered
throughout the manuscript combines conventional theology with a strong
echo of Neoplatonic idealism: 'Our body is under the rule of heaven and
heaven under the rule of the spirit' (36v); 'The senses are terrestrial and
reason stands outside them when reason contemplates' (33r); and, his most
Neoplatonic statement of all, to the effect that 'The lover is moved by the
thing beloved as the senses are by the sensible object, and is united with
it and become one and the same' (6r). At other times his quirky in-
dividuality is apparent: 'The soul can never be corrupted with the cor-
ruption of the body, but behaves in the body like the wind which causes the
sound of an organ, which, on the breaking of a pipe, will not result in good
effect' (40v); while on occasion we are presented with a clear, terse state-
ment of the kind of principle which dominated his later science: 'All our
knowledge has its foundation in our sensations' (20v). This assertion of
empiricism is strongly Aristotelian in flavour and reads like a paraphrase
of the axiom cited by Thomas Aquinas among others: 'Nothing is in the

intellect that has not first been through the senses.'

The impression at this stage is of an intellectual magpie, cramming his nest with glittering fragments of knowledge, speculation, and attractive trivia. But behind the apparent disarray, certain unifying themes are beginning to emerge, most notably in his studies of the human body and the principles of architectural design.

The only prominent concern of an artistic nature in the *Codice trivulziano* is architectural, relating to the project for the *tiburio* (domed crossing tower) on the huge Gothic Cathedral of Milan. Leonardo and a carpenter assistant were preparing a wooden model for the Cathedral authorities during 1487 and 1488, in competition with a number of other architects including the great Donato Bramante and the unfailingly clever Francesco di Giorgio. Leonardo's model was withdrawn before a decision was made and apparently was not resubmitted. In 1490 the contract was awarded to two local men, Amadeo and Dolcebuono. Although he was not finally involved with the actual problems of erection on a large scale, his experiences in designing the *tiburio* (Plate 35) and his contacts with Francesco di Giorgio were vital in shaping his conception of the arts of man in relation to nature.

At the head of a sheet of drawings in the Trivulzio manuscript (4r) showing a remarkable roof structure and pulleys for raising curtains is an apparently unconnected note: 'Medicine is the restoration of elements out of equilibrium; illness is the discord of elements infused into the living body.' This formula is undoubtedly related to classical medical theory, probably through the medium of the Roman treatise *De Medicina* by Cornelius Celsus (first century AD) which we have seen him quoting at length from Valturio's compendium earlier in the same Codex. The lack of connection between the medical note and the architectural studies is, however, illusory. The letter which he probably sent to the Cathedral authorities, when he submitted his *tiburio* model in 1488, endeavoured to impress the authorities with an elaborate medical analogy:

> Doctors, teachers and those who nurse the sick should be aware what sort of thing is man, what is life, what is health and in what manner a parity and concordance of the elements maintains it; while a discordance of these elements ruins and destroys it; and one with a good knowledge of the nature of the things mentioned above will be better also to repair it than one who lacks knowledge of them...the same is necessary for the ailing cathedral, in that a doctor-architect understands what kind of thing is a building and from what rules a correct building derives and whence these rules originate and into how many parts they may be divided and what are the causes which hold the building together and make it permanent, and what is the nature of weight and what is the potential of force, and in what manner they may be conjoined and interrelated, and what effect they will produce combined. He who has true knowledge of the things listed above will present the work satisfactorily to your understanding (C.A.270rc).

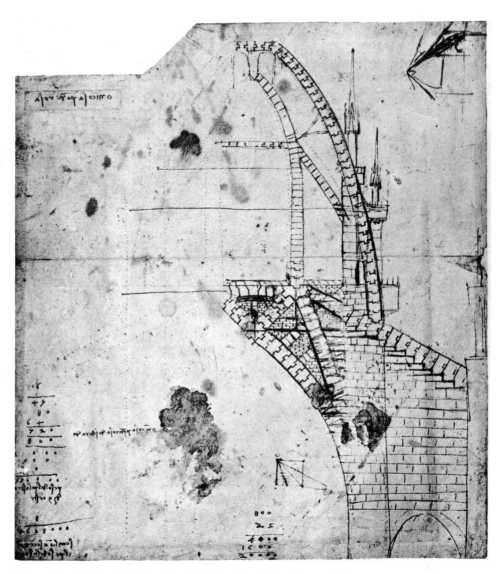

Pl.35 *Study for the Tiburio of Milan Cathedral* (*c.* 1487), pen and ink, Milan, Biblioteca Ambrosiana (C.A.310rb)

The comparison between the doctor and the architect was an old one. It had been made by Alberti, by Filarete in his Milanese treatise on the ideal city, and most relevantly by one of Leonardo's rivals and companions, Francesco di Giorgio. But none of his predecessors took the analogy to the same lengths as Leonardo, and none of them exhibited in their designs such a highly developed sense of a building as a kind of natural organism. Natural similes jump to mind when looking at his *tiburio* drawings — a skeleton, with vertebral columns and ribs, the shell of a sea urchin, its geometrical segments encrusted with spikes, and the reader may well sense other analogies.

At the same time as he was planning the *tiburio* for Milan Cathedral he was also thinking deeply about other forms of architectural design. In particular he was experimenting with a remarkable series of designs for centralized 'temples' — that form which was as beloved of Renaissance theorists as it was seldom adopted in practice. Alberti, Filarete and Francesco di Giorgio all left their readers in no doubt that the most beautiful form for a religious building was a centralized design, that is to say square, polygonal or, most perfectly, circular in plan. It was the total unity of the circular plan which conformed perfectly to the Vitruvian definition of beauty formulated by Alberti: 'The harmony and concord of all the parts achieved in such a manner that nothing could be added or subtracted except for the worse.' For practical examples of such buildings, Renaissance architects could look towards ancient Roman temples and some Early Christian Churches — Leonardo drew the ground plan of one such, S.Maria in Pertica, Pavia (Figure 6) and a superb example was readily available in the Milanese church of S. Lorenzo. So strong was the belief in the Roman pedigree of centralized designs that the twelfth-century Baptistery in Florence continued to be regarded as an ancient temple of Mars adapted to Christian use. Liturgically, however, centralized designs for actual churches had to fight a long and predominantly unavailing battle against the basilical (longitudinal) form, which had become interwoven with the fabric of religious ceremonial and custom. Only a handful of centralized churches were commissioned in the fifteenth century. The most notable example was Brunelleschi's unfinished S. Maria degli Angeli in Florence, the plan of which Leonardo sketched in Manuscript B, on the same page as Brunelleschi's basilical S. Spirito (11v).

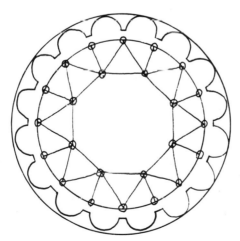

Fig.6 *Ground Plan of S. Maria in Pertica, Pavia,* based on B.55r

It is manuscript B and the related Ashburnham Codex (2037) which contain the substantial part of Leonardo's designs for churches and 'temples'. In some of the drawings, he experimented with longitudinal schemes in the basilical tradition, but the greater part of his energies were

devoted to a series of centralized designs in the Renaissance-antique manner. His starting point was close to Filarete; one design combines an ill-integrated ground plan of rectangular, diagonal and circular elements (Figure 7) with an elevation of piled-up, almost Byzantine forms in the Filarete manner. But he rapidly advanced beyond this to achieve a remarkable degree of plastic and spatial integration, probably under the

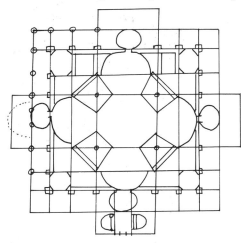

Fig.7 *Ground Plan of a Centralized Church*, based on Ash.I, 4r

stimulus of Francesco di Giorgio's architectural geometry. The culmination of this development can be seen in the illustrated design for a smallish 'temple' (Plate 36), possibly an idea for a Sforza mausoleum, in which a complex plan of geometric interlace is transmuted through a corona of concave and convex shapes into a cluster of geometric solids capped by a Brunelleschian dome. The mathematical integration of the parts somehow achieves a compelling sense of organic unity in the exterior perspective of the building in a way which is uniquely his own. Equally impressive and characteristic is the spatial vision which allows him to display his design as a fully three-dimensional concept, like a piece of sculpture, rather than as a compound of plan and flat elevations.

His series of centralized designs show him moving with complete fluency between largely abstract conceptions of a geometrical kind (Figure 8) and the actual elements of buildings — walls, piers, columns, capitals, ribs, etc. The rhythmic interlinking of elements in the more abstract designs uncannily resembles the system of illustration employed in Gaffurio's diagrams of musical harmonies (Figure 9), and such a resemblance is unlikely to have been coincidental. Alberti had written that linear designs such as those for pavement patterns should 'pertain to musical and geometrical matters, so that everywhere the cultivation of the mind is enhanced'. One of Leonardo's designs, significantly, is a variation upon just such a pavement pattern (Figure 10), a pattern used by Verrocchio among others, in his design for Cosimo de' Medici's tomb slab beneath the dome of Brunelleschi's S. Lorenzo in Florence. Leonardo

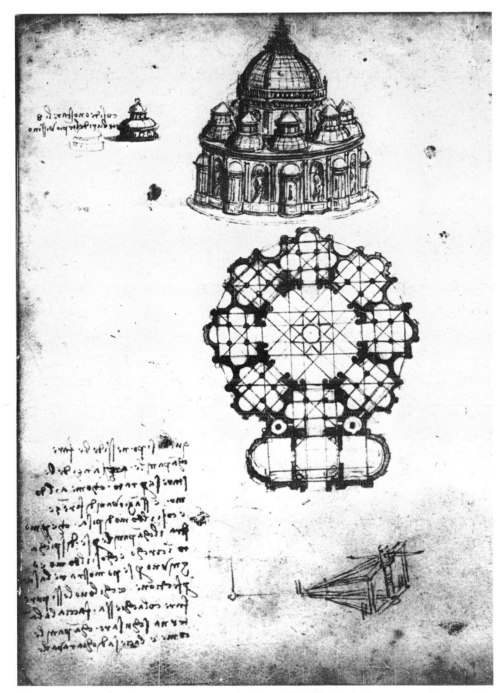

Pl.36 *Design for a Centralized 'Temple'* (*c.* 1488), black chalk, pen and ink and wash, Paris, Bibliothèque de l'Institut de France (Ash.I, 5v)

does not appear to have philosophized about the 'divine' origins of such geometrical harmonies, but an acceptance of their elevated status is utterly implicit in his architectural designs.

Fig.8 *Ground Plan of a Centralized Church*, based on B.35r

Fig.9 *Diagram of Musical 'Proportions'*, based on F. Gaffurio, *De Harmonia*, 1518, H8b

Fig.10 *Ground Plan of a Centralized Church*, based on B.57v (following in part Richter's tracing of a very faint sketch; the heavier lines are those which are most fully apparent)

Just as implicit as the musical parallels are the analogies with the forms of nature, like those we have sensed in the *tiburio* schemes. The parallel between his temples and his drawings of the human skull from 1489 (Plate 37) are especially striking, not merely in visual terms of the 'dome of the skull' but also in their underlying principles of design. Within the bony dome of the cranium, sectioned along the main axes like some of the temple designs, he searched for the inner secrets of proportional design, the secrets which were the vital concern of every Renaissance architect from Brunelleschi to Palladio.

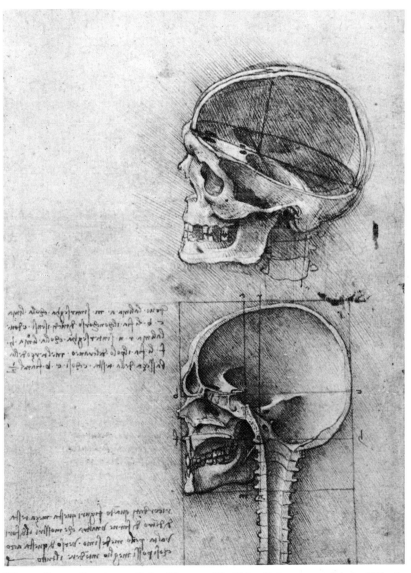

Pl.37 *Cross Sections of the Human Skull* (1489), pen and ink, Windsor, Royal Library (19057r)

Such a search for human proportionality had earlier much exercised the mind of Alberti, whose treatise *On Statuary* (composed about 1450?) described in detail measuring techniques for determining the relations of each part of the human body to each other and to the whole. When he wrote about architecture, he explained that it was the innate ability of man to appreciate the harmonies of proportion underlying God's design of nature which would provide the means by which the architect could design beautiful buildings. The concept of proportion which he discerned as inherent in the universe and essential for good building was, as we have already seen, essentially musical in nature, in that the concordances of the parts would be like the intervals of the musical scale of Pythagoras.

Everything participated in this harmony: the heavens moved according to a divinely orchestrated pattern, the so-called 'music of the spheres'; and although each individual man varied from the norm to a greater or lesser extent, the underlying principle of human beauty, the 'archetype', the 'essence', the 'idea' (or whatever else it might be called) reflected in miniature the harmonies of cosmic design. Man was, to use a term which Leonardo related to Ptolemy's *Cosmography*, a microcosm or 'lesser world'. And man, in his microcosmic way, should design his works according to the same principles of harmony as the Almighty had used in his creation of the universal macrocosm.

The idea of the microcosm had a venerable history, stretching back at least as far as Plato's *Timaeus* (fourth century BC): 'The god, wishing to make this world most nearly like that intelligible thing which is best and in every way most complete, fashioned it as a single, visible, living creature, containing within itself all the living things whose nature is of the same order' (30a). This order, shared by the body of the world and the body of man, was generally believed to consist of a fragile union of the four elements, earth, air, fire and water, each characterized by the coupled properties of two of the four 'natures': cold-dry, wet-hot, hot-dry and cold-wet respectively. The elements were responsible for the composition of the four humours of man: black bile (earthy), blood (airy), yellow bile (fiery) and phlegm (watery). Any disequilibrium which resulted in the predominance of one over the others gave rise to one of the four temperamental peculiarities which beset man and which doctors claimed to rectify in pathological cases: those suffering from a preponderance of earthiness were called melancholic; those with an airy disposition possessed the red-blooded vigour of the sanguineous; the fiery, irascible choleric suffered from an excess of yellow bile; while phlegmatics were characterized by the stillness of deep waters. This is what Leonardo called the 'four universal states of man' (W.19037v).

In fashioning the physical structure of the world, God was (in the words of Alanus de Insulis from the twelfth century) seen as operating 'like a splendid world's architect, like a goldsmith working in gold, like the skilful architect of a stupendous production, like the industrious workman

of a wonderful work, fashioning the form of this earthly palace'. Or, to express the analogy according to its proper precedence, the human architect should always reverentially follow the designs of the divine artificer. In medieval architecture, this analogy remained on the general level of broadly symbolic parallels — most typically between the cruciform plan of a church and the form of Christ crucified. A similarly broad analogy was drawn by the Renaissance humanist, Gianozzo Manetti, who considered that 'the body should be chosen as the noblest possible form' in designing a temple because 'many of the most learned have argued that it was made as a likeness of the whole world'. Renaissance writers on architecture supplemented such general prescriptions with precise analyses of microcosmic proportions, based upon a detailed study of nature, which could be applied in a systematic and detailed manner during the design of an actual building.

Such ideas had become the common currency of advanced architectural theory in the fifteenth century. Francesco di Giorgio, in whose company Leonardo was to visit Pavia in 1490 and whose treatise on architecture Leonardo owned, even superimposed a human figure on some of his ground plans for buildings, to underline their dependence upon human, microcosmic modules. Francesco made the classical pedigree of his ideas very explicit, by illustrating an idea from the *Ten Books* of Vitruvius.

> In the components of a temple there ought to be the greatest harmony in the symmetrical relations of the different parts to the magnitude of the whole. Then again, in the human body the central part is naturally the navel. For if a man be placed flat on his back, with hands and feet extended, and a pair of compasses centred at his navel, the fingers and toes of his two hands and feet will touch the circumference of the circle described therefrom. And just as the human body yields a circular outline, so too it yields a square figure (III, 1).

Luca Pacioli, probably echoing Leonardo's opinions, recorded the same concept: 'Having considered the right arrangement of the human body, the ancients proportioned all their work, particularly the temples, in accordance with it. In the human body they discovered the two main figures without which it is impossible to achieve anything, namely the perfect circle and the square.'

Francesco's rather slack illustration of Vitruvius' formula was redrawn with much greater tautness by Leonardo in his famous 'Vitruvian Man' (Plate 38), which adapts and extends the Roman author's prescription. The ghost of this man, his arms and legs eternally tracing the perfect geometry of God's creation, haunts the ground plans of Leonardo's most unified designs for centralized buildings. Within this overall geometry, the building and the body also exhibit a harmonic series of secondary proportions, and an investigation of these internal relationships occupied a considerable amount of space in his early notebooks. The

1489 skulls, for example, were encouraged to yield their secrets: 'Where the line *rh* intersects the line *hf* will be the pole of the cranium, at a third of the head, and *cb* will therefore be half' (see Plate 37). The internal proportions of the human body run precisely parallel to the proportional systems which he illustrated in his analysis of architectural elements, as in the column base which he anatomized about 1492 (Figure 11).

Fig.11 *Proportions of a Column Base,* based on Forster III, 45r

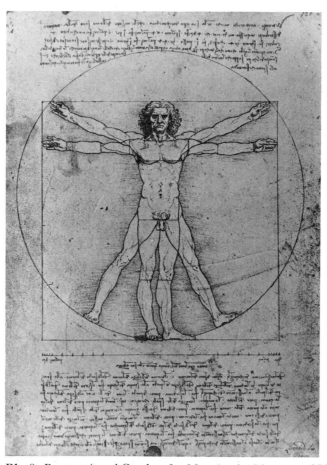

Pl.38 *Proportional Study of a Man in the Manner of Vitruvius* (*c.* 1487), pen and ink, Venice, Accademia

The proportional relationship of the parts reflects universal design. And a 'medical' equilibrium of elements ensures a stable structure. These qualities are thus shared equally by God's creation of the human body and the human being's own production of a good building. In the late 1480s, this theme of the artistic microcosm emerged as one of the great unifying principles of his thought. This architectural application is not the end of the matter, however; it only represents the beginning of a concept which had a literally universal application.

Not only was man a 'lesser world' in structure and beauty, but also in terms of the dynamic processes of nature. The excerpt from the early seventeenth-century poem by George Herbert, quoted at the head of this chapter, perfectly captures this microcosmic complexity of formal and dynamic affinity. This dynamic sense had also been present in Francesco di Giorgio's writings. Francesco characteristically used a classical story to make his point. Plutarch and Vitruvius had told how an architect called Dinocrates had presented Alexander the Great with a plan to shape Mount Athos 'into the form of a man, in whose left hand is shown a very extensive city and in his right a bowl to receive all the rivers in that mountain'. Francesco took this story to mean that Dinocrates intended to illustrate 'the similarity of a city to the human body'. The rivers, for example, were equated with the veins of the body. As Leonardo wrote, 'The water which arises in the mountains is the blood which maintains the mountains in life' (H.29r).

Leonardo's own city designs in Manuscript B (which also contains the centralized temple designs) exhibit a characteristically organic sense of dynamic function, with circulatory passages criss-crossing at as many as three distinct levels: at the highest level will be arcaded walk-ways for gentlemen, the *piani nobili* of beautiful houses and 'hanging' gardens; in the middle range will be the lower stories of houses where goods are stored etc., and the roads for carts and provisions, a role alternatively fulfilled by canals (Plates 39 and 40); finally, the underground channels will carry away sewage and 'fetid substances' (B.16r). Vigorous circulation makes for a healthy city: 'One needs a fast flowing river to avoid the corrupt air produced by stagnation, and this will also be useful for regularly cleansing the city when opening the sluices' (B.38r). With the Milanese plague of 1484-5 fresh (or rather putrid) in everyone's mind, the promise of a healthy city would have been urgently welcome. Town planners today still talk about roads as the 'arteries' of cities or about a metropolis 'choking to death', but these images now only exist as neat metaphors, without the cosmological implications they possessed for the Renaissance mind.

Leonardo expounded an elaborate account of man as a 'lesser world' of natural flux:

> By the ancients man was termed a lesser world and certainly the use of this name is well bestowed, because, in that man is composed of water, earth, air and fire, his body is an analogue for the world: just as man has

in himself bones, the supports and armature of his flesh, the world has
the rocks; just as man has in himself the lake of the blood, in which the
lungs increase and decrease during breathing, so the body of the earth
has its oceanic seas which likewise increase and decrease every six
hours with the breathing of the world; just as in that lake of blood the
veins originate, which make ramifications throughout the human
body, similarly the oceanic sea fills the body of the earth with infinite
veins of water. The nerves are lacking in the body of the earth. The
nerves are not to be seen there because the nerves are made for the
purpose of movement, and the world being perpetually stable, move-
ment does not occur, and movement not happening, the nerves are not
necessary there. But in all the other things they are very similar
(A.55v).

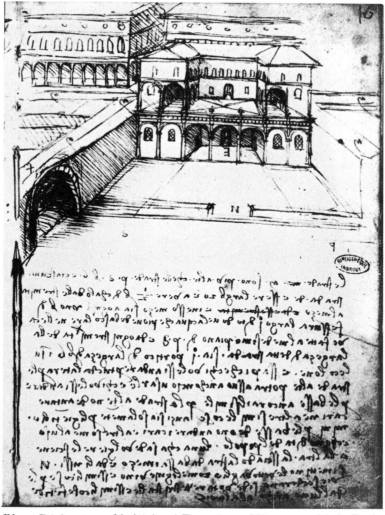

Pl.39 *Design for a Multi-level Town* (*c.* 1488), pen and ink, Paris, Bibliothèque
de l'Institut de France (B.16r)

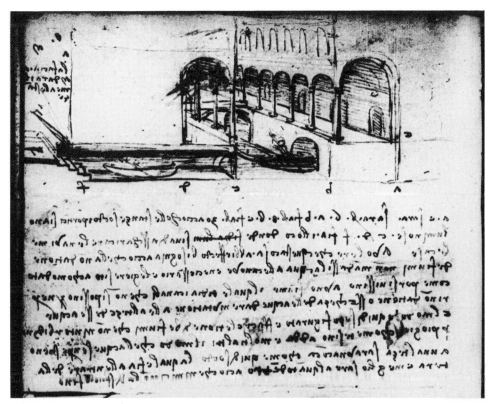

Pl.40 *Design for Canals, Tunnels and Arcades* (c. 1488), pen and ink, Paris, Bibliothèque de l'Institut de France (B.37v)

The direct catalyst for his ideas may well have been the physiological analogy which Ristoro d'Arezzo had drawn in the thirteenth century between the body of the world and the body of man, rather than the texts of the 'ancients' which he claimed to be citing.

The extended analogy in Manuscript A was written about 1492 as the intended introduction for his 'Treatise on Water', but it could equally well have served as the opening of his planned work 'On the Human Body', which in its turn was to be prefaced by his books on machines. As he wrote in the same manuscript, 'Do not forget that the book on the elements of machines with its beneficial functions should precede proofs relating to the motion and power of man and other animals; then on their basis, you will be able to verify your propositions' (A.10r).

Leonardo's projected book on the 'Elements of Machines', which he mentioned a number of times, was intended to present the 'anatomical' elements of mechanical devices — levers, pulleys, joints, gears, springs, screws, bearings, etc. — as might be applicable in a variety of circumstances, rather than individual machines designed for single purposes of the kind which had predominated in his earlier work. Some idea of what his proposed treatise might have looked like can be gained from the first of

the Madrid Codices, which contains some of his most highly finished studies of technology.

Many of the components were invented in response to specific problems of a practical kind,but even at their most specific the generality of universal law is unfailingly apparent. His beautiful series of designs from the late 1490s for the equalizing of force from an unwinding spring is a nice case in point. The problem with a barrel spring as a source of power for clocks and suchlike was that its power steadily diminished as it uncoiled. The fifteenth-century answer had been the 'fusee', a conical spindle which reeled out catgut thread in such a way as to regulate the spring's motion. Leonardo's great predecessor, Filippo Brunelleschi, had been closely involved with the invention of such clockwork devices. Leonardo's own improvements include three designs in the Madrid Manuscript which brilliantly exploit spiral gears. The ramshackle imprecision of the fusee is replaced by compact mechanisms in which the ratios could be precisely controlled at each stage. The illustrated example (Plate 41) displays a complex orchestration of spiral, circular and lateral motions: as the spring within the cylindrical barrel turns the central axis, the tapering pinion will climb the toothed volute, while the vertical motion of the pinion's revolving axis will be accommodated by a sliding gear on the vertical shaft (a cutaway detail of which is shown above). The differential turning motions of the tapered pinion and spiral volute will proportionally compensate for the spring's declining power during the course of its action.

The compact potency of such a device stands in marked contrast to the strung-out mechanisms of his earlier designs, and is equivalent in design terms to the development from the additive qualities of the *Annunciation* (see Plate 9) to the orchestrated massing of form in the *Last Supper* (see Plate 52). Even the individual components of mechanisms, such as his revolutionary worm gear (Figure 12) and his stable axle bearing (Figure 13), exhibit an integratedly condensed quality, as one element is married to another in perfect formal union. They possess that sense of inevitability which characterizes all mechanical design at its finest.

The universal laws of motion behind such mechanisms are always powerfully implicit, and in many cases Leonardo's notes make them entirely explicit. At the top of two pages containing his spring equalization devices he wrote: 'Weight increases when approaching the end of its motion and force always diminishes' (Madrid I, 4r); 'The power of a spring which moves is pyramidal, because, as I will show, it proceeds to diminish towards its end' (16r). This pyramidal law of progressively changing potency will be encountered repeatedly during the course of this chapter, and we have already seen one manifestation of it in the form of linear perspective. For the present, we can note that it provides the theoretical underpinning for both the pyramidal profile of the pinion and the tapering spiral of the volute gear.

Every one of his mechanical devices was, in a sense, a new kind of

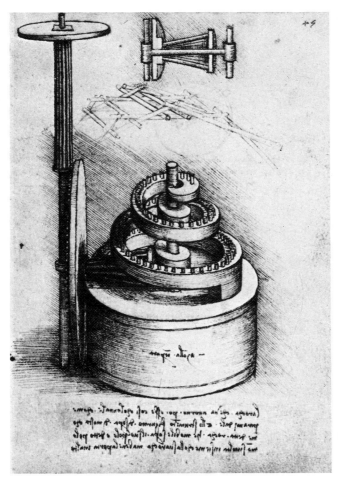

Pl.41 *Design for an Equalizing Device for a Barrel Spring* (*c.* 1499), Madrid, Biblioteca Nacional (I, 45r)

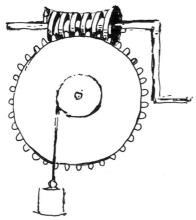

Fig.12 *Design for a Worm Gear,* based on Madrid I, 17v

Fig.13 *Design for an Axle Bearing,* based on Madrid I, 119r

'body' springing into life when activated by force. The invented bodies of machines and the created bodies of nature were comparably conceived to operate in infallible harmony with the universal laws of dynamics. The actual forms of machines and organic systems were not, of course, identical — not even Leonardo could claim that there were screws and gears in the human body — because mechanical inventions were often conceived to achieve different effects, but the design principles were the same in every instance. In some cases, the analogies were so close that the products of the engineer and nature seemed to merge inseparably. This was true, above all, of his schemes for a flying machine, a number of which are to be found in the same Codex as the centralized churches and city schemes, Manuscript B, where we have already seen the divine and human designers working in parallel.

The tone of his investigation is set by the following formula (written after 1500 but certainly implicit in his early designs): 'The bird is an instrument operating through mathematical laws, which instrument is in the capacity of man to be able to make with all its motions' (C.A.161ra). This is why it never occurred to him to call his flying machine anything other than a *uccello* ('bird'). It was the example of huge flying birds which encouraged him to think that man-powered flight was eminently feasible:

> The same force is made by an object encountering the air as the air against the object. See how the percussion of the wings against the air is able to support the heavy eagle in the rarefield air close to the element of fire [the outer sphere of the atmosphere.]. Also see the air moving over the sea and repercussing in the swelling sails to transport burdens in heavy ships. Thus from these demonstrations and their appropriate causes man may learn, with large wings attached to him, to draw power from the resistance of the air, being victoriously able to overcome the air, raising himself upon it (C.A.381va).

It was his admiration for the flight of birds, signs of which appear in his drawings as early as 1481, coupled with his conviction that nature's inventions perfectly obey natural law in every part, which continually drew him back to the imitation of birds' and bats' wings for the solution to the problems of human aviation. This correspondingly militated against his fully exploring more wholly 'mechanistic' systems of flight, such as appear occasionally in his Milanese notebooks. On one page of Manuscript B (83v) he planned a promising-looking 'air screw' of two shallow spirals made from sized linen, cane and wire. But in the last resort he returned to wing systems of an imitative kind. Using his knowledge of bird and human anatomy, he devised palmate wings, composed of cane skeletons, leather tendons, muscular steel springs and membranes of starched taffeta (Figure 14). Sometimes leg power was to be used, sometimes the arms, and on other occasions both together. One drawing (B.80r) shows a stooped man in a diabolical kind of body mill, bending and unbending to pump a piston with his head while turning windlasses with his arms, in order to operate

four flapping appendages, each of which was to be almost eighty feet long. The effect would have been like a monstrous dragonfly carrying a giant's soup bowl between its legs. One of his nicer ideas was the construction of 'skin' flaps to allow air to penetrate the wings on the upstroke while closing completely with the pressure of the downstroke (B.74r).

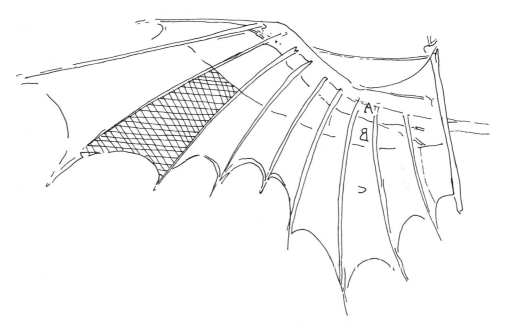

Fig.14 *Design for a Wing of a Flying Machine,* based on B.74r

A 'blades of deal'
B 'fustian, on which will be glued feathers'
C 'starched light silk'

How far he went in actually constructing his *uccello* is unknown, but he certainly kept a lookout for a suitable place in the Corte Vecchia, a Sforza palace near the Cathedral in which he had his quarters. There he could hide from the prying eyes of the public and from the inquisitive gaze of the builders working on the Cathedral *tiburio:* 'Bolt the upper hall and make a large and tall model; and you will have a room on the upper roof. That is the best place in Italy in all respects. And if you stand on the roof, to one side of the tower, people in the *tiburio* will not see you' (C.A.361vb). He also devoted some thought to the precautions necessary during a test flight. 'The machine should be tried over a lake, and you should carry a long wineskin as a girdle so that in case you fall in you will not be drowned'(B.74v). There is something both funny and sad to think of the elegant Leonardo, encased in his smelly contraption of sized cloth, bent cane and leather, pumping frantically at the groaning system of levers —

only to plunge with soggy ignominy into a Lombard lake. If such a trial took place, he certainly would not have boasted about it. That he did not succeed in inventing man-powered flight is as certain as it is not surprising; even modern inventors, with their range of light materials, are now only beginning to make inroads into the problem.

To his already extensive range of studies in the late 1480s — proportion, architecture, mechanics, military engineering, flying machines, and other 'speculations' — he added in 1489 his project for a treatise 'On the Human Body'. This was to be not so much an anatomical book as a far-reaching exposition of man's role in the natural order of things:

> This work must commence with the conception of man, and must describe the nature of the womb, and how the baby lives in it, and in what degree it resides there, and the way it is enlivened and nourished, and its growth and what interval there will be between one degree of growth and the next, and what it is which pushes it out of the mother and for what reason it sometimes comes out of its mother's womb before the due time. Then I will describe which members grow more than the others when the baby is born, and set out the measurements of a one-year-old baby. Then describe the grown man and woman, and their measurements and the nature of their complexion, colour and physiognomy. Then describe how they are composed of veins, nerves, muscles and bones. This I will do at the end of the book. Then I will show in four expositions the four universal states of man; that is: mirth, with the various acts of laughing and describe the cause of laughter; weeping in various manners with its causes; contention with various acts of killing, flight, fear, ferocity, boldness, murder and all the things pertaining to similar instances; then show work, with pulling, pushing, carrying, stopping, supporting and similar things. Then describe attitudes and movement; then perspective through the function of the eye, and hearing — I will speak of music — and describe the other senses (W.19037v).

What happened in Leonardo's life between his thirtieth and fortieth birthdays was not so much a diversification of his thought, as an awesome discovery of such a compelling sense of underlying unity that the various pursuits which he had previously followed to a greater or lesser extent were each given a new impetus, a new inner purpose. Those authors who have written that Leonardo began by studying things as an artist but increasingly investigated things for their own sakes have missed the point entirely. What should be said is that he increasingly investigated each thing for each other's sake, for the sake of the whole and for the sake of the inner unity, which he perceived both intuitively and consciously. In moving from church architecture to anatomy, from harmonic proportions to mechanics, he was not leaping erratically from one separate branch to another, like a frenzied squirrel, but climbing up different branches of the same huge tree, always returning to the main trunk. Each branch of knowledge was an organic part of the whole and grew from the same roots.

This vision of 'universal science' as a single structure had been expressed most brilliantly by certain medieval disciples of the Greek philosopher, Aristotle, most notably by Roger Bacon. In Leonardo's own writings, this vision is not openly advocated in Bacon's philosophical terms, but it is implicit in every part, and nowhere more so than in his science of the human body, in which he depended heavily upon medieval concepts of a basically Aristotelian kind.

The investigations into the science of the human body which can be associated with the earliest scheme for his book 'On the Human Body' concern themselves very little with the superficial aspects of anatomy, which had been the focus of attention of the Florentine anatomical artists (including Leonardo himself in Florence), but strike immediately towards the innermost causes of reproduction, perception, thought, movement and all the actions of the bodily soul. The marvellous series of 1489 skull drawings, which we have already encountered in the context of his search for nature's proportional 'architecture', were actually devoted in large measure to the search for the secrets of man's soul and brain, using the methods of medieval science.

At the very point where the proportional axes of the skull intersected, the point which he called the 'pole of the cranium', was appropriately located 'the confluences of all the senses', that is to say the *sensus communis*, the place at which impressions from the five senses were conflated. The idea of the *sensus communis* was of great authority and antiquity, as Leonardo himself acknowledged:

> The ancient speculators have concluded that the degree of judgement which is given to man is caused by an instrument to which the other five [instruments of sensation] refer via the receptor of impressions, and to this said instrument they have assigned the name *sensus communis* and they say that this *sensus* is situated in the middle of the head between the receptor of impressions and the memory (C.A.90rb).

The 'ancient speculators' to whom he referred were those interpreters of Aristotle's *De anima* who had formulated a system of perception and cognition known as faculty psychology. Most influential of these commentators was the Arabian philosopher, Avicenna, who so convincingly outlined the role of the 'inner senses', of which the *sensus communis* was one, that his scheme was adopted with little modification by most subsequent writers on the brain, including Albertus Magnus, Roger Bacon and Mundinus — all sources known to Leonardo.

According to the medieval Aristotelians the brain possessed three vesicles, or ventricles, one leading from the other, and each the site of a particular stage in perception. In the first ventricle was the *sensus communis*, the collecting house of the senses, together with imagination (*imaginatio* and / or *fantasia*). The second contained the more intellectual of the inner senses: cogitation (a kind of 'rational' imagination), cognition, apprehension, estimation, invention and reason. Finally, the results of in-

tellectual deliberation were transferred to the third ventricle, a cerebral storage jar called *memoria*. On a number of occasions Leonardo sketched the three flasks of this system (Figure 15), wholly accepting the basic premise of the medieval theory, but working his own variations on the actual location of the faculties.

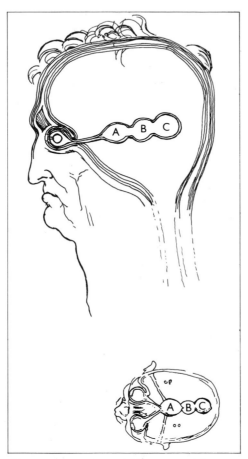

Fig.15 *Vertical and Horizontal Sections of the Head to Show the Ventricles*, based on W.12603r

A *imprensiva* (receptor of impressions)
B *sensus communis* (coordinator of sensory information), with *fantasia* (imagination), intellect, judgment, etc.
C memory

He briefly experimented with an extraordinary arrangement in which sight alone passed the first ventricle, which is labelled 'intellect', while the lesser senses converge on the second (W.12626, and Figure 16). Appealing though this idea may have been in view of the enormous priority he placed on sight as the 'chief means of understanding the infinite works of nature' (Urb.8r-9r), it really could not stand up to logical inspection and he seems

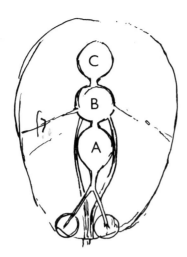

Fig.16 *Horizontal Section of the Head to Show the Ventricles,* based on W.12627r

A *'imprensiva'* (receptor of impressions), with 'intellect' on W.12626
B *'sensus communis'* (coordinator of sensory information), with 'voluntary action' on W.12626
C 'memory'

to have rapidly abandoned it. He settled upon a system which may be summarized as follows: in the first ventricle, resided the *imprensiva* ('receptor of impressions'), an idea not expressed by his sources in these terms; in the second cavity were the *sensus communis* and *fantasia* (imagination), together with intellect and judgment; the third ventricle, as in traditional theory, was devoted to memory. The major innovation in all this is the shared habitation of *fantasia* and *inteletto* in the central cavity, a rearrangement which is profoundly associated with his conception of artistic imagination, as we shall see in the next chapter.

Resonating harmonically to nature's beauty at the very centre of this system was the ultimate beneficiary of the perceptual process, the human soul: 'The soul apparently resides in the region of judgment, and the region of judgment is to be located where all the senses run together, which is called the *sensus communis,* and not all throughout the body as many have believed' (W.19019r). Leonardo is here arguing against the unappealing idea of a diffused soul-intellect as advocated by another of the great Arabian commentators on Aristotle, Averroes, whose followers had been especially influential in Padua. Leonardo obviously regarded the anatomical 'facts' of the ventricles and inner senses as so firmly established that they could conclusively prove the localization of the soul at the centre of the brain. Residing at the administrative centre of the cranium, receiving information, making judgments and issuing commands, the soul could be seen as governing its bodily territory just as did the Duke from his *Castello*: 'The nerve branches with their muscles serve the nerve chords as soldiers serve their officers, and the nerve chords serve the *sensus communis* as the officers serve their captain, and the *sensus communis* serves the soul as the captain serves his lord' (W.19019r) — another microcosmic analogy, physiologically and sociologically.

The whole of this 'society' of inner and outer senses had clearly been designed with the end of sensory perception in mind. For Leonardo the greatest function of man's soul was to understand the operation of the

natural world, not to indulge in the kind of abstract speculation which was so popular among certain Florentine philosophers of his day, the philosophers who followed the ideas of Plato so keenly. For the Florentine Neoplatonists, such as the Medicean favourite, Ficino, the highest truth was obtained by a mystical ascent of the human mind towards the divine realm. The senses were of little account in this. As the great Christian Platonist, St Augustine, wrote in the fourth century: 'Do not go out; return into your own self. The truth resides within man himself.' And in Renaissance Florence, Pico della Mirandola wrote that sensory knowledge 'is imperfect knowledge, not only because it requires a brute and corporeal organ, but also because it only attains to the surface of things. It does not penetrate to the interior, that is to the substance, but is vague, uncertain and shifting' (*De ente et uno*, V). The Platonists' introverted quest for truth within man's soul was denounced as vigorously as possible by Leonardo — he believed fervently that the 'knowledge' which the Platonists claimed to possess could never be verified against objective truth, because their 'knowledge' could only 'begin and end in the mind' (Urb.1v). With purely internal speculation, he could see no reason why one man's wild ideas should not be as good as another's, since neither could be confirmed by the supreme test of certainty, the test of 'experience': 'Wisdom is the daughter of experience' (Forster III 14r); 'All our knowledge has its foundation in our sensations' (Triv.20v); 'All science will be vain and full of errors which is not born of experience, mother of all certainty. True sciences are those which experience has caused to enter through the senses, thus silencing the tongues of the litigants' (Urb.19r).

These ideas as expressed by Leonardo in the late 1480s are not original. They take their ultimate cue from a statement in Aristotle's *On the Soul* — 'no one can learn anything in the absence of sense' — which had echoed and re-echoed throughout the works of those medieval natural philosophers to whom Leonardo looked for knowledge of natural principles. As Roger Bacon said, 'Nothing can be known sufficiently without experience.' Sensory experience alone was not an end in itself, however. The rational faculties of the brain, under the direction of the soul, were designed to extract the underlying causes, and the system of the brain was perfectly adapted to this procedure. The eye, in particular, as the 'window of the soul' and traditionally as the organ of the 'noblest sense' was especially conceived as 'an instrument working through geometrical law' in experiencing natural design.

Although his interpretation of the inner structure of the eye developed considerably during his years in Milan, and thereafter, he continued to adhere unshakeably to the fundamental idea of the eye as a geometrical instrument composed of spherical and segmental components. Of these spheres, the lens (or 'crystalline humour' as it was generally called) was the key component, lying at the centre of the system and containing the vital element of 'visual power'. The lens is shown in

this spherical manner in his vertical section of the human head at Windsor (see Figure 15). This configuration was a commonplace of classical anatomy, lead by the supreme authority of Galen, and was enshrined in the standard medieval texts on optics and opthalmology, namely Alhazen's *Opticae thesaurus*, Witelo's *Opticae libri decem*, Bacon's *Opus majus* and most conveniently in Pecham's *Perspectiva communis*. We have already noticed Leonardo's reminder to look at a manuscript of Witelo in Pavia, and he actually owned a printed copy of Pecham's text-book, from which he quoted a substantial section (C.A.203ra, see below). If his acceptance of the traditional scheme seems to be surprisingly at odds with the actual structure and functioning of the human eye — and we may recall that he continually stressed observational 'experience' over and above bookish authority — it is worth recording the difficulties under which he laboured in making anatomical investigation. Even if material were available, which was often not the case, simple techniques of hopeful dissection would reveal little clear information. Dissection is a messy and confusing business, not least in the case of they eye, which rapidly collapses into a gelatinous heap, with the detensioned lens adopting a spherical shape.

In the first chapter I stressed that medieval opticians revered optics as the true science in which nature and geometrical certainty were most transparently allied. The following statement is a perfect summary of their attitudes:

> Among all the studies of natural causes and reasons, light most delights the contemplators; among the great things of mathematics, the certainty of its demonstrations most illustriously elevates the minds of the investigators; perspective must therefore be preferred to all human discourses and disciplines, in the study of which the radiant lines are expounded by means of demonstrations and in which the glory is found not only of mathematics but also physics: it is adorned with the flowers of one and the other.

This hymn in praise of optics occurs in Leonardo's notebooks (C.A.203ra), but it is not his own. It is part of a laboured translation — probably made by Leonardo himself — of the opening words in John Pecham's *Perspectiva communis*, the most popular optical handbook of the Middle Ages and Renaissance. It cannot be doubted that Leonardo was totally in accord with Pecham's attitude: 'No human investigation can be called true science which has not passed through mathematical demonstrations' (Urb.1v); 'Perspective is a rational demonstration which by experience confirms the images of all the things sent to the eye by pyramidal lines' (A.10r); and 'All the instances of perspective are elucidated by the five terms of the mathematician: point; line; angle; surface and solid' (C.A.132r).

Not surprisingly his earliest descriptions of optical perception are founded upon the visual pyramid which Alberti had established as a fundamental doctrine in the science of art. Probably soon after his arrival

in Milan we find him illustrating the extrinsic, intrinsic and centric rays of Alberti's pyramid neatly converging upon a vertex within a rudimentary eye: 'All the things seen come to the eye by pyramidal lines and the point of the aforesaid pyramid makes its termination and end in the middle of the pupil as is illustrated' (Figure 17). Like Alberti he placed emphasis upon the centric ray as the 'duke or prince of rays': 'The pupil does not give anything perfectly to the intellect or *sensus communis* except when objects are given to it... straight along the line *ab* as may be seen with the line *ca*... and the proof is this; if the eye... wishes to count letters placed in front of it, the eye will necessarily turn from letter to letter because it cannot discern them if they are not in line with *ab*.' This is an echo, either directly or via Alberti, of Pecham's observation that 'perception is certified by the axis being conveyed over the visible object' (I, 38).

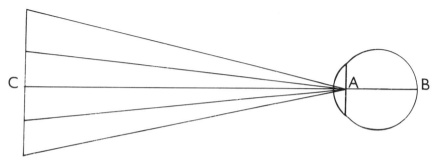

Fig. 17 *The Visual Pyramid and the Eye*, based on C.A.85va
C-A-B visual axis corresponding to Alberti's centric ray

During the early 1490s his study of medieval optics began to bear fruit and we find regular derivations from the standard texts, particularly from Pecham's *Perspectiva communis*. His statement that 'every opaque body fills the surrounding air with infinite images, by which infinite pyramids diffused in the air present this body all in all and all in every part' (Ash.II,6v) is a paraphrase of Pecham, and his accompanying diagram (Figure 18) may well have been derived directly from an illustrated manuscript of the medieval treatise. Under the influence of medieval *perspectiva* he was led to modify his interpretation of the mechanism by which the eye 'sees'. At first he accepted the ancient (and specifically Platonic) idea that the eye functioned by emitting a special type of visual ray towards objects, a kind of perceptual spot-light: 'I say that the visual power is extended [from the eye] by rays as far as the surfaces of non-transparent bodies' (C.A.270vb). But by 1492 he came to accept the overwhelming arguments to the contrary, arguments expressed by Alhazen, Witelo and Pecham, to the effect that the primary mechanism of vision was the reception (intromission) of light rays from objects into the eye. One of the clinching arguments was that a ray from the eye could never reach out

to a very distant object, such as the sun, quickly enough to give in-
stantaneous vision as soon as the eye is opened. The same medieval
authorities who were responsible for his abandonment of the emission
theory also led him to adopt an increasingly complex system of refractory
spheres within the eye, and ultimately to abandon the neat simplicity of
the Albertian pyramid altogether — as will be explained in Chapter V.

Fig.18 *Radiant Pyramids Arising from a Circular*
Object, based on Ash.II, 6v

Leonardo's expositions of optics and ophthalmology were intended
to form integral parts of his book 'On the Human Body'. Remember the
section 'then describe attitudes and movements, then perspective through
the function of the eye, and hearing — I will speak of music — and
describe the other senses'. After the 'noblest sense', the science of sound
and hearing was of the greatest consequence for him, on a practical level as
an accomplished performer, according to contemporaries, on the *lira da
braccio* (an ancestor of the violin) and more profoundly because the trans-
mission of sound could be shown to reflect the same laws of universal
transmission as light. The same laws were apparent in the percussive
transmission of ripples in water: 'Just as a stone flung into water becomes
the centre and cause of various circles, and as sound moves to disperse
itself circularly, so every body placed in an illuminated atmosphere dif-
fuses itself circularly and fills the surrounding area with infinite images of
itself' (A.9v). The essence of this analogy is very ancient, and he may well
have been encouraged to explore it by Vitruvius' account of acoustics in
theatrical design: 'Voice is a flowing breath of air, perceptible to the
hearing by contact. It moves in an endless number of circular rounds, like

the innumerably increasing circular waves which appear when a stone is thrown into smooth water' (V, 4). This circular progression of percussion was conceived by Leonardo as a series of successive 'tremors' rather than as linear movements of actual material. He noted that tremors from different sources crossing the same space will mingle yet remain discrete and separately discernible, as revealed by the manner in which we can simultaneously see more than one light source and distinguish more than one source of sound, just as the circular ripples from two stones thrown into water intersect yet retain their geometrical integrity (Figure 19).

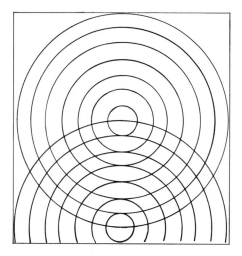

Fig.19 *Circular Diffusion of Waves from Two Centres,* based on A.61r

This circular transmission exhibited the kind of ordered progression in space which Leonardo believed was inherent in all actions of force in the world, 'diminishing its images through the equidistant spaces' in a regular manner according to set laws of diminution. In the case of light this ordered diminution was, of course, called perspective, the pyramidal theory of decreasing size we have already seen operating in the painter's science (Figure 20). In fact, all the powers of transmission in the natural world were subject to comparably pyramidal laws, which would be geometrically expressed by the direct proportionality of the height and base of similar triangles. Essentially the same diagram was used by Leonardo for the fading of sound, the action of gravity (inversely) and the perception of size (Figure 21). The geometrical principle in operation was that X, intersecting the pyramid at half its height, would possess a size (or power) half that of the base, Z. Subsequently, W would be a quarter and so on, diminishing regularly to the vanishing point at V.

Given the parallels between sound and light, the musician and the painter must found the sciences of their respective arts upon analogous laws of mathematical progression and harmony: 'I will... make my rule [for perspective] as the musician has done with notes... arranging them in steps

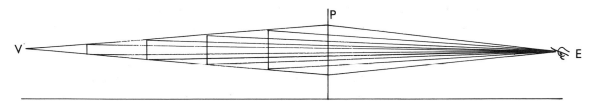

Fig.20 *Pyramids of Visual Diminution*, based on A.37r

V vanishing point
P picture plane
E eye

Fig.21 *Diagram Illustrating the Pyramidal Law*,
based on M.44r
Z:Y:X:W = 4:3:2:1
V = 0 (vanishing point in perspective and silence in sound)

as first, second, third, fourth, fifth, and thus from step to step he has assigned names to the varieties of raised and lowered notes' (Ash.II, 23r). Musical harmony was microcosmically 'composed of the conjunction of proportional parts acting simultaneously. It is obliged to arise and terminate in one or more harmonic intervals of time which circumscribe the proportionality of the parts of that harmony of which it is composed in no other manner than the contour lines made around the limbs and from which human beauty is generated' (Urb.16r-v).

Not only did linear perspective operate proportionately in a pyramidal fashion, but the other two 'perspectives', colour and disappearance, acted in a comparably regular manner: disappearance of colour worked according to the rule that the strength of colour diminished to four-fifths of its previous value for every twenty *braccia* in depth (Ash.II, 22v); and when painting a far-off mountain which was 'five times distant, make it five times bluer' according to its degree of atmospheric disap-

pearance (Ash.II, 22v). Shadow similarly 'is in the nature of universal things which are more powerful at their origins and grow weaker towards the end'; and, with a characteristic multiplication of microsmic analogies, he compared this to 'the oak tree which is more powerful at the point of its emergence from the ground, that is to say where it is thickest' (Ash.II 21v). His analysis of a sphere illuminated by light from a window, showing the graded intensities of 'primary shadows' (on the object itself) and 'secondary shadows' (cast behind the object) conveys a good impression of the mathematical nature of shadow in the 'nature of universal things' (Figure 22).

Fig.22 *Grades of Primary and Secondary Shadows on and behind a Sphere illuminated from a Window*, based on Ash.II, 13v

These systems of mathematical grading for natural effects were not static but occurred in terms of percussion and movement, the positive actions of force in the universe. Reflections of light were thus analogous to bouncing balls: 'Reverberations are caused by bodies of bright nature with flat and semi-opaque surfaces, which, struck by light like the bounce of a ball, rebound it back to the former object' (Ash.II, 14v). And, inevitably, similar rules operated: just as the ball makes its hardest impact when thrown at an angle perpendicular to a surface, rather than glancingly, so light will have its brightest effect when it strikes directly from in front (Ash.II, 29r). The varying degrees of light intensity on a human face could thus be analysed precisely according to angular impact (Figure 23).

All these causes and effects were to take their place in his universal analysis of movement: 'Movements are of [5?] natures, of which the first is called temporal because it is concerned solely with the movement of time...; the second is the life of things; the third is called mental and

resides in living bodies; the fourth is the images of things which diffuse through the air in light; the fifth is that of sounds which go through the air... also of odours and tastes and those things called sensory movements' (C.A.203va).

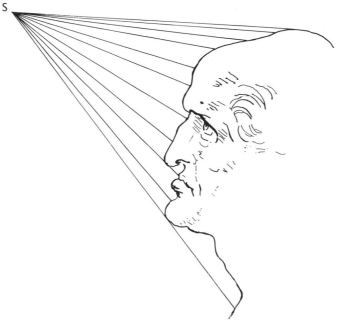

Fig.23 *Angular Impacts of Light on a Face*, based on W.12604r

S light source

The receptor of 'sensory movements', the perceptual mechanism for this astonishing world of universal harmonics, was, as we have seen, the system of 'inner senses' located in the ventricles of the brain. In addition to their receptive and analytical roles, these ventricles also performed the vitally dynamic function of transmitting the commands for human motion and emotion — the third category of the five 'natures' of movement. Thus the central vesicle is labelled both '*sensus communis*' and '*volontà*' on one of his schematic cross-sections of the brain (W.12626). *Volontà* is what we could call voluntary action or motion and is responsible for all aspects of human movement, from overall locomotion, like running, to small details of expression, such as raising the eyebrows. Taking his lead from classical and medieval authorities, he devised a system of neurological plumbing for the transmission of motor impulses down the spine and into the peripheral regions of the body, using a 'tree' (his term) of tubular nerves or 'chords', the terminal branches of which formed the sheaths of the muscle fibres. He explained that 'the perforated chords carry commands and sensations to all the operative limbs; these chords command movement among the muscles and sinews' (W.19109r).

The medium through which the impulses were transmitted was the 'medulla' of the nerve tubes (Figure 24, upper right), which contained the 'animal spirits', and it was these same 'spirits' which were thought to convey the sense of touch back to the ventricles for processing in the *sensus communis* (W.12623v). The 'animal spirits' thus performed their functions through a dynamic mechanism of ebb and flow. The 'passage of animal spirits' took place along the lateral canals of the spinal chord, while the central chord (Figure 24) was reserved for the transmission of 'generative power' to the reproductive organs, by means of an entirely fictitious series of ducts derived from the Hippocratic tradition. Leonardo's primary source for such ideas was probably the popular fourteenth-century text-book by Mundinus.

Fig.24 *Nerves of the Neck and Shoulders*, based on W.19040r

M medulla of the nerves conveying the 'animal spirits'
B base of brain

All this bears little relationship to the nervous system of the human body as we now know it. But to make this kind of judgment is to impose anachronistic principles on his late medieval concepts of physiology. The psychological and neurological systems he drew should not be equated in form or intention with dissection drawings. While there are clear signs that he made sketches of animal dissections, particularly horses, the majority of his Milanese anatomies were designed according to his conceptions of their underlying 'causes'. In other words, he was devising inner forms according to their supposed functions in the context of microcosmic law. This was essentially similar in approach to the way in which he designed his *uccello*. Strange though this anatomical 'research' may seem today, it was fully sanctioned by the prevailing scientific method of his time; indeed, the composition of 'effects' from 'causes' was regarded as the culminating achievement of scientific demonstration. If the scientist understood the secret of natural function so well that he could recompose the mechanism on his own account, he could fully claim to have gained complete understanding. Later Leonardo was to realize how complex the problems really were, but at this stage he confidently created inner mechanisms which perfectly fulfilled their necessary functions. In a sense, his early anatomies generally show what ought to be there, rather than what really is.

The dynamism of the human machine, driven by the ebb and flow of its 'animal spirits' held endless fascination for him. No artist or scientist has ever possessed a stronger sense of man in motion as a sentient, responsive and expressive being. In dozens of little sketches of figures in action he studied the outward effects of the inner motive powers, noting the dynamic forces and counterpoised balances which operate during 'movement, running, standing, being supported, sitting, leaning, kneeling, lying, carrying or being carried, pushing, pulling, hitting or being hit, pressing down and lifting' (Ash.II, 29r). Typical of his observations is the following:

> When a man jumps high, the head has three times the velocity of the heel of the foot, before the tip of the foot leaves the ground and twice the velocity of the hips. This is because three angles extend themselves at the same time [Figure 25], of which the uppermost is where the torso joins the thighs in front, and the second is where the backs of the thighs join the backs of the legs, and the third is where the fronts of the legs join the bones of the feet (Urb.130r).

These synchronized motions of the human frame — its levers, its pulleys, its joints and so on — were of the greatest significance to Leonardo as a painter, not only in terms of naturalism but also, as we shall see, in creating narrative expression of a kind suitable for each subject.

The whole impression conveyed by his book 'On the Human Body' was to be a dynamic one, embodying growth, emotion, action and perception — a complete picture of a man as a living organism in a mobile

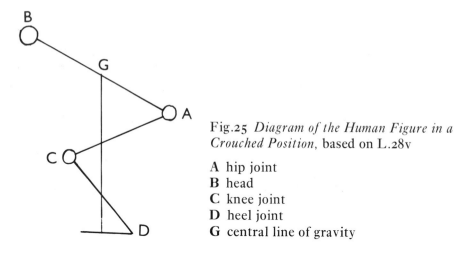

Fig.25 *Diagram of the Human Figure in a Crouched Position*, based on L.28v

A hip joint
B head
C knee joint
D heel joint
G central line of gravity

universe, subject to the complex disequilibrium of the four elements in universal flux. Behind it all was the action of force, creating all movement and change, and ultimately responsible for life itself: 'motion is the cause of every life' (H.141r). His special feeling for the ubiquitous potency of universal force gave his studies of dynamics an expressive power beyond the normal bounds of scientific investigation This is particularly apparent about 1492:

> Force is . . . an immaterial power [*virtù spirituale*], an invisible potency which is created and infused by animated bodies in inanimate ones through acquired violence, giving to these bodies the appearance of life; this life is of marvellous efficiency compelling and transmuting all created things from their places. It rushes with fury to its destruction and continues changing in accordance with the causes. Slowness makes it greater [in duration] and speed diminishes it. It lives by violence and dies at liberty. . . Great power gives it a great desire for death. It drives away with fury whatever opposes its self-destruction . . . It always opposes natural desires . . . It always desires to weaken and extinguish itself . . . Nothing moves without it. No sound or voice is heard without it (C.A.302vb, and a related passage in A.34v).

These transitory qualities of violent motion were contrasted with the properties of weight, which was characterized as 'eternal' and 'material', always striving to act vertically, and continually seeking 'stability and permanence'.

This contrast between weight and force clearly reflects, albeit in a highly personal manner, the basic premises of classical mechanics, according to which all motion originated from one of two sources. The first was 'natural', in that every object possessed an inherent tendency or desire to move to its natural level in the scheme of things as determined by its relative weight of elemental composition. Fire would be absolutely predisposed to ascend, and earth to fall, while relatively light air and

relatively heavy water would each seek their appropriately intermediate levels. Any body above or below its proper gravitational position would move accordingly: 'No dissimilar body will ever come to rest within another if it is at liberty [to move]...The thing which is most dissimilar will separate itself from the other with the greatest movement' (Triv.10r). The second kind of force was 'violent', acting against the natural state of rest, disturbing the stability of weight and disrupting the verticality of natural motion.

Like Aristotle and all subsequent Aristotelians, Leonardo considered than an object would only move as long as it was subject to force: 'Nothing whatever can be moved of itself, but its motion must be affected through force' (A.21v). This attitude caused obvious difficulty in explaining why a projected object, such as a thrown stone, continued to move after direct contact with the moving agent had ceased. To resolve this difficulty, late medieval philosophers had developed a sophisticated theory of 'impetus' whereby a motive power (*virtus motiva*) was 'impressed' in a propelled body, remaining within it as an inherent force. This power persisted until consumed by some opposing force, according to Jean Buridan, the most brilliant of the fourteenth-century impetus theorists, or gradually draining from the body in a manner comparable to heat loss according to some authorities. In fifteenth-century Italy, impetus mechanics were advocated by Biagio Pelacani, whose works Leonardo certainly knew (Ash.II, 2v), and by the Marliani in Milan. During the late 1480s and early 1490s, Leonardo gained at least some understanding of the late medieval notions: 'All movement tends to maintenance, or rather all bodies continue to move as long as the impression of the force of their movers remains in them' (A.22v); 'impetus is frequently the cause why movement prolongs the desire of the thing moved' (C.A.123ra); and 'impetus transports every movable thing beyond its natural position. Every movement has terminated length, according to the power which moves it, and upon this one forms the rule' (Forster II, 141v).

Medieval impetus mechanics had arisen in opposition to Aristotle's dubious theory of 'antiperistasis', which had explained the continued movement of a thrown stone on the basis that the displaced air snapped back into place behind the stone in such a way as to propel it forwards. Leonardo's patchy knowledge of late medieval ideas resulted in his attempting to combine more recent theories with continued hints of Aristotle's discredited antiperistasis. Having analysed the progressive proliferation of circular waves in air or water in front of a moving object — he followed Jordanus of Nemore (thirteenth century) in believing that these waves facilitated the object's movement — he added a marginal note to the effect that 'because no place can be a vacuum, the place where the boat has left desires to reclose and makes force, like the stone of a cherry pressed together between the fingers, and thus makes the force to press and catch the boat' (A.43v). A few years later he wrote that a falling body

'makes a turning wave which helps drive it down' (M.46r). Aristotelian antiperistasis was thus used by Leonardo to provide a helping hand (of a strictly unnecessary kind) for Buridan's impetus.

Leonardo realized that his ideas had not reached a satisfactory point of resolution. About 1497 he reformulated a series of basic questions and listed authorities who might help him to answer them:

> What is the cause of movement; what movement is in itself; what is it that is most adapted to movement; what is impetus; what is the cause of impetus in the medium in which it is created; what is percussion; what is its cause; what is rebound; what is the curve of straight movement and its cause? — Aristotle, 3rd of the *Physics* and Albertus [Magnus?] and Thomas [Aquinas] and others on the rebound; in the 7th of the *Physics*, and *De caelo et mundo* [also by Aristotle] (I.130v).

Unfortunately these texts would have done little to clear up the confusion, because they include none dealing with medieval mechanics in its most advanced form — no Buridan, no Bradwardine and no Oresme.

Impetus, whatever its causes, ensured that each moving body would inexorably complete its assigned motion. The performance of a bouncing ball, in Leonardo's earliest thoughts on the matter, would be equivalent to that of the same ball thrown freely through the air by the same force without bouncing, in terms of its total path travelled and time taken (Figure 26). This inevitability moved him to write, 'O admirable justice of thine, prime mover. You have not willed that any force should lack the order and quality of its necessary effects' (A.24r). The remorseless desire of force to complete its effects could be most vividly witnessed in the natural world in the action of water. He studied the erosion of river banks, as the current percussively rebounded from an irregularity on one side to 'gnaw' at the opposite bank, zig-zagging back and forth in a series of curving diagonals in accordance with its irresistible surge of impetuous motion (Figure 27). He explained that water was even more continuous in its inexorability than a bouncing ball, because water acts as a 'continuous quantity'; that is as an incompressible column of material in uniform motion, moving as rapidly at the top of a wave as the bottom, unlike a ball which slows towards the top of its bounce before accelerating downwards again (Figure 28).

The element of water often assumed an awesome potency in Leonardo's thought. It combined both mobility and heaviness, unlike buoyant fire, light air and inert earth. It was the supremely dynamic element, rising in vapour, falling in rain, remorselessly seeking its true level and restlessly buffeting obstructions in such a way that 'against its fury no human defence avails' (C.26v). 'Moving water strives to maintain the course pursuant to the power which occasions it, and if it finds an obstacle in its path it completes the span of the course it has commenced by circular and revolving movement' (A.6or and Figure 29). These vortices form 'hollows in which the water, whirling around in various eddies,

Fig.26 *Comparison between the Paths of a Freely Thrown and Bouncing Ball*, based on A.24r

A-B trajectory of a bouncing ball
A-C trajectory of a freely thrown ball

Fig.27 *Analysis of Water Flow in a River*, based on C.26v
x and z — lateral irregularities in the bank

Fig.28 *Comparison between a Bouncing Ball and Waves of Water*, based on I, 115v

Fig.29 *Turbulent Flow caused by Circular and Triangular Obstructions*, based on H.64

erodes and excavates and enlarges these chasms . . . consuming and eating away whatever stands in its path, changing its course in the midst of the havoc it has made' (A.59r). On one occasion he attempted to formulate a descriptive vocabulary of water movements, but his classification was rapidly inundated by a surging cascade of categories: 'Rebound, circulation, revolution, rotation, turning, repercussing, submerging, surging, declination, elevation, depression, consumation, percussion, destruction...' and so it goes on until the impetus of his thought has consumed itself — but not before sixty-four terms have poured forth (I.72r-71r).

In performing its inexorable destiny, living by violence and dying at liberty, each force produced effects which obeyed absolute rules in relation to distance travelled, time taken and effective resistance (i.e. the weight of the moved object together with any other adverse forces). These rules were expressed in direct ratios or 'proportions' as they were then called. Leonardo correctly acknowledged that the proportional rules of classical dynamics had been established by Aristotle in the seventh book of his *Physics* and the third book of *On the Heavens and Earth*, where it was stated that a doubling or halving of force or weight would result in a proportional modification to velocity: 'Aristotle says that if a power moves a body a certain distance in a certain time, the same power will move half this body twice the distance in the same time' (M.61v); 'or the whole of that power will move a weight double that first weight half that distance in the same time' (L.78v). Of all Aristotle's scientific laws none was more severely criticized by late medieval philosophers than his proportional rules for force, weight, distance and time. Bradwardine and Oresme were particularly effective in exposing the absurd consequences of these rules: for example, a very large resistance (R) should in theory be given a finite velocity (V) by even the smallest force (F), since the ratio of force to resistance would always be mathematically positive; that is when V is proportional to F/R, V will always be greater than zero for any given force. Or at the other extreme of very low resistance, as Leonardo wrote,

> A very small object should be moved as rapidly as thought itself . . . If one shoots a small grain with gun-powder [from a canon] . . . it should be by this reasoning be sent a million miles in the time when a thousand pounds of ball will go three miles . . . You investigators should therefore not trust yourselves to authors who by employing only their imaginations have wished to make themselves interpreters between nature and man, but only to those who have exercised their intellects... with the results of experiments (I. 102r-103v).

Albert of Saxony attracted Leonardo's particular scorn for advocating Aristotle's rule (I.120r).

All this looks straightforward enough. Leonardo has apparently rejected Aristotle's ideas in favour of the more recent science of Bradwardine, Oresme and their followers. But the problem is that his rejection in Manuscript I (about 1497-9) was actually followed by his readoption of the

discredited formulas — not only in Manuscript L, the relevant sections of which probably just postdate the Manuscript I passages, but also more conclusively in Manuscript F, which is firmly dated 1508 (L.78v and F.26r,51v). A proper analysis of his statements from 1508 must wait until a subsequent section of this study; for the moment we can say that during the late 1490s his attitude towards the proportional theory of velocity was no more satisfactorily resolved than his interpretations of impetus and antiperistasis. I suspect that much of the difficulty came from his failure to comprehend the proportional formula which the late medieval philosophers had adopted in place of Aristotle's and which relied upon the tricky concept of 'proportions of proportions' (actually the title of a treatise by Oresme). Halving the velocity was accomplished by taking the square root of the ratio of force to resistance; that is $(F/R)^{1/2}$. Or to express it for any given change in velocity: $F_2/R_2 = (F_1/R_1)^n$, where n $= V_2/V_1$. There is no indication that Leonardo came to terms with this exponential system.

Nor, when it came to investigating gravitational force, did he appear to understand the Merton uniform acceleration theorem to determine the distance which a body would fall in a given time. He acknowledged that every falling body 'gains a degree of speed with every degree [*grado*] of movement' (M.49r) — thus following Buridan's idea of a falling object acquiring increments of impetus — and he devised a neatly pyramidal method for determining the gain (see Figure 21), but his mathematical grasp of advanced mechanics generally remained on a rudimentary level at this time. One of the rudiments which he unfortunately accepted without question was that the length of fall was directly proportional to time an important error which seriously hindered a proper understanding of gravitational acceleration.

Against this relative lack of mathematical sophistication, we must set Leonardo's unfailing ingenuity in relating abstract theory to concrete 'experiences', some observed from independent phenomena and some contrived by Leonardo as what may legitimately be called experiments. He hoped that analysis of the ballistics of canons (Figure 30) and bows would

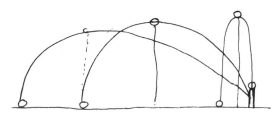

Fig.30 *Studies of the Trajectory of a Ball from a Mortar*, based on I.128v, showing the relationship between height of trajectory and distance travelled

provide definitive answers to questions of power and motion; he was convinced, for example, that there was an incrementally proportional correspondence (inversely) between the angle of a taut bowstring and the force required to withdraw it, based upon a 'pyramidal' law 'almost like the perspectivists' diminution' (Madrid I,51r, Figure 31). He also recorded his intention of staging experiments with glass balls bouncing on stone, and balls colliding from tubes. He assessed the results of heavy and light hammers driving nails into wood (Figure 32). He devised a nice technique for studying the effect of percussion on a thrown ball by saturating it with dye 'so that it marks the spots where it strikes upon the marble... and so one deduces the rule' (I.128r). Perhaps such as an experiment led him to understand that a certain amount of force is consumed in each bounce (L.42r), in contradiction to the 'conservation of impetus' which he had advocated some years earlier (A.24r; see Figure 26). In these experimental aspirations he was extending the more empirical tendencies in medieval science. Buridan had set an excellent example, with his readiness to cite 'experience'. Buridan's analysis of a mill wheel's high level of continuing impetus finds a direct echo in Leonardo's observation that the 'continuance' of a mill wheel's motion 'necessitates but little force' (B.26v). Newton's law of inertia does not seem far away, although the conceptual leap from Buridan's principles (and Leonardo's) to Newton's remained considerable.

Fig.31 *Pyramidal Law of Force in a Bow String*, based on Madrid I, 15r

Fig.32 *Studies of Hammers of Differen Weights*, based on M.83v

The medieval 'science of weights' (roughly equivalent to what we now call statics) was dominated by proportional considerations to at least as great a degree as medieval dynamics, with the advantage that static proportionality could be more simply understood in visual terms. In his investigations of balances, levers, pulleys, pivots and inclined planes

Leonardo turned again to the proportional formulas of classical and medi-
eval science. In a number of these cases the formulas possessed imma-
culate accuracy, at least in the theoretical terms of a frictionless universe.
The basic law of balances as deduced by Euclid and Archimedes had been
reconfirmed many times, for example by Jordanus in the thirteenth cen-
tury: 'If the arms of a balance are proportional to the weights suspended in
such a manner that the heavier weight is suspended from the shorter arm,
the weights will have equal positional gravity.' This law was accurately
restated by Leonardo (A.45r) and provided the basis for numerous vari-
ations of simple and compound equilibrium, using the formula that W_1 x
$L_1 - W_2$ x L_2 (Figures 33 and 34). His sources included Pelacani's *De pon-
deribus*, and almost certainly the treatise of the same title by Jordanus. A

Fig.33 *Studies of Balances*

A and B based on Madrid I, 129v
C based on Madrid I, 157r
D based on Madrid I, 167v
E based on C.A.86rb

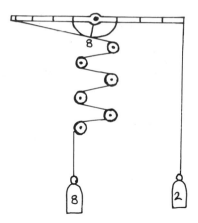

Fig.34 *Compound Balance and Pulley System* based on M.38r

comparably proportional rule governed pulleys: 'Whatever the proportion of the number of chords placed in the pulley blocks which draw the weight to those which sustain the weight, such is that of the weight that moves to that which is moved' (Forster II,72v, Figure 35). Systems of pivots functioned according to similar ratios and one eight-pivot series in which the axle to circumference ratio was 1:6 achieved a proportion of effort to load of 1:279,996 (Figure 36) — what he called a 'marvel of mechanics', which it would indeed be in a frictionless world. Some of the systems have no obvious practical implications (Figure 37) but set up ideal situations of harmonic equilibrium which are as much sources of contemplative delight as musical intervals or bodily proportions. In other instances his studies of forces in resolution lead clearly into his architectural researches, which include brilliant analyses of such matters as the stresses and thrusts in arches, conducted with far greater precision than had previously been accomplished (Figure 38). And we will recall that architectural equilibrium was analogous to bodily equilibrium. The mechanical and organic worlds are nowhere to be divorced in Leonardo's science and art.

The universal rules of visual and functional proportion — in the human figure, in architecture, in dynamics and in statics — were the physical manifestations of nature's underlying order, the divine order which found its ultimate expression in the abstract perfection of pure mathematics. Leonardo had hitherto exhibited little in the way of sustained interest in mathematics for its own sake but had largely concentrated upon the solution of certain problems which had specific implications for other aspects of his work, such as the construction of polygons with straight edge and compass. A more systematic study of mathematical questions is not apparent until about 1496, the year of Luca Pacioli's arrival in Milan. The conjunction of these events is not coincidental. It is clear that Luca provided the direct stimulus for a sudden transformation in Leonardo's mathematical ambitions, effecting a reorientation in Leonardo's interests in a way which no other contemporary thinker accomplished. And it seems that the influence was reciprocated to a considerable degree.

Fig.35 *Pulley System with a Ratio of 1 : 33,* based on Madrid I, 36v

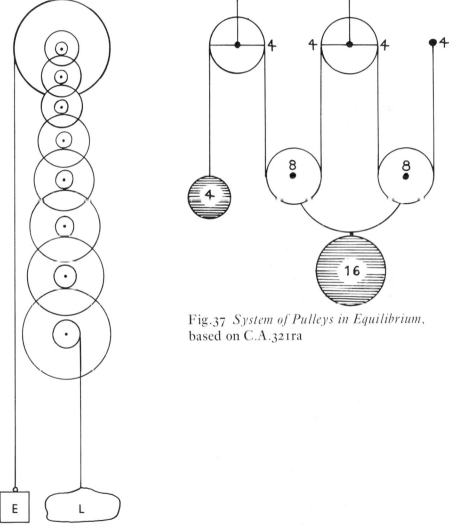

Fig.37 *System of Pulleys in Equilibrium,* based on C.A.321ra

Fig.36 *Systems of Pivots for Raising a Load,* based on I.58r and 114r

E effort
L load

Fig.38 *Analysis of the Statics of an Arch,* based on Madrid I, 142v, showing the effective weights of 40 lb stones as 40, 20, 10, 5 and 0 lb

A Franciscan monk since 1476, Fra Luca Pacioli had published his *magnum opus,* the *Summa de arithmetica, geometria, proportione et proportionalità,* two years before his peripatetic career brought him to Milan in 1496. Elements of Aristotelian empiricism from his Venetian training were combined in his thought with a Pythagorean-cum-Platonic reverence for the divine mystery of mathematical order. He was as prepared to cite the Aristotelian maxim that 'there is nothing in the intellect which was not previously in sensation' as he was to quote Plato, Euclid, Ptolemy and Boethius in praise of the 'very great abstraction and subtlety of mathematics'. Luca's presence in Milan served to encourage Leonardo to pursue far more explicit and fundamental investigations into the mathematical order which had formed the implicit basis for so much of his earlier art and science. For his part, Luca expressed unqualified admiration not only for his friend's artistic achievements, especially the Sforza horse and the *Last Supper* — with suitable references to Pheidias, Praxiteles, Apelles, Myron, Polycleitos, Zeuxis and Parrhasios — but also for his 'invaluable work on spatial motion, percussion, weight and all forces, that is to say accidental weights, having already with great diligence completed a worthy book on painting and human motions'. The remarkable convergence of their thought after 1496 was such that many of Luca's published opinions would sit easily in Leonardo's notebooks. When we listen to Luca arguing for the superiority of perspective over music — 'if you say that music satisfies hearing, one of the natural senses', perspective 'will do so for sight, which is so much more worthy in that it is the first door of the intellect' — we may well imagine that we are hearing an echo of Leonardo's own voice.

All the quotations from Pacioli cited in the preceding paragraph come from *De divina proportione,* originally produced in two splendid manuscripts in 1498 for Ludovico Sforza and Galeazzo Sanseverino. It was printed in 1509. The illustrations of the five 'Platonic solids' in various guises together with some of their derivatives were, as the printed edition and Luca's *De viribus quantitatis* recorded, 'made and formed by the

ineffable left hand' of the 'most worthy of painters, perspectivists, architects and musicians, one endowed with every perfection, Leonardo da Vinci the Florentine, in Milan at the time when we were both in the employ of the most illustrious Duke of Milan, Ludovico Maria Sforza Anglo, in the years of Our Lord 1496 to 1499, whence we departed together for various reasons and then shared quarters at Florence'. The five regular bodies and derivatives were each depicted in three dimensions in their solid form (*solidus*), followed by a see-through version in skeletal form (*vacuus*), brilliantly demonstrating their total configurations in space (Figures 39 and 40). Not all the illustrations in *De divina proportione* depend upon Leonardo's designs, but the accomplished draughtsmanship of the more complex figures can readily be recognized as his. Working directly from actual models, such as Luca had offered to the Duke of Urbino in 1494, rather than labouring with abstract perspective projections, Leonardo provided his friend with the prototype drawings for the presentation manuscripts and printed edition.

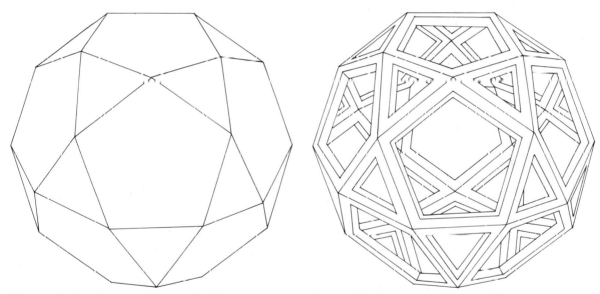

Fig.39 *Dodecahedron Absiscus Solidus,*
based on C.A.263rc

Fig.40 *Dodecahedron Absiscus Vacuus,*
based on C.A.263rb

A nice reminiscence of their collaboration is to be found in Leonardo's Manuscript M, shortly before 1500. A rough sketch of the five basic solids (Figure 41) — the tetrahedron (composed from four equilateral triangles), the hexahedron (six squares), the octahedron (eight equilateral triangles), the dodecahedron (twelve pentagons) and the icosahedron (twenty equilateral triangles) — is accompanied by the little rhyme which Luca quoted in his treatise. The five bodies speak to the reader:

El dolce fructo, vago e si dilecto
constrinse gia i philosophi cercare
causa de noi, che pasci l'intellecto.

('The sweet fruit, so attractive and refined, has already drawn philosophers to seek our origins, to nourish the mind.') This delight in the intellectual beauty of abstract mathematics is precisely that which motivated Leonardo from 1497 onwards to embark upon a programme of self-education in his friend's speciality, primarily using Euclid's *Elements*, the standard text for anyone who sought a comprehensive induction in the beguiling order of mathematical perfection. Manuscripts I and M bear witness to his efforts, as he grappled with basic propositions from Campanus' Latin version (published in Venice in 1482), noting down the properties of angles, triangles, polygons, rational and irrational numbers, continuous and discontinuous quantities and so on. At this stage he was doing little more than provide some foundations for what was to become one of his major obsessions, but already there are characteristic indications of his interplay between abstract deductions and natural appearances. One instance is his elegant exposition of a water droplet's changing configuration on a progressively inclined plate (Figure 42), whereby the droplet's contours meticulously obey the laws of geometrical 'necessity'.

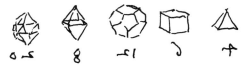

Fig.41 *Sketch of the Five 'Platonic Solids'*, based on M.80v

A B C D E

Fig.42 *Analysis of a Water Droplet on a Progressively Inclined Plane* (A, B, C, D and E), based on I.90r

'Necessity' was the name he gave to the inexorable principle of obedience to law as manifested in all operations of the 'prime mover' in the universe, from the largest of planetary motions to the minutest detail of nature. 'Necessity is the mistress and teacher of nature; necessity is the theme and inventor of nature, the curb, the rule and theme' (Forster III, 43v). In the interlocked components of the universal mechanism, imperfection of causes is unthinkable. The human mind can perform no higher

function than to investigate the effects of this mechanism through 'experience', endeavouring to discover the principles behind its operation. Once the investigator had achieved such a discovery, he could then 'forecast' how everything worked, reconstructing natural order in his own mind. If the resulting demonstrations of natural systems tend to look oversimplified in a mechanical manner, this is because even Leonardo, with his incredible sensitivity for nuances of natural form, only imperfectly realized at this stage the functional complexity of natural design.

His way of interpreting nature — deriving causes from a study of effects and reconstructing effects from causes — was explicitly endorsed by those medieval authors he most respected. He had quoted Pecham's method, 'sometimes deducing effects from causes and at other times causes from effects', and he later wrote on his own account that 'in nature there is no effect without a cause; understand the cause and you will not need experience' (C.A.147va). He did not yet apply Pecham's method in a systematic manner but it did colour his thought to a considerable degree. Given this attitude, it is easy to see why art and science could become one in his mind. The artist-scientist extracted rules from nature and could then remake nature in his own works as the ultimate confirmation of natural truth.

III The Exercise of Fantasia

Venite, dicho, a Athene hoggi Milano,
Ov'e il vostro Parnaso Ludovico.
(Bernardo Bellincioni)

'Come, I say, to today's Athens in Milan, for here is the Ludovican Parnassus.' Not a few Renaissance cities had aspired to the image of a 'new Athens', and there was nothing essentially novel in Ludovico's ambition to create a metaphorical 'Parnassus' which the Muses would favour with their gifts. As a court poet Bellincioni could hardly be called an unbiased witness when he painted such a glowing picture of Ludovico's artistic beneficence, but his testimony does at least give some idea of the image which Il Moro wished to present to contemporaries and posterity.

The earlier Milanese regimes of the Visconti and Sforza had lacked nothing in grandeur and Galeazzo Sforza's court had been noted for its ostentatious magnificence. In 1471 when the Milanese court had paid a state visit to Lorenzo de' Medici's Florence, the residents were astonshied and in some quarters not a little repelled by the blatant *superbia* of Duke Galeazzo and his brother, Ludovico, accompanied as they were by an entourage of thousands — and this in a city which was no novice in sumptuous pageants. What Ludovico did when he came to power in Milan was to succeed in shaping this magnificence according to the Renaissance style *all'antica* to a greater extent than his predecessors had done, bringing his court fully into fashionable line with the trendsetting regimes of North and Central Italy. His aspirations in this respect were not fundamentally different in kind from those of his Gonzaga and d'Este relations, though a certain individuality of style was apparent, as I hope to show. And in sheer scale Ludovico's court was unmatched.

Like other Renaissance tyrants Il Moro exploited festive celebrations of notable events, saturated in antique and religious imagery, as political vehicles to parade his magnificence as well as occasions for personal pleasure. Alongside annual festivals of a religious nature, which occurred in any city, there was a series of dauntingly impressive Sforza celebrations: in 1490 the enormous festivities for the wedding of Gian Galeazzo to Isabella of Aragon, Princess of Naples, included a performance of Bellincioni's *Paradiso* staged by Leonardo; this was followed in 1491 by the doubly huge celebrations, again involving Leonardo, for the marriages of Ludovico to Beatrice d'Este, and Anna Sforza (Ludovico's niece) to Alfonso d'Este; 1493 not only saw the immensely prestigious wedding of

Bianca Maria Sforza (another niece) to the German Emperor, Maximilian, for which the city was transformed with temporary architecture, but also the birth of Il Moro's first son, Ercole (later diplomatically renamed Massimiliano), which occasioned sumptuous decorations including gesso panels of the Labours of Hercules, special tapestries and an unspecified *fantasia* ordered from Bramante; the clouds surrounding Gian Galeazzo's death in 1494 were totally dispersed in 1495 by Ludovico's triumphant investiture as legitimate Duke of Milan; and also in 1495 a second son, Francesco, was born to the accompaniment of suitable delight. At its peak Sforza pageantry must have been an industry in itself, regularly involving Leonardo, Bramante and many others in the brilliant invention of dazzling ephemera, whose disappearance has inevitably impoverished our visual picture of late fifteenth-century Milan.

In addition to these grand occasions there were regular performances of new plays by court authors, the recitation of new Italian poems, both refined and burlesque, and the presentation of Latin panegyrics and epigrams. In true d'Este fashion, Ludovico's young wife, Beatrice, took a special delight in promoting literature, music and dance. Some of these artistic presentations were linked to special events, while others were produced independently in their own right. Ludovico's new theatre was inaugurated in 1493 by Niccolò da Correggio's *Mopsa e Daphne*, and in 1495 the same author presented his *Innamoramento de Orlando*, a chivalrous romance of the kind especially favoured at the d'Este court of Ferrara, where Niccolò was equally at home. Its subject matter occupied that same territory of love and war as had been exploited by Boiardo at Ferrara and was shortly to reach its apogee in Ariosto's *Orlando Furioso*. Also in 1495 Gasparc Visconti, a member of the noble family succeeded by the Sforza as rulers, presented his *De Paulo e Daria amanti* which begins with a eulogy of Bramante. This was followed a year later by a play on the theme of Danae's 'seduction' by Jupiter designed by Leonardo and written by Ludovico's chancellor, Baldassare Taccone. When Isabella d'Este visited Pavia in 1496 she was royally entertained by a performance of *Timone*, a joint production of Bellincioni and Leonardo. In literary terms Sforza theatre conformed closely to the Italian court taste for a compound of classical conceits in imitation of antiquity and late medieval chivalry.

If the court possessed any style of its own, it lay in Ludovico's love of bewilderingly intertwined allegories, heraldry, astrology and personal symbolism. He was depicted in one portrait wearing a costume decorated with no less than six different *imprese* or *divise*, personal emblems symbolizing his self-proclaimed virtues. The painted and sculptural decorations of the *Castello* and provincial buildings contained a wealth of allusions to Il Moro, providing a rich feast of heraldic symbols. Tapestries, furniture decorations, costumes and jewelry were all called upon to play their part. One surviving manuscript (Biblioteca Trivulziana 2168) illustrates no less than seventy-seven family *imprese*, many invented

specially for Ludovico himself, and this is by no means an exhaustive collection. This taste was not merely heraldry for the sake of display; the Duke clearly believed in the inner meaning of his devices, each acting as a kind of magic talisman. His love of such things was all of a piece with his taste for astrology. The court star-gazer, Ambrogio Varese da Rosate, appears to have played at least as large a role in regulating Ludovico's life as his political advisers. The practice of astrology blended in Ambrogio's activities with the care of his master's health. If the body was dominated by zodiacal influences, as they both believed, only someone proficient in astrology could ensure the maintenance of bodily equilibrium.

Although Leonardo was scathing about the claims of predictive astrology, which he described as 'that fallacious judgment by means of which (begging your pardon) a living is made from fools' (Urb.13r), there is no reason to suspect that he ever felt himself seriously out of tune with the general character of court iconography, and he appears to have satisfied many of Il Moro's tastes in this direction with real conviction and pleasure. Even if his concept of valid intellectual pursuits excluded the extremes of celestial magic embraced by much popular 'science' at this time, he shared with many contemporary scientists an ability to move with complete freedom between science and symbolism, between observation and signification, and between fact and fable. The book of nature was a text to be read for meaning as well as an illustrated manual of scientific theorems. Our modern attitude to the proper scope of scientific inquiry has made us ill-equipped to understand what was essentially a late medieval outlook towards nature and symbolism, and in our eyes the more allegorical aspects of Leonardo's interpretation of nature too easily seem little more than whimsical appendages of his real self. But his contemporaries, most relevantly those at the Milanese court, would have thought otherwise.

Leonardo's own booklists include a conspicuous group of texts devoted to what may be called the secret mysteries of nature and to allegorical fantasies on the natural world. His writings show that he studied them with real relish. In addition to Cecco d'Ascoli's popular 'scientific' poem, *L'Acerba*, his library contained the popular medieval corpus, the *Fior di Virtù*, a copy of Aesop's *Fables* in French and Federigo Frezzi's *Quadrerigio* (a religious-scientific poem). Pliny's *Natural History* could also be included in this category, at least on account of its fabulous animals. During his period at the Sforza court he drew upon these texts to construct a rich vocabulary of nature's allusions, often expressing their meaning with a succinct potency which his sources lacked.

Drawing upon *L'Acerba* and the *Fior di Virtù*, he attributed intrinsic properties of significant behaviour, both moral and immoral, to familiar and fabulous creatures. The turtle dove, for instance, was an embodiment of chastity: 'The turtle dove is never false to its mate, and if one dies the other observes perpetual chastity and never sits on any green branch and

never drinks clear water' (H.12r). This myth of the dove from the *Fior di Virtù* accounts for its presence in Botticelli's posthumous portrait of the assassinated Giuliano de' Medici (c. 1478, National Gallery, Washington). Leonardo had sketched one of Giuliano's hanged assassins (Bayonne, Musée Bonnat) and probably knew his colleague's painting. Other animal exemplars were known only through fabulous descriptions. The mythical basilisk made regular appearances in Leonardo's bestiary: 'The basilisk is so cruel that when it cannot kill animals with its venomous glance, it turns to the herbs and plants, and fixing its gaze upon them withers them up' (H.7r, from the *Fior di Virtù*); 'All snakes flee from this creature, but the weasel by means of rue attacks it and thus kills it' (H.14v, from *L'Acerba*); 'This is found in the province of Cyrenaica and is not larger than twelve fingers and it has on its head a white spot resembling a diadem; with whistling it hunts all serpents' (H.24r, from Pliny's *Natural History*). If all this seems little more than a courtly joke, we should remember that the basilisk's cruel ability to kill with its 'venomous glance' was cited by Leonardo when he conducted a debate about the feasibility of the emission of 'seeing rays' from the eye rather than the passive reception of light into the eye.

This compatibility between science and allusive signification also pervades his fables, as the following example shows:

> The water, finding itself in the proud sea, its own element, was over-come with a desire to rise above the air, and encouraged by the fiery element, raised itself as subtle vapour, almost appearing as rarified as the air; and moving higher it reached more rarified and chilly air, where it was abandoned by the fire, and the minute particles became constrained, were united and made heavy, whence fell its pride and it was thrown into flight and fell from the sky; then it was drunk up by the dry earth, where it was imprisoned for a long time doing penance for its sin (Forster III, 2r).

A nice piece of meteorology is used to convey an allegory of *superbia*, pride before a fall.

Composed in emulation of Aesop's *Fables* and Alberti's *Apologhi* — he once referred (H.44r) to the story of a lily from Alberti's hundred moral tales — his fables could clearly serve as suitable snippets of literary delight for courtly consumption. Most exhibit his characteristically vivid feeling for the individual life or 'essence' of each 'participant' and possess a freshness which transcends their essentially imitative nature. Parti-cularly neat are those which reflect his practice as an artist and author: 'The paper seeing itself all spotted with the murky blackness of the ink grieves over it; and this ink shows that by the words it composes upon the paper that it becomes the cause of its preservation' (Forster III, 27r). False pride, false hope, false grief, false scorn, self-love and all varieties of stupid sentiment are the targets of his fables, and they are attacked with a brisk conviction which carries a real air of sincerity. No less compelling

are the bitter little aphorisms of the *Fior di Virtù* type: 'He who thinks little, errs much' (H.119r); 'He who does not value life, does not deserve it' (H.15r); 'Whosoever does not curb lustful desires places himself on the level of the beasts' (H.119v); and 'Nothing is to be feared so much as evil report' (H.40r). This last is paraphrased from Sallust's *Bellum Iugurthinum* (XXXV), which we have already seen as the learned source for his disparagement of book learning.

The pithy sayings and the anthropomorphized animals, plants and objects in Leonardo's fables belong within established literary genres of the kind popular at court. His *facetie*, satirical tales of human foibles, stand within the same tradition. The often ribald vulgarity of *facetie* might seem at first sight to stand in irreconcilable contrast to the high Latin seriousness of Renaissance ideals, but previous anthologists of such tales included two of the finest classical minds of the fifteenth century, Poggio Bracciolini and Angelo Poliziano. Such an impeccable pedigree, which dated back at least to Boccaccio and ultimately to classical antiquity, ensured that Renaissance wit was not to be considered a trivial pursuit, even if it genuinely was a laughing matter.

Leonardo owned a copy of Poggio's *Facetie*. His own compositions contain clear evidence that he read Franco Sacchetti's *Novelle* and Lodovico Carbone's *Cento trenta novelle* (written in d'Este Ferrara), both collections of often scurrilous tales which depend directly upon the example of Boccaccio's *Decamerone*. One of the standbys of such humour was the infallibly ticklish compound of sex and sanctity, and Leonardo's *facetie* were no exception.

> A woman washing clothes had very red feet from the cold. A priest who was passing nearby asked her with amazement where the redness came from. In answer the woman immediately replied that this result came about because she had a fire down below. Then the priest took in his hand that member which made of him more a priest than a nun, and coming close with sweet and caressing tones begged her to be so kind as to light that candle (C.A.119ra).

The Sforza court undoubtedly enjoyed such things and Leonardo was not the only artificer involved; his fellow Florentine, Bellincioni, turned a lively hand to the production of burlesque verse in a similar vein.

These *facetie* provide the literary background for the satirically grotesque drawings of bizarre characters which Leonardo produced at this time, particularly those of a narrative nature. An instinctive delight in emphatic characterization had already been apparent in his years in Verrocchio's studio, and indeed in the work of the master himself. In the d'Este court at Ferrara, Francesco del Cossa had already developed an entertaining repertoire of grotesque characters in his paintings and drawings. The most elaborate of Leonardo's Milanese grotesques, most spectacularly the *Five Characters* at Windsor (Plate 42), developed this genre in such a way as to become the visual equivalent of the Italian *novelle* and

facetie. The *fessi* (the naïve, the gullible, the cuckolds, and all ill-starred fools) are typical subjects of hooting derision, perhaps tempered with a leavening of compassion, as is undoubtedly the case here. The literary quality of this drawing is consistent with the theory that the shop-soiled and bemused caesar with his crown of oak leaves was intended to play the role of a bridegroom in a satirically pathetic marriage betweeen himself and a pug-faced crone in another drawing at Windsor (12449).

Pl.42 *Study of Five Characters* (*c.* 1494), pen and ink, Windsor, Royal Library (12495r)

Just as his fables had breathed a special sense of the deeper 'essence' of things, so the ribald grotesques exude a profound feeling for the inner causes of external effects. The causes of facial effects were embraced by the medieval science of physiognomy, a science which had progressed from a minor branch of the Greek legacy — minor but with a crucially Aristotelian element in its pedigree — to become a subject worthy of serious philosophical attention. Medieval physiognomic theory was fully integrated with the study of the soul in procreation and the four temperaments, with important implications for medicine and morals, to say nothing of its associations with astrological mysticism. Physiognomy was regarded as 'a science of nature; by its application anyone sufficiently well versed can ascertain the characteristics of the nature of animals and men'. So wrote Michael Scot in his *Liber phisionomiae*, a copy of which Leonardo owned. By reading the 'external signs' of human and animal features, the initiates of this science possessed the power to see the 'inner truths' of character, as demonstrated in Roger Bacon's *Secretum secretorum*, a treatise apocryphally based upon advice given by Aristotle to Alexander. At its most sophisticated, in the fifteenth-century hands of Michele Savonarola, physiognomics was solidly based upon the ubiquitous doctrine of the four temperaments, each temperament being characterized by a particular set of 'signs' and 'complexions'. The choleric, for example, would tend to have a round face, strong teeth, prominent forehead with conspicuous eyebrows, deep-set eyes of bright power, and dark hair of a crisply curly quality. That these features are recognizably 'leonine' is no coincidence, since the physiognomics of man contained an inherent reflection of the animal whose temperament they most resembled. Thus the leonine man would be courageous and magnanimous (following the character of the lion in the bestiary), while a foxy-faced person would be naturally cunning and deceitful.

Leonardo despised the more crudely predictive aspects of physiognomy — 'false physiognomy and chiromancy [palmistry] I will not consider because there is no truth in them as is shown by the way in which such chimeras have no scientific foundation' — but he willingly subscribed to the view that 'the signs of faces show in part the nature of the men, their vices and their complexions' (Urb.109r-v). Twice in his early schemes for his anatomical treatise he reminded himself to 'describe a grown man and a woman and their measurements and their complexions and physiognomy' (W.19037r and 19018r). In his notes on the rendering of character in painting he regularly talked about the importance of the *complessione* and *aria* of a figure. 'To gain facility in remembering the *aria* of a face' he recommended that the painter should use a physiognomic classification of features: 'for example, noses are of ten kinds . . .' (Ash.II, 26v). Carrying a little sketchbook with him at all times the artist would use shorthand 'signs' for recording any features which caught his eye.

Contemporary accounts testify that Leonardo did exactly this, mak-

ing quick *aide-mémoire* of faces seen, searching particularly for extremes of physiognomy and expression. He delighted especially in the rudely uninhibited laughter of peasants. These 'field' studies provided the raw material for the endless profiles, grotesque and otherwise, which he 'later reconstructed at home' in his drawings (Ash.II, 26v). By these means he commanded an inexhaustible parade of characters, each evoking through its facial 'signs' an 'air' expressive of its inner temperament. Using this repertoire he claimed to move his audience to laughter, compassion, fear or desire, exploiting the whole gamut of reactions even more vividly than the poet. Leonardo was certain that a drawing such as the *Five Characters* would possess a greater immediacy of impact than even the most racy *facetia.*

This remarkable combination of objective study, imaginative re-creation and emotional response reached its most compelling literary expression in a relatively extended though incomplete composition from the very end of his period at the Sforza court. Cast in the form of a letter to the 'Diodario of Syria, lieutenant of the Sacred Sultan of Babylon', it purports to explain a terrible natural disaster in his territory, and is so convincingly vivid that it was long believed to document an actual journey to Armenia. His geographical 'analysis' centred upon Mount Taurus and its environs:

> The mountain at its base is inhabited by a wealthy population and is full of the most beautiful springs and rivers . . . but after ascending for about three miles we begin to find a forest of enormous extent of firs and beech and other similar trees; after which for a distance of three more miles there are to be found meadows and vast pastures; and all the rest, as far as the slopes of Mount Taurus, is eternal snows which never disperse at any time, extending to a height of about fourteen miles in all. From this begins the mountain itself; to the height of a mile the clouds never pass away . . . Half way up is found scorching air where a breath of wind is never felt, but nothing can live there . . . This is all bare rock, that is from the clouds upwards, and the rock is purest white . . . (C.A.145va).

He had begun to practise this type of imaginative word painting as early as about 1480 in his poetic reconstruction of a fossil fish. Looking at its shadowy remains, 'destroyed by time . . . with bones stripped bare, serving as a support and prop for the mountain', he meditated upon its past grandeur: 'O how many times the terrified shoals of dolphins and big tunny fish were seen to fly from the vehemence of your fury, and lashing with swift branching fins and forked tail you generated instant tempests in the sea, with great buffeting and foundering of ships . . . ' (B.L.156r). This flight of reconstructive fantasy was closely inspired by a description credited to Pythagoras in Ovid's *Metamorphoses* (XV).

Some eight years or so later, in a related if more thoroughly fantastic vein, he composed a letter 'from the East' to Benedetto Dei (a Florentine

traveller and author) describing as an 'eye-witness' the arrival 'in the month of June' of a horrific 'giant who comes from the Libyan desert': 'When the proud giant slipped down on account of the bloody and miry ground, it seemed as if a mountain had collapsed, so that the countryside seemed to quake and infernal Pluto was thrown into terror . . . and Mars, fearing for his life, took refuge under the bed of Jove.' As hordes of people swarmed all over the fallen giant, attacking it with puny weapons,

> He was aroused, immediately feeling the smarting of the stabs, letting forth a roar which seemed as if it was terrifying thunder. Placing his hands on the ground, raising his terrible face, and lifting one hand to his head he found it full of men clinging to his hairs like the mites which are commonly found there. Whereupon, shaking his head, the men resembled nothing so much as hail driven by the fury of the winds, and it was found that many of those men were killed . . . (C.A.311ra).

This account, written on an unwanted page from a book used by the administration of Milan Cathedral, is amplified on a similar page with a description of the giant's physiognomy: 'The black face at first glance is most horrible and terrifying to look upon, especially the swollen and bloodshot eyes . . . the nose is arched upwards with gaping nostrils from which protrude many thick bristles. Below this is the arched mouth with gross lips from the extremity of which there were whiskers like those of cats . . . ' (C.A.96vb).

The literary antecedents of this kind of writing are clear enough. In addition to Ovid, direct sources of inspiration can be found in Luigi Pulci's epic poem of an unruly giant, *Morgante*, which Leonardo recorded in his possession, and in Antonio Pucci's *Historia della Reina d'Oriente*, eight lines of which he transcribed with slight variations in Manuscript I (139r). If Leonardo's composition lacks the literary polish of his exemplars, it lacks nothing in urgency and *terribilità*. And its level of visual invention is exactly what one would expect from the man who could sketch such frighteningly credible monsters.

All this exercise of imaginative fantasy might seem at odds with the discipline of scientific demonstration described in the previous chapter. But it is, in reality, as much an integral part of Leonardo's mind as the obverse of a Renaissance medal is part of the whole. On one side, the objective portrait; on the other the imaginative emblem. Or to express it more in keeping with Leonardo's own concept of cerebral functions, imagination is an output process of the human mind, dependent upon an accurate understanding of the observational input but transcending the orderly data of rational induction. In terms of the medieval psychology of the inner senses which he adopted and adapted, this is the realm of *fantasia* — active, combinatory imagination — which continually recombines sensory impressions, visualizing new compounds in unending abundance.

As we have seen, he transferred the faculty of *fantasia* from the first to

the second of the brain's ventricles, where it was able to act in concert with the rational faculties. The inventions of his *fantasia*, even at their most truly fantastic, are never out of harmony with universal dynamics as rationally comprehended; they are fabulous yet not implausible, each element in their composition deriving from the causes and effects of the natural world. He took pains to compose truly 'realistic' monsters: 'If you wish to make an animal invented by you appear natural, let us say a dragon, take for the head that of a mastiff or hound, for the eyes a cat, and for the ears a porcupine, and for the nose a greyhound, and the brows of a lion, the temple of an old cock, the neck of a terrapin' (Ash.II, 29r).

None of this is inconsistent with the scientific method of his day, with its two stage procedure of *resolutio*, induction of underlying laws from observed effects, and *compositio*, explanatory synthesis of effects on the foundations of laws. The fantastication of monsters certainly was not the legitimate job of scientific *compositio*, but fantasy acted for Leonardo as an imaginative extension of the inventive process which he used in his science for rational demonstration. In this he adopted a position not dissimilar to that of his Florentine predecessor in Milan, Antonio Filarete. In his treatise Filarete set great store upon his faculty of *fantasia*, his ability to fantasticate brilliant buildings and ingenious allegories. He was clearly convinced that *fantasia* was an imaginative extension of rational thought rather than a negation of it. A comparable attitude was taken by Leonardo's one-time colleague in Milan, Francesco di Giorgio, who proudly characterized man's 'almost infinite' but rationally based powers of invention as the supreme factor which differentiated man's intellect from that of the animals. Francesco's concept of artistic invention was philosophically sophisticated — it was founded upon Aristotelian ideas — but only Leonardo incorporated artistic imagination into a clearly defined system of psychology, setting it within the scientific context of the 'inner senses'. This gave the whole business of artistic invention the status of a scientifically recognized process of the human mind.

Again and again he exulted in the artist's powers of invention. 'If the painter wishes to form images of animals or devils in the inferno, with what abundance of *inventione* his mind teems' (Ash.II, 24v).

> If the painter wishes to see beauties which will enamour him, he is the lord of their production, and if he wishes to see monstrous things which frighten or those which are buffoonish and laughable or truly compassionate, he is their lord and god. And if he wishes to generate scenes, deserts or shady and cool places in hot weather, he portrays them, and similarly hot places in cold weather. If he wants valleys, if he wishes to disclose broad meadows from high mountains, and if he wishes afterwards to see the horizon of the sea, he is lord of them; similarly if he wishes to see high mountains from low valleys or the low valleys and sea shores from high mountains. And, in effect, that which is in the universe by essence, presence or imagination he has it first in

his mind and then in his hands, and these are of such excellence that in a given time they will generate a proportional harmony in a single glance' (Urb.5r).

Painting is defined as 'a subtle *inventione* which with philosophy and subtle speculation considers the natures of all forms' (Ash.II, 20r). '*Inventione* or composition' is the 'culmination of this science' (Urb.13r). Like the divinely inspired poet, whom Leonardo was openly challenging, the painter is in the position of a microcosmic god: painting is 'not only a science but also a divinity, the name of which should be duly revered and which repeats the works of god the most high' (Urb.5or-v).

At the highest level, therefore, the exercise of *fantasia* was a matter of the greatest consequence. Like Dante's '*alta fantasia*' — the concept of 'elevated imagination'which Leonardo would have known from his reading of the *Divina commedia* and *Convivio* — the visual artist's faculty of invention gave him a 'divine' power to fabricate his own universe, a universe which existed in parallel to the real one. In matters of content it granted him the ability to devise 'fictions which signify great things' (Ash.II,19v), that is to say, learned allegories and symbolic compositions which express profound truths. He cited as a classical exemplar the lost painting of *Calumny* by Apelles, an allegorical masterpiece known only through literary descriptions. The *Calumny* had been recommended as a model by Alberti and was imaginatively reconstructed in a drawing by Mantegna and a painting by Botticelli. Leonardo's own letter to Benedetto Dei was probably intended to be a 'fiction' which signified 'great things', since the coda of his supplementary account drew melancholy implications for the human condition: 'Certainly in this way the human species has need to envy every other race of animals' because unlike birds and fishes 'We wretched mortals are not availed any flight in that this giant with his slowest movements exceeds by a great amount the speed of every swift racer. I do not know what to say or do and I seem to find myself swimming head down through the great throat and remaining disfigured in death, buried in the vast belly' (C.A.96vb).

Fantasia embraced the whole gamut of inventions, from inconsequential jests to great if sometimes obscure significations. One of his literary genres, his prophecies cast in the form of riddles, he actually planned to arrange according to their philosophical import: 'Reserve the great exemplars until the end and give the lesser ones at the beginning' (C.A.145ra). Prophecies classifiable as '*cose filosofiche*' would undoubtedly have included those scourging man's vileness and violence: 'Animals will be seen on earth which will always fight among themselves with great destruction and frequent death on either side ... By their bold limbs a great proportion of the trees in the huge forests will be laid low ... Nothing will remain on the earth or under the earth or in the water which will not be persecuted, disturbed and despoiled' (referring to man himself, C.A.370va); 'and they will be inflamed to seek those things which are most beautiful in order to

possess them and utilize their vilest parts; afterwards, having returned to their senses with loss and penitence, they will be greatly amazed at themselves' (concerning sexual lust); 'emerging from under the ground with terrible noise it will stun those standing nearby and with its breath it will kill men and ruin cities and castles' (i.e., a cannon cast underground, C.A.129va). His prophetic riddles often jolt the reader into awareness of the way in which man mindlessly abuses nature. Animals are slaughtered to provide food for man's 'fetid guts', beaten as beasts of burden and endlessly ill-treated: 'Numberless ones will have their little children taken from them, flayed and most barbarously quartered' (i.e. sheep, cows, etc. C.A.145ra).

Another type of *profetia* appears to paint a vision of cosmic malignity, but turns out to be a joke: 'There shall also hurtle through the air a nefarious species of flying creature which will assault men and animals and will feast themselves upon them with great commotion, filling their bellies with scarlet blood' (i.e. mosquitoes! I.63r). Delivered by a speaker in the manner he intended — 'in a frenzied or berserk way, as of mental lunacy' (C.A.370ra). — the listener would not be able to anticipate whether the punch line, the solution to the riddle, would douse him with the acid of philosophical pessimism or the sparking wine of humour. Finally, at the lowest level of significance, were prophecies which were simply riddles, in the form of neat paradoxes: 'Many will be busied in taking away from a thing which will accordingly increase as it is diminished' (i.e. digging a ditch); 'the high walls of great cities will be seen upside down in their moats' (i.e. by reflection, C.A.370ra).

Like the sayings of King Lear's fool, Leonardo's jests, fables and prophecies could conceal wisdom in wit. Or they could just be witty. His pictographs fall primarily into this latter category, consisting of picture writing in which punning images or symbols form a short phrase or text, like a parody of Egyptian hieroglyphs. Readers may recall simple examples of such puzzles from childhood comics. The deciphering of Leonardo's pictographs involves rather more erudition than is expected of a child, but the principle is the same. Thus the sentence '*Pero se la fortuna mi fa felice tal viso asponero*' ('However, if fortune makes me happy I will show such a face', W.12692v) is represented by a pear tree (*pero*), a saddle (*sella*), a woman holding a sail (the emblem of 'fortune'), two notes of music on a stave (*mi* and *fa*), a fern (*felce*), *tal* (written normally), a face (*viso*) and a black yarnwinder (*aspo nero*). Some aphoristic pictographs seem actually to have been painted as decorations for the Castle.

Alongside such diversions for courtiers' idle hours, he could also supply party tricks of a mathematical nature, like this one: take equal numbers of small objects (e.g. beans) in each hand; transfer four from right to left; cast away the remainder on the right; cast away the same number from the left; pick up five and add them to the left; you will now have thirteen (C.19v). Not very difficult, certainly, but ingenious enough

on first airing. In this matter of mathematical games, as in so many other things, Leonardo had been preceded by Alberti, who had dedicated a book of *Ludi mathematici* to Medialuso d'Este in 1450. Luca Pacioli, a mathematician of unimpeachable seriousness as we have seen, collected a large number of such games in his *De viribus quantitatis,* an anthology which contains fulsome praise of Leonardo. The concoction of these brainteasers no doubt helped both men justify their positions as *stipendiati* of Il Moro's expensive court.

As a master of allegory, symbolism, allusion and visual puns, Leonardo was well fitted to feed Ludovico's considerable appetite for personal *imprese* and allegorical representations. There was a sense in which Il Moro seemed to regard the conduct of his affairs as the realization of a celestial pattern, so that the allegories came to represent the higher truth of which actual events were merely a reflection, rather than the other way about. There is more than a whiff of magic in the way in which Ludovico regarded his personal symbols. Although Leonardo would have little truck with the dafter aspects of this nonsense, he enthusiastically exploited the 'essential natures' of animals and things to signify certain qualities. At its most straightforward, the desired attribute was embodied in a single, simple, unified *impresa,* such as might be embroidered on a garment or painted on a shield. Thus the antithesis between the 'oneness' of a sieve and the plurality of the sand grains which pass through carried the meaning 'I do not fall because I am united' (H.130v). Sometimes clever puns were involved: a motto from a popular phrase, *'di bene in meglio'* ('from good to better') was cunningly expressed by an image of marjoram (*megliorana*) grafted on a bean plant (*bene*) (H.99v).

All this was standard practice in Renaissance courts and seems to have been cultivated to a particularly high level in Il Moro's circle. After all, his nickname was a pun on Maurus, his baptismal second name: Maurus = *morus* (Latin for mulberry) = *moro* (Italian for mulberry and black man). Thus Ludovico could be happily symbolized by a mulberry tree, whose leaves provided vital nourishment for Lombard silkworms, or by a black man, or by both in conjunction as happened in one manuscript. Leonardo himself devised one literary snippet which contains no less than five 'moors' in sixteen words: 'O *moro,* io *moro* se con tua *mora*lita non mi a*mori* tanto il vivere m'é a*maro'* ('O Moro, I shall die if with your goodness you will not love me, so bitter will my existence be' (Madrid II, 141r).

The Milanese court had traditionally been fond of complex conceits, symbols and allegories. Filarete described the way in which he and his patron, Francesco Sforza, had delighted in fantasticating composite images, densely cluttered with attributes. Without textual guidance, their images of 'Will' and 'Reason' would become iconographers' nightmares. If anything, Leonardo's allegories are even more complicated and seem at their most extreme to border upon elaborate absurdity, even by the profligate standards of Ludovico's *imprese.* One of his simpler (!) schemes

shows 'Il Moro with spectacles and envy represented with lying slander and justice black for Il Moro' (H.88v). The corresponding drawing in the Musée Bonnat, Bayonne, shows haggard Envy in full retreat, firing a tongue-tipped arrow at Ludovico and carrying a banner on which is represented a bird pierced by an arrow, while Justice protects the Duke with his cloak. The symbolism of the spectacles is explained elsewhere as 'to know [see] better' (H.97v). The tongue-tipped arrow signifies evil report. The bird (the Visconti-Sforza dove?) may represent Envy's resentful slaughter of beauty and freedom. It is possible that the whole allegory may refer to the death in 1494 of young Gian Galeazzo, the nominal Duke of Milan, whose passing occasioned malicious rumours of Ludovico's complicity — hence the manner in which Justice protects Il Moro from evil report.

When he provided a written explanation of his more complex drawings, we may legitimately be astonished at their density of allusive meaning:

> Envy is portrayed making figs [manual gestures of an obscene nature] towards heaven, because, if she were able, she would use her strength against God; make her with a mask of beautiful appearance; show her as wounded in the eye by palm and olive; make her wounded in the ear by laurel and myrtle, to signify that victory and virtue offend her; make many thunderbolts emanate from her to signify her evil talk; make her shrivelled and desiccated because she is continually wracked with longing; make her heart gnawed by a bloated serpent; make her a quiver containing tongued arrows, because with these she often offends; make her a leopard skin, because it kills the lion by envy and deceit; give her a vase in her hand full of flowers which will be full of scorpions and toads and other venomous creatures; make her ride on death, because envy never dies but insidiously continues to rule; make her bridle loaded with various weapons because all her tools are deadly (Oxford Ashmolean 29v).

When no explanation of the allegories has survived we can only grope towards a partial understanding and wonder if even his contemporaries could make full sense of them. A case in point is a drawing at Oxford (Plate 43) which mixes a plethora of symbols, ranging from the general (and reasonably lucid) to the obscurely specific. The two main figures are recognizable as Justice, holding a sword, and double-headed Prudence, half man and half woman. Justice obligingly holds Prudence's mirror, because the latter's hands are so manifestly full. In his/her right hand are a serpent (a Visconti-Sforza-Milanese emblem), a branch (laurel for virtue), a *scopetta* (a small besom brush for clothing etc., with which Ludovico saw himself dusting off all Italy according to one of his *imprese*) and a string attached to a bird (the *columba*, the Sforza-Visconti dove). Sitting dismissively on a cage (an act symbolic of Ludovico's love of liberty?), Prudence is aided by an eagle (the imperial and hence dukely symbol of the Milanese rulers), a further serpent, and a cock (a *gallaccio*, a

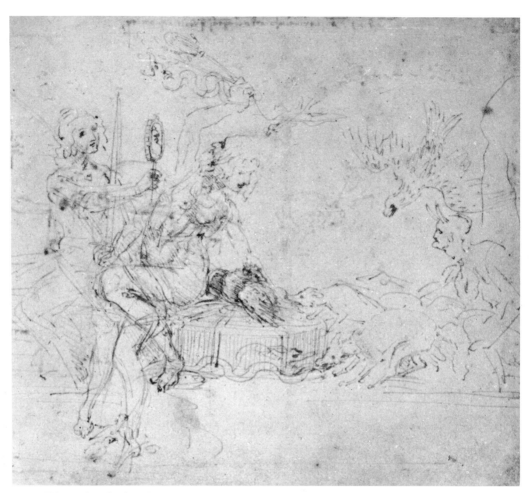

Pl.43 *Study for an Allegory of Justice and Prudence* (*c.* 1494), pen and ink, Oxford, Christ Church

punning reference to Galeazzo Sanseverino?). They are all resisting the onslaught of rapacious 'dogs' (probably foxes, the embodiments of falsehood) in the charge of a horned satyr who possesses the desiccated breasts of envy. The generally evil nature of the assault is clear, as are the Sforza 'weapons' in Prudence's right hand, but some of the allusions remain elusive. What, for instance, is the bird at the foot of Prudence doing? And to what particular situation does the whole image allude?

Such mind-bending *fantasie* may have been included in permanent decorations, but they are more likely to have been devised for some more transitory purpose, as visual 'orations' in praise of Ludovico, to be produced at appropriate moments as contributions to temporary decorations. We can readily envisage these overly condensed images extending more satisfactorily in time and space to occupy a whole pageant or masque. If we do so we can begin to catch the flavour of the theatrical designs by Leonardo which were so admired in the court.

It is only by such imaginative reconstruction that we can appreciate his gifts as 'a rare and masterful inventor of every fine and novel thing in delectable theatrical spectacles' (Paolo Giovio). The surviving record of these spectaculars could hardly be more disproportionately meagre in relation to their original size and impact. Only a few of his designs can be reconstructed, and these only in fragmentary form.

The most substantial account from Leonardo's own pen concerns an allegorical pageant of the kind we have already envisaged. As a contribution to the celebrations for the Sforza-d'Este weddings of 1491, a pageant was staged in the *palazzo* of Galeazzo Sanseverino. Leonardo planned a feast of allusive delights:

> Every ornament which appertains to the horse should be of peacock feathers on a gold ground to signify the beauty which results from the graciousness coming from he who serves well. On the shield a large mirror to signify that he who wishes favour must be mirrored in all his virtues. . . On the left side will be a wheel, the centre of which will be attached to the horse's thigh piece, and at the centre will appear Prudence dressed in red, and Charity sitting on a flaming throne with a sprig of laurel in her hand to signify the hope which is born of good service... (B.L.250r)

The reader may doubt whether his audience would have picked up all these allusions, even granted their familiarity with the richness of Sforza heraldry. Such doubts are justified. Ludovico's secretary, Tristano Calco, recorded the spectacle in its final form without the slightest hint that he grasped its symbolism: 'First a wonderful steed appeared, all covered with gold scales which the artist has coloured like peacock eyes . . . The head of the horse was covered with gold; it was slightly bent and bore curved horns . . . From his [the warrior's] head hung a winged serpent, whose tail touched the horse's back. A bearded face cast in gold looked out from the shield . . .'

From 13 January of the previous year, 1490, we have our earliest account of a Leonardo design for a theatrical spectacular, a performance in the Sforza castle of Bernardo Bellincioni's *Paradiso*, composed to honour the marriage of Gian Galeazzo and Isabella of Aragon. The author himself stated that the scenic effects, 'made with great brilliance and skill by Maestro Leonardo Vinci, the Florentine', showed 'all the seven planets which turned, and the planets were represented by men'. The bare bones of Bellincioni's reference are given at least some flesh by an eye-witness account:

> The Paradise was made to resemble half an egg [displayed hollow side forward] which from the edge inwards was completely covered with gold, with a very great number of lights representing stars, with certain gaps where the seven planets were situated, according to their high or low ranks. Around the upper edge of the aforesaid hemisphere were the twelve signs [of the Zodiac]. . . All of which made a fine and

beautiful sight. In the Paradise were many singers, accompanied by many sweet and refined sounds.

With reflected lights glittering in the golden orb and the planets rotating according to their divinely orchestrated motion, the effect must have been ravishing. At the climactic moment of the performance, the planetary gods descended to greet Isabella, pressing Mercury forward to render homage to the young bride.

There is no way of knowing how much stage machinery was involved in the *Paradiso* — the golden orb itself was probably static — but there are clear indications that Leonardo exploited his twin skills of artistry and engineering to the full in two of his other stage designs. The better documented concerns his designs for Baldassare Taccone's *Danaë*, staged in the palace of Giovan Francesco Sanseverino on 31 January 1496. A drawing in New York (Metropolitan Museum) shows a huge figure, presumably Jupiter, surrounded by a mandorla [an almond-shaped framing device] and situated within an elevated niche. Leonardo has scribbled down the rudiments of a cast list, which tells us that Taccone, the author, was to play the modest role of Sirus (King Acrisius' servant), while the King was to be performed by Gian Cristoforo Romano, a sculptor-singer of accomplished versitility. The final moments of the play certainly involved elaborate machinery to effect Danaë's conversion into a star: 'There is seen on the ground the birth of a star, and little by little it ascends to the heavens with such sounds that it seems as if the palace would collapse' (to quote Taccone's own account). After the ascent, a note on Leonardo's drawing informs us that 'Those who marvel at the new star kneel down and worship it, and kneeling down close the *festa*'. An elaborate system for raising a figure within a mandorla was sketched about this time on a sheet in the *Codice atlantico* (358vb) and probably represents his mechanism for Danaë's stellar elevation. The whole concept recalls Brunelleschi's invention in 1426 of a machine for raising and lowering a mandorla during a performance of the 'Annunciation' in S. Felice, Florence.

Leonardo's most complete design for stage machinery is also the most problematical. Two sketches in the Arundel Codex (B.L.224r and 231v) show a mechanism for displaying 'Pluto's Paradise', in which the front of a mountain opens by means of revolving sectors to reveal the infernal Pluto with attendant devils (Figure 43): 'When Pluto's paradise is opened, then there will be devils, which are in twelve pitchers acting as the mouths of hell; here will be death, the furies, Cerberus, many cherubs who weep; here fires will be made of various colours ..' (B.L.231v). The pivoting motion may echo Pliny's description of an ancient Roman design by Curio for two pivoted amphitheatres. This improbable scheme — dangerous for the audience, according to Pliny — was sketched by Leonardo during the 1490s (Madrid I, 110r). The problem with the Pluto design is that we do not know when it was drawn or why. One tempting suggestion is that it was

made in 1490 for the staging at Mantua of Poliziano's *Orpheus*, in which the title role was played by none other than Atalante Migliorotti, the musician who was said to have accompanied Leonardo on his journey to Milan. But this connection cannot be proved and a much later dating for the Pluto drawing is not out of the question. In any event, the scheme for the mobile mountain helps fill out our meagre knowledge of the mechanical virtuosity with which he delighted Milanese audiences.

In all these events music played a crucial role, and he would have been integrally concerned with its implications for his designs. His concern would have been that of someone with a degree of musical understanding, both from the theoretical viewpoint of harmonics and from the practical standpoint of performance. Contemporaries attest that he was an accomplished improviser of songs on the *lira*. Music was without doubt the most courtly of artistic accomplishments, and the Sforza sponsored considerable numbers of religious and secular musicians. No event, large or small, would pass without suitable accompaniment. In 1471 Duke Galeazzo inevitably required musicians to accompany his entry to Florence, but he had imprisoned his own for 'having committed a certain misdemeanour' and had to borrow some from the d'Este at Ferrara. Ludovico's musical employees do not appear to have suffered similar indignities, and his leading musicians were accorded a high status, most notably Franchino Gaffurio, his *magister biscantandi in ecclesia majori Mediolani*.

By the time Gaffurio was appointed in 1494, he had already published one treatise, his *Theorica musicae*, and he was to compose three more, one in Italian 'because many unlearned people make their profession in

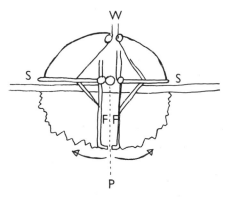

Fig.43 *Mechanism for 'Pluto's Paradise'*, based on B.L.231v

W weight acting over pulley wheels
S, S pivot arms
F, F front face of 'Pluto's Paradise'
P plane along which the mountain opens to reveal Pluto and his attendants

music'. Gaffurio may well have introduced Leonardo to the definitive theory of musical harmonics. On a 'practical' level Leonardo responded to his contacts with court musicians by attempting to invent new musical devices, particularly mechanized systems for sounding drums, bells and strings. One gadget displays a bell, beaten externally by two hammers at its rim, while four dampers at different levels modify the sound: 'The same bell will appear to be four bells' (Madrid II,75v).

His boundlessly inventive ability as a gadgeteer, as a contriver of curious mechanical novelties, found a ready outlet in the court. Although he expressed exasperation at some of the more trivial tasks he was asked to perform, he undoubtedly delighted in inventing mechanical automata, syncopated marvels of ingenious motion. The following selection gives some idea of his courtly gadgets and scientific tricks: a mechanism for raising and lowering curtains (Triv.6r) a water-regulated alarm clock which jerks the feet of the sleeper vigorously upwards (B.20v); a chemical trick for turning white wine into red (Forster III, 39v); a device for the 'bath of the Duchess' (I.28v); and various schemes for ingenious fountains. He seems to have particularly enjoyed water-driven contraptions. A highly finished drawing in the *Codice atlantico*, probably executed by one of his assistants, illustrates the kind of delights he concocted. A small fountain is set within a square pavilion, the upper part of which is an open loggia of classical design. An external water-wheel drives two pumps, which create the necessary head of water to operate the fountain. The whole contraption looks as if it was intended to be an outdoor bathing machine, designed to sprinkle cool water on hot courtiers (C.A.395v).

There can be little doubt that classical precedents helped to enhance the sense of stylish ingenuity which characterized his water devices. Vitruvius gave fulsome praise to Ctesibius, the inventor of a famous pump, who turned his talents to the contrivance of 'black birds singing by means of water works . . . figures that drink and move and other things that are found pleasing' (X,7). Another classical engineer, Heron of Alexandria, appears to have built his career around the invention of automata driven by water, steam, air and weights. Leonardo recorded his interest in Heron's treatise on water at a later date (C.A.96va and 219va), and already at this time he almost certainly possessed some knowledge of his Alexandrian predecessor's works, either directly or through secondary sources. Leonardo's own inventions were considered to be pleasing in their own right; if they could also be shown to have a classical pedigree, so much the better in Renaissance eyes.

Inevitably, little physical evidence of his activities as a contriver of devices has survived, particularly in Milan, but the Duke's favourite country retreat still contains suggestive remains of the beguiling environment which Ludovico's designers and engineers helped to create. This retreat was Ludovico's birthplace, Vigevano, some twenty miles or so south-west of Milan. It is in and around Vigevano that we can most clearly

appreciate today a major aspect of Sforza life and society, an aspect with which Leonardo was closely involved.

Ludovico's court, and most importantly Beatrice and the Duke himself, seem to have enjoyed themselves at Vigevano as nowhere else. The richly fertile countryside offered superb hunting and other 'rural' pursuits in plenty. A visiting Frenchman wrote that 'it savours more of Paradise than of Earth'. Though in one sense it was a 'Paradise' of nature, it owed much of its abundance to successive Milanese Dukes, above all to the system of canals and hydraulic engineering which the Visconti and Sforza rulers had sponsored. The main canal, the Naviglio Sforzesco, had been formed as a branch of the River Ticino by Filippo Maria Visconti and was given to the city in 1463 by Francesco Sforza. However, it was Ludovico who was responsible for transforming the Naviglio Sforzesco into a major asset, using it as the source for a rich network of subsidiary canals, which criss-cross at different levels, tumbling down stepped cascades, turning mill wheels and feeding irrigation channels via controlled sluices. Even allowing for a certain element of hyperbole, the 1492 inscription on the tower of Vigevano Castle gives some idea of the metamorphosis: Ludovico is said (with an obligatory reference to Gian Galeazzo, still nominal Duke) to have 'turned the course of rivers and brought flowing streams of water into the dry and barren land. The desert waste became a green and fertile meadow; the wilderness blossomed like a rose.' The fertile legacy of Il Moro's activity is still in abundant evidence around Vigevano and the names of prominent features testify to his enduring influence: La Morella, the main tributary of the Naviglio Sforzesco; the Torrente Mora, a cascade drawn from the Sesia in 1487; and the Mulini (mills) of the Mora Alta.

Model farms were built just south of Vigevano at La Pecorara and Castellazzo. And a huge country villa, a princely farm-cum-palace called La Sforzesca, was completed in 1486. On his marriage, Ludovico made over the villa and its lands to Beatrice. And greatly she enjoyed it: 'Every day we go out riding with the dogs and falcons and my husband and I never come home without having enjoyed ourselves exceedingly' she wrote to her sister, Isabella d'Este. 'Nor must I forget to tell you how every day Messer Galeazzo [Sanseverino] and I with one or two other courtiers amuse ourselves at playing ball after dinner.'

Leonardo recorded his presence in this 'Paradise' during the early months of 1494. He was probably called there in connection with a project for a series of scenes from Roman history, to which he referred in Manuscript H. (124v-5r). This manuscript, which has already provided our major source for his bestiary, contains a number of observations specifically concerned with Vigevano and the nearby Ticino, together with a series of notes relating in a more general sense to what he saw there. Not surprisingly, it was the extensive hydraulic engineering which fascinated him most, particularly the systems of *scalini* (stepped cascades) which formed

controlled falls of water. Over a dozen years later he was still discussing the most impressive of these at the Mulino della Scala: 'The *scala* below La Sforzesca, of one hundred and thirty steps, each a quarter of a *braccio* high and half a *braccio* wide, by which the water falls and does not consume anything in its final percussion; and by such *scale* so much soil has descended that it has dried up a large pool, that is to say filled it, and it has made meadows from a pool of great depth' (Leic.32r). The system of canals around La Sforzesca stimulated a characteristically extensive series of analyses by Leonardo, in which he laid down principles of improved operation for canals and mills, theories of erosion and accretion, and methods for the measurement of water concessions. This last was an important matter, and provided continual bones of contention between the owners of waterways and those who purchased the right to draw off a measured quantity to transform their 'barren land' into 'fertile meadow'. Leonardo himself was to become directly involved some years later when he was granted the right to a certain amount of water at a carefully stipulated rate of flow for his Milanese vineyard. None of his notes contain any proof that he personally designed any part of the system at Vigevano, although he was certainly in a position to contribute valuable ideas to the common pool of hydraulic technology, and some of his innovations may well have been adopted.

La Sforzesca, the farms, the waterworks and the construction of a nearby church (S. Antonio) were only part of Ludovico's grand design for Vigevano. In a massive bout of construction during the late 1480s and early 1490s he transformed the old Visconti-Sforza *Castello* and totally remodelled the heart of the city. Here Leonardo appears to have played a more directly formative role.

The schemes for urban planning we have already seen in Manuscript B, dating from before 1490, were not intended for Milan — though Leonardo did experiment elsewhere with a plan for extending Milan in a series of radial segments (C.A.65vb) — but were designed for a town irrigated by the waters of Ticino, either near or at Vigevano. The fundamental characteristics of his schemes, the graceful arcades, aisled halls, varied levels of circulation and navigable canals, all featured in Ludovico's subsequent works in the city itself, certainly not with the concentrated complexity of Leonardo's ideal projects but as applicable to the given situation of a pre-existing town.

Il Moro's centrepiece at Vigevano was the Piazza Ducale (Plate 44), one of the most attractive of all surviving pieces of Renaissance town planning. The eastern boundary of the square was formed by the Cathedral (since rebuilt in a later style), while the other three sides, which have survived with mercifully few alterations, were formed by delightfully arcaded buildings of two-and-a-half stories, richly decorated with monochrome paintings of Renaissance motifs. Some of the motifs provide architectural articulation for the two upper stories — pilasters, arches,

cornices, candelabrum-type columns, etc. — while others present a pageant of Sforza imagery. The numerous spandrels of the arcade arches on the ground floor are decorated with roundels which contain images of Roman Emperors, Sforza portraits and a plethora of Ludovican emblems. The centre-piece of the facade opposite the church regales the citizens with a boldly coloured display of Ludovico's arms surrounded by further *imprese*. A broad staircase under the southern arcade leads through an arched gate at the base of a considerable tower, and into the courtyard of the *Castello*, at the heart of which is the old palace in which Ludovico was born. The existing structure was radically adapted and extended by the addition of new wings, adorned in the Renaissance style with classical arcades and linked at one point by an elevated walk-way which proved excellent for falconry. Ludovico also enclosed the curving western boundary of the courtyard with a series of splendid stables, consisting of three-aisled halls capable of housing three hundred horses. Two of these features at Vigevano find particularly close parallels in Leonardo's drawings from the late 1480s: the elevation of the Piazza facades is foreshadowed in the most elaborate of his townscapes (see Plate 39); and the stables provide a close match for his designs in the *Codice trivulziano* and Manuscript B (especially B.29r).

Pl.44 Unknown Architect, *Piazza Ducale and Entrance Tower of the Castello at Vigevano* (early 1490s)

Such parallels, however striking, do not provide firm grounds for attributing the actual designs for the Vigevano works to Leonardo himself, even less for crediting him with responsibility for the building operations. Indeed, the very incomplete documentation provides better grounds for recognizing Bramante as directly contributing to the projects, in the conception at least, although much of the detail as executed clearly falls below Bramante's exacting standards and is recognizably Lombard in production. But the basic outlines of Ludovico's schemes bear the unmistakable imprint of Leonardo's ideas, far more clearly than any other architectual complex of this period. When they are experienced first-hand, the square and the additions to the Castle exude a strongly Leonardesque aura. As a whole, regardless of which architect or architects were actually responsible for the buildings as erected, Vigevano can be regarded as the realization in a minor key of his urban ideas, as someone else's neat compromise between Leonardo's utopian schemes and the exigencies of a given situation.

In a list of Ludovico's engineers, from the 1490s, comprising some thirteen in all, four are named in the top category of *Ingenariis ducalis:* 'Bramante engineer and painter; Giovanni Battagio, engineer and builder [one of the competitors in the *tiburio* competition]; Giovan Giacomo Dolcebuono, engineer and sculptor [the joint winner of the *tiburio* competition]; Leonardo da Vinci, engineer and painter.' Leonardo's notebooks testify that his mind was busily active in his capacity as a ducal engineer, devising ingenious solutions to engineering problems — large and small, architectural and mechanical, military and domestic, feasible and fanciful. There was hardly a field of mechanical endeavour in the Renaissance which did not come under his scrutiny. The most prominent industries in Milan, arms and textiles, received especially sustained and detailed treatment in his drawings at this time. The difficulty in studying these in their historical context does not lie in judging the quality of his designs — their conceptual and illustrative brilliance is spectacularly apparent — but in knowing how far they played a productive role in the practice of the various trades and professions. Rarely do we possess adequate records of actual machines from this period, and when a later working design appears to reflect a Leonardo invention, there is generally no way of knowing whether they were both dependent upon a common prototype. The best the historian can do is to suppose that his designs were made directly in response to his contacts with contemporary practitioners of the trades involved, and that a certain percentage of his more feasible ideas did bear productive fruit. Some of the many pupils and assistants mentioned in his memoranda, most of whom are unknown as painters, may have served him in various technical capacities, putting his designs into practice. Later sources suggest that this was the case, but hard evidence is almost nonexistent. In any event, his mechanical ingenuity is undeniable, and can be illustrated briefly here by two drawings,

one of a textile machine and the other of weaponry.

A splendidly incisive drawing from the 1490s (Plate 45) displays an elaborate machine for napping woollen material, the tedious job of shearing all the hairy excess from the surface of the newly woven cloth. A single source of power, presumably a water mill, provides motion for two co-ordinated actions: the first moves four strips of cloth steadily across the frame; the second automatically operates spring-jointed shears to nap the material. Not only would this save labour and time, it would also produce a constant level of nap. One suspects that a system of this complexity would not have been adopted at this time, at least on a widespread basis; its construction almost presupposes the materials and engineering precision of the Industrial Revolution. His more limited modifications of existing mechanisms, such as improved winding shafts for bobbins, are more likely to have had immediately productive results.

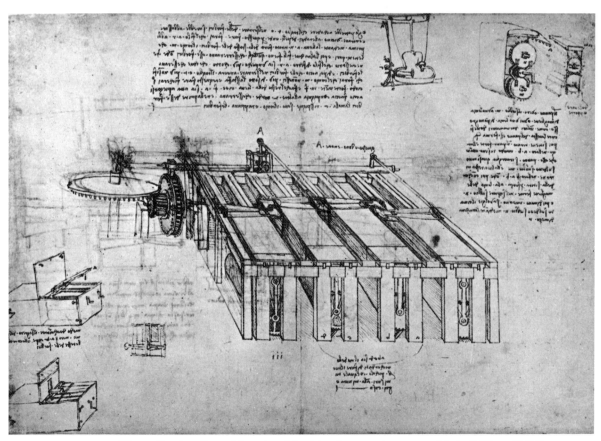

Pl.45 *Design for a Napping Machine* (*c.* 1497), pen and ink, Milan, Biblioteca Ambrosiana (C.A.397ra)

Leonardo's extensive studies of weaponry correspond closely in scope and ambition to the claims he made in his letter to Ludovico, embracing all types of contraptions, both ancient and modern: he drew up annotated lists of classical devices, based upon sources such as Valturio and Vitruvius; he worked on feasible designs for modern cannons, crossbows, etc., with careful investigations of their ballistics; and he sketched military fantasies which certainly outstrip the technological realities of the period. One family of designs from the 1480s combines all these elements at the same time: classical precedent, military reality and a dash of inventive fancy. The illustrated example (Plate 46) shows one of his many schemes for scythed chariots of a decidedly nasty kind; a related drawing in Turin (Royal Library) displays its chopped-up victims to underline its intended effect. Such designs were generically based upon classsical descriptions and were conceived as much for their sense of stylishness as for their practicality in modern warfare. Indeed, he expressed serious doubts about the value of such scythed chariots, pointing out that they 'often did as much injury to friends as they did to enemies' (B.10r). Below the chariot drawing is a disarmingly charming idea for a deadly wood-louse which was intended to scuttle across the battlefield on its four wheels, dispensing a hail of shot from around its rim. Similarly automated systems of mutiple weapons, deploying fusilades of crossbows or closely ranked gun barrels, occur regularly in his Milanese drawings.

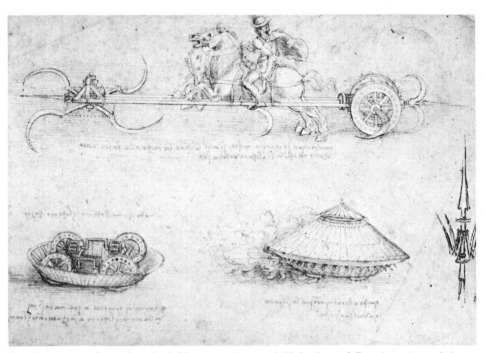

Pl.46 *Designs for a Scythed Chariot, Amoured Vehicle and Partisan* (*c.* 1487), pen and ink and wash, London, British Museum

A certain ambivalence is apparent in his military engineering. He was irresistibly attracted by the possibility of perfecting weapons, not only as a technical challenge but also more profoundly in terms of the physical principles involved. The design of cannons embodying his beloved laws of precussive motion (with acoustical implications) proved to be especially fascinating for him. But against such attractions we have to set his undoubted abhorrence of war in human terms. Some of his most spectacularly menacing designs for military machinery, schemes for giant crossbows and such like (e.g. C.A.53vb), carry strong implications of the weapons' power to subjugate their human creators, so that man becomes the helpless servant of his own inventions. His famous drawing of a cannon foundry (Plate 47) takes this feeling a stage further, subordinating the carefully descriptive drawing of the mechanical elements to its total impact of expressive turmoil, as the Lilliputian progenitors of the obscenely monstrous gun strive frantically to deal with their creation. The emotional implications of this drawing are unmistakably the same as his *profetie*, recalling in particular the riddle of the cannon cast in a pit: 'Emerging from the ground with terrible noise it will stun those standing nearby and with its breath it will kill men and ruin cities and castles.' Man's brutal destructiveness towards man and nature is a recurrent theme of his literary compositions.

The picture of Leonardo in Milan which is beginning to emerge from this and the preceding chapter is one of astonishing richness and complexity. The heroic probing of natural law on a meagre foundation of formal learning; the boundless fertility of mind, ranging from carefully rational invention to the poetic exercise of creative fantasy; and behind it all the personality of the man himself, remorselessly insistent upon establishing truth, sternly intolerant of mindless pedantry, yet beguilingly attractive with his courtly imagination and full of tender respect for the integrity of every living thing. He was described as buying caged birds in order to set them free, something we can well believe after reading the prophecies with their tone of compassion towards animal life. Contemporary evidence also suggests that he became a vegetarian. The savage *profetie* concerning the use of animals for food would thus assume a more than purely literary significance — 'that which nourishes them will be killed by them and scourged with merciless deaths' (i.e. 'things which are eaten and killed beforehand').

Those descriptions of Leonardo which have survived all testify to his aura of gracious brilliance. A handsome man who dressed in a refined manner with carefully groomed hair, he self-consciously cultivated an impression of poised and stylish individuality. His self-image as a courtly painter is neatly encapsulated in the following account of his profession's inherent refinement: 'The painter sits in front of his work at perfect ease. He is well dressed and wields a very light brush dipped in delicate colour. He adorns himself with the clothes he fancies; his home is clean and filled

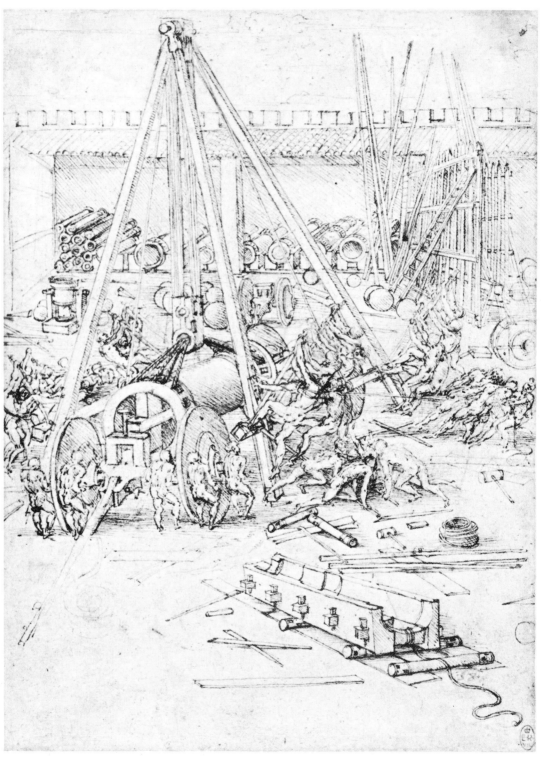

Pl.47 *Men Struggling to Move a Huge Cannon* (*c.* 1488), pen and ink, Windsor,
Royal Library (12647)

with delightful pictures and he is often accompanied by music or by the reading of various beautiful works' (Urb.20r-v). The fine youths in his entourage were stylishly dressed at his personal expense. In 1497, for instance, he purchased a magnificent cloak of silver fabric, velvet and ribbons for his servant, Salai, who seems to have been something of a seductive wastrel as a young man — 'thief, liar, obstinate, glutton' (C.15v) — and towards whom Leonardo extended an exasperated but enduring affection.

The image which he conveyed in Milan rivalled the legendary genius of ancient inventors as described by Vitruvius and others. In his designs for fountains, pumps and hydraulic contraptions he was a new Heron of Alexandria. In his city designs he was Dinocrates reborn. In painting and sculpture the parallels with Apelles, Pheidias and company were widely proclaimed. On his own behalf he seems to have felt a special affinity with Archimedes, perhaps hoping himself for some measure of the respect which he believed had been accorded to the greatest scientist-inventor of all:

> Archimedes, not withstanding that he had greatly damaged the Romans during the seige of Syracuse, did not lack offers of great rewards from the Romans themselves, and when Syracuse was taken a diligent search was made for Archimedes, and being found dead no lesser lamentations were made by the Senate and people of Rome than if they had lost their army; and they did not fail to honour him with entombment and a monument (B.L.279v).

This account may be dubious history, but it does convey Leonardo's attitude towards the proper status of the inventor. He had already expressed admiration for Archimedes' *architronito*, a steam-cannon (B.33r), and later we shall see him drawing direct inspiration from Archimedes' mathematical writings.

It is difficult to know how soon or how completely the insistent debater we meet in the notebooks was apparent in his public persona at court. His letter to Il Moro does not suggest that he was backward in coming forward. The Leonardo of the 1480s as reflected in the *Codice trivulziano* certainly was not ready to parade a coherent body of natural philosophy, whereas his writings from the next decade show that he was increasingly well equipped to hold his own in a number of areas of scientific debate. He could always fall back upon his insistent reliance upon 'experience' if the arguments moved outside his philosophical range.

The impression is that he was not reticent in expressing his ideas in company — which he enjoyed — and we know that he was never slow to ask questions of his acquaintances. But prolonged spells of solitary contemplation were equally essential to his well-being: 'In order that the welfare of the body may not sap the mind, the painter or draftsman ought to remain solitary . . . when intent on studies and reflections of things which continually appear before his eyes' (Ash.II, 27). The best account of

him at work describes this alternation of action and contemplation:

> Many a time I [Matteo Bandello, the novelist] have seen Leonardo go
> to work early in the morning and climb on to the scaffolding, because
> the *Last Supper* is somewhat above ground level; and he would work
> there from sunrise until the dusk of evening, never laying down the
> brush, but continuing to paint without remembering to eat or drink.
> Then there would be two, three or four days without his touching the
> work, yet each day he would spend one or two hours just looking,
> considering and examining it, criticizing the figures to himself. I have
> also seen him (when the caprice or whim took him) at midday when the
> sun is highest leave the Corte Vecchia, where he was working on the
> stupendous Horse of clay, and go straight to the Grazie; climbing on
> the scaffolding, he would pick up a brush and give one or two
> brushstrokes to one of the figures, and then go elsewhere.

At least some of the *lacunae* in his erratic pattern of work were
occupied by his active study of nature's dynamic variety:

> When Leonardo wished to portray a figure he first considered its
> quality and nature . . . and when he had decided what it was to be he
> went to where he knew people of that type would congregate, and
> observed diligently the faces, manners, clothes and bodily
> movement . . . noting it down in a little book which he always kept at
> his belt. After having done this again and again, and feeling that he had
> collected sufficient material for the image he wished to paint, he would
> proceed to give it shape and succeeded marvellously (Giovanbattista
> Giraldi).

There is more than a hint in this of the Grecian artist, Pheidias, intensively
studying the patrons of the Athenian gymnasia.

Leonardo's own notebooks convey the impression of continual per-
egrinations: wanderings in the hills, valleys, cities and villages of Lomb-
ardy, always looking, asking, thinking and recording; and mental journeys
into the conceptual realm of the causes behind the observed effects,
improvising theories to explain the underlying structure of nature. If he
was not productive in the sense which contemporaries expected, he was
certainly never idle. His mind seems to have been one of those con-
stitutionally unable and unwilling to remain inert: 'Just as the iron rusts
from disuse, and stagnant water putrefies or turns to ice when cold so our
intellect wastes unless it is kept in use' (C.A.289vc).

It would have been easy to be beguiled by his agile genius, like his
Milanese followers who repeated smiling Madonnas of Leonardesque
mien as if dazzled into anonymity by his magic; but it would have been
equally possible to share Pope Leo X's later irritation at the elusiveness of
his actual achievements. Any student of Leonardo cannot but encounter
both sides of this picture. Our delight in the precious legacy of the
surviving manuscripts is balanced by frustration at the few surviving

products of a definite kind. In terms of finished works of art, all we possess
from almost twenty years in Ludovico's employment is a handful of
paintings: the *Madonna of the Rocks*, a small group of more or less auto-
graph portraits, the ravaged remains of the *Last Supper* and the mutilated
decoration of the *Sala delle Asse*. Of these, the *Sala delle Asse* most closely
reflects the courtly Leonardo we have encountered in this chapter and
provides a good starting point for an analysis of the works in painting and
sculpture he made for Sforza Milan.

The *Sala delle Asse* ('Room of the Wooden Boards', a name which
apparently pre-dates Leonardo's decorations) is a ground floor room of
ample dimensions in the square northern tower of the *Castello*, nicely cool
in the summer but rather gloomy in winter. It has two windows, one
looking north-west and the other north-east. To understand the deco-
ration and significance of this room, I believe it is necessary to look at the
personal circumstances which lie behind Ludovico's remodelling of this
corner of the castle for his personal use during the later 1490s. From the
'room of the tower', also known as the *Sala delle Asse*, Ludovico built an
arched bridge in a north-easterly direction over the moat, on which was
constructed a suite of domestically-scaled rooms, linked externally by a
neatly classical loggia. This suite was designed to provide a personal place
for quiet retreat, much like the *camerini* which were built within the
castles of Urbino and Mantua. By the time the rooms were ready for
occupation, the Duke's personal happiness had been clouded by the tragi-
cally early death of Beatrice in January 1497, after she had given birth to a
stillborn child. Although his marriage to the d'Este princess had been
politically motivated, he had been genuinely captivated by the charming
vitality of his young wife and was deeply grieved by her death. As a
spontaneous renunciation of the pleasure-ground they had made es-
pecially their own he gave up all his rights to their Vigevano 'Paradise',
assigning La Sforzesca and its grounds to the Dominican convent of S.
Maria delle Grazie in Milan, the institution which became the focal point
for his religious life during the last years of the century. In his mood of
increased sobriety, the modest privacy of his new rooms would have been
welcome, and the name of the first of them, the *Saletta negra* (small black
room), suggests that its decorations may have possessed suitably sombre
qualities.

We know from an official memorandum written on 20 April 1498 that
Leonardo was involved in the decoration of the *Saletta negra* and that it
was a matter of urgency: 'Time is not to be lost in finishing it.' A day later a
similar note reiterated that 'in the *Saletta negra* time must not be lost', and
mentions Leonardo's activities in the 'room of the tower'. This note and a
further reference on 23 April are not easy to interpret, but their sense in
free translation seems to me to be as follows: 21 April — 'on Monday the
"large room of the boards" [*camera grande de le asse*], that is in the tower,
will be cleared out. Maestro Leonardo promises to finish it all by

September, and with this [going on] it will still be possible to avail oneself of it, because the scaffolding which he will make will leave room underneath for everything'; 23 April — 'the *camera grande de le asse* is evacuated, and in the small room time must not be lost'. This sense of impatience characterizes so many of the documents relating to Leonardo's artistic projects.

Nothing is left of his work in the *Saletta negra*, but at least some portion of his painting in the *Sala delle Asse* has remained. Enough of the vault decoration has survived the vicissitudes of overpainting, restoration, repainting and further restoration to convey at least some impression of Leonardo's invention: his caprice of intertwined branches through which a meandering gold rope performs a series of geometrical arabesques (Plates 48–50). On the wall in the northern corner somewhat above head level restorers also uncovered fragmentary underpaintings of roots insinuating themselves among rocky strata (Plate 51). The handling of the underpaintings does not appear to be Leonardo's own, but the remarkable conception is unquestionably his. Whether or not the roots and rocks featured in the decoration in its final state (assuming that it ever reached a final state), they clearly occupied a prominent place in his ideas for the room's final effect, and would have contributed splendidly to its dazzling marriage of naturalistic and formal decoration.

Pl. 48 Leonardo and workshop, *Sala delle Asse, detail of Vault Decoration showing the Central Oculus* (1498-), Milan, Castello Sforzesco

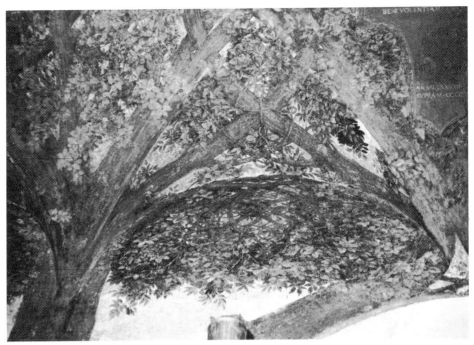

Pl. 49 *Sala delle Asse, detail of Decoration above North-East Window*

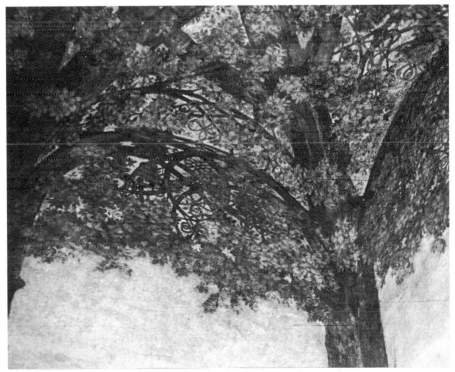

Pl. 50 *Sala delle Asse, detail of Decoration in Southern Corner*

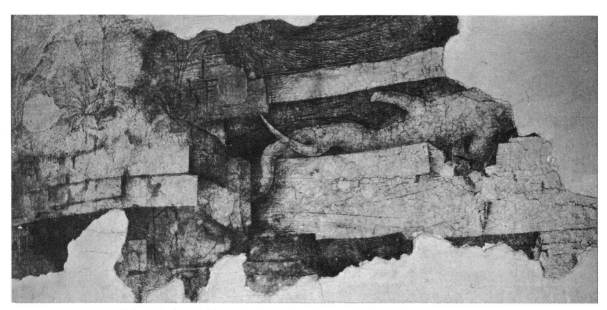

Pl.51 Leonardo workshop, *Sala delle Asse, Roots, Rocks and Plants on the North-Eastern Wall.*

As decoration, the scheme of the intertwined trees is nicely ingenious. But is this all it is? It would be out of keeping with what we know about both Ludovico and Leonardo if this were so, and it would be inconsistent with the tone of the castle's decorations under the Sforzas. The room immediately to the west is overpowered by an emblazoned display of Duke Galeazzo's *imprese,* and the next room is smothered with his wife's favourite device, the *columba* (a dove at the centre of a radiant sun with the motto '*a bon droit*'). We would not expect Ludovico to have been less thorough in giving a personal stamp to his *sala,* as the grandest room in his newly remodelled wing of the castle. We might hope, however, that with Leonardo's assistance he would have been more cunning and subtle. I believe that this was the case, and that this very subtlety has concealed one of the main threads of its decoration, the thread of meaning (personal and political) which is woven into its sophisticated fabric.

One aspect of the room's meaning is obvious. Four tablets are suspended over the main axes of the room, recording political events from the 1490s. One no longer contains its original text, having been defaced by later owners of the castle, but the Latin messages of the other three are clear, elegantly written in the kind of Roman capitals for which Luca Pacioli devised geometrical schemata. Tablet 'B' (Figure 44) celebrates his arrangement of the marriage of his niece, Bianca Maria, to the Emperor Maximilian in 1493. The inscription on 'A' establishes the Sforzas' claim to the Dukedom after the death of Filippo Maria Visconti and underlines the proclamation of Ludovico as Duke by Maximilian in 1495. The pronouncement on tablet 'C' records Ludovico's victory ('with Italy') over

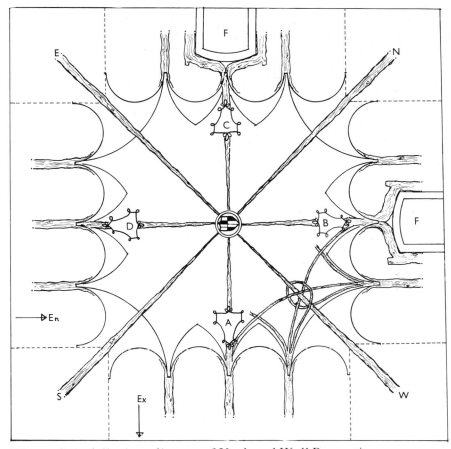

Fig.44 *Sala delle Asse, diagram of Vault and Wall Decoration*

A, B, C, D inscribed tablets
F, F windows
N, S, E, W North, South, East and West and corners of the Sala delle Asse
En present entrance to the Sala delle Asse
Ex present exit from the Sala delle Asse

Charles VIII's French troops at the Battle of Fornovo, and his journey with Beatrice to Germany to cement an anti-French alliance with Maximilian in 1496. It is reasonable to assume that the lost text would have referred to an event of 1494. The conspicuous manner in which Maximilian features in all three inscriptions accurately reflects the way in which Ludovico was pining his hopes at this time upon his 'nephew-in-law' to counter the menace of French territorial ambitions.

In addition to these literary proclamations, it would have been in character with Ludovico and Leonardo if the conception of the decoration as a whole was intended to possess a hidden meaning or meanings of the kind which so saturated Sforza court imagery. There are a number of clues to suggest that this was the case.

The armorial shield within the gold-rimmed oculus at the centre of the vault bears the joint arms of Ludovico and Beatrice. This same shield appears in an altogether comparable context — set within a regular network of entwined branches — on the tapestry *pallio* (altar frontal) presented by Ludovico in 1491 to the Sanctuary of the Madonna del Monte near Varese. In the *pallio* the shield is accompanied by the *divisa* IVGALES ('conjugals'). A comparably conjugal motif also appears in Leonardo's own design for a diamond lattice-work with alternating LV(dovico)s and BE(atrice)s (Figure 45). We may therefore suspect that the entwining of the *Sala delle Asse* branches was also intended to commemorate the union between the Milanese Duke and d'Este Princess, a commemoration which assumed a new kind of meaning after Beatrice's death.

The portrayal of the trees with roots may be seen as confirming the personal nature of the decoration. The motif of a tree with roots was one of Ludovico's many *imprese* (Figure 46), featuring twice in the Piazza Ducale roundels at Vigevano, presumably with a different motto each time, though in both cases the written *divisa* is no longer legible. It is not difficult to imagine a suitable motto for the tree with roots. How about '*stare saldo*' (to stand firm)? When a number of such trees are linked together, this could become '*stare saldo e congiungersi*' (to stand firm and united). Neither Leonardo nor his patron would have experienced any difficulty in devising a suitable meaning along these lines.

Fig.45 *Design for a Decorative Lattice with the Initials of Ludovico and Beatrice*, based on I.14r

Fig.46 *Sforza Emblem of a Tree*, based on a roundel in the Piazza Ducale at Vigevano

How does the intertwined gold chord fit with this idea of the decoration as a Ludovican *impresa* writ large? Nowadays we tend to associate the interlock motif too exclusively with Leonardo's individual

proclivity for such forms, but we should remember that this pattern of design was all the fashionable rage in the d'Este-Sforza circle at this time. As a specific motif, called the *fantasia dei vinci*, it had been given its definitive formulation by Niccolò da Correggio, whom we have already encountered as the author of plays for the Milanese court. Niccolò devised the *fantasia* in 1492 for Isabella d'Este, probably as an *impresa* which expoited a pun on the word *vinci* — as 'osiers' used in basket-work and as *vince* ('she conquers'). Within a year Beatrice was seeking her sister's permission to appropriate the *fantasia* for her own use, and it seems to have featured prominently in Beatrice's court garments as a filigree decoration of gold 'knots'. To some extent it became common property. Leonardo, with or without leave, borrowed the *vinci* for his own purposes — his knot designs were engraved with mottos on the theme of LEONARDI.ACADEMIA.VINCI. — exploiting the coincidental pun on his own name. Furthermore, both he and Bramante had earlier devised knot patterns of a related kind, as Leonardo himself testified (C.A.225rb). However, for Ludovico the *fantasia* of gold interlace would have possessed one overriding association; it would have recalled his d'Este wife, Beatrice.

Adding all this together, we may see the *Sala delle Asse* as decorated with the conjugally entwined motifs of the Duke and Duchess, underpinning their heraldic union at the summit of the design. Although I am generally reluctant to heap unwanted meaning on works of art, this idea is totally in keeping with the proclivities of both patron and artist. The evidence is not such as to make this interpretation more than a working hypothesis, but it is at least consistent with the tone of the Castle's decoration as a whole.

Compared to the blatant displays of heraldry in the halls of Galeazzo and Bona, any possible meaning in the *Sala delle Asse* is so brilliantly absorbed into its decorative and naturalistic structure that it is impossible to disentangle content and form — as in all his productions. And, as always, the balance between formal artifice and descriptive naturalism is struck in a manner utterly appropriate to the work's function. An incredible elaboration of artifical design is somehow rendered compatible with great vivacity of natural form, a vivacity apparent even in the present state of the painting, much of which has acquired a murky and blurred quality closer in effect to congealed vegetable soup than a latticework open to the sky.

The basic wall system comprises eighteen trunks (Figure 44). The two trees flanking each of the two windows coalesce above the windows, leaving a vaulting system of sixteen units. With a characteristic sense of integrity towards natural form, he has rationalized the arching of the trunks around the windows by a credible piece of pruning. Each main trunk has been severed at the level of the top of the window at some remote time in its life, leaving an amputated stump, while a lateral shoot from slightly lower has assumed the trunk's role. The lateral shoot emerges at an

angle to the main trunk, passing over the window, but naturally curves upwards again after a short distance, finally ascending to the vault.

On the ceiling, the four trees from the corners of the room together with the main trunks from the centre of each wall ascend recognizably to the central oculus, while the trees in the intermediate positions ramify without a dominantly vertical accent. As far as we can tell, and assuming that the restorations have not grossly perverted the basic pattern, he used the thicker branches to establish a series of primary accents which link the main elements of the design in a series of harmonic curves. Around these he has woven an amazing series of secondary motifs, endlessly syncopated into semi-symmetrical patterns. Some idea of the major accents is conveyed in Figure 44. The effect of the ramified branches in their restored form is probably over-repetitive in detail, but its underlying cunning can still be appreciated in the more authentic areas.

The main articulation is designed to follow the actual vaulting of the room, corresponding to the four lunettes on each wall. The main trunks perform the function of columns supporting the springing of the vaults, and the branches assume the role of complex rib structures, criss-crossing the vault in a series of tracery patterns, rather in the manner of a late Gothic structure. This visual pun on nature and architecture is utterly characteristic of Leonardo's tastes and would have been enjoyed by his contemporaries, all the more so since it recalled man's most ancient habitations as described by Vitruvius: 'The men of old . . . began in their first society to construct shelters; some made them of green boughs' (II, 1). The tree-column pun, or (to express it more learnedly) the proportional analogy between trees and columns, was exploited by Bramante in his Milanese cloister of S. Ambrogio, where two of the columns have assumed the appearance of lopped tree trunks, and by Leonardo himself in drawings from both early and late periods of his career (C.A.357va and 315b). Their common source was no doubt Alberti, who praised in his book on architecture the 'beautiful effect some of the more lively architects used ... to make columns, especially in the porticos of their gardens, with knots in the shafts in imitation of trees which had their branches cut off, or girded round with a cinture of boughs' (IX, I).

The idea for the roots, whatever their heraldic connotations, seems to have no direct antecedents in a full-scale decoration. They are remarkably personal expressions of natural force, equivalent in type to his fable of the nut and the wall: the nut, given shelter by the wall,

> began to burst open and put its roots in between the crevices of the stones and push them apart and throw up shoots from its hollow; and these soon rose above the building, and as the twisted roots grew thicker they began to thrust the walls apart and force the ancient stones from their places. Then the wall too late and in vain bewailed the cause of its destruction, and in a short time was torn asunder and a great part of it fell into ruin(C.A.67ra).

Tree and vegetable designs were common enough forms of interior decoration in North Italian palaces, but Leonardo transformed a potentially routine motif of a heraldic type into a unified vision of 'natural architecture', improvising in a characteristically opportunist way a whole series of clever resonances in form and meaning.

The knowing ingenuity and courtly sophistication of the arboreal *fantasia* seems at first sight to share almost nothing in common with the high narrative seriousness of his other surviving wall painting from this period, the *Last Supper* in S.Maria delle Grazie (Plate 52 illustrated for the sake of clarity from an old photograph, before the removal of retouchings). The contrast between the two is obvious and is clearly a result of their very different functions. But they do share an underlying affinity in their mutually cunning relationship between natural depiction and imaginative artifice. If the *Sala delle Asse* is a *fantasia cortese* (courtly fantasy), the *Last Supper* is what Dante would have called an *alta fantasia* (elevated fantasy).

Although the *Last Supper* is not a court painting in the literal sense, it nevertheless occupied a highly personal place in Ludovico's life. Apparently combining a real sense of piety with his often dubious behaviour and belief in astrological magic, Ludovico became increasingly devoted to

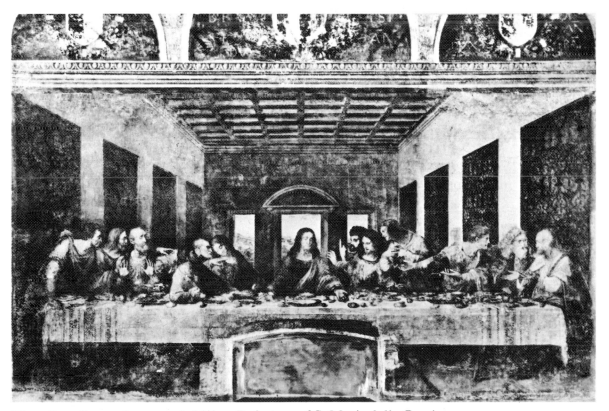

Pl.52 *Last Supper* (*c.* 1495-7), Milan, Refectory of S. Maria delle Grazie

S. Maria delle Grazie, dedicating the productive aspects of his religious activities during the late 1490s to the aggrandizement of the Dominican Church and Convent. He directed Bramante to reconstruct the east end of the church creating a magnificent centralized space which dwarfs Guiniforte Solari's old-fashioned nave. The interior of Bramante's domed crossing exudes an extraordinarily abstract sense of Euclidian geometry, while the exterior agglomerates geometric solids in a manner strongly reminiscent of Leonardo's designs in Manuscript B. It was to S. Maria delle Grazie, we may remember, that Ludovico assigned his Vigevano estates after the death of Beatrice in 1497. A canopied sepulchre was erected in her memory under Bramante's towering *tribuna*. The Duke appears to have envisaged the long-term transformation of his favourite church into a pantheon for his dynasty, and he arranged for a permanent memorial to himself and Beatrice to be sculpted in marble by Cristoforo Solari. (The resulting tomb sculptures are now to be found in the Certosa of Pavia.) His attachment to the monastery was such that he made a habit of dining at the prior's table on Tuesdays and Thursdays — in the refectory which was to receive Leonardo's master piece.

One of the two end walls of the refectory had been assigned to an image of *Calvary*, which was painted in a solidly Lombard manner by Donato Montorfano and dated 1495. Two years later we have our first reference to Leonardo at work on the opposite wall, depicting the narrative which was almost axiomatic in any refectory decoration. During his regular meals in the refectory, Ludovico would have watched Leonardo's painted extension of the hall's space beginning to cast its virtuoso spell of space, light and colour. Seated at the centre of a long table across the far end of the refectory, the prior and his distinguished guest would have finally been presented with an astonishingly vivid sense of the physical presence of Christ and his disciples at supper within the monastery's precincts.

The *Last Supper's* primary purpose was that of Biblical story-telling. It was what Alberti would have termed an *istoria*, that is to say, a controlled and significant exposition of a worthy subject. How easily Alberti's praise of Giotto's *Navicella* (Christ and St Peter walking on the water) could be adapted to Leonardo's painting: 'Giotto represented the eleven disciples struck with such fear and wonder on seeing their colleague walking on the waves, each showing such clear signs of mental perturbation in his face and entire body, that the individual emotions are apparent in every one of them.' Or, conversely, how readily the following passages from Leonardo's notebooks could be applied to Giotto's paintings, such as the *Christ before the High Priest* (see Plate I): 'That figure is most praiseworthy which by its action best expresses the passion of the soul' (Ash. II, 29v); and 'Painted figures must be done in such a way that the spectators are able with ease to recognize through their attitudes the thoughts of their minds [*il concetto dell'anima*], and if you wish to show a

good man speaking make his attitudes fitting accompaniments for good words. And, similarly, if you have to portray a bestial man, make him with fierce movements' (C.A.139r). The mechanism through which *il concetto dell'anima* achieved expression in bodily movement was the system of neurological plumbing which we have described in the previous chapter, and which must be fully understood by the narrative painter: 'That painter who has an understanding of the nature of the nerves, muscles and tendons will know very well in moving a limb which and how many nerves are the cause of its movement' (Ash.II, 27r). Below one of his demonstrations of the hollow nerves in the neck and shoulders he wrote: 'This demonstration is as necessary to good draughtsmen as is the origin of words from Latin to good grammarians' (W.19021v). Regarded in this light, the ebb and flow of movement in the *Last Supper* is the outward effect of the inner causes of motion; the individual movement of each disciple speaks the bodily language of their individual minds, as each is propelled into motion by the dynamic coursing of 'animal spirits' from their cerebral recesses. Look, for example, at the group to the left of Christ: the impulsive surge of shock expressed by Peter's angular motion, as he elbows his way towards Christ, is carefully contrasted with the sleepy curves of young John, and set in counterpoint to the tense recoil of Judas, whose tendons contract like taut bow strings.

It is this ability to identify Judas 'physiologically' which allows Leonardo to differentiate him from the surrounding disciples, thus circumventing the practice of placing Christ's betrayer on the other side of the table as was traditional and as happened in Leonardo's first thoughts for this painting (Plate 53). Even in its present ruinous state the mental 'air' and 'complexion' of each figure still insinuates itself perfectly into the total texture of the drama, but we have irretrievably lost many of the vivid details of individual characterization which emerge from the four surviving chalk drawings for the disciples' heads, one of which is illustrated here (Plate 54).

Since he has portrayed all the disciples in expressive motion, he has in one sense shown a moment in time, but we should not read the *Last Supper* as if it were a modern photograph of a stage play snapped at one five-hundreth of a second using an efficient flash gun. The actions and attributes of the participants effect a series of resonances in time, like the diffusion of ripples in water (to use an analogy close to Leonardo's heart). Many aspects of the gospel narratives are explicitly or implicitly apparent. Most obvious are the ripples caused by Christ's pronouncement, 'I say to you that one of you is about to betray me' (Matt. 26:21). But other implications are clearly present: Judas' left hand, hovering above a dish, echoes Christ's continuing words, 'He that dippeth his hand with me into the dish, he shall betray me' (26:23); Christ's own hands, his right closing towards a glass of wine and his left directed towards a piece of bread, suggest his institution of the Eucharist, either immediately after his

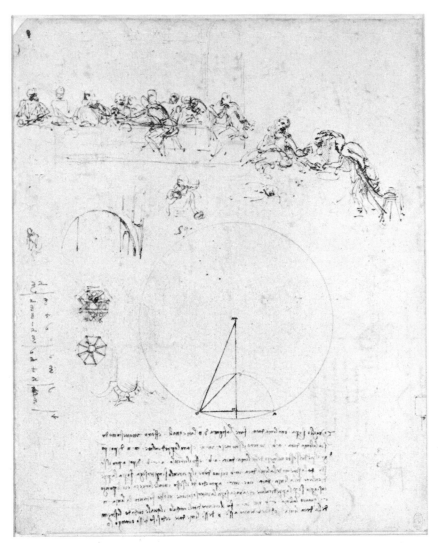

Pl.53 *Study for the Last Supper, with Method of Constructing an Octagon and Arithmetical Calculation* (*c.* 1495-6), pen and ink, Windsor, Royal Library (12542)

betrayal announcement (according to Matthew) or immediately before (in Luke's Gospel); and over an even wider temporal range, Peter holds a knife which prefigures his severing of a soldier's ear, and which is also pointed towards Batholomew at the end of the table, perhaps in anticipation of the latter's martyrdom by flaying. The preliminary sketches show how fluently Leonardo moved across the time scale of the narrative, considering various events for portrayal: the administration of the Eucharist to Judas (Venice, Accademia); Christ's pronouncement about the bowl (see Plate 25); and Judas dipping into the dish with Christ (Plate 53). None of these incidents fails to leave its mark in the final picture.

The complex subtleties of the narrative are contained with no sense of

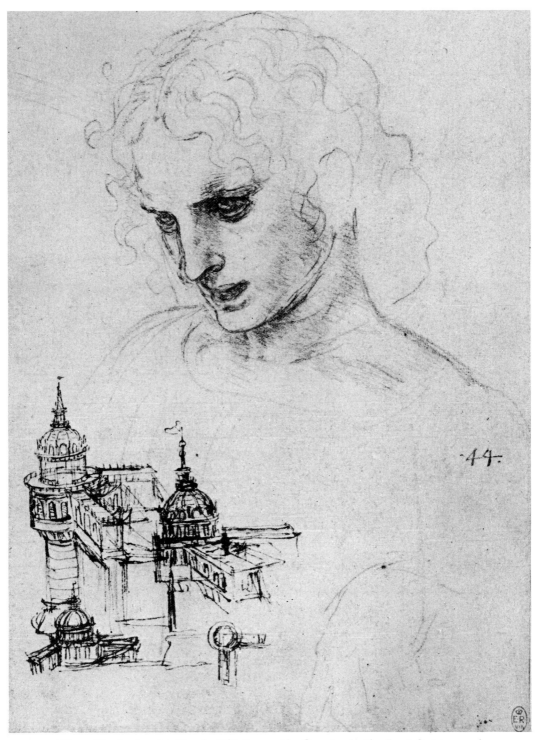

Pl.54 *Study for the Head of St James the Greater in the Last Supper and a Domed Corner Pavilion for the Castello Sforzesco(?)* (*c.* 1496), red chalk, pen and ink, Windsor, Royal Library (12552)

strain within an image which at one time exhibited a compelling illusion of three-dimensional light and colour. It was his desire for richness of tone and colour which led him to abandon the traditional fresco method for wall painting in favour of an experimental technique, more akin to tempera painting on a gessoed panel. His new technique possessed the added advantage that it suited his meditatively slow working procedures — the true fresco technique demanded speedy application of pigment before each day's area of freshly applied plaster was dry — but on the debit side it contributed to the rapid deterioration of the painting's surface, with the flaky results that are all too apparent today. However, even in its present state, the colour retains some measure of efficacy. The 'upper room' in which the participants have gathered towards the end of the day is appropriately illuminated as if the light were coming from the high windows in the western wall of the actual refectory (Plate 55). As the late afternoon sun slants through the windows it appears to pick out the objects and figures as it moves across the painted space, finally creating the relatively bright area on the right hand wall of the disciples' room. As in the *Madonna of the Rocks,* the rich colours respond with controlled harmony to the insistent caress of light and shade. The relatively saturated hues of red and blue in Christ's garments are given a high colour value across a substantial area of their surface. The colours of the disciples' clothes are not permitted to assert their hues with comparable directness, and even at points of direct illumination reveal themselves to be blended with white and grey and intermixed with other colours. Optical truth, narrative focus and a kind of spiritual decorum of colour all operate in perfect concert.

All the factors we have described so far — narrative skill, psychological expression and colouristic control — convey the impression that we are dealing with a supremely rational depiction of natural phenomena. This is undoubtedly the impression which Leonardo aimed to produce, and corresponds to the effect which his contemporaries recorded. But when we analyse the structure of his painted illusion we find unexpected extremes of artifice and visual paradox. The first and most immediate paradox is that he has failed to provide a table of adequate width for all the figures to be seated. There is barely room for four figures on each side of Christ (who is, incidentally, depicted on a larger scale than the other figures) and there are certainly no seats from which Peter and Thomas could have risen and none to which they could return. His resorting to such contrivance was undoubtedly occasioned by problems of scale in relation to narrative concentration: a rationally scaled arrangement with correspondingly smaller figures would have presented too strung-out an effect, and the clustering of emotional focuses would have been dispersed.

The artifice of figure grouping is only the start of the paradoxes. The very structure of the illusionistic room, apparently such a tidy demonstration of Albertian perspective and seemingly comparable in spatial lucidity to Masaccio's *Trinity* (see Plate 2), is actually founded upon an

Pl.55 *North-Western Corner of the Refectory of S. Maria delle Grazie* (with the outlines of the tapestries within the Last Supper emphasized)

illogical contrivance. The first problem concerns the viewpoint. Every perspective picture has one perfect viewing position, and Leonardo asserted that 'The painter of a wall which is to receive a narrative composition must always consider the height of the place in which the figures are located, and to portray things realistically in their setting he must place the eye [i.e. the viewpoint] below the thing he is painting' (Ash.II,10r). In terms of the *Last Supper* this would mean that we should be looking up

at the table and should be able to see none of its upper surface, nor indeed much of the disciples' bodies. The viewpoint of the actual painting, carefully located at a distance from the wall surface equal to the width of the end wall, is in an impossible position at more than twice the height of a man. It is possible to take up an off-centre position within the refectory so that one of the lateral walls of the painted room acts reasonably well as an illusionistic extension of the real wall (Plate 55), but the other wall in the painting will then be thrown badly out of perspectival line with its corresponding feature in the actual hall. The perspectival extension of the refectory, for all its conceptual integration with the real space of the hall, is thus perceptually impossible for a spectator standing on the floor.

Again the artist has compromised the requirements of naturalism in the face of particular circumstances: a low viewpoint would have vitiated the clarity of narrative exposition which was so essential; and a workable viewing position for a spectator standing at a particular point within the refectory would have rendered it highly vulnerable to a change of viewpoint. To reduce this vulnerability he once recommended a viewing distance 'at least twenty times the greatest height and width of your work' (A.41v). This formula would have resulted in an unacceptably condensed perspective construction for this painting, so he has done the next best thing; having ensured that no spectator could occupy the perfect position, he has then masked many of the clues which would normally define the precise relationship between the painted and real spaces. The side walls of the painted room are not actually in the same plane as the refectory walls, because the painted room is slightly wider, as the analytical diagram of its perspective shows (Figure 47). Similarly, the coffered ceiling does not abut the horizontal cornice but continues upwards behind the lunettes as far as the height of the central lunette. The relation of the table to the space is nowhere explained and on analysis can be shown to occupy so much of the width of the room that no one could be seated at its ends. All this ambiguity is contained within a border which is itself deeply ambiguous — as far as can be judged in its present condition — functioning both as a flat frame and as the perspectively inclined edge of the opening in the refectory's end wall.

Conceptually, this concealed artifice takes naturalistic painting a stage beyond Masaccio's *Trinity*. Masaccio's work looks logical and is logical, but such logic is inflexible. Leonardo's *Last Supper* looks logical and he relies upon us assuming that it is indeed logical. But it is not. Its apparent reality veils a series of visual paradoxes. This system gave him a crucially greater range of expressive rhythms than is possible within a doctrinaire piece of Albertian perspective.

Even complete awareness of the contrivance does not, however, destroy the impression of harmonic space (I use the term harmonic deliberately). We have already seen that he intended to formulate his rules of optical diminution 'as the musician does for music', and the *Last Supper*

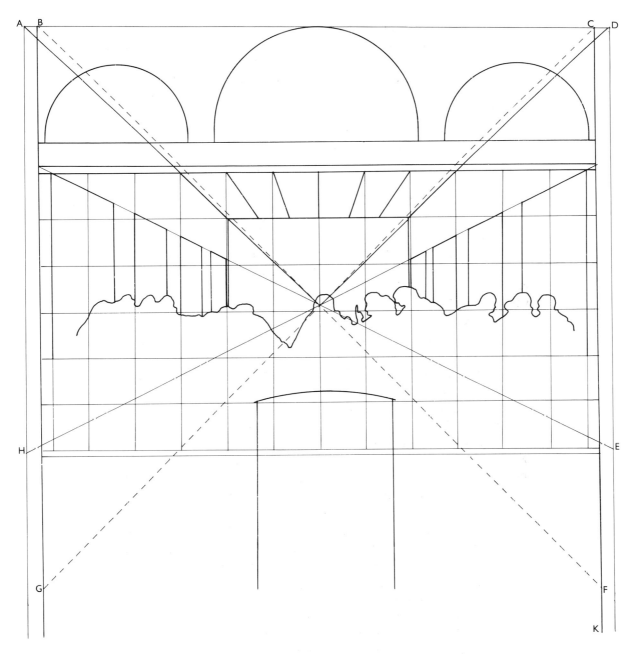

Fig.47 *Analysis of the Perspectival and Modular Structure of the Last Supper*
B-L left lateral edge of the end wall of the refectory
C-K right lateral edge of the end of the refectory
A-H left lateral edge of the room in which the Last Supper is taking place
D-E right lateral edge of the room in which the Last Supper is taking place
C-G and B-F diagonals used to determine the centre of the painting and the perspective scheme before modification(?)

appears to be founded upon a substratum of mathematical intervals. The basic interval is the width of one of the ceiling coffers at the optical intersection of the cornice. This interval or 'module' is expressed twelve times in the width and six times in the height of the painting (Figure 47). The resulting grid of longitude and latitude provides the location for many of the straight edges of prominent objects, including the junction of ceiling and rear wall, the top and bottom of the table, and the forward edges of two tapestries. The tapestries also appear to diminish in size according to the ratios $1:\frac{1}{2}:\frac{1}{3}:\frac{1}{4}$ or to express it in whole numbers, $12:6:4:3$. In musical terms $3:4$ is the tonal interval of a fourth, $4:6$ is a fifth and $6:12$ is an octave. It is impossible to be absolutely certain about the presence of such grid and harmonic structures in paintings — the artist in his execution of the work and the historian in his analysis are each subject to at least small errors in measurement, to say nothing of modifications made by restorers — but the conformity of the *Last Supper* to these schemata looks too close to be coincidental. That arithmetical progressions of a musical kind were in his mind at this time appears to be confirmed by the peculiar 'calculation' (involving twos, threes, fours and sixes) on the most preliminary of his studies for this painting (see Plate 53). Comparable combinations of harmonic numbers also occur during this very period in Manuscripts M and I. The geometric diagram on the same drawing, which demonstrates the construction of an octagon within a circle, also helps to confirm the association between Leonardo's work on the *Last Supper* and his mathematical interests — and it will be recalled that this work on the painting can be firmly dated to the period of his collaboration with Luca Pacioli on the illustrations for *De divina proportione*.

One disturbing fact is that the focus of the perspective and the centre of the grid are slightly but unquestionably out of conjunction. I should like to suggest that this was a consequence of his contriving a perspectival disjunction between real and painted space. Let us suppose that he began with a design in which the perspective apex and the centre of the grid coincided, and that this design fitted perfectly into the width of the end wall. The location of the perspective apex on the actual wall could be established by the diagonals *BF* and *CG*, the upper termination of the diagonals being determined by the horizontal limit of the disciples' room at the level of the top of the central lunette. If he then decided to widen the perspective space, extending the perspective diagonals to points A and D, he would find that the twelve units of his grid would no longer fit into the wall's width, since the module of the ceiling coffers had been correspondingly widened. One solution would be to insert a narrow band below the cornice — the lines of the coffers do indeed appear in places to penetrate through this band — effectively reducing the widths of the coffer and corresponding grid to their original values. But the grid would now occupy a slightly lower position and its centre would fall below the perspective focus. This disjunction would perhaps be tolerated as the least

disruptive consequence of the widened perspective scheme. This sequence of events is, of course, hypothetical, but it does correspond to the visual evidence, and it does reflect the nature of the intuitive adjustments which he made for the sake of required effects — even if these adjustments were incompatible with the rules of scientific naturalism which he so loudly proclaimed.

The whole work is what we may call in Renaissance terms a beautiful *fantasia.* The lovely reflections of red on the right of Christ's bowl and blue on the left are not only passages of natural description, they are also beautiful *fantasie.* The motif of Judas upsetting a salt cellar with his right arm as he recoils is a beautiful *fantasia.* And so on. The supreme disciple of nature has created a work of supreme imagination. No one can ask more of any artist.

While Leonardo was still working on the *Last Supper,* during the summer of 1497, Ludovico sent a memorandum to one of his secretaries directing that his court painter should next turn his attention to the 'other wall' of the refectory. The customary note of impatience can be detected in the Duke's wish to have Leonardo 'sign a contract obliging him to finish the work within the stipulated period'. What this new work was to be we do not know. Possibly it concerned the addition of Sforza portraits (Ludovico, Beatrice, Massimiliano and Francesco) to the foreground of Montorfano's *Calvary,* but even in their present battered state we can be reasonably certain that the added figures are at best the work of pupils.

One of the odder aspects of the surviving record of Leonardo's years at the Sforza court is that there is no evidence of his having portrayed either Ludovico or Beatrice. A standard image in profile seems to have served for years as the automatic template for the Duke's portrait in every medium, and a corresponding model was formulated for Beatrice after 1491. These 'authorized' versions probably had nothing to do with Leonardo. The delicately refined *Portrait of a Lady* in the Ambrosiana, Milan, which appears to be at least partly by Leonardo himself, cannot be readily identified as Beatrice in relation to known portraits of the Duchess.

We do, however, have written accounts of two court portraits by Leonardo, both of the Duke's mistresses. One dated from the period of the *Last Supper* and *Sala delle Asse,* and portrayed Lucrezia Crivelli, who gave birth to one of Ludovico's illegitimate children. Three Latin epigrams were composed by a court poet in praise of Lucrezia's portrait, the first of which runs: 'How well learned art responds to nature: Vincius might have shown the soul here as he has portrayed everything else. He did not, so that the image might have greater truth, for it is thus: the soul is owned by Maurus [Il Moro] her lover.' It is tempting to identify the so-called *Belle Ferronière* in the Louvre as Lucrezia's portrait — the date of the painting on stylistic grounds is about right — but there is no firm evidence for so doing. The other mistress portrayed by Leonardo was Cecilia Gallerani, a lady whose accomplishments gained her a notable place in Milanese

society in her own right, not merely as Ludovico's favourite, nor simply as a member of the noble Gallerani family. The authoress of Latin letters and Italian poetry, she was the dedicatee of two novels by Bandello and acquired an almost legendary renown for the intellectual grace with which she fostered literature, music and philosophy. She held supreme place in Ludovico's affections until her marriage in 1491 — a marriage precipitated by the arrival of Beatrice as Il Moro's legitimate wife. In 1498 the aesthetically avaricious Isabella d'Este asked to borrow the portrait to compare it with works by Bellini. Cecilia agreed with elegant reluctance, pointing out to Isabella that her appearance had changed over the years and the portrait was no longer a good likeness. The painting in question can be identified with reasonable security as the *Lady with the Ermine* (Plate 56), because the animal she is holding provides a clever pun on her surname: the Greek for ermine is γαλέη (galêe).

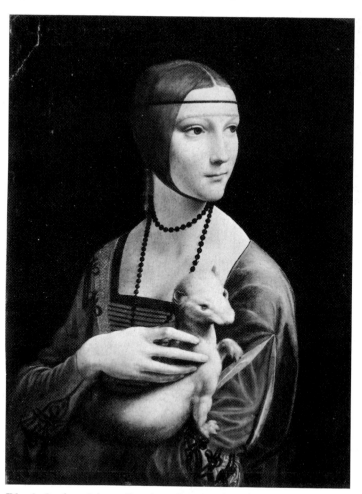

Pl.56 *Lady with an Ermine (Cecilia Gallerani)* (*c.* 1485), Cracow, Czartoryski Museum

The ermine represents, as Leonardo's bestiary informs us, the essences of purity and moderation: 'The ermine would die rather than soil itself' (H.48v); and 'because of its moderation it only eats once a day' (H.12r). The pristine sheen of the animal's coat and the delicate refinement of its bearing express these qualities with a brilliance of visual metaphor matched only in Jan van Eyck's Netherlandish style. The whole image is an essay in svelte refinement. Never before, not even in Verrocchio's most animated portrait busts, had a portrait conveyed such a living sense of the sitter's deportment — the carriage of the head, the slope of the shoulders, the slim elegance of an aristocratic hand, and the total 'air' of courtly grace. Form turns effortlessly upon form, amplified by the three-dimensional curves of coiffure and necklace, and decorated by arpeggios of interlace pattern on sleeves and shoulder. As in the *Madonna of the Rocks*, the formal sophistication is devoted to a sense of human communication — indeed to what may almost be called a narrative. Cecilia turns and reacts, a gentle smile of welcome sparkling in her eyes and playing across the corners of her mouth as she glances at a companion outside the formal limits of her picture space. There simply is no equal for this effect in contemporary or earlier portraiture.

The system of light and colour also relates to the *Madonna of the Rocks*. X-rays show that a window has been eliminated from the right background, almost certainly by Leonardo himself, leaving the figure to emerge from the matrix of shadow. The primary pools of light reflect with wonderful subtlety from form to form: the coat of the ermine casts a secondary radiance on Cecilia's hand and arm; her neck and chin play intricate games with bouncing light; and the ermine's cheek shines softly through its veiling shadow. The shadows, positive yet softly diaphanous, correspond precisely to his recommended practice for portrait painting: 'When you wish to make a portrait, do it in dull weather or as evening comes, making the subject stand with his back to one of the walls of the courtyard. Note in the streets when evening comes or when it is gloomy weather, how much grace and sweetness may be seen in the faces of men and women. Therefore, painter, have your courtyard designed with the walls tinted black' (Ash.II, 20v). A softly harmonized *grazia* of light, colour and line radiate from Cecilia's portrait. It well deserved its elegant compliment of a sonnet by Bellincioni, cast in the form of a dialogue between the poet and envious nature.

The relative intensities of light and shade across the three-dimensional contours of her face are calculated with unerring accuracy according to a rule formulated repeatedly in his Milanese writings (e.g. Ash.II, 5r, 14r C.12r, C.A.32r). This rule stated that the greatest intensity of illumination on a surface would be where the light struck that surface at right angles. Different angles of incidence would produce proportionately varied intensities. This optical formula, illustrated in a Windsor drawing (see Figure 23), may sound rather chilling in the face of the 'sweetness' of

light on Cecilia's features, but such a scientific command of natural phenomena provided the essential foundation for Leonardo's exposition of nature's grace. Behind the Milanese paintings lie meticulously detailed studies of light: classifications of different kinds of light source; the effects of different light directions on an object; the relationships between size of object and size of light source; the passage of light through apertures; the distinctions between 'light' and 'lustre'; grades of 'simple' and 'compound' shadows in enclosed spaces; reflections in water; and so on. Manuscript C, dated 1490-1, is full of such matters, reflecting years of exhaustive enquiry as well as his reading of Pecham and Witelo. The portrait of Cecilia comes from a relatively early time during this period of sustained investigation; it was probably painted about 1485.

The total list of the surviving portraits painted at least in part by Leonardo from his years in Milan comprises no more than four: the *Cecilia Gallerani*; *'La Belle Ferronière'*; the *Lady in Profile* in the Ambrosiana, whose features possess a delicacy of contour beyond the abilities of his pupils, even if an assistant may have contributed to the subsidiary parts of the portrait; and the beautiful if unfinished portrait of an unidentified *Musician*, also in the Ambrosiana, which vibrates with at least some measure of the inner life characteristic of Leonardo's autograph paintings. We can also legitimately regard his greatest single project for the Sforza court as a portrait in the broadest sense — a sculptural portrait of the Sforza dynasty in the person of Ludovico's father, Francesco. The project concerned a vast equestrian statue which would proclaim the inherent might of the Sforza regime, just as the equestrian statue of Bernabo Visconti (S. Giovanni in Conca, now Castle Museum) appeared in its stiff grandeur to symbolize the Visconti's early autocracy. When Leonardo listed his engineering abilities for Ludovico, he added a coda which precisely conveyed the spirit of the project: 'It will be possible to execute the bronze horse which will be to the immortal glory and eternal honour of the auspicious memory of the lord, your father, and of the illustrious house of Sforza' (C.A.391ra).

Francesco's eldest son, Duke Galeazzo, had conceived the idea of a bronze equestrian monument to the first Sforza Duke. In 1472 he unsuccessfully sought the services of the Milanese Mantegazza brothers, and a year later he instituted a widespread search for a suitable master of bronze sculpture. Just as the Venetian state looked towards Florence for its equestrian monuments to Erasmo da Narni (by Donatello) and Bartolomeo Colleoni (by Verrocchio), so it would have been natural for Galeazzo to have sought a sculptor in the city of his Medici allies. We know that Antonio Pollaiuolo drew up schemes for an equestrian statue of Francesco Sforza, and it may have been to Antonio that Galeazzo first turned. In any event, Galeazzo's death and Leonardo's arrival in Milan eventually resulted in the commission settling upon Leonardo's shoulders — and a considerable burden it proved to be.

The first reference to Leonardo's participation is not especially encouraging. In 1489 the Florentine Ambassador reported to Lorenzo de' Medici:

> Prince Ludovico is planning to erect a worthy monument to his father, and in accordance with his orders Leonardo has been asked to make a model in the form of a large horse ridden by Duke Francesco in full armour. As His Highness has in mind something wonderful, the like of which has never been seen, he has directed me to write to you and ask if you would kindly send him one or two Florentine artists who specialize in this kind of work. Moreover, although he has given the commission to Leonardo it seems that he is not confident that he will succeed.

The most favourable interpretation is that Ludovico was seeking technical experts to assist Leonardo in the foundry work; the worst is that Leonardo was to be sacked.

At this time Leonardo appears to have been thinking of a rearing horse (Plate 57), a project of staggering technical difficulty, though not so unique in conception as is often assumed. Pollaiuolo's two surviving designs both depict a rearing horse, and the Bentivoglio Monument in Bologna posed the horse in this manner, albeit on a more limited scale in a marble relief. The rearing scheme may even have been the patron's idea. The dynamism of the rearing pose obviously exercised great appeal for Leonardo and seemed to present him with the possibility of transmuting something of the animal vigour of his *Adoration* background into three dimensions. Like Pollaiuolo, he proposed to overcome the structural problems by placing a fallen foe under the horse's forehooves. Pollaiuolo's schemes alternatively showed a figure symbolizing vanquished Verona or a more generalized image of a defeated soldier in armour. Leonardo's nude adversary with shield and spear obviously would have conveyed the same sense of Sforza triumph. Even with this expedient, the technical difficulties remained formidable and may alone have caused the abandonment of this plan.

What happened to Ludovico's request in 1489 for 'one or two Florentine artists' is not known. By April the following year, however, Leonardo had taken a deep breath and embarked upon a revised scheme, having apparently regained the Duke's confidence: 'I restarted the horse', as he wrote in Manuscript C (15v).

A crucial element in the second phase may well have been his experience of the only complete equestrian monument to have survived from Roman antiquity outside Rome, the so-called *Regisole* at Pavia. Visiting Pavia in 1490, as an architectural consultant in company with Francesco di Giorgio, he studied the bronze statue with special interest. Its horse was similar to that of Marcus Aurelius in Rome, but the rider was raising his face towards the sun in a more animated fashion — hence its colloquial name, 'Sun king'. His experience of the *Regisole* occasioned a series of

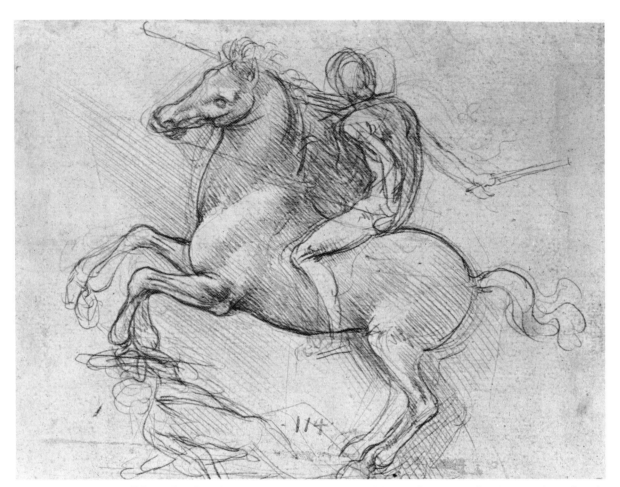

Pl.57 *Study of a Horseman on a Rearing Horse above a Fallen Enemy* (*c.* 1485-9), silverpoint, Windsor, Royal Library (12358r)

brief notes: 'Of the one at Pavia, the movement is more praiseworthy than anything else. The imitation of antique work is more praiseworthy than those of the moderns...The trot almost has the quality of a free horse. Where natural liveliness is lacking it must be produced by ancillary means' (C.A.147rb). The way in which the Roman sculptor had conveyed a sense of vitality had clearly impressed him and pointed the way towards the creation of a vivid image without recourse to the extravagant motion of the rearing pose. He henceforth reverted to a walking horse in the *Regisole* manner. In relating his own work to the Roman tradition of bronze horses he was taking up the challenge which had faced Donatello and Verrocchio in their equestrian monuments — the challenge of emulating antiquity, the challenge which lay at the heart of Renaissance ambitions. Leonardo strove to vanquish his Renaissance and Roman predecessors in two ways: the first was by a uniquely intense study of equine structure; and the second was by sheer scale.

Just as the Greek painter Apelles had sought the most beautiful girls of Athens as multiple models for his image of Helen, so Leonardo visited the stables of his patrons in Milan in search of beautiful exemplars for his Sforza horse. The Duke's captain and son-in-law, Galeazzo Sanseverino, owned at least two specimens which caught the sculptor's eye, a 'big genet' (W.12319) and a 'Siciliano' (W.12294). Another of his patrons, Mariolo de' Guiscardi, for whom he appears to have designed a palace, owned a Florentine horse 'with a fine neck and beautiful head' (Forster III, 88r). These and other horses were meticulously measured to ascertain their underlying system of proportions, which proved to be no less complexly musical than those of man (Figure 48). They also provided the material for

Fig.48 *Study of the Proportions of the Foreleg of a Horse owned by Galeazzo Sanseverino,* based on W.12319

wonderfully vibrant studies of surface anatomy. The example illustrated in Plate 58, marked with four vertical lines of proportion, scintillates with latent energy — no one has ever captured more convincingly the rippling beauty of a finely bred and groomed horse. The pose upon which Leonardo finally settled was a high stepping walk, closer to the ceremonial pose of the Marcus Aurelius than to either the restrained gait of Donatello's *Gattamelata* in Padua or the aggressive prance of Verrocchio's Venetian *Colleoni*. The outlines of this pose are consistently recorded in his diagrams for casting procedures (Figure 49).

The clearest proclamation of his wish to 'surpass the ancients' on behalf of the Sforza dynasty was the projected size of the monument. It was to be of the order of three times life size and to weigh sixty tons or more. Such an undertaking would have involved prodigious feats of casting and almost unthinkable expense in materials. Even the casting of a relatively small cannon was a cacophonously frenzied activity, and the multiple furnaces of Leonardo's scheme would have rivalled the inferno

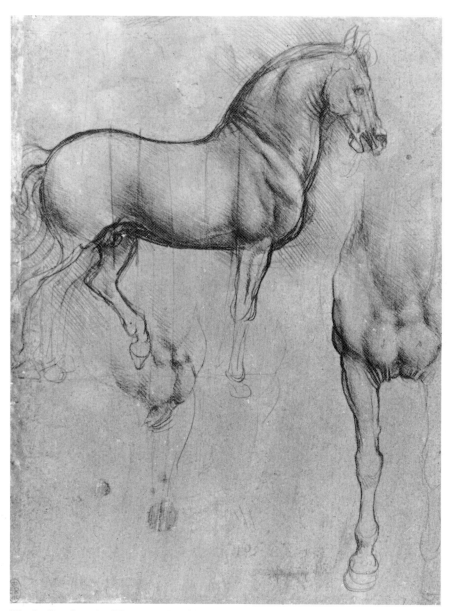

Pl.58 *Study of a Horse in Profile and from the Front* (*c.* 1490), silverpoint, Windsor, Royal Library (12321)

itself. The second of the Madrid Codices contains outlines of his intended procedures: 'Here a record shall be kept of everything related to the bronze horse, presently under execution' (157v, written on 17 May 1491). Between 1491 and 1493 he devoted much thought to the casting (and moving!) of his colossus. He appears to have devised a method which brilliantly modified the traditional 'lost wax' technique. His first stage was to make a full-scale clay model. A hollow piece-mould or *forma* would then

Fig.49 *Outline of a Walking Horse from a Casting Diagram for the Sforza Monument,* based on Madrid II, 149r

be made from this as the 'female' for the cast. One of his drawings (Plate 59) beautifully illustrates the *forma* for the horse's head within its casting hood, a kind of metal corset to hold the clay in shape. The mould would be lined with a uniform layer of fusible material, the quantity of which would indicate the exact amount of bronze required. Next would come a heat-resistant inner layer of fire-clay, making the 'male' for the cast. The fusible material, probably wax, would be melted out, leaving a space between the 'male' and 'female' sections of the mould, which would subsequently be filled with molten bronze. All this, of course, is easier said than done, but a procedure close to the one described here later became the standard method for casting large bronzes; and if anyone in the Renaissance could have done it Leonardo could. Perhaps the enigmatic 'epitaph' at the end of his technical discussion in Madrid II — 'If I could not make. If I . . .' (121r) — should be completed, 'then no one else could'.

By the winter of 1492-3, his full-scale model of the horse in clay, with its little-mentioned rider, was completed in time for the wedding celebrations of Bianca Maria and Maximilian. It was displayed under a suitably triumphal arch within the Cathedral, as Beatrice reported to Isabella d'Este. The mould for the statue may have been made, but, for reasons which will become clear shortly, the project proceeded no further.

The fame of the 'earthen horse' was immense. Latin epigrams were composed in its honour, inevitably proclaiming its Vincian victory over the ancients, and its colossal scale excited universal awe. Paolo Giovo was especially impressed by its tense vivacity — 'vehemently aroused and snorting' as he described it. The master of suggestive paint had shown himself to be a great modeller of monumental sculpture. But which art was the more important in his eyes? Or were their qualities to be fully equated?

Pl.59 *Design for a Casting Hood for a Horse's Head* (*c.* 1491–3), red chalk,
Biblioteca Nacional, Madrid (II, 157r)

These may seem like pointless questions today, in an age when few would be interested in arguing at length that one fine art was inherently superior to another. We now generally accept that each has its special qualities, to which we individually respond with greater or lesser degrees of enthusiasm according to our individual tastes. But many theorists in the Renaissance were vitally concerned with the establishing of artistic priorities: between the visual arts and poetry; between painting and sculpture; between music and painting; between the arts and sciences; and so on. For anyone who regarded the arts as reflections of universal truth, as did Leonardo, the question as to which was most truthful was no idle matter. Which of the arts, given their very different spatial, plastic and temporal qualities, most perfectly transmitted nature's design to human understanding? Discussions of this question, the so-called *paragone*, appear to have been popular in Italian Renaissance courts and we know from Luca Pacioli that Leonardo participated in one such debate on 9 February 1498 in the Sforza Castle. Leonardo's notebooks contain repeated rehearsals of the arguments he found most telling.

His notes on the *paragone* contain some of the most sustained discussions he has left us on any topic. His arguments in support of the visual arts, above all painting, are at times subtle and incisive, while at others they are rambling, naïve and not a little fraudulent in the way in which they misrepresent the other arts. But, whatever their unevenness of quality, they consistently breathe an air of real debate, and it is easy to envisage them as spoken contributions to actual discussions.

The intellectual core of his argument depended upon the traditional supremacy of sight over the other senses, a supremacy proclaimed by Aristotle and much repeated thereafter. Leonardo argued that

> The eye, which is said to be the window of the soul, is the primary way in which the sensory receptacle of the brain may more fully and magnificently contemplate the infinite works of nature, and the ear is the second, gaining nobility through the recounting of things which the eye has seen. If you, historians or poets or mathematicians, had not seen things through your eyes, you would only be able to report them poorly by writing. And if you, poet, claim to portray a story as if painting with your pen, the painter with his brush will more readily satisfy and will be understood less tediously. If you assert that painting is dumb poetry, then the painter may call poetry blind painting (Ash.II, 19r).

Using a weapon of the type favoured by the court humanists with whom he would generally have found himself in disagreement, his last sentence learnedly alludes to Simonides' statement in Plutarch's *De gloria Atheniensium* that 'Painting is dumb poetry, and poetry speaking painting'.

In addition to its superior descriptive power, painting also possessed a unique command of beauty, on account of the special relationship

between visual harmony and time:

> Painting represents its essence to you in one moment through the power of sight by the same means as the receptor of impressions receives natural forms, at the same time compounding the proportional harmony of the parts of which the whole is composed, and delighting the senses. Poetry transmits the same thing but by a less noble means than the eye, carrying it more confusedly to the receptor of impressions and describing its configurations more slowly than is done by the eye. The eye is the true medium between the object and the receptor, which immediately transmits with highest fidelity the true surfaces and shapes of whatever is presented outside. And from these is born the proportionality called harmony, which delights the sense with sweet pleasure no differently from the proportionality made by diverse voices to the sense of hearing. But hearing is less noble than sight, in that as it is born so it dies and its death is as swift as its birth. This does not apply to the sense of sight, because if you represent to the eye a beautiful human body composed of proportionately beautiful parts, this beauty will not be so mortal or so rapidly destroyed as music. Instead it has great permanence and remains to be seen and considered by you and is not reborn like music which needs to be played many times, nor will it induce weariness in you (Ash.II, 19v).

Elsewhere the same arguments were placed in the mouth of Matthias Corvinus, King of Hungary (Urb.14v-15r), a major patron of the arts for whom Leonardo may have undertaken to paint a Madonna in 1485 and who had visited Milan in 1474. Again a real sense of contemporary debate is urgently apparent.

Leonardo's major argument thus relied upon contrasting the simultaneity of visual harmonics with the disjointed beauties of literature and the transitory harmonies of musical performance. Around this central argument he clustered secondary reasons for painting's superiority: it does not require translators because its language is universal; it does not need commentators, unlike recondite poetry (Dante especially?); it can effortlessly transport the spectator into winter or summer, place him in valleys or on hills; it can instaneously move the spectator to love or hate, and to joy or terror; whatever the painter wishes to fantasticate 'he is their lord and god' (Urb.5r). Anything the poet can do, the painter can do better. The same with the musician.

Within the exalted ranks of the visual arts, Leonardo rated painting decisively above sculpture:

> The painter has ten considerations with which he is concerned in finishing his works, namely light, shade, colour, body, shape, position, distance, nearness, motion and rest; the sculptor has only to consider body, shape, position, motion and rest. With light and shade he does not concern himself, because nature produces them for his sculpture. Of colour there is none. With distance and closeness he only concerns himself in part, in that he only uses linear perspective [in reliefs] but

not the perspective of colour which varies in hue and distinctness of outline with different distances from the eye. Therefore sculpture has fewer considerations and consequently is less demanding of talent [*ingegno*] than painting (Urb.21v).

For good measure, he added that sculpture was dusty, dirty and physically exhausting — certainly not the ideal pursuit for a courtly gentleman.

Standing supreme among all the arts, painting deserved to be released from its traditional classification as a mechanical art: 'With justifiable complaints painting laments that it has been dismissed from the number of the liberal arts, since she is the legitimate daughter of nature and acts through the noblest sense. Thus it was wrong, O writers, to have omitted her from the number of the liberal arts, since she embraces not only the works of nature but also infinite things which nature never created' (Urb.15v). Only in painting can science and *fantasia* find their perfect and eternal marriage in time and space.

Ironically it has been the passage of time, the supposed enemy of poetic beauty and musical harmonies, which has dealt so severely with Leonardo's major projects in painting. We have seen the way in which time has eroded the *Last Supper* and the *Sala delle Asse*. In sculpture, nothing remains. The colossal clay horse survived for no more than eight years and it was never cast in bronze. Responsibility of the ultimate failure of the *Cavallo* project lies in the collapse of Ludovico's reign in Milan.

Not surprisingly, Alfonso of Aragon in Naples was not happy to see his daughter, Isabella, nominal Duchess of Milan as wife of Gian Galeazzo, playing second fiddle to Beatrice. Ludovico hoped to counter Alfonso's antagonism by encouraging the French King, Charles VIII, in his claim to the Neapolitan kingdom. With Ludovico's ready acquiescence, the French invaded Italy in 1494. Advancing through Northern Italy — pausing at Asti, when he was met by Ludovico, Beatrice and Ercole d'Este — Charles and his armies passed through Tuscany, where they provided the catalyst for the anti-Medici revolution in Florence. The presence of the French rudely disturbed the uneasy balance of power which had persisted in Italy during the second half of the century. Ludovico began to harbour doubts about the wisdom of his policy. The Duc d'Orléans, who entertained a hereditary claim to Milan itself, was ensconced in the fortress of Asti, far too close for Il Moro's comfort. In 1495 Ludovico was moved to join a league of Italian states against Charles, and provided soldiers for the final confrontation with the French at the Battle of Fornovo. The Italians, under the command of Ludovico's Mantuan relative, Francesco Gonzaga, claimed a great victory, and it is true that the invaders departed, but the league's forces had failed to destroy the French army. In retrospect, it may be said that the Italian troops snatched inconclusiveness from the jaws of victory.

All this turbulence could not but affect Milan's internal affairs, and had one especially direct consequence for Leonardo. The huge quantity of

metal for his bronze horse was sent to Ercole d'Este in Ferrara in November 1494 to be made into anti-French cannon. Leonardo knew that his chance had gone, for the time being at least: 'Of the horse I will say nothing, because I know the times,' he wrote to his employer (C.A.335va). In fact, his chance was gone for good. Outwardly Ludovico's reign continued on an apparently grand scale, and his political future still looked reasonably secure as a consequence of his marriage alliance with Maximillian — an alliance which was thrice celebrated in the *Sala delle Asse*. But the French episode had sown the seeds of his destruction. In 1498 Charles VIII was succeeded by the feared Duc d'Orléans, as Louis XII. Using his position as grandson of Valentina Visconti to legitimize his claim, Louis declared his intention of ousting the Sforza. When Louis invaded Lombardy in August 1499, Il Moro precipitately left Milan, and the commander of the *Castello* surrendered to the French King for a considerable bribe. On 6 October Louis was able to effect his triumphant entry. Sponsored by Maximilian, with whom he had taken refuge, Ludovico returned with a brief military flourish in February 1500, but by April he was soundly defeated and captured by Louis' forces, passing the remaining years of his life in French captivity. 'The Duke lost the state, property and liberty, and none of his works was completed by him,' wrote Leonardo on the cover of his Manuscript L.

Leonardo himself remained in Milan for over three months after the initial fall of the *Castello*. It is possible that he witnessed the tragedy of the Gascon bowmen shooting arrows into his clay horse. The piece-mould may have survived at least until 1501, when Ercole d'Este vainly tried to obtain it (or less probably the damaged clay model) to use for his own equestrian statue, but no more is subsequently heard of either model or mould. Notwithstanding the brutal treatment of the *Cavallo* by his troops, the new lord of Milan seems to have been as impressed with Leonardo's talents as the deposed Duke had been, and they entered into some kind of business agreement. But on 14 December, Leonardo's dispatch of six hundred florins to Florence for deposit in his bank account in the Hospital of S. Maria Nuova clearly signals his intention to leave Milan, the city in which he had spent eighteen of the most creative years of his life.

IV The Republic: New Battles and Old Problems

On 6 June 1505 at the stroke of the thirteenth hour I began painting in the palace; at the moment of laying the brush down the weather deterioratedThe cartoon came unstuck . . . and great quantities of rain poured down until evening and it seemed like night (Madrid II, 1r).

In important respects the Florence to which Leonardo returned in 1500 provided a very different environment from the city he had left little less than twenty years earlier. However, the main changes which would have struck him were not artistic in nature. The resident Florentine artists of the last two decades of the old century had not wrought any revolution in style. Indeed, no one painter had fully absorbed all the potential lessons of Leonardo's own Florentine work, let alone approached the innovatory standards of his Milanese paintings. The artist who most nearly approached his level of compositional complexity was Filippino Lippi, appropriately enough the painter of the *Adoration of the Kings* which finally took the place of Leonardo's unfinished panel. The tonal qualities of Leonardo's colour system had been partially adopted by Perugino, but without the expressive power of Leonardo's light effects. In professional terms, the dominant painter of the 1480s was Domenico Ghirlandaio, an artist of crisp visual intelligence who combined a highly ordered sense of composition in the best Italian manner with a feeling for detail inspired by Netherlandish models. Ghirlandaio's large and efficient studio provided Michelangelo with his first introduction to the world of the professional artist. Michelangelo himself had only flexed his youthful muscles in Florence, and the great works of his early maturity, the *Bacchus* and the *Pietà*, had both been made in Rome. Nothing Leonardo saw on his return would have astonished him with its novelty.

The great changes were political and social. We have already touched upon the way in which Charles VIII's invasion of Italy had precipitated the overthrow of the Medici in 1494 and the re-establishment of a functioning Republic under the stern guidance of the Dominican prior, Girolamo Savonarola. The execution of Savonarola four years later, partly in response to Papal pressures, did not signal the collapse of the Republic, and the basis of the 1494 revolution continued to set the pattern for political structures in Florence throughout the first decade of the new century. The greatest single reform had been the establishment of the *Consiglio Maggiore*, a huge voting council of franchised citizens modelled on the Venetian constitution. The Great Council was formed to broaden the base of the government, not in terms of modern democracy — only

three thousand of the one hundred thousand inhabitants possessed any kind of voting rights — but in such a way as to militate against the re-emergence of a narrowly based ruling clique. The provision of a suitable chamber for the Great Council occasioned the most spectacular building project of the Republican period. A large, low hall was erected with remarkable speed between 1495 and 1498 as an extension to the Palazzo della Signoria, and the subsequent plans to adorn the hall in a suitable manner were to involve Leonardo in the largest commitment of his career as a painter.

Accompanying these administrative reforms had come corresponding changes in social atmosphere and artistic patronage. The unifying principle of Renaissance culture, the emulation of classical antiquity, was too deeply rooted to be swept away with the Medici, and the proponents of Republican ideals viewed themselves no less in the light of classical precedent than their Medicean predecessors had done. But in the wake of Savonarola's injunctions against personal ostentation, rich patrons became more circumspect in what they commissioned. It would be wrong to believe that the system of patronage totally collapsed, but no artist could expect to be in Verrocchio's position under Lorenzo de' Medici, and certainly Leonardo could not even remotely entertain a situation like that in the Sforza court. Things had become extremely difficult for at least one of Leonardo's friends, Sandro Botticelli, who had been the supreme purveyor of classical allegories for the Medici circle. Deeply affected by the events of the 1490s and sincerely unsettled by the religious tone of the Savonarolan revolution, Botticelli not only found that important areas of his earlier activity had been severely curtailed but also on his own account adopted a disturbingly mystical style in religious painting which seems to have met with limited approval. The business of commissioned fresco cycles and altarpieces continued to provide a few leading painters with good careers, most notably Filippino Lippi, but we can hardly expect Leonardo on past form to forge an orthodox living from such activities. Fortunately for him some patrons continued to be more optimistic about the likelihood of his fulfilling contracts than they had any right to be. He certainly does not seem to have been short of money to support himself and his household, but the easy security of his Milanese position had disappeared.

Leonardo's career was to be more or less based in Florence during the subsequent eight years, but this period was punctuated by numerous absences of varying duration, and his initial stay in Florence between March 1500 and the summer of 1502 appears to have been his longest period of continuous residence in the city. The complexity of his career between 1500 and 1508 was such that we would be well advised to acquire a chronological outline of his movements before looking at the continuing development of his art and thought. Such an outline may not make for easy reading, but it will be a useful preliminary step.

After leaving Milan during the winter of 1499-1500, he appears to have made Mantua his first port of call. There he could have been reasonably assured of an appreciative reception from Isabella d'Este, whom we have already encountered as the borrower of Cecilia's portrait. It is not surprising, therefore, to find that Isabella sat for her own portrait. One of the resulting drawings has survived, albeit in a rather damaged and reworked condition (Paris, Louvre). When he left Mantua he probably promised to send Isabella a finished painting at some future date. Her subsequent negotiations with the painter comprise a minor saga of the kind which is already depressingly familiar.

By 13 March 1500 he was in Venice, acting as a military consultant to the Venetian Republic, which was greatly concerned at this time with the threat of Turkish invasion. He prepared a report, known to us only in a rough and incomplete draft (C.A.234vb), in which he stated that an overland attack through Friuli would necessarily have to cross the River Isonzo, and that the Venetians should develop the river as a water barrier since it would serve as a natural line of defence. Later he referred to a particular kind of sluice, 'such as I arranged in Friuli' (B.L.270v), which suggests that his advice was put into practice.

At the very end of March he was back in Florence, perhaps having briefly visited Rome, and was acting as an architectural consultant for the church of S.Francesco al Monte (previously S. Salvatore) which had become structurally unsound. In August, at the request of Francesco Gonzaga's agent, he made a drawing of the Florentine Villa Toviglia which was to be sent to Mantua so that Francesco, Isabella's husband, could build a replica for himself. Later he gave advice to Isabella's agent on some precious vases which she intended to purchase. The impression is that he willingly adopted the role of consultant on all matters artistic and military, not only because it suited his extensive talents but also because he could hope for remuneration without the need for bringing works of art to completion. This role is one he continued to fill whenever the opportunity offered itself.

Isabella's keenness to acquire a painting by Leonardo occasioned an exchange of letters between herself and Fra Pietro da Novellara (or Nuvolaria), the head of the Carmelites in Florence, who was acting as her emissary. On 27 March 1501 she wrote that she needed a replacement for the portrait drawing which Leonardo had left her, because Alfonso had given it away in an act of unwanted generosity, and she further expressed her wish to obtain a painting of any subject by Leonardo for her 'studio', with particular interest in a Madonna. In letters of 3 and 14 (?) April, Fra Pietro reported on the painter's activities. His first letter described at enthusiastic length a cartoon of the Virgin, Child, St Anne and a lamb which was not completely finished, adding that 'otherwise he has done nothing, apart from two pupils who are making copies to which he sometimes puts his hand. He is obsessed with geometry, being most dis-

gruntled with the brush.' By the time of his second report, Fra Pietro had been promised that Leonardo would 'immediately make the portrait' if he could 'detach himself from his obligation to the King of France without dishonour, as he hopes'. The second letter also described a little picture (*quadrettino*) of the *Madonna with the Yarnwinder*, painted for the Secretary of State to the French King, Florimond Robertet, who was later responsible for conducting the King's correspondence with Leonardo. Isabella's agent further confirmed that 'mathematical experiments had so distracted' Leonardo that he was no longer painting. The St Anne cartoon and Robertet's *Madonna* will concern us in detail later. For the moment we may comment on two points in the reports which Isabella received. The first is that Pacioli's influence was obviously still playing a major role in determining Leonardo's intellectual priorities, which is not surprising, since Pacioli testified that they were sharing lodgings at this time. The second is that his obligation to the French King does not appear to have involved a commission for a painting, as will become clear when we look at their later correspondence, but involved serving Louis XII in some other capacity, perhaps as a military engineer.

During the summer of 1502 he entered the service of Cesare Borgia. His authorization as *Architecto e Ingegnero Generale* to visit all the fortifications under Cesare's command was dated 18 August. Leonardo travelled extensively throughout the broad sweep of territory in central Italy which provided the arena for Cesare's cynically brilliant talents as an empire builder on behalf of his father, the Borgia Pope Alexander VI. Cesare could generally count on the support of Louis XII; his title Duke of Valentinois had been granted by the French King, and he had conspicuously accompanied Louis on his triumphal entry to Milan in 1499. It is just conceivable that Leonardo had entered into a commitment to serve Cesare at the King's instigation. In any event, his activities on behalf of the Borgia Duke are unlikely to have invoked Louis' displeasure. The attitude of the Florentine authorities would have been less favourable. In 1501 they had promised Cesare a retainer as a *condottiere* (hired general) and during June 1502 Machiavelli and the Bishop of Volterra were sent as emissaries to greet him in Urbino, but this apparent support was more in the nature of a precaution against the Duke turning his territorial ambitions towards Florence, than indicating any real enthusiasm for what the Borgias were doing.

Leonardo cannot be documented as travelling in Cesare's service after October 1502, but neither is there any record of him in Florence until March 1503, when he drew some money from his account in the Ospedale di S. Maria Nuova. During July he became involved with one of Machiavelli's favourite projects, the diversion of the Arno around Pisa, the city which Florence had been intermittently struggling to re-conquer after its 'liberation' by Charles VIII in 1496. Concurrently he appears to have devised a canal which would bypass the unnavigable section of the

Arno to the west of Florence. It is clear that painting was again taking a back seat. In October, however, the situation abruptly changed. His name reappears in the accounts of the Company of Painters, for a very good reason: he had been offered and had accepted the commission for the immensely prestigious wall-painting of the Battle of Anghiari for the Council Hall of the Republic. On 24 October he received the keys to the Sala del Papa and other rooms in the convent of S. Maria Novella, which were to serve as his workshop during the preparation of the huge cartoon.

Work on the cartoon and preparations for painting on the wall continued during the winter and throughout the summer of 1504, but were interrupted in November when he went to Piombino on the west coast to act as consultant on military matters to Jacopo IV Appiani. The story of Piombino and the reasons for Leonardo's visit neatly encapsulate the unpredictable nature of the events with which he was involved. Jacopo, ruler of Piombino, had been ousted by Cesare Borgia in 1501, at a time when Florence was reluctantly supporting the Pope's son. But the situation was so changed in 1504 that Machiavelli (once ambassador to Cesare) was dispatched in April to establish friendly relations with the re-established lord of Piombino. The Florentine authorities were obviously willing to divert Leonardo from his work in the Council chamber in order to follow up Machiavelli's mission with practical advice of a military nature.

Presumably at the end of the time stipulated for his work in Piombino, which occupied less than two months, he returned to Florence, and during 1505 embarked upon the actual painting in the Hall. Meanwhile, Isabella had requested that Leonardo should paint an image of Christ at about twelve years old, 'made with that air of sweetness and suavity in which his art peculiarly excels'. Early in May 1506, two years after her original request, she was still persisting, in the hope that Leonardo would welcome a break from his large-scale work on the battle-piece. Later in May work in the Council Hall was broken off again, but not for Isabella's purposes; he was granted three months leave of absence to work in Milan. Once again, Florentine political considerations lay behind the authorities' willingness to release him — temporarily, as they hoped. Florence was still committed, albeit with occasional reservations, to an alliance with France, and the government would have been reluctant to refuse a request from the French rulers for Leonardo's presence in Milan. This certainly was the reason for the granting of an extension to his leave in August, in response to a letter from Charles d'Amboise, the governor of Milan. When the patience of the Florentines was beginning to wear thin, the French King himself weighed in with a request that Leonardo should remain in the city until the King's visit there in May 1507. The Florentine government could only reply that they 'cannot have any greater pleasure than to obey his wishes and that not only the said Leonardo but all other citizens are at the service of his wishes and needs'. During the next eighteen months,

Leonardo's Florentine commitments, including a lawsuit arising from his uncle's inheritance, and his French involvements sent him on a frustrating series of shuttles between the two cities: in March 1507 he was in Florence; he was probably back in Milan in time for Louis' entry on 24 May; in August he returned to Florence, where he remained until the spring or summer of 1508; by September, if not before, he was living in Milan and was henceforth effectively lost to Florence as a practising artist.

On the face of it these eight erratic years, fragmented by conflicting demands upon his time as well as his own multiplicity of interests, would not appear to provide promising circumstances for sustained creativity in painting. But, surprisingly, this period is marked by an astonishing richness of artistic activity, in which more than a dozen significant compositions were conceived and taken to various stages of completion by Leonardo himself or his assistants. The *Madonna and Child with the Yarnwinder* was the first completed picture, and is known through studio versions and reproductions. Various schemes for the *Madonna, Child and St Anne* were generated; as many as three cartoons may have been designed and a painting possibly begun. The Louvre drawing for Isabella's portrait is pricked through for transfer, suggesting that a start was made on actual painting. Her *Young Christ* seems to have been conceived if not executed, and is reflected in paintings by followers, including Luini. A closely related composition of Christ as *Salvator Mundi* is known through drawings and studio copies. An image of the *Angel of the Annunciation* was painted, perhaps largely by assistants, and may have been that seen by Albertini before 1510 in the church of S. Salvi. A finished drawing of *Neptune* was presented to Antonio Segni, one of Botticelli's patrons. Two different compositions for *Leda and the Swan* were invented, one of which was eventually developed into a painting by Leonardo himself. Both versions of the *Leda* are known through drawings and versions by followers. The *Portrait of a Lady on a Balcony* in the Louvre, known as the 'Mona Lisa', was certainly conceived during this period, although in its final form it may be the result of continuing work after 1508. Also traceable in drawings or copies, though less definitely than those listed above, are projects for a *Hercules and the Nemean Lion*, a *Mary Magdalene* and a *Madonna with the Infants Christ and John*, in which the children were shown playing with a lamb and a reed cross. And, of course, dominating all in size and prestige, was the great battle painting for the Council Hall.

In spite of the characteristic dearth of finished paintings in this list, a large proportion of these compositions left indelible marks upon the history of sixteenth-century art. Six of them — the *Madonna with the Yarnwinder*, at least one of the *St Anne* cartoons, the *Neptune*, the standing *Leda*, the *Portrait of a Lady* and the *Battle of Anghiari* — can be seen to have played formative roles in determining Raphael's mature style. Michelangelo was demonstrably influenced by more than one of Leonardo's inventions, whatever his personal hostility towards the older

artist. When Fra Bartolomeo resumed painting, after 1504, he adopted important aspects of Leonardo's compositional techniques. And Andrea del Sarto, in his late teens when Leonardo was at the peak of his powers in Florence, reflected more sensitively than any other painter what Isabella called the 'suavity' of Leonardo's style. In addition to these, a host of lesser and later artists struggled more or less successfully to master Leonardo's innovations.

There is clear evidence of the excitement with which the Florentines greeted each demonstration of Leonardo's mature powers. To the expressive fluidity of the *Adoration* underpainting he had added profoundly meditated qualities of psychological and formal grandeur, supported by subtle harmonies of tone and colour. In the reports to Isabella, which provide our first notices of his paintings after 1500, Fra Pietro da Novellara seized particularly upon two qualities in the works he had seen. He was struck by the way in which devotional images of a potentially routine kind had been imbued with a story-telling quality, and he was no less impressed by their compositional intricacy. These aspects were worthy of comment because they represented departures from the normal usage.

The finished painting for Robertet contained a remarkable complexity of narrative interaction within the previously limited format of a small Madonna and Child. Fra Pietro explained that the Virgin was apparently intending to spin some yarn, but 'the child, resting one foot in the basket of flax, has taken hold of the yarnwinder and gazes attentively at those four spokes in the shape of a cross and smiles as if he desires the cross and keeps hold of it firmly, not wishing to yield it to his mother, which it seems she wants him to do'. The original painting described to Isabella is no longer traceable, but various copies and a study for the Madonna's torso (W.12514) give us a good idea of its appearance. The finest copy is in the Buccleuch Collection (Plate 60) and differs from the written account only in that Christ's foot does not rest in the flax basket. This painting is the best of all candidates for being one of those copies which Fra Pietro recorded two assistants as making with occasional touches by the master himself. The beautiful handling of the rocks below Christ's body may be an instance of Leonardo's own contribution to what basically was a studio product.

Robertet's painting represented a new kind of Madonna. The inclusion of a symbol of the Passion, or as here specifically of the crucifixion, was not in itself remarkable; what was exceptional was the way in which the significance of the symbol was integrated into the psychological fabric of the picture, the way in which the reaction of Virgin and Child told a subtly unified story. An apparently innocent act of playfulness has acquired implications far beyond its temporal context in Christ's infancy; his divine destiny is inescapably prefigured in the painting. Jesus' eager surge to embrace the cross elicits a complex response from Mary, whose emotion, like her poised right hand, hovers uncertainly between anxiety

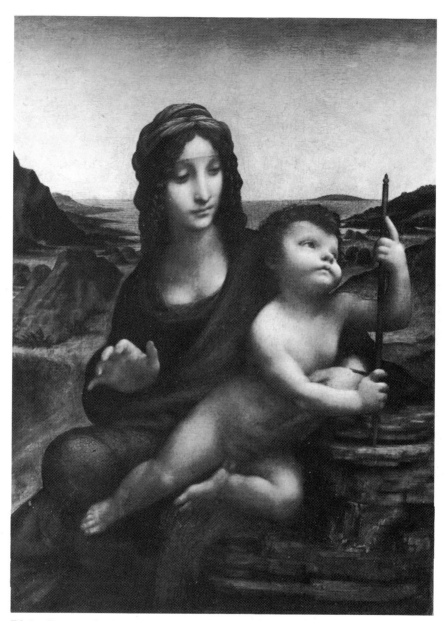

Pl.60 Leonardo (?) and workshop, *Madonna and Child with a Yarnwinder* (*c.* 1501), Collection of the Duke of Buccleuch and Queensberry

and acquiescence. To a public accustomed to the beautifully characterized and uncomplicated piety of traditional Madonnas, such subtle dualities of reaction must have seemed amazingly intricate in the emotional demands made on the spectator — and not a little disturbing.

The *Madonna, Child and St Anne* cartoon recorded in the first letter embodied a comparable quality of implied narrative, in an even more complex manner because three participants were involved, not to mention

an animal: the cartoon, according to Fra Pietro

> depicts a Christchild of about one year, who almost climbs out of his mother's arms and seizes a lamb which he appears to embrace. His mother, almost rising from the lap of St Anne, seizes the Child to separate him from the little lamb (the sacrificial animal) which signifies the Passion. St Anne rises slightly from sitting, and it seems as if she would wish to restrain her daughter so that she should not separate the baby child and the lamb, which perhaps may be intended to represent the Church, who would not have the Passion of Christ impeded.

Fra Pietro followed this sensitive response to the cartoon's emotional subtleties with a nice acknowledgment of its compositional novelty: 'And these figures are all as large as life, but they exist within a small cartoon, because they are either seated or in curved poses and each is a certain amount in front of the other towards the left; and the drawing is not finished.' This cartoon, like the original of Robertet's Madonna, has disappeared. The characterization of the Madonna, Child and lamb immediately calls to mind the painting in the Louvre (Plate 61). However, the relationship between the cartoon and the painting is far from straightforward. An integral component of the described narrative, St Anne's gesture of restraint, is absent from the painting. A further difficulty is caused by the description of the figures as arranged 'in front of each other to the left' ('*verso la man sinistra*'). If Fra Pietro meant towards *his* left, this would not correspond to the painting, but he may have been thinking in terms of the left hands of the figures themselves, a not uncommon form of description. A more fundamental problem arises from the style of the painting, which can be securely recognized as dating from a later period of Leonardo's career.

The situation is further complicated by the account given by Vasari, whose life of Leonardo was first published in 1550. Vasari wrote that when Leonardo returned to Florence, Filippino Lippi generously allowed him to take over his commission for an altarpiece in Santissima Annunziata. He added that Leonardo and his household were provided with accommodation by the Servite brothers of SS. Annunziata. This sounds highly plausible: Filippino had twice taken over commissions left unfinished by Leonardo, providing paintings for S. Donato and the Chapel of St Bernard; and Leonardo's father was the convent's procurator. The altarpiece in question was a magnificent, double-sided structure of carved wood, designed by Filippino and made by Baccio d'Agnolo (a partnership we shall meet again) between 1500 and 1504. At the centre of the framework were to be set two large panels, a *Deposition of Christ from the Cross* at the front and an *Assumption of the Virgin* at the rear, while subsidiary areas were to be decorated with separate paintings of standing saints.

According to Vasari, all that eventually resulted from his residence in the convent was a cartoon depicting the Madonna, Child, St Anne and St

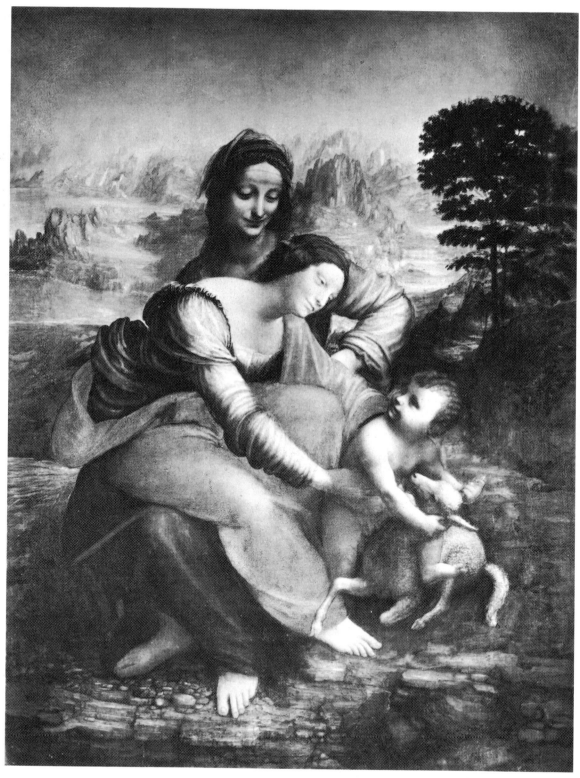

Pl.61 *Madonna, Child, St Anne and a Lamb* (*c.* 1508 onwards), Paris, Louvre

John, which for two days was visited by a stream of 'men and women, young and old, as if they were going to a solemn festival'. This cartoon is unlikely to have been intended for the altarpiece: its subject does not correspond to any of the paintings eventually executed by Perugino after Leonardo's default and Filippino's death; and unless it was made on an improbably larger scale than his other versions of this subject, it would have been much too small for the framework.

Can we identify the cartoon he made while he should have been working on the altarpiece as the one seen by Fra Pietro in 1501? Vasari's description does not tally with that in the letter. The Virgin, 'tenderly holding Christ', was described by Vasari as looking down at 'the little infant St John, who has engaged in play with a little sheep, not without a smile from St Anne, who with joy realized that her earthly progeny had become divine'. Fra Pietro described no such St John. The easiest way to reconcile these accounts is to assume that Vasari was perpetrating one of his not infrequent imprecisions in his inclusion of St John, and this remains the likeliest explanation. However, as has recently been argued, there is at least some slight evidence to suggest that he might actually have been describing an entirely separate cartoon. This evidence confusingly involves the preparatory stages for the only surviving cartoon by Leonardo, the *Madonna, Child, St Anne and St John* in London (Plate 62), which in itself is clearly not identical with either of the described versions.

The only certain preliminary study for the composition of the London cartoon is a black chalk drawing (Plate 63), heavily revised in ink to the point of obliteration and eventually transferred with a sharp stylus to the other side of the sheet. Leonardo has so reworked the main drawing that its chalk basis is no longer discernible for the most part, but the slighter drawing below still retains some of its original features. To the right we can just see the figure of a second infant, stooped over a bulky shape on the ground. This shape in the transferred version on the reverse of the sheet appears to be a saddle (referring to the Holy Family's flight into Egypt), while in the final version it is a grassy hummock. In the chalk underdrawing it is not recognizable as either of these but could be interpreted as Vasari's lamb. This would mean that the main outlines of Vasari's version are preserved in the London cartoon, albeit with the lamb eliminated for the purposes of greater narrative concentration.

In style the London cartoon is likely to be no earlier than 1507 — although strenuous efforts have been made to assign it to 1499 — but its starting point might be a design from several years earlier. The relationship between Vasari's cartoon and the London version would thus be essentially the same as that between Fra Pietro's cartoon and the Louvre painting. The London cartoon and Paris painting would both represent more resolved reworkings of earlier ideas. Such reworking is altogether characteristic of Leonardo's creative procedures in his art and science from about 1507 onwards.

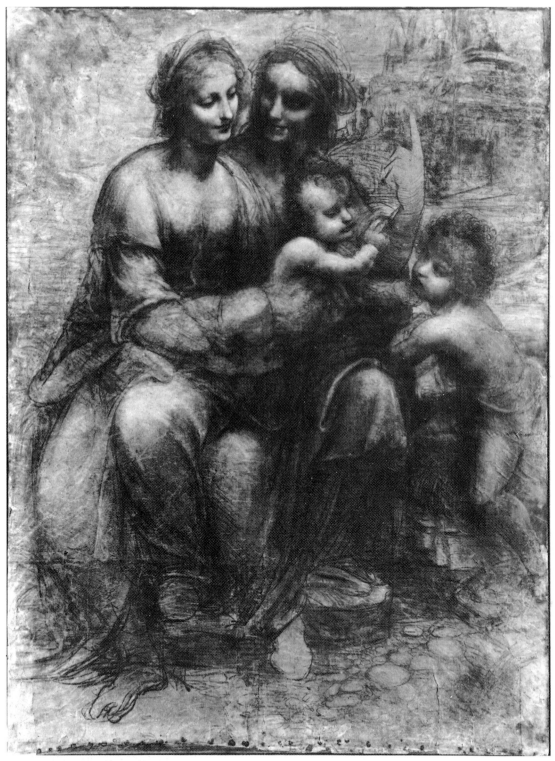

Pl.62 *Cartoon for the Madonna, Child, St Anne (?) and St John* (*c.* 1508),
London, National Gallery

Pl. 63 *Study for the Cartoon of the Madonna, Child, St Anne (?) and St John*
(*c.* 1508), black chalk, pen and ink and wash, London, British Museum

This idea of a second St Anne cartoon from the 1500-3 period has much to recommend it, but in the final analysis the visual evidence is too slight and Vasari's testimony too remote to allow its adoption as a working hypothesis. And I fear that it must be reluctantly cast aside in favour of the traditional identification of the Vasari version with that described by Fra Pietro in 1501. Even if there was only one cartoon, we are still faced with the problem that he devoted a considerable degree of effort to a composition which does not correspond to any known commission, at a time when Isabella and the Servite brothers were clamouring for works. Why did he elect to concentrate on the St Anne theme?

I suspect that he had not received a specific commission for a painting on this theme, and that he saw his efforts in this direction as playing a valuable role in re-establishing his position as an artist in Florence — under the particular circumstances of the Republic during the early years of the century. St Anne was especially favoured for her associations with Florence's Republican aspirations. It was on St Anne's day (26 July) that the Florentine citizens had risen against the 'Duke of Athens', Walter of Brienne, the hated foreign tyrant who had governed them as absolute ruler for ten months during 1342-3. In the altarpiece which Fra Bartolomeo began in 1510 for the Council Hall, St Anne was to be accorded a prominently central role, and it is likely that he was following the programme established in 1498 when the frame was commissioned from Baccio d'Agnolo to Filippino's design. Filippino had also been expected to paint the single panel of the altarpiece and received an interim payment on 17 June 1500. In this context, Leonardo's St Anne could be regarded as an attempt to throw his hat into the Republican ring, not perhaps in such a way as to displace Filippino, but certainly as a public contribution to Republican iconography. This would help to explain his otherwise remarkable willingness to display the work or works in cartoon form. If there was indeed a second cartoon, including St John, this would have been even more explicitly Florentine in significance, since St John was the major patron saint of Florence. The four protagonists in the cartoon described by Vasari also conspicuously form the pyramidal centre of attention in Fra Bartolomeo's unfinished altarpiece for the Council Hall. It is worth noting that two other compositions for which Leonardo made drawings, the *Hercules* and the *Salvator Mundi*, carry strong Republican associations. Hercules was an established symbol for the Florentine Republic: in 1495 statues of Hercules had been appropriated from the Medici Palace to adorn the Palazzo della Signoria; and Michelangelo was commissioned to make a Hercules in 1508 as a companion piece to his *David*. The *Salvator Mundi* possessed equally close links with the new Republican order, since it was on the day of S. Salvatore that the Medici were expelled in 1494.

Not only would Leonardo's St Anne cartoon have been a convenient demonstration that his political heart was in the right place, but it would

also have served to demonstrate his unrivalled compositional skill, showing how his revolutionary drawing style allowed him to interweave formal and emotional relationships in highly integrated patterns within small areas of condensed space. Fra Pietro certainly did not miss this point, and nor would anyone who had a reasonable knowledge of earlier devotional images. Isabella's informant was particularly impressed by the way in which the interlocked figures were arranged in curved poses ('*stano curve*'), that is to say in complex postures in which one part of the body turns and bends upon another. The Virgin in the *Madonna with the Yarnwinder* is seated in a twisted position of considerable intricacy and tension, her left knee drawn up to the level of her hips, with her right leg placed lower in such a way as to create a momentum towards her right side, while her torso and head pivot progressively in the opposite direction. The Virgin's foreshortened hand emerges from the very point around which these torsions revolve. The poses in the cartoon(s) cannot be known with any certainly but it is likely that they exhibited *contrapposto* motions of similar novelty.

Fra Pietro also showed himself sensitive to the way in which Leonardo's technique suggested past actions and immanent intentions. The Virgin *was* about to spin flax, but the child *is* holding the yarnwinder and grips it firmly in anticipation that his mother *will* try to take it back. Leonardo's characterization of emotion, of *il concetto dell'anima*, implies the potential for continuing reaction — what he would have called a 'continuous quantity' in mathematical terms. It is accomplished by a painting technique in which the 'signs' of the face are left understated. The ambiguity of contour at the corners of the mouth is particularly important in this respect, and will become one of the signal characteristics of his late style. We will say more about this technique when we are able to study its effect in finished paintings by Leonardo himself rather than having to rely upon copies.

By the spring of 1502, after some two years in Florence, he does not appear to have achieved much in the way of tangible results in his attempts to re-establish himself as a practising artist in the city. A few pieces of consultancy work, a little painting for a French patron and a cartoon which may not have been finished, hardly constitute the foundations for a new career. His 'mathematical experiments' may have been intellectually engrossing, but he was certainly in no position to obtain employment as a professional mathematician, unlike Luca Pacioli. Salaried service with Cesare Borgia as a peripatetic consultant on military architecture would therefore have seemed an increasingly attractive proposition. There was also the personal magnetism of Cesare: 'This lord is truly splendid and magnificent, and there is no enterprise so great that it does not appear small to him . . . He is popular with his soldiers and has collected the best men in Italy.' This report was given to the Signoria by no less an analyst than Machiavelli, who served on an embassy to Cesare during June 1502,

after the Duke had staged his brilliantly sly conquest of Urbino. A month later Leonardo recorded his own presence in Urbino (L.6r); presumably he was already in Cesare's employ and may have previously inspected Piombino on the Duke's behalf. In August, while Cesare was in Milan successfully confirming his alliance with Louis XII, Leonardo cast his expert eye over the defences of the Duke's eastern cities, Pesaro, Cesena and Rimini. On 18 August, after he had already been working for Cesare for some time, he was presented with an official authorization as '*Architecto e Ingegnero Generale*', which granted him free access to all the Borgia strongholds and gave him complete discretion to initiate any necessary improvements. He and his assistants were to receive all their expenses and he could requisition the services of local men to assist him in 'measurement and estimation'. The numerous pages in Manuscript L recording dimensions of town walls and related features testify to many man-hours spent pacing out distances in and around Cesare's fortifications. The finest surviving fruit of these surveying activities is the map of Imola (Plate 64), a city which was strategically one of the Duke's most important possessions. It was in Imola on 7 October that Machiavelli began a three-month embassy to Cesare, at a time when the Pope's son was under temporary pressure from some of his erstwhile allies. Leonardo's map was almost certainly made during this period.

The Imola map is the most magnificent surviving product of the Renaissance revolution in cartographic techniques. A conspicuous role in this revolution had been played by Alberti, who had used a horizontal surveying disc to make a measured drawing of Rome. His technique was outlined in his *Descriptio urbis Romae* and *Ludi matematici,* the latter of which was known to Leonardo, probably as a result of his association with Pacioli. The basis of the method was to use a surveying disc, mounted at a central vantage point, to measure the radial angles of significant features, much as had been done in late medieval portolan charts of the seas. What was new was the coordination of these bearings with precisely measured distances, in such a way that an accurately proportioned plan could be produced. Alberti's *Ludi* records his use of more than one vantage point in order to establish a network of triangulation, thus obviating the need for multiple measurements of distances on the ground. In contrast, a preparatory drawing for Leonardo's Imola map (W.12686r) shows that he retained the more laborious method of pacing out all the major distances of roads, squares, open spaces, etc., and subsequently coordinated these measurements with his 'wind rose' of radial angles.

From the centre of Leonardo's circular plan, corresponding to the point in the city at which he placed the centre of his disc, radiate sixty-four equally spaced lines. Eight of these lines are drawn more heavily and labelled with their names in the wind rose tradition: *Septantrione* (North), *Grecho* (N.E.), *Levante* (E), *Scirocho* (S.E.), *Mezzodi* (S), *Libecco* (S.W.), *Ponente* (W), and *Maesstro* (N.W.). With concentrated labour and con-

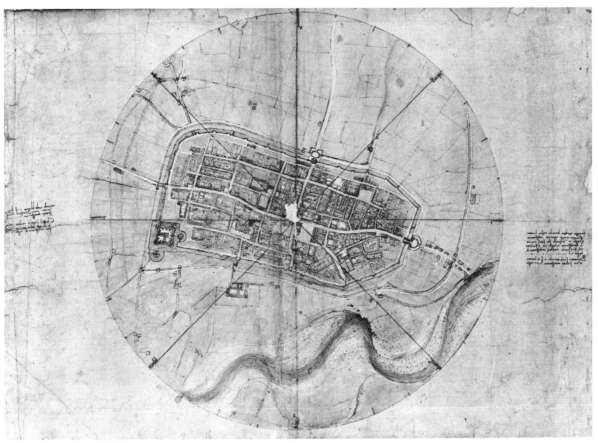

Pl.64 *Map of Imola* (1502), pen and ink with watercolour, Windsor, Royal Library (12284)

summate visual skill he has drawn in the roads, squares, walls, gates, fortifications, surrounding villas and farmhouses, indicating the plans of major buildings such as churches and denoting colonnades by rows of dots. The area occupied by houses has been tinted dark pink, the town spaces yellow-green, the countryside pale yellow-buff, and the moats, canals and River Santerno light blue. It is a plan-map in the modern manner and as such is the objective product of surveying precision rather than an impressionistic landscape in the manner of his 1473 sketch of Tuscan panorama (see Plate 11). Yet it is far from being a lifeless object, a blandly flat record of measured features. It perceptibly stirs with life, particularly when seen in the original, almost like a greatly magnified picture of a micro-organism. We may recall his earlier parallels between city plans and the human body. In his portrayal of the river this sense of emergent life becomes overtly apparent as the waters surge dynamically in a series of percussive parabolas from one bend to the next, biting jagged chunks out of the higher banks on the Imola side and excavating a bed

far wider than its immediate stream. Under the touch of Leonardo's pen and the scrutiny of his eye, nothing remained inert, not even a flat map.

It is easy to imagine that Cesare was attracted by the precision which Leonardo's techniques offered. In conducting his campaigns, either by subterfuge or overt force, the Duke would have had cause to welcome such exact records of entrances and exits, of circulatory routes within the city, of defensive blind spots, of potential lines of fire and so on. In Manuscript L, which we could almost call his Borgia notebook, Leonardo portrayed lines of fire from bastions in terms of geometric interlace (Figure 50), like the intersecting pyramids of his optical diagrams. Here, in a true sense, is something which can be termed 'the science of war'.

Fig.50 *Lines of Fire from Gun Placements,* based on L.45v

For a man in a military hurry as was Cesare, who seemed to conquer a new fortress each month, Leonardo's precise skills in the cartography of defence would have been especially valuable. Presented with a map of the Imola kind, Cesare could have literally grasped matters in his own hands, formulating plans of action, ordering the dispositions of forces and weapons even more accurately than was possible on the spot. For good measure, Leonardo has added the compass bearings and distances of neighbouring towns. The note to the left of the map begins 'Imola sees Bologna at five-eighths from the *Ponente* towards the *Maestro* at a distance of twenty miles'. Cesare's recorded ability to 'arrive in one place before it is known he has left another' (Machiavelli) would have thrived on such information.

While travelling in the Duke's service, Leonardo quite naturally continued his obsessive habits of observing, noting and attempting to explain all manner of things, not just the matters immediately in hand. At Urbino he was interested in a novel kind of dovecote (L.6r) and made thumb-nail sketches of architectural features in the magnificent Montefeltro Palace, including the Capella del Perdono designed by his friend Bramante (Figure 51) and the graceful staircase leading from Luciano Laurana's beautiful courtyard (Figure 52). He studied methods of transporting grapes and a novel kind of window frame at Cesena, wave formations at Piombino, wheeled vehicles in the Romagna, a musical fountain at Rimini, visited the library at Pesaro and noted the action of a bell at Siena. The reference to Siena (L.19v) suggests that he remained with

Fig.51 *Sketch of Bramante's Capella del Perdono in the Ducal Palace at Urbino*, based on L.73v

Fig.52 *Sketch of the Staircase of the Ducal Palace at Urbino*, based on L.19v

Cesare until January 1503, when the city fell briefly into Borgia hands. Perhaps he also went to Rome with his employer in February, returning to Florence thereafter.

Within three months of his return he followed his experiences in Cesare's service with employment by the Florentine government in its war against Pisa. On 24 July he was called to the Florentine camp outside Pisa to advise on the project to divert the Arno around the besieged city 'to deprive the Pisans of their source of life', in the words of an official report. It is not known how far Leonardo may have sown the seeds of this idea during his earlier contacts with Machiavelli, but its adoption as official policy certainly cannot be credited to him in the personal and single-handed sense suggested in many of the later accounts. A number of *maestri d'acque* (hydraulic engineers) were consulted, and on the basis of their over-optimistic reports a start was made on digging operations during August 1504, at a time when Leonardo certainly was in no position to participate directly in the excavations because he was fully involved with the preparations for his painted battle scene. Work on the ambitious canal proceeded with some two thousand labourers, but the Arno obstinately refused to be pushed around. The new ditches attracted water only when the river was in flood, and the half-finished weir only succeeded in deepening the Arno's original bed. In spite of Machiavelli's pleading, the whole venture was abandoned as an irredeemable fiasco in October.

Leonardo's consultancy work on the Pisa project was probably responsible for rekindling his interest in the ancient scheme to render the Arno navigable between Florence and the sea which, if accomplished, would have brought immense economic and naval benefits. In 1487 one of his colleagues, Luca Fancelli, wrote a report from Milan outlining just such a scheme, and Leonardo also seems to have considered the idea at

about this time, while still in Milan (C.A.46rb). Leonardo's eventual solution, illustrated brilliantly in a series of maps of the Arno valley dating from the period 1503-5, was to construct a curving canal to the north of the unnavigable section of the river. His canal was to pass in a north-westerly direction through Prato and Pistoia, subsequently bearing westwards through a cutting at the pass of Serravale, before curving southwards again to rejoin the Arno at a navigable point above Pisa. The almost semi-circular loop, according to his calculations, would actually have been shorter than the convoluted meanderings of the existing river. If this scheme for such a considerable canal should have seemed impractical and utopian, he could have pointed to the Naviglio Grande and Naviglio Sforzesco, in Lombardy, canals on a vast scale which not only served the needs of transport but also brought agricultural benefits to a huge area of territory. The sponsors of such a canal could hope to recoup their enormous outlay from the sale of water concessions and the charging of tolls; his own calculations indicated benefits to Prato, Pistoia and Florence to the tune of some two hundred thousand ducats a year (C.A.46rb). The maps in the series (e.g. W.12279, Madrid II, 2r, 22v and 23r) are brilliant cartographic achievements, exploiting not only flat mapping techniques in which different colours indicate the different height of various features but also an amazing relief method of depicting topography in which his remarkable visualization of form in space is used to create 'aerial views' of Tuscany (e.g. W.12682r).

These great schemes of canalization led him characteristically to reconsider the whole process of excavation, which at this period required immense numbers of labourers to dig out the soil and even greater numbers to remove it. A highly finished drawing in the *Codice atlantico* (lvb), suitable for submission to the authorities, displays a gigantic machine in which huge buckets hanging from pivoted arms convey the excavated soil to the sides of the canal. When the buckets return, having deposited their loads, each was intended to carry a workman who would act as an ingenious counterweight to the soil in the other buckets. He explained that conventional wheelbarrows were wasteful of effort, as 'is shown in my treatise on local movement, force and weight', while 'the instrument shown here would possess a higher degree of usefulness and efficiency, the reasons for which will not be in dispute but will always be confirmed by experience' (C.A.335vd). Unfortunately there is no evidence that this attempt to put the theoretical principles of mechanics into practical effect achieved any tangible results in actual excavations. The Arno canal remained a paper project only.

The sole scheme of excavation definitely initiated and directed by Leonardo was on a much smaller scale and had a military purpose. On 20 November 1504, during his few weeks of activity in Piombino as a military consultant to Jacopo Appiani, he made a small sketch of 'the moat I am straightening' (Madrid II, 24v). This work followed a programme he had

outlined at the beginning of the month: 'On All Saints Day [1 November] I made in Piombino for the lord this demonstration' (Madrid II, 25r). His designs for Piombino's fortifications embodied two main ideas. The first was for a series of moats, trenches and covered ways between the citadel, city gates and other strategic points. The covered ways would serve as escape tunnels in the event of the lord's betrayal by the people or by his commander 'as happened at Fossombrone' (C.A.43vb) — a reference to one of Cesare's successfully devious conquests. The second idea was for a squat round tower which would pugnaciously command a wide sweep of land near the citadel. To maximize the scope of its fire power he suggested cropping some obstructive humps of adjacent land, and made elaborate calculations to determine the volume of soil to be moved, with estimates of the labour costs.

The round tower, with its bluntly aggressive assertion of invulnerability, grew in Leonardo's mind into a more extensive scheme for a circular fortress (Figure 53), an ideal conception of the kind which he so often distilled from his actual involvement with a real project of a more restricted nature. The circular fortress, which we can piece together from a number of drawings, was to consist of three fortified rings in concentric arrangement, each constructed from massive masonry, surrounded by floodable moats and further protected by four outlying bastions. It was Leonardo's most remarkable conception in the field of military engineering, and represented a total rethinking of the principles of fortification. No longer were castellated walls to be protected by projecting bastions and towers, in the conventional manner, but the whole defensive system was to be condensed into a unified whole, no part of which was less mighty than any other in its concentrated assertion of strength. The curved contours of the squat rings were designed to deflect the percussion of cannon balls, rather than standing up to be bombarded in the four-square manner of normal walls. The design was in accordance with the laws of reflected motion: 'that percussion will be of less potency which is made against an object of greater obliquity' (C.A.48rb). He also made detailed designs for angled and curved window embrasures in order that shots should be

Fig.53 *Design for a Circular Fortress displayed in Solid Section*, reconstructed from designs on C.A.48ra-b

diminished in impact: 'Every blow diminishes by half, because it jams between them' (L.50v). Communications between the fortified rings were to be made via underground tunnels, floodable in emergency, and combustible bridges. These precautions were designed as much to protect the lord of the castle from internal betrayal as external attack, a concern which had reached an understandably high level after he had witnessed the duplicity of Ludovico Sforza's commander and the successful exploitation of organized treachery by Cesare Borgia. Nowhere are Leonardo's theoretical principles, his sense of form and his observational acumen more brilliantly combined than in the circular fortress designs.

By the time he went to Piombino for his few weeks of service to Jacopo Appiani, Leonardo had already spent a year or so working on the great battle-piece for the *Sala del Consiglio* of the Florentine Republic. It is entirely appropriate that his major painting during these years of military consultancy should have depicted a military engagement. This situation accurately reflects the historical circumstances of the period and precisely indicates the dominant concerns of the Florentine government at this time.

The history of the Council Hall in its original form covers no more than seventeen years, from its conception in 1495 to the reinstatement of the Medici in 1512. Had its sculptural and painted adornments been completed, they would have comprised the greatest of all sets of political decorations — unified by a coherent programme of religious and historical imagery, and executed by artists of unrivalled stature. The Hall itself had been designed and built largely by Antonio da Sangallo the Elder, with important contributions from Il Cronaca. In 1498 the great master of wood carving, Baccio d'Agnolo, took over from Sangallo with special responsibility for all furnishings, including the altarpiece frame, balustrades, panelling and a loggia for the *Gonfaloniere* with his eight Priors. Baccio and his design partner, Filippino Lippi, provided the Hall with carved woodwork of unparalleled beauty, decorated with an abundance of motifs *all'antica.* Filippino himself was asked to produce the painting for the altar on the west wall (Figure 54). On the east wall, opposite the altarpiece, was the raised loggia of the *Gonfaloniere* and Priors, on top of which was to stand a marble statue of Christ as Saviour, in keeping with Savonarola's proclamation of Christ as 'King of Florence' and as a reference to the expulsion of the Medici on St Saviour's Day (9 November). The statue was commissioned from Andrea Sansovino in 1502. The contracts with Leonardo for the *Battle of Anghiari* in the autumn of 1503 and with Michelangelo for the *Battle of Cascina* about a year later set in motion the final elements in the decorative scheme.

The four main figurative elements were conceived as acting in concert, mutually reinforcing each other in proclaiming the religious and historical status of the Florentine Republic. The anti-Medicean Saviour above the *Gonfaloniere's* throne would have been complemented in the

Fig.54 *Reconstruction of the Locations of the Main Elements in the Pictorial and Sculptural Decoration of the Sala del Consiglio,* based on Wilde and Pedretti

F altarpiece assigned to Filippino Lippi
G loggia of the *Gonfaloniere* and Priors, with the statue of the Saviour commissioned from Andrea Sansovino
M hypothetical location of Michelangelo's *Battle of Cascina*
L hypothetical location of Leonardo's *Battle of Anghiari*

altarpiece by the presence of St Anne, whose association with the overthrow of tyranny has already been noted. The altarpiece was also to contain the patron saints of Florence, St John, St Bernard, St Zenobius and St Reparata, together with those saints upon whose days important battles had been won. Thus St Vittore would have been assigned a conspicuous place, because his day (28 July) was that on which the victory at Cascina was celebrated each year, following the actual triumph in 1364 (actually on 29 July), and we would also expect to find Saints Peter and Paul, whose feast days (29-30 June) coincided with the victory at Anghiari in 1440. In the historical outline of the events at Anghiari which the Signoria provided for Leonardo, it was stated that 'St Peter appeared from a cloud' to provide timely encouragement for the Florentine and Papal forces before their fight with the Milanese army. For the citizens of Florence, the battles of Anghiari and Cascina were more than historical events. The Florentines regarded historic landmarks in their Republican history as living deeds rather than dusty memorials of the remote past, and

the particular events at Anghiari and Cascina were vividly relevant to their present-day struggles for mastery of Tuscany and indeed for their very survival. As a splendid victory against Pisa, the battle of Cascina set a precedent which contemporary Florence hoped to emulate, canal or no canal, while the enemy at Anghiari, the dreaded Milanese, had posed a serious threat to the city's existence on more than one occasion and had entertained their own designs on Pisa during the 1490s.

The precise disposition of the two battle paintings and other figurative elements in the Hall is harder to ascertain than their thematic coherence. Recent studies suggest that the west and east walls both possessed flat spaces of more than adequately huge dimensions to contain both battle scenes. It is probably more appropriate to see them flanking the *Gonfaloniere's* throne than the altarpiece, though the latter is far from impossible in view of the thematic links. One thing we can say with reasonable certainty is that Michelangelo's painting would have been situated on the left section of the chosen wall, because the direction of light in his cartoon presupposed a light source in the windows of an end wall to its left, while Leonardo's battle was shown as illuminated from an end wall immediately to its right.

In the event, the carefully planned coherence of the works commissioned from Filippino, Sansovino, Leonardo and Michelangelo was never to be realized in visual terms. None of the works was to be completed, and of the unfinished pieces only one has survived, the underpainting for the St Anne altarpiece which Fra Bartolomeo began in 1510, following Filippino's death six years earlier. The greatest tragedy is not just the loss of Leonardo's cartoon, which in itself would be matched by the destruction of Michelangelo's, but the disappearance of that part of Leonardo's painting which he had actually begun on the wall. A series of ultrasonic investigations of the underlying layers of the two long walls was commenced in 1976 to discover if Leonardo's painting might have miraculously survived under the coat of plaster which Vasari added in the 1560s for his own fresco paintings of Florentine history. The ultrasonic readings for the favoured east wall revealed nothing, but the echoes received from the west wall suggested that some earlier work might have survived under Vasari's plaster. However, exploratory removal of small sections of Vasari's frescoes has as yet failed to reveal anything positive, and it appears increasingly likely that Leonardo's actual painting is irrevocably lost. Fortunately, though, the surviving documentation allows us to follow the history of his work on the *Battle* in some detail, and the visual evidence of drawings and copies permits a reasonably accurate reconstruction of its incomplete appearance.

No record is known of the original agreement between the artist and the Signoria. Our first notice of Leonardo's involvement is on 24 October 1503, when he was given the keys to the rooms in S. Maria Novella, including the Sala del Papa, a hall large enough to accommodate the full-

scale cartoon. During December of that year and the first months of 1504, money was granted to him for paper and other materials, certain sums were authorized for the construction of scaffolding for his work on the cartoon, and he received payment for 'part of his work' (28 February). On 4 May a revised contract was agreed with the Signoria, for whom Machiavelli was one of the two signatories. That such a revised agreement should have been necessary suggests that Leonardo had characteristically fallen behind schedule. The new contract, with strict penalty clauses, stated that the artist should completely finish the cartoon by the end of February 1505 or alternatively should begin painting on the wall that part of the composition for which he had completed the cartoon, in which case the date of completion for the whole cartoon would be correspondingly extended. This latter expedient was apparently the one Leonardo chose to adopt.

At the end of June 1504 he received '88 pounds of sieved white flour' to make a paste for 'sticking' his paper cartoon to a backing material. During the summer work seems to have begun on scaffolding in the *Sala del Consiglio* itself, and at the end of August he received substantial quantities of the ingredients for whitewash. Since he had not yet applied the final layer of plaster, the whitewash may have been to mask earlier motifs on the wall so that he could rough out some of the major forms *in situ* to judge their likely effect. After the Piombino interlude during November, work was resumed. The Signoria authorized payments for window coverings of waxed cloth during the winter on behalf of both Leonardo and Michelangelo. Leonardo had sat on the committee to decide the best location for Michelangelo's *David* earlier in the year; since October or thereabouts he faced the younger artist as a companion and direct rival in the Council Hall.

The February deadline came and went, while Leonardo pressed on with arrangements to begin painting. At the end of April, payment was authorized for materials to plaster and prime the wall. In addition to a pair of trestle tables, colours and vessels for preparing pigments, the following supplies were approved: '260 pounds of wall plaster; 89 pounds eight ounces of Greek pitch for the painting; 343 pounds of Volterra plaster [sulphate of lime with size]; 11 pounds 4 ounces of linseed oil; 20 pounds of Alexandrian white; 2 pounds 10½ ounces of Venetian sponges.' This list tells us a good deal about his proposed technique.

His procedure in the *Last Supper* appears to have resembled that described by Cennino Cennini for painting in *tempera a secco*, that is to say using an egg-based medium on top of dry plaster which had been suitably primed with a kind of mastic or size. It is likely that Leonardo also used some oil in mixing his colours for the *Last Supper*, in place of or in addition to the fig latex recommended by Cennini. His adoption of such methods in preference to the traditional *fresco* technique was no doubt encouraged by his direct contacts with northern masters of the oil medium: 'Get from Jean de Paris [Jean Perréal who accompanied Charles VIII and Louis XII

to Italy] the method of colouring *a secco*' (C.A.247ra). For the *Battle* he seems to have adopted an even more unconventional method, close to a technique later described but not recommended by Vasari. The materials suggest that a layer of granular plaster would have been laid down, and primed to a hard, flat finish with a layer of resinous pitch applied with sponges. This preparation would provide a suitable ground for oil-based colours. Early sources indicate that he lit a fire beneath his painting to dry the pigments on the wall, a procedure that was probably necessitated by his use of faulty linseed oil. Antonio Billi, writing about 1518, recorded that Leonardo had been cheated by his supplier of oil — perhaps he had been supplied with oil which had not been fully concentrated by heating until it reached the proper consistency.

During the spring and summer of 1505 his preparation of the first section of the wall was completed and he was able to begin applying his colours: 'On 6 June 1505 at the stroke of the thirteenth hour, I began painting in the palace; and at the moment of laying the brush down the weather deteriorated . . . The cartoon became unstuck; the water was spilled and the vessel which carried it was broken; and suddenly the weather became worse and great quantities of rain poured down until evening and it seemed like night' (Madrid II, 1r). This memorandum should not be taken to mean that this was the date on which he first began painting in the Hall; rather it is a record of a meteorological phenomenon which occurred shortly after he had begun to paint on that particular day. Nonetheless, it does provide our first notice of his actually working in colours on his wall painting.

Payments for work by Leonardo and assistants, among whom were Rafaello d'Antonio di Biagio and Ferrando de Llanos (a Spaniard), were made during the spring and summer, and in October some canvas backing was provided for his scaffolding, together with more oil and plaster, but this is the last we hear of his activities in the *Sala del Consiglio*. His departure for Milan in May 1506, on what was supposed to be three months' leave of absence, effectively marked the end of his contribution. Piero Soderini, the *Gonfaloniere*, was to write rather testily later in the year that the artist 'has taken a goodly sum of money and provided a small beginning of the great work which he should have made'. Soderini, justifiably aggrieved at Leonardo's failure to return, minimized the extent to which the painter had actually worked on the wall. A quantity of wood (approximately 25 metres of wooden boards, 20 centimetres wide) was ordered in April 1513 to provide a protective barrier around or across the painted area. This suggests that the painted surface was of considerable dimensions and was not at that time considered an irredeemable wreck. The unfinished masterpiece remained as one of the sights of the Palazzo della Signoria (Palazzo Vecchio) until its final disappearance in Vasari's remodelling operations during the 1560s.

The unfinished painting and cartoon made an enormous impact on the

young artists of the day, including Raphael, and fortunately a few of the resulting copies have survived. These copies, together with a small group of preliminary drawings, provide the raw material for our reconstruction of Leonardo's painting. There are two painted copies of reasonable quality. Of these, the version in the G. Hoffman Collection, Munich, is marginally more convincing than the familiar example in the Uffizi. A detailed if unaccomplished early drawing is in the Palazzo Rucellai. And a rather pedestrian engraving was made by Lorenzo Zacchia in 1558, not long before the painting's disappearance. The only copyist who proved himself fully equal to the task was Rubens. Although his drawing (Plate 65) was based upon Zacchia's laboured version and is inaccurate in a number of details, Rubens has intuitively penetrated to the very heart of Leonardo's invention — some fifty years or so after the original had disappeared.

The painted copies and the Rucellai drawing substantially agree as to the extent of the painting which was visible on the wall. Of the four horsemen, the right hand figure was only sketchily outlined, apart from his face, while the others had been brought up to a relatively high degree of

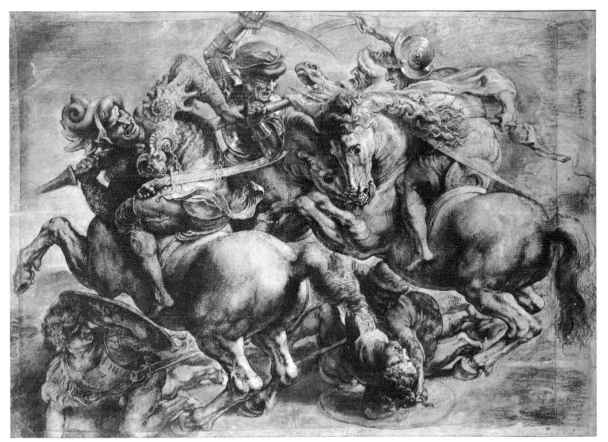

Pl.65 Peter Paul Rubens, *Copy of Leonardo's Battle of Anghiari* (based on the engraving by Lorenzo Zacchia), Paris, Louvre

finish, as had their horses. At the lower edge of the composition, there appears to have been a fairly sharp cut-off at the horizontal level of the foremost horse's hocks, perhaps caused by the protective framing erected in 1513.

Four drawings by Leonardo can be related specifically to the painted group, two for the composition and two for the warrior's heads. What is probably the earlier of the two compositional studies is illustrated here (Plate 66), together with the drawing for the central head (Plate 67). These drawings splendidly exemplify his creative method: he recommended the painter to improvise around 'the invention made originally in your imagination'; 'compose roughly the parts of the figures, attending first to the movements appropriate to the mental motions of the protagonists involved in the narrative' (Urb.62r); 'proceed to take away and add until you are satisfied'; 'then let clothed or nude models be posed as you have arranged in your work' (Urb.38v). The definition of individual parts must, therefore, be preceded by the fluent search for narrative force in the composition as a whole. The dynamism of his compositional drawings found its perfect vehicle in the battle studies. Never before had the motions of an artist's hand and his expressive intention been so perfectly married. As the forms emerged from the maelstrom of swirling lines, some by design and some by spontaneous accident, so he progressively condensed his image, locking the percussive forces together in an ever more concentrated implosion. The two horses on the left of the drawing were transformed into one, and the right hand horseman was drawn more closely into the engagement. This tightening of the compositional knot eliminated the fallen horse and his threatened rider, leaving room only for the strikingly foreshortened pair of fighting soldiers below the horses' bodies.

Once the rhythms had been inextricably bound together — and only then — were the details added. The details of the armour, which work fantastic variations upon organic and metallic themes; the anatomy of the horses, exhibiting the supreme mastery of equine form which Leonardo had acquired during his work on the Sforza monument; and above all the characterization of the faces. Vasari testified to the stupendous effect of all these details. The drawing for the old warrior's head marvellously shows how the component parts augmented the expressive vigour of the whole. Every feature of the head participates in the violent cry of rage, as his face is transformed into a physiognomic map of primitive ferocity. This conforms perfectly to his earlier advice on how to characterize fighting soldiers: 'The sides of the nose should have certain furrows, going in an arch from the nose and terminating at the edge of the eyes; make the nostrils drawn up, causing these furrows, and the lips arched to disclose the upper teeth, with the teeth parted in order to shriek lamentations' (Ash.II, 30v). On one drawing from the Anghiari series (W.12326) he set a comparably shrieking head beside those of an enraged horse and roaring

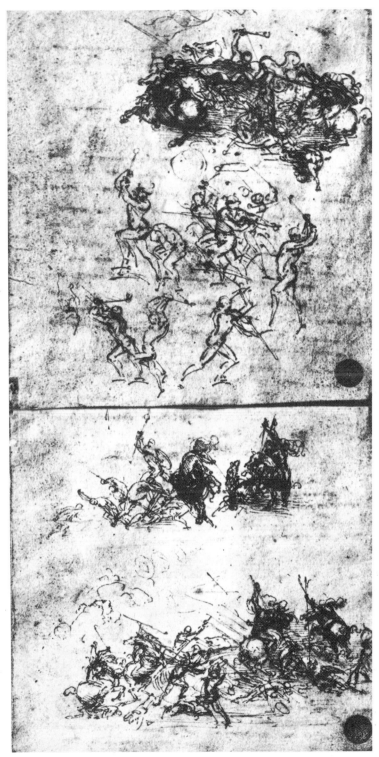

Pl.66 *Studies for the Battle of Anghiari showing the Fight for the Standard and Other Incidents* (1503), pen and ink, Venice, Accademia

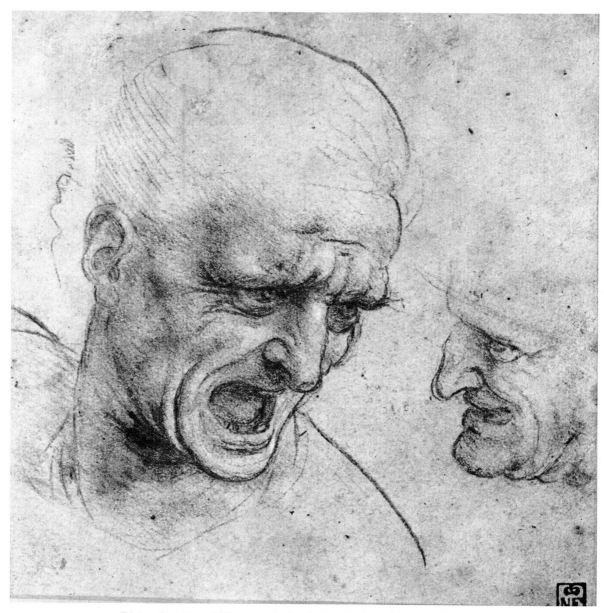

Pl.67 *Studies of Warriors' Heads for the Battle of Anghiari* (1503), red chalk, Budapest, Museum of Fine Arts

lion to emphasize the physiognomic universality of such elemental passion.

The cumulative effect of the compositional turbulence and dynamic detail must have presented an image of astonishing force, which combined a rich density of surface effects with great surges of rhythm in space. The horn-like volutes on the leftmost rider's helmet, the shell-like whorls and spiky encrustations on his shoulder-pieces, the horses' tangled manes, the

fluttering spirals of drapery and a host of similarly energetic details all appeared to embody in microcosm the violent vortex which animated the whole group. Threading through the centre of this writhing tangle, like a knitting needle through a skein of wool, was the shaft of a flag. The furious energy with which the warriors contest possession of the flag indicates clearly that it possessed a central importance and should in all probability be identified as the standard of Florence herself. The leftmost rider grasps its shaped handle in his right hand, clamping it behind him in a swastika grip. The assailants' force has bent the thick shaft into a curve across his back. A quick sketch by Raphael (Oxford, Ashmolean Museum), probably based upon the cartoon or preliminary drawings rather than the painting, shows that the fabric of the flag was to be shown fluttering turbulently from the top of the shaft which projected diagonally upwards to the right of the fighting group.

The emphasis accorded to the standard does not correspond to the historical account which was transcribed for Leonardo's benefit from Poggio Bracciolini's *History of Florence* (C.A.74rb-vc), but it is unlikely to have resulted from a personal whim. There is no case, in a commission of this kind, for thinking that the artist would have been granted the freedom to proceed with a design which had not been approved or did not conform closely to stipulated requirements in both content and form — any more than there is reason to believe that Michelangelo himself 'chose' to dwell upon the events leading up to the battle of Cascina because it suited his personal fondness for portraying nude figures. Michelangelo's painting was to show, as its central feature, the moment on the day before the battle (actually St Victor's day) when Manno Donati deliberately created a false alarm by shouting to the bathing soldiers that they were being attacked; Donati did this in order to alert the Florentines to what would happen if they lowered their guard in a moment of self-indulgence. The moral 'be prepared at all times' was perfectly clear and was selected for its relevance to Florence's contemporary situation. Machiavelli was particularly vociferous in encouraging Florence to raise its level of preparedness, above all by establishing a readily mobilized militia drawn from her own citizens rather than relying upon hired mercenaries whose loyalty was often suspect. The case of the Milanese commander at Anghiari vividly illustrated this point; Piccino had previously fought for the Florentine Republic, but switched his allegiance to Visconti Milan. Leonardo's concentration on the fight for the standard would have encouraged all citizens to 'rally round the flag', to defend the sovereignty of Florence against any assailants, to hold on tenaciously to the city's precious liberty. There was no more potent symbol of the Republic than the city's banner, the *gonfalone*. When the Duke of Athens temporarily gained tyrannical power in 1342 he immediately destroyed the Florentine standard to signify the change in constitutional circumstance.

A painting representing a subsequent defence of the *gonfalone* would

have been particularly apposite in the Council Hall, in which the most prominent architectural feature was the raised loggia of the Republic's chief officer, the *Gonfaloniere di Giustizia* (the 'Standardbearer of Justice'). A little less than a year before Leonardo received his commission, the office of *Gonfaloniere* had been reformed. Previously no man could hold office for more than two months during any three years, but on 1 November 1502 Piero Soderini had been appointed 'Gonfaloniere for Life', giving him a position as the figurehead of state approximately equivalent to that of a Venetian Doge. This reform was aimed at stabilizing the government at a time when nervous indecision was debilitating Florence's ability to act decisively. The *gonfalone* at the centre of Leonardo's struggle would have provided the symbolic focus for the action in the same manner as the *Gonfaloniere* was to provide the focal point for Florence's civic resolution.

The way in which Leonardo has abstracted his battle from its historical context in 1440 is also in keeping with the timeless relevance of its patriotic message. The warriors' costumes, more akin to the fantasy armour of contemporary pageants than the garb of fifteenth-century soldiers, provide strong visual links with the classical past. These classical associations are reinforced by the splendid motif of the colliding horses, which is derived from an antique *Fall of Phaeton* sarcophagus (Florence, Uffizi). In political debate the Florentine councillors were as fond of extrapolating from the classical past as they were of drawing precedents from their own history, and Leonardo's portrayal of the *Battle of Anghiari* as a contest *all'antica* would have corresponded effectively to the tenor of the discussions within the great Council Hall.

However, for all its temporal abstraction, it was a specific battle, and the participants were doing specific things. There has been a general acceptance that the two soldiers to the left are Milanese — their identification with Niccolo Piccino and his son has been suggested — while those who charge from the right are Florentine. This is certainly a feasible reading of the narrative, but for my part I am not sure that it is correct. A number of pieces of evidence point in the other direction.

The key figure in any interpretation of what is happening is the central warrior with upraised sword. The preliminary drawing (see Plate 66) reveals quite clearly that he was conceived as one of the victors, since his immediate adversary has already fallen. Even in the final version he occupies a position of potential ascendancy and is about to deliver a slashing blow to the hand of an opponent. His characterization fiercely combines the *fortezza* (strength) and *ira* (rage) which were regarded as essential attributes for those entrusted with the defence of Florence's civic virtues. His horse apparently shares his belligerent degree of resolution and causes a perceptible recoil in the impetus of the right hand charger. And his prominent red cap, mentioned by Vasari and vividly confirmed in the painted copies, may have been emphasized by the painter to echo the red

hat of the *Gonfaloniere,* seated nearby. His companion at the left of the group, dressed in a sheepskin carapace entirely appropriate for a 'soldier of St John', appears to have a decisively firm grasp on the standard's shaft and since he is holding its proper hand-grip he may by implication be its original custodian. Finally, we may note that the motif on the helmet of the less prominent warrior on the right as shown in the Rucellai drawing and painted copies (but not in the engraving or Rubens drawing) recalls the winged Milanese serpent which Calco described in the 1491 pageant.

I do not claim that these arguments are decisive, and the absence of supporting clues, such as the heraldic motifs on the standards and banners, prevents absolute certainty in reading the narrative. But it makes more sense to me to see Leonardo's painting as illustrating the repulse of an attack on the Florentine standard, showing the charging Milanese being savagely beaten back, and this would fit well with the actual events at Anghiari, where the Milanese were the aggressors in territorial and military terms.

What we have been discussing is, of course, only an unfinished portion of an incomplete scheme. Soderini may have exaggerated, but there was certainly a great deal of work left to do on the wall and probably also on the cartoon when Leonardo abandoned them. The spaces available for the paintings were potentially huge, measuring up to eighteen by seven metres according to the best estimates. Unusually long in relation to their heights, these fields would have resembled giant *cassone* panels, that is to say, the oblong paintings used to decorate marriage and other chests with narrative scenes. We know of one such *cassone* from the mid fifteenth century which actually depicts the *Battle of Anghiari* (Dublin, National Gallery). Its companion piece shows the *Fall of Pisa in 1406*, and together they constitute a pair which thematically foreshadows the Council Hall paintings. The narrative principle of *cassone* painting was episodic. One common type combined a central illustration of the major event in the story with flanking scenes of preceding and subsequent episodes. Leonardo's group of horsemen fighting for the standard would have been equivalent to the central scene, pressed close to the foreground and portrayed on a large scale — considerably more than life-size in the actual hall.

For the subsidiary events on either side he considered a variety of motifs, including the swashbuckling foot-soldiers shown below the sketch for the standard group, and horsemen spearing fallen foes (see Plate 66). In the middleground to the right of the main struggle, to judge from a drawing in Venice (Accademia 216), was to be shown the bridge around which so much of the fiercest fighting occurred. The river flowing under the bridge would have presented him with a splendid opportunity to portray another of the motifs described in his earlier recipe for a battle painting: 'Also include a river, into which the horses are galloping, churning up the surrounding water into turbulent waves of mixed spume and water which leap into the air between the legs and the bodies of the horses'

(Ash.II, 30v). The extreme right-hand side of his intended composition appears to be shown in one of the Windsor drawings (Plate 68), the sharp cut-off at the right corresponding to the edge of the picture. This composition of prancing horses was known to Raphael, and was probably to be incorporated into the final painting much in its present form. It appears to represent the assembly of Florentine and Papal troops under their massed banners before the battle. The account given to Leonardo stated that the Patriarch of Aquilea, leader of the joint forces, stationed himself at a high vantage point, from which he saw Piccino's army 'coming from Borgo San Sepolchro with great dust'. It is not difficult to envisage this group on higher ground to the right of the river, overlooking the valley in which the battle was to occur. The Patriarch himself may be identifiable as the foremost horseman, holding aloft what appears to be a crucifix. The corresponding space on the left of the composition could have been most suitably devoted to a triumphant manifestation of Florentine victory, adjacent to the *Gonfaloniere's* throne, but none of the various motifs which appear in the preliminary drawings can be certainly assigned to this area.

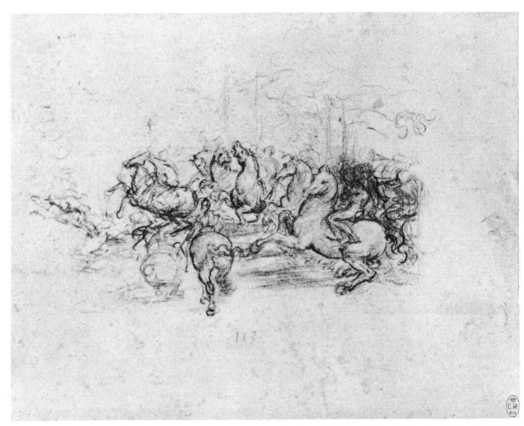

Pl.68 *Study for a Cavalcade* (for the right hand side of the *Battle of Anghiari?*) (*c.* 1504), black chalk, Windsor, Royal Library (12339)

I believe that it is dangerous to make too definite a reconstruction of Leonardo's intentions. Probably none of the subsidiary groups progressed as far as the cartoon stage, and in view of the extreme fluidity of his creative methods we may be reasonably sure that his ideas for them had not crystallized indissolubly. It might be a good idea to ask ourselves how well we would reconstruct the *Adoration of the Magi* given the few preparatory drawings and some copies of the central group of the Virgin, Child and three Kings. Not very well, I suspect. This is roughly the position in which we find ourselves when we attempt to visualize the complete *Battle of Anghiari.*

All told, allowing a few weeks for his service in Piombino, he could have devoted a total of about two-and-a-half-years to his work on the cartoon and painting before his departure for Milan in May 1506. By his own standards, he must have spent a considerable part of his time on the battle-piece, if we include his design of scaffolding with a novel kind of mobile platform and his technical experiments with the medium and priming. We would not expect, however, his devotion to have been single-minded — that would have been absolutely impossible for Leonardo. Fra Pietro da Novellara had testified that his appetite to paint when he first returned to Florence had been sapped by his 'mathematical experiments'. Obviously the Anghiari period was not marked by a comparable disinclination to paint, but nor did it signal the submergence of his scientific interests.

On the second and third folios of Madrid Manuscript II — adjoining the page on which he wrote his memorandum of the storm during his work in the Council Hall — he compiled the most extensive of all his book lists. This comprises some one hundred and sixteen named items — ninety-eight 'locked up in a chest' and eighteen 'in a box at the monastery' of S. Maria Nuova — together with fifty unnamed 'books' classified according to size, binding and material. Not all the named volumes can be definitely identified on the basis of his abbreviated references, but the general shape of his library is apparent. If we roughly classify his books into four broad categories, we find as expected a substantial section concerned with natural philosophy (more than forty books) and, less expectedly, an even larger group of literary works (if we include in this category a few dictionaries and grammars). There are only ten relating to art, architecture and engineering, and eight volumes of a religious nature. The small number concerned with his professional activities is deceptive; there simply were not many books available in this field, unless we count his own notebooks, such as 'a book of horses sketched for the cartoon' which appears as the hundredth item on the list. Many of the listed books also appeared in his Milanese inventories, but there are new items of considerable significance, reflecting the extent to which his intellectual interests were continuing to develop. Particularly notable are three mathematical works which can be shown to have exercised a direct influence on his

thought at this time: 'Euclid translated, that is to say the first three books'; Giorgio Valla's *De expetendis et fugiendibus rebus*, published in Venice in 1501; and a book on 'the squaring of the circle', either one of the retitled versions of Archimedes' *De mensura circuli*, such as that published by Gauricus in 1503, or a medieval treatise on this theme.

His continuing self-education in Euclid's *Elements* is amply documented in his manuscripts from the early years of the century, particularly Manuscript K (e.g. 31r-48r); and the second Madrid Manuscript contains a translation from Euclid (by Pacioli?) which must be related to the otherwise unknown '*Euclid volgare*' in the book list (138v-140v). The dominant educative impluse continued to come from his friendship with Luca Pacioli, who was teaching at the Tuscan *Studio Pisano* between 1500 and 1505. The illustrations of the geometric solids in *De divina proportione* assumed a new significance at this time: at the end of August 1504 Pacioli was paid by the Florentine authorities for models of the geometric bodies, which the *Signoria* presumably regarded as being conducive to elevated thought among the citizens; and a new manuscript copy was prepared for presentation to *Gonfaloniere* Soderini. Leonardo's possible involvement and certain interest in these projects are reflected in the icosahedron sketched below one of his studies for the Piombino fortifications during November 1504 (C.A.343vb). He had also acquired for 119 soldi a copy of Pacioli's encyclopedic *Summa de arithmetica, geometria, proportione et proportionalità*, Venice, 1494 (C.A.104ra), which he used extensively for a series of attempts to come to terms with the arithmetical concepts of continuous and discontinuous proportion, multiples, fractions, etc. Once he reminded himself 'to learn the multiplication of the roots from maestro Luca' (C.A.120ra), with results which can be seen extensively in his notebooks during this period (e.g. C.A.69ra-va,L.20-23v and B.L.207v). He also intended to consult 'Giovanni del Soldo, mathematician' for 'the fractions of geometrical bodies' (B.L.190v).

His studies of Luca's *Summa* included transcribing two of its diagrams in Madrid Manuscript II: the number square (Figure 55), which he began to mark at the left with the proportional categories ('multiples — double, triple, quadruple — superparticular, sesqui'); and the family tree of arithmetical proportions (Figure 56), which he characteristically transformed from a laboured diagram in the printed text into a rhythmic semblance of a living plant. The same number square with a similarly incomplete analysis of the proportional categories appears in the Arundel Codex, appropriately accompanied by his echoing refrain, 'tell me if ever a thing was done . . . ' (B.L.153r). These arithmetical endeavours gave him a grasp of some relatively complex procedures and enabled him to make elaborate calculations of such matters as the time-and-motion of excavation. Nevertheless, it remains true to say that he was never fully at home with arithmetical calculation, as his frequent errors and incompletions testify. His natural abilities were far better suited to geometry.

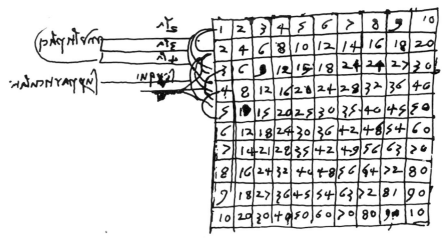

Fig.55 *Number Square transcribed from Luca Pacioli's Summa de Arithmetica...*, based on Madrid II, 48v

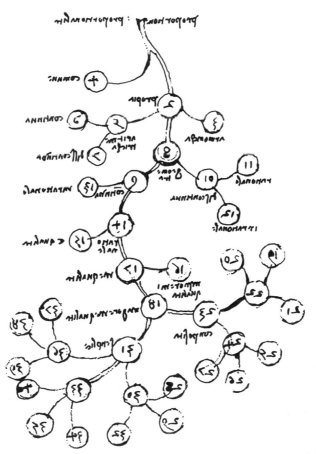

Fig.56 *Tree of Arithmetical Proportions transcribed from Luca Pacioli's Summa de Arithmetica...*, based on Madrid II, 78r

The principles which motivated these mathematical researches were clearly stated in Madrid II, where he twice argued that arithmetic and geometry 'embrace all the things in the universe' and are of such centrality that without them 'nothing can be done' (62br and 67r). Mathematical rules hold absolute sway everywhere: 'Proportion is not only to be found in number and measure, but also in sounds, weights, times and places and every potency which exists' (K.49r). As a practical instance of the way in which man could exploit these harmonies, he cited the example of an organ driven by water (Madrid II, 55r), similar to those described by Vitruvius and seen by Leonardo at Rimini (L.78r). Even fragrance is governed by harmonic laws 'similar to music' (Madrid II, 67r). The definition of point, line and surface which he adopted at this time, probably from Bacon's *Opus majus*, works particularly well with his vision of harmonic time and motion in living nature: 'A line is made by the movement of a point; a surface is made by the movement of a line which travels in straight lines; the point in time is to be compared to an instant, and the line represents time with a length' (B.L.190v).

Among the types of mathematical proportion which he studied so assiduously between 1500 and 1506, the geometric variety exercised the most enduring fascination for him. Whatever his delight in the magic of number ('discontinuous quantity'), he responded far more intuitively to the arithmetically inexpressible relationships between geometric forms ('continuous quantity'). It was in this respect that Valla's *De expetendis* (1501) was so important for him. Valla's compendium, drawn from a wide range of sources, including Euclid, Theon of Alexandria (?), Eutocus, Simplicius and Philoponus, inspired his first sustained investigations into three of the closely related geometrical topics which were to occupy so much of his subsequent time, namely mean proportionals, *lunulae* and transformation. The clearest instance of his debt to *De expetendis* was his translation of a section on mean proportionals which Valla had drawn with occasional errors from the ancient commentator, Philoponus (B.L.178v–9v). The technique of mean proportionals involved the finding of the length of lines x and y in relation to two given lines a and b such that $a:x = x:y = y:b$. It possessed an obvious appeal for someone as proportionally minded as Leonardo. He was also fascinated by Valla's exposition of the so-called 'lunula of Hippocrates', a construction which enables the geometer to create surprising equalities of area between curvilinear segments and rectilinear forms. Starting with a few basic patterns (Figure 57), he began to work his own endless variations upon these apparently miraculous conjunctions of area — as we will have further cause to notice (see Plate 83). The third of the major topics inspired by his reading of Valla was transformation, 'that is to say of one body into another without subtraction or addition of material' (Forster I, 3r), a procedure which made extensive use of the two preceding techniques. In studying transformation, he probably supplemented Valla with Cusanus'

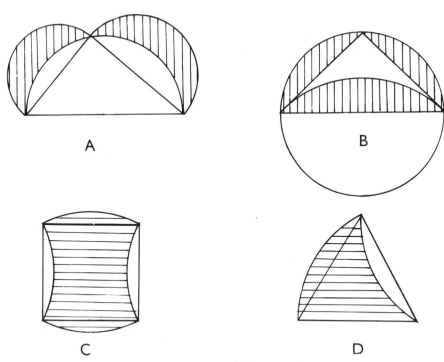

Fig.57 *Studies of Lunulae and Related Constructions*

A based on C.A.142vb (shaded areas together equal the area of the triangle)
B based on C.A.96va (the two smaller segments together equal the area of the larger segment)
C based on C.A.233ra (shaded area equal to the area of the square)
D based on C.A.134va (shaded area equal to the area of the triangle)

De transformationibus geometricis (Corte Maggiore, 1502), and by 12 July 1505 he felt confident enough to begin his own 'book entitled On Transformation', the contents of which are outlined in the first Forster Manuscript.

In the 'first book' of his treatise he planned to demonstrate the transformation of the four other regular bodies into a cube (7v), and there are clear signs that he attempted to assemble his material in what for him was an unusually systematic order. As an example of his approach to transformation we may look at the way in which he tackled the cubing of a dodecahedron (Figure 58). He divided the dodecahedron into twelve pyramids on pentagonal bases, each of which was further sectioned into five triangular pyramids. The resulting pyramids could be cubed quite simply and multiplied by sixty to give the total cube of the dodecahedron. He also provided demonstrations of the cube transformed without change in volume into rectangles of various dimensions, using the technique of mean proportionals to answer the kind of problem posed in Madrid II: 'A square

of equal angles and sides is raised to the height of a given point above it: what is the width into which it will be transformed?' (57r). And he took special pleasure in the rules governing the stereometry of pyramids: 'All pyramids of equal height and arising from the same base are equal to each other,' which he neatly illustrated with a drawing of an upright and inclined pyramid (Figure 59a); and 'Among pyramids arising from the equal bases there will be the same proportion in volume as in their heights' (Figure 59b).

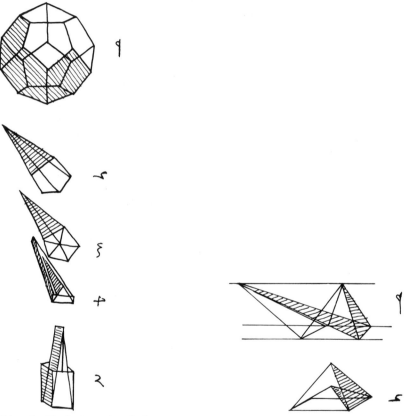

Fig.58 *Technique for Cubing a Dodecahedron*, based on Forster I, 7r

Fig.59 *Study of Pyramids arising from the Same Base*, based on Forster I, 28r

All his work in solid geometry was characterized by his ability to visualize geometrical forms in concrete terms, his intuitive grasp of shape and volume as visible and tangible realities to be manipulated like pieces of geometrical sculpture in an infinitely malleable medium. He characteristically sensed the physical implications of transformation: 'Geometry extends to the transmutation of metallic bodies which are materially suitable to be extended and shortened according to the needs of their manipulators' (Forster I, 40v). His instinctive feeling for the visibly con-

crete nature of solid geometry, his delight in the geometric slicing and moulding of the regular bodies into new configurations, accounts for the relative strengths and endurance of his geometrical investigations compared to his fragmentary studies in other branches of mathematics. However abstract the geometrical problem, his sense of its relationship to actual or potential forms in the physical universe was never far away. This accounts for his almost irresistible desire to shade geometric diagrams as if they portrayed existing objects (Figures 58, 59 and 62).

Leonardo's attempts to square the circle are a perfect illustration of this point. He first expressed interest in this ancient problem — how to construct a square precisely equivalent in area to a given circle — as early as 1492 (Ash.I, 9v), probably having read Albert of Saxony or another medieval author, but his most sustained efforts to arrive at a solution date from after 1503. His most favoured method exhibits particularly strong associations with observable phenomena in the physical world. He 'cut' a circle into a series of radial 'slices' or sectors, separating each from its neighbour and unrolling the circumference like a piece of orange peel (Figure 60). He aptly devised a scheme for measuring the circumference with a roll of bark, and later related this procedure to Vitruvius' method of measuring distances with a rolling wheel (G.96r). The resulting row of unrolled triangles (with the curved segments at their bases conveniently ignored) could be easily squared, thus arriving at the formula that the square of a circle equals its circumference multiplied by one-quarter of its diameter. This formula is essentially the same as that given in the first proposition of Archimedes' *On the Measurement of the Circle*, as later paraphrased by Leonardo: 'The circle is equal to the right triangle formed by the circumference and half the diameter' (C.A.85ra).

Fig.60 *Technique for Squaring a Circle,* based on K.80r

Another method he tried at this time was geometrically more sophisticated, relying upon equivalences of area similar to those which he studied in the *lunulae.* The basis of this method was to 'slice' circles in such a way that they were reduced to rectilinear figures. The removed 'slices' were subsequently juxtaposed and squared in a separate construction — in theory at least — and added to the square of the remainder. He really thought he had found the answer: 'On the night of St Andrew [30 November] I reached the end of squaring the circle; and at the end of the light of the candle, of the night and of the paper on which I was writing, it was

completed' (Madrid II, 12r). This optimism proved to be ill founded, and his search for a correct solution continued to occupy him long after he thought he had found the answer late that night.

In attempting to square the circle he was taking up the challenge of the revered Archimedes, whose influence figured with increasing prominence in Leonardo's writings during the sixteenth century. At one point he boldly declared that he had 'made the quadrature closer to the truth than Archimedes' (Madrid II, 105v), a claim which suggests that he as yet possessed an incomplete understanding of Archimedes' *On the Measurement of the Circle*. From about 1502 he made persistent efforts to rectify this situation by studying the available writings of his great predecessor. In Manuscript L he noted two Archimedes manuscripts, one owned by the Bishop of Padua and the other 'from Borgo San Sepolchro' (2r). He also referred to a 'complete Archimedes . . . formerly in the library of the Duke of Urbino . . . taken away at the time of Duke Valentino [Cesare Borgia in 1502]' (C.A.349v). This was probably the manuscript now in the Vatican (Urb.lat.261). Archimedes is mentioned regularly by Leonardo during this period (L.94v, K.79v and 80r, B.L.16 and 77v and C.A.20vb, 85ra, 153ve and 349v). Particularly interesting is a damaged page from a medieval version of Archimedes' *On the Square and the Cylinder* (C.A.146rb), the other side of which he used for his own geometrical notes and diagrams. The influence of this treatise on Leonardo's solid geometry is very clear, and one excursus in the Arundel Codex concerning the proportional areas of a sphere, cylinder and cube (B.L.77r) is based closely upon Archimedes (I.33).

The Arundel Manuscript also bears witness to his study of Archimedes' *On the Equilibrium of Planes:* his analysis of the centre of gravity of a triangle was based upon Archimedes I, 14 (B.L.16v); and he corrected his erroneous version of the centre of gravity of a trapesium (B.L.3r and 17v) on the basis of Archimedes I, 15. From this starting point, he extended Archimedean principles to solid bodies, devising a neatly geometrical and apparently innovatory method for determining the centre of gravity of a tetrahedron (Figure 61). This centre of gravity, the 'natural', was one of three different centres which he distinguished for each body: the 'natural' centre was defined as that point in a body (or outside it in the case of certain irregular objects) through which any sectioning plane would produce two parts equal in weight; the centre of 'magnitude' was the geometrical centre of the body; while the centre of 'accidental gravity', an odd concept, appears to have been that point around which an object settled in asymmetrical balance. An alternative method for comparing the 'natural' centre of gravity and the centre of 'magnitude' for a tetrahedron is illustrated in Madrid II (Figure 62). This technique for sectioning the tetrahedron into secondary pyramids is less geometrically satisfactory, but it nicely illustrates the 'concrete' quality of his geometrical vision. Given this quality, it is easy to see why geometry and natural science were

inseparable entities in his mind.

Some two months before he composed the opening sections of his geometrical treatise 'On Transformation' he had written what may be regarded as its counterpart in natural science, the Turin Codex 'On the Flight of Birds', which is dated 15 April 1505 (18v). The miracle of bird flight held an enduring fascination for him, and the more he studied it the greater was his reverence for the intricate subtleties of the natural mechanism which made it possible. In the 1505 codex the bird is beautifully characterized as a marvellous instrument, whose every nuance of design is tuned with incredible precision to the mathematical ratios of dynamic law. Its aerodynamics are perfectly adjusted to exploit with utmost economy the impetus which it acquires by flapping its wings or from gravity in free fall. The 'hand of the wing is that which gives impetus', while the 'elbow' acts obliquely to create a 'wedge of air' which provides the necessary lift (15v). With effortless fluency the bird adjusts the angles of its wings and tail in response to air currents, rising, falling and turning, often in circular or spiral motions in concert with the vortices of the air itself.

Fig.61 *Study of the Centre of Gravity of a Tetrahedron*, based on F.51r

Fig.62 *Alternative Technique for Determining the Centre of Gravity of a Tetrahedron*, based on Madrid II, 66r

Nowhere is the marvellous tuning of this instrument seen more brilliantly than in the bird's deliberate manipulation of its centre of 'natural gravity' to achieve ascent or descent. Unlike a geometrical body, the bird can voluntarily shift its centre of gravity so that this centre would be in front of or behind the 'centre of resistance' which its wings make with the air (8v). If the centre of gravity is shifted forwards, the bird will tilt downwards in a diagonal descent, while a rearwards shift would cause the 'nose-up' position of ascent. To prevent the bird from turning right over, the tail acts as a reciprocating lever against the air currents, creating a turning moment around the bird's 'centre of revolution', in accordance

with the basic laws of levers as expounded in the '1st of the Elements of Machines' (9v). The relative degrees of diagonal descent and ascent in relation to the speed of the air currents and the conditions necessary for horizontal flight were analysed by Leonardo in diagrams which demonstrated the resolution of forces in an entirely geometrical manner (15v), in precisely the same way as he analysed wind direction and sail angle in boats (Madrid II, 121r–124v). A bird in flight — an 'instrument working according to natural law' (C.A.161r) — was a living manifestation of Archimedes' *On the Equilibrium of Planes* in the context of medieval impetus dynamics.

Clearly, the science of bird flight possessed a satisfaction in its own right and it is easy to imagine many hours of Leonardo's time spent in solitary contemplation of large birds wheeling on air currents around the Tuscan hills: one memorandum concerns a 'bird of prey which I saw as I was going to Fiesole, above the place of the Barbiga in 1505, on the fourteenth day of March' (Turin 18v). But his studies were also made in the service of his continuing quest for human flight. He was even more committed than before to the belief that man would be able to fly only if he imitated the perfect forms of nature — the Turin Codex contains none of the mechanical systems of air screws which he considered briefly in Manuscript B — and he argued that the construction of the machine's wings 'ought not to resemble anything but the bat because the membranes form . . . a web with the armature . . . and if you imitate the wings of feathered birds, the wings must be more powerful in bone and tendon through being pervious. . . while the bat is aided by the membrane which is not pervious' (16r). In answer to the well-founded objection that man cannot possibly supply a power-to-weight ratio equivalent to that of a bird's or bat's breast muscles, he argued that flying animals possessed more power than was necessary simply to sustain themselves in the air. He now clearly accepted that man could not achieve the full dynamism and force of natural flight but should concentrate upon gliding motions supported by air currents, with extensive use of a tail as a rudder and with minimal flapping of the wings. Thus it was that he sought to launch his contraption like a giant bird of prey 'from the mountain which bears the name of the great bird' (i.e. Monte Ceceri, 'Mount Swan', near Fiesole): 'The great bird will take its first flight on the back of the great swan, filling the universe with stupor, filling all writings with its renown and bringing glory to the nest in which it was born' (Turin back cover). Unfortunately, his triumphant manifestation of man's power to exploit natural law was never to be realized.

The compilation of the codices 'On Transformation' and 'On the Flight of Birds' during the spring and summer of 1505, at the very time when Leonardo's work on the *Battle of Anghiari* was reaching its definitive point, is indicative of the direction in which his career was to move. Equally symptomatic, in its own way, was the fate of the sheet of paper on which the Florentine official had written out the historical account of the

battle; it was used by Leonardo for sketches of his flying machine. After his summons to Milan in May 1506, he was apparently to pursue no more work in the Council Hall itself, although some of the drawings for subsidiary motifs in the battle may date from after this time. He returned to Florence for a few months in the spring of 1507 and also for a period of about ten months from August 1507 onwards. By this time he was already heavily committed to serving the French King, and whatever energies he may have directed towards painting during 1507 and 1508 appear to have been largely devoted to this end. During the second of these periods of residence in Florence he was lodging with the sculptor Gian Francesco Rustici in a house owned by Piero di Braccio Martelli (B.L.1r). Leonardo's presence clearly exercised a profound influence upon the bronze group of *St John Preaching* which Rustici was making for the Florentine Baptistery at this time. However, his own most concentrated activity during his final residence in Florence was not artistic, but anatomical. So much of his intellectual development after 1507 was concerned with picking up the threads of his Milanese researches, and his anatomical investigations during the winter of 1507–8 represent the first major instance of his later compulsion to recast and intensify his earlier investigations.

The main focus of his anatomical work was the dissection of an old man in the Hospital of S. Maria Nuova (where Leonardo banked his money and stored some of his books). His record of the old man's anatomy constitutes the only complete dissection by Leonardo which we can adequately document. 'This old man, a few hours before his death, told me that he had lived one hundred years and that he was conscious of no bodily failure other than feebleness. And thus sitting on a bed in the hospital of S. Maria Nuova, without any movement or sign of distress, he passed from this life. And I made an anatomy to see the cause of a death so sweet.' With great brilliance Leonardo diagnosed circulatory failure to have been responsible: 'It proceeded from weakness through failure of blood and of the artery which feeds the heart and lower members, which I found to be very parched and shrunk and withered.' 'Apart from the thickening of their walls, these veins grow in length and twist themselves in the manner of a snake [Figure 63]. The liver loses the humour of the blood ... and becomes desiccated like congealed bran both in colour and substance, so that when it is subjected to even the slightest friction its substance falls away in tiny flakes like sawdust and leaves behind the veins and arteries.' Due to the closing of the small vessels, 'the old dread the cold more than the young, and those who are very old have skin the colour of wood or dried chestnut, because the skin is almost completely deprived of sustenance. And the network of vessels behaves in man as in oranges, in which the peel becomes tougher and the pulp diminishes the older they become' (W.19027v). His gifts of observation, deduction and argument by analogy are nowhere more finely exemplified.

This post-mortem examination of the centenarian's blood supply was

Fig.63 *Comparison between Blood Vessels in the Old and Young,* based on W.19027r

characteristically developed by Leonardo during the succeeding months into a synoptic study of the 'irrigation' systems of the human body, not only the circulation of the blood, but also the urino-genital, alimentary, nervous and respiratory systems. These systems, like the rivers of the earth and the canals of man's contrivance, ferried the vital supplies of life to all the regions of the body. They did so according to the hydrodynamic laws which he had formulated during the 1490s and confirmed in Florence during his work on the Arno canals. The most fundamental law was that the velocity of a constant volume of fluid transmitted through a channel was indirectly proportional to the channel's cross-sectional area (A.57r-v and Leic.6v and 24r). In the case of a branching system in which a constant volume was to be passed at uniform velocity, this would mean that the total cross-sectional area of all the branches at one level must be equal to that at any other level. Thus each of the two branches in a bifurcating system must possess half the cross-sectional area of its parent branch. This principle is perfectly realized in his drawing of the trachea and bronchii (Plate 69), in which the windpipe bifurcates with perfect regularity in response to dynamic necessity: 'The total amount of air which enters the trachea is equal to that in the number of stages generated from its branches, like . . . a plant in which each year the total estimated size of its branches when added together equal the sizes of the trunk of the plant' (W.19064v). The beautifully coralline structure in the drawing expresses the natural analogy in visual terms more cogently than the rather awkward text. Any constriction or widening of the tubes would disrupt the flow to produce noisy turbulence, and he incorrectly assumed that the human voice arose from a deliberate manipulation of the main tube's width: 'The rings of the trachea are disunited . . . for the voice . . . Differences of voice arise from the dilation and contraction of the rings' (19050v). This design of the trachea as a 'musical' instrument operating in the context of fluid flow was precisely paralleled by the design of the urinary system, which obeyed the principles outlined in Leonardo's books 'On Conduits' and 'On Water' (19054r).

Natural analogies retained their centrality in his vision of the human body, and he was quite willing to use botanical similes to illuminate important issues in embryology. Galen (second century AD) had argued

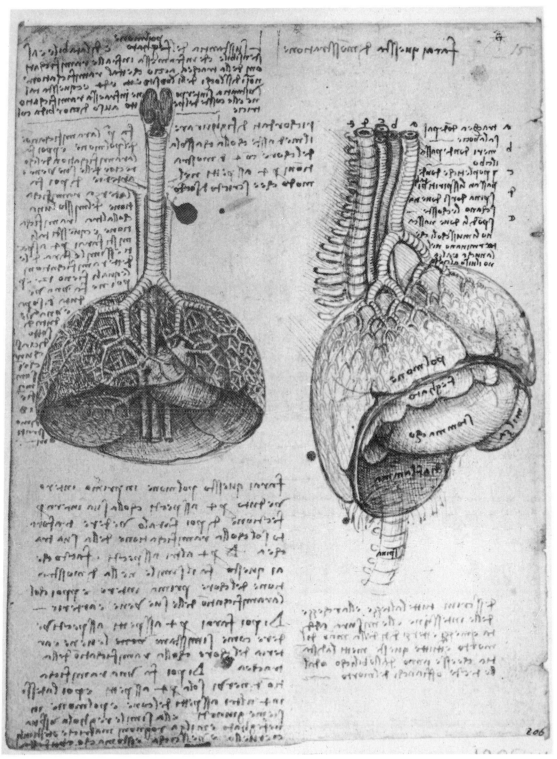

Pl.69 *The Trachea and Bronchii Studied in Isolation and a Study of Thoracic
and Abdominal Organs* (*c.* 1508), black chalk, pen and ink, Windsor, Royal
Library (19054v)

that the liver was the vital organ in the generation of the vascular system, but Leonardo was convinced otherwise:

> If you should say that the veins arise in the protuberances of the liver . . . just as the roots of the plants arise from the earth, the reply to this analogy is that plants do not have their origin in the roots but . . . the whole plant has its origin in its thickest part, and in consequence the veins have their origin in the heart where is the greatest thickness. . . and the example of this is to be seen in the growth of the peach which proceeds from its stone as is shown above (W.19028r).

The corresponding diagram displays a germinating seed beside a rough outline of the heart and major vessels (Figure 64), in such a way as to demonstrate that the 'tree of the veins has its roots in the dung of the liver'. He concluded that 'the heart is that which produces the tree of the vessels'.

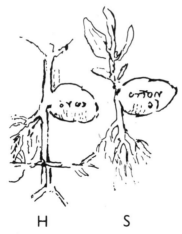

H S

Fig.64 *Comparison between the Heart as the Origin of the Vascular System and a Seed as the Origin of a Plant*, based on W.19028r

> **H** heart and the 'tree of the vessels'
> **S** seed and germinating plant

The technique he developed at this time for illustrating the 'tree of the vessels', the 'tree of the nerves' and the other ramifying systems of the human body was entirely novel and highly sophisticated. He aimed to build up a complete picture of each system, demonstrating its full complexity of spatial design within the 'transparent' outlines of the body: 'You will draw the outlines of the members with a single line and in the middle you will place the bones' in order that 'the shape of the limb which you describe shall not remain a monstrous thing from having its parts removed' (W.19027r and 19035r). His aim was a synthesis of form rather than dissection drawings as such: 'To you who say it is better to watch an anatomy made than to see these drawings would be right if it were possible

to see in a single figure all these things which are shown in such drawings' (W.19070v). This synthesis of form was not simply a question of composite drawings based upon many dissections but relied upon a conscious demonstration of the way in which such systems were designed in strict accordance with natural law. Ultimately, his goal was to display the synthesis of each system 'topographically' within the body from at least three different aspects: 'Here shall be represented the tree of the vessels generally, as Ptolemy did with the universe in his *Cosmography*. Make the view of the ramification of the vessels from behind, from the front and from the side, otherwise you will not give the knowledge of their ramifications in shape and position' (W.12592r). The kind of effect he hoped to achieve can be seen in his 'great lady' anatomy (Plate 70), in which the circulatory, respiratory and urino-genital systems are combined into a single image of astonishing intricacy. He has exploited a bewildering variety of illustrative techniques: some forms are shown in full relief, such as the trachea; other organs are rendered in 'magic' transparency (e.g. the inaccurately spherical womb); the heart is sectioned to illustrate (erroneously) its two cavities; while the outline of the body as a whole is used to imply the spatial setting of the parts within the human frame. Ultimately, this synthesis has proved to be over ambitious, and its legibility has broken down in the more densely packed areas — but it remains an awesomely heroic attempt. Its remarkable combination of monumental form and minute detail gives a new dimension to his perpetual analogy between the body of man and the body of the earth. The way in which the microcosm participates in macrocosmic magnificence is made visually manifest as never before.

The complementary studies of the 'body of the earth' which he undertook with special intensity between 1506 and 1509 reaffirmed the essential validity of the micro-macrocosm analogy. His increasing awareness of some superficial discrepancies in the mechanisms of man and the earth had as yet done nothing to unsettle his sense of their underlying affinity: 'This earth has a spirit of growth, and its flesh is the soil; its bones are the successive strata of the rocks which form the mountains; its cartilage is the tufa stone; its blood the springs of the waters. The lake of the blood that lies within the heart is its ocean. Its breathing is by the increase of the blood in its pulses and even so in the earth is the ebb and flow of the sea' (Leic.34r). This image pulses with life even more compellingly than his early restatement of this ancient theme. The essential basis for the life of the earth, no less than that of the body, was the circulation of fluids: 'The ramification of the veins of water in the earth are all joined together as are those of the blood in animals, and they are all in continual revolution for the vivification of it, always consuming the places in which they move, both within and without the earth' (Leic.28r). The veins of the earth were not merely superficial features, but penetrated deeply into its permeable body, interweaving from one side to the other in such a way that all its

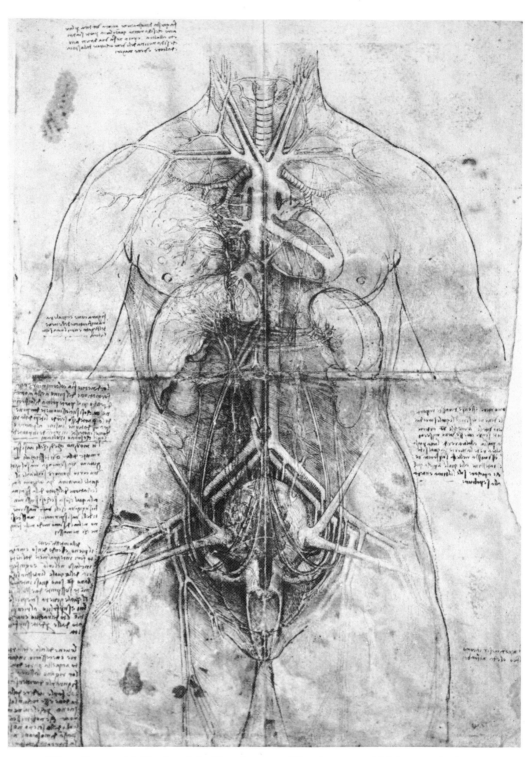

Pl.70 *Composite Study of the Respiratory, Circulatory and Urino-genital Systems in a Female Body* (c. 1508), black chalk, pen and ink and wash, Windsor, Royal Library (12281)

waters were part of a continuous system in constant ebb and flow.

The beauty of this analogy as developed by Leonardo lies at the very heart of the *Portrait of a Lady on a Balcony*, the so-called 'Mona Lisa' (Plate 71). There is a profound affinity between the artistic grandeur of her portrayal and the anatomical magnificence of the 'great lady'. The parallels are both formal and philosophical. In terms of design, (they share a similar use of contour,) which now consists of sonorous curves rather than the delicate vibrancy of line in his earlier portrayals of women. Their shared implication of 'anatomical' depth, of forms lying in front, beside, around and behind each other, is equally compelling. This is achieved jointly by his use of translucency — in the portrait by the veils and in the anatomy by the 'transparent' organs — and by his ability to describe opaque surfaces in such a way that they seem to imply their fulness of form both in front and behind. Underlying these formal affinities is his feeling for microcosmic vitality, for the way in which the two ladies are 'vivified' (to use Leonardo's term) by the ebb and flow of their inner spirits. The background of the portrait insistently underlines this affinity, illustrating the bodily mechanisms of the earth as clearly as the anatomical drawing demonstrates the passage of fluids in the body.

The landscape portrays the earth as a living, changing organism, incessantly subject to the cycles of evaporation, precipitation, erosion and accretion. It is closely comparable to a section in the Codex Urbinas entitled 'Painting which shows the configuration of the Alpine mountains and hills':

> The configuration of the mountains called the 'Chain of the World' is generated by the courses of the rivers born from the rain, snow, hail and ice melted by the rays of the summer sun, which in melting accumulate in many small rivulets flowing from diverse directions into larger rivers, growing in magnitude as they acquire motion, until they meet together in the oceanic seas, always cutting away from one bank and accumulating on the other until they achieve the size of their valleys.

Eroded at their base, mountains collapse and 'close the valleys as if they wished to be avenged, blocking the course of that river and converting it into a lake, where the water in slow motion seems pacified, until such time as the dam caused by that fallen mountain is newly consumed by the course of the said water' (Urb.236r). The damned-up lakes, the sharp cuttings caused by the rivers deriving from them and the wider valleys of the lower plains are all clearly visible in the painting. There is even a suggestion of future collapse in the distant mountain range to the right of the lady's head; the summits on the near side of the mistily radiant cleft are inclined noticeably towards the right and will ultimately become unstable.

This sense of geological flux was closely related to the studies he undertook in connection with the Arno canals. His magnificent studies of Tuscan topography not only revealed to him the present state of geological

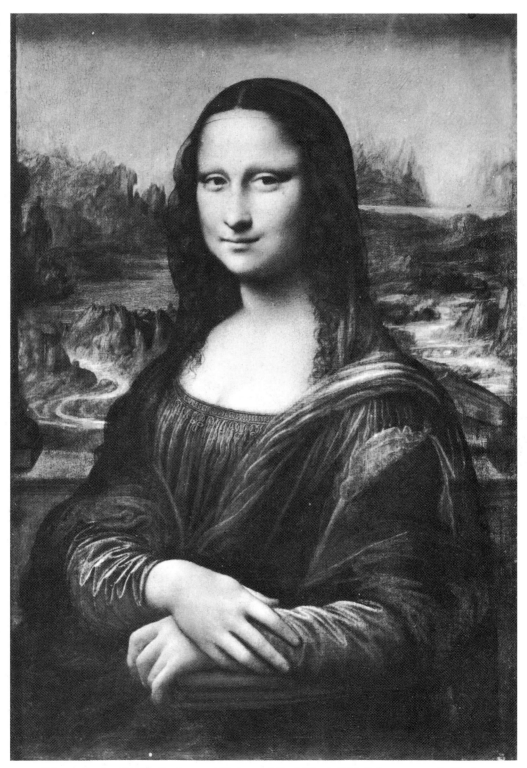

Pl.71 *Portrait of a Lady on a Balcony (the 'Mona Lisa')* (*c.* 1505-14), Paris, Louvre

affairs but also bore witness to the vast processes in the distant past which had been responsible for the configurations he observed. He came to the same conclusion as Giovanni Villani had done in his fourteenth-century *Chronicle*, namely that the Arno had once been dammed by a huge rock barrier which 'formed two huge lakes, the first of which is where we now see the city of Florence flourish together with Prato and Pistoia . . . In the upper part of the Val d'Arno as far as Arezzo, a second lake was formed and thus emptied its waters into the aforementioned lake' (Leic.9r). The two great lakes in the painting, one at a higher level than the other, resemble in type these primeval progenitors of the Arno valley. If any landscape can be said to embody a geological narrative, this one can. The abstract quality of time has never been more irresistibly implied in any painting of natural form.

The processes of living nature are not only mirrored by anatomical implication within the lady's body, but are more obviously echoed in the surface details of her figure and garments, which are animated by myriad motions of ripple and flow. The delicate cascades of her hair beautifully correspond to the movement of water, as Leonardo himself was delighted to observe: 'Note the motion of the surface of the water which conforms to that of the hair, which has two motions, of which one responds to the weight of the strands of hair and the other to the direction of the curls; thus the water makes turning eddies which in part respond to the impetus of the principle current, while the other responds to the incidental motion of deflection' (W.12579r). The little rivulets of drapery falling from her gathered neckline underscore this analogy, as do the spiral folds of the veil across her left breast. And the delicately streaked touches of paint in the highlights of both the drapery and the landscape underline this sense of identity between foreground and background.

The portrayal of a sitter in this particular spatial relationship to the background — set high above a receding landscape — was very unusual. But there was one important Italian precedent which Leonardo would have come to know in 1502, courtesy of Cesare Borgia. This was the Montefeltro diptych by Piero della Francesca, a double-panelled portrait of Federigo da Montefeltro and Battista Sforza, probably painted in 1472 or shortly thereafter. Piero displayed the Duke and Duchess of Urbino in profile in front of magnificent landscape panoramas. The relationship between the heads and the landscapes shows clearly that Federigo and his wife are situated high above the great sweeps of land, as lord and lady of all they survey. When Leonardo visited Urbino in July 1502, after Cesare had deviously ousted Federigo's son, he surely paid as close attention to Piero's innovatory portrait images as he did to Bramante's architectural works in the same palace. Leonardo has, however, made a crucial adjustment to Piero's formula. Piero did not explain the high position of his sitters — there is no indication of their architectural support — and this may have offended Leonardo's strict sense of visual propriety. For his

part, Leonardo has described the retaining wall of the high balcony and has given clear indications of the flanking columns in what was presumably a classical loggia. These two columns, as early copies confirm, were once more fully visible; the present panel has been insensitively trimmed on either side at some remote time in its history.

It is when we set Leonardo's painting beside even such masterpieces of preceding portraiture as Piero's Montefeltro diptych that its astonishing novelty becomes truly apparent. We are all so familiar with this most famous of painted images that its jolting degree of historical originality has become difficult to appreciate. There simply had not been another portrait like it — not even remotely. Only Antonello da Messina of the great fifteenth-century masters had openly exploited a communicative liaison between sitter and spectator, but even the brilliance of Antonello's characterizations never approached the complex nuances of psychological reaction captured in Leonardo's portrait. Even Leonardo's own *Cecilia Gallerani*, a brilliant 'reaction' portrait, does not prepare us for the communicative challenge which is presented here. I use the word 'challenge' deliberately. He loudly proclaimed the painter's ability to affect the spectator at the profoundest level of emotional response, and this portrait is his most knowing exploitation of his own unrivalled powers in this direction. She reacts to us, and we cannot but react to her. Leonardo is playing upon one of our most basic human instincts — our irresistible tendency to read the facial signs of character and expression in everyone we meet. We are all intuitive physiognomists at heart. No matter how many times our expectation of character on the basis of facial signs may be proved false, we cannot stop ourselves doing it. As soon as the observed face moves, a further series of interpretative responses are automatically invoked, constituting a crucial element in the complex language of non-verbal communication. The greatest narrative artists — Giotto, Masaccio, Donatello and Leonardo himself — had long exploited these qualities in narrative painting and sculpture. The real originality of the *Lady on a Balcony* is not to introduce this technique into portrait painting — his own *Cecilia Gallerani* had been anticipated by Antonello and by Verrocchio's portrait bust of Giuliano de' Medici in this respect — but to create in painting the equivalent of a mobile face, in which the physiognomic signs do not constitute a single, fixed, definitive image. It is this lack of immutably fixed signs which accounts for the diversely subjective reactions to the portrait on the part of different spectators, and even of the same spectator at different moments.

Leonardo has challenged us to interpret, to read the face, to discern the lady's true character and reaction, but at the same time he has drawn a veil of ambiguity across the crucial clues. There are none of those eloquently definitive facial lines with which he spelt out the emotions of the Anghiari warriors. All we are left with is a series of tonal transitions which denote changes of contour, a soft prominence here and a curved hollow

there. But not even these rounded contours are definite. The surfaces do not exist as tangible realities, but float within a haze of glazed pigments. Using a technique of almost indescribable delicacy and refinement, he has built up the head from a series of translucent membranes, microtome thin and infinitely subtle in tonal gradation. The admixture of dark pigment in the shadows is never so dense that it kills the underlying radiance — whatever reproductions and the present viewing conditions in the Louvre may suggest to the contrary — but achieves an effect akin to a thin deposit of lamp-black on a pane of glass. The very areas where we search most assiduously for definitive characterization, in and around the eyes and mouth, are those where the veiling glazes work their ambiguous magic with greatest subtlety.

The recognition that the eyes and mouth play the most potent roles in communicating human emotion had provided a vital weapon in the armoury of Italian poets from the time of Dante. Renaissance *canzoni* of love, the standard fare of vernacular poetry during the fourteenth and fifteenth centuries, had evoked the beautiful smiles of a thousand lips and the beloved gleams of no fewer eyes. Leonardo was well versed in this tradition — he once gently mocked Petrarch's swooning affection for Laura (Triv.iv) — and he unquestionably paid close attention to Dante's poetry. In his *Convivio* Dante conveniently provided a commentary on his own phrase 'In her eyes and in her sweet smile':

> The soul operates very largely in two places, because in these two places all the three natures of the soul have jurisdiction, that is to say in the eyes and mouth, which it adorns most fully and directs its whole attention there to beautify them as far as possible. And in these two places I state these pleasures by saying 'in her eyes and in her sweet smile'. These two places, by a beautiful simile, may be called the balconies of the lady who dwells in the architecture of the body, that is to say the soul, because she often shows herself there as if under a veil (III, 8).

These architectural similes were further extended by Dante's subsequent reference to the 'window of the eye', the classical metaphor which Leonardo also quoted. Dante's imagery would have possessed enormous appeal for Leonardo and the conjunction of the *Convivio* similes in the portrait seems too good to be coincidental. The manifestation of the soul in the eyes and mouth 'as if under a veil' is precisely what Leonardo is doing in this portrait. The literal exposition of the 'motions of the mind' which had characterized the *Last Supper* is here rendered in a much more subtle, ambiguous and reticent manner. In short, it is veiled. The lady's knowing reticence of expression also corresponds nicely to Dante's recommendation that a true lady's expression of good humour should be decorously modest and restrained, a recommendation which was repeated again and again in Renaissance writings on behaviour. The tone of Leonardo's portrait is, I believe, deeply imbued with Dantesque qualities and is fully

in keeping with the poetic tradition which Dante largely instigated. This was the first painted portrait to be composed in the equivalent of the *dolce stil nuovo*, some two centuries or more after the debut of the 'sweet new style' in poetry. She is Dante's Beatrice and Petrarch's Laura — at least in a generic sense.

But who was she in the specific sense? The short answer is that we do not know, and anyone who argues to the contrary is building bricks without straw. The earliest probable reference to the *Portrait* was written in 1517 by Antonio de' Beatis who visited Leonardo at Cloux in the entourage of the Cardinal of Aragon. He indicated that it was the portrait of 'a certain Florentine Lady, made from nature at the instigation of the late Magnificent Giuliano de' Medici'. Based upon Antonio's actual meeting with the aged artist, this account must be given considerable weight. I believe that it definitely rules out the possibility of identifying her as one of the great ladies of the Renaissance, such as Isabella d'Este or Costanza d'Avalos. The first time she was given a name was as late as 1550 in Vasari's *Lives*, where she was described as 'Mona Lisa' (short for 'Madonna Lisa'), the wife of Francesco di Bartolomeo di Zanobi del Giocondo, a rich silk merchant closely involved with the Republican government of Florence. It is likely that Vasari was confusedly drawing his information from an earlier account of a portrait by Leonardo depicting Francesco del Giocondo — but not his wife. However, Vasari's identification has stuck, and no amount of historical scepticism has lessened its popular hold. She remains, for the millions who have seen her in Paris, Washington (1963), Tokyo and Moscow (1974), 'La Joconde', 'La Gioconda' or the 'Mona Lisa'. I cannot disprove this identification — at least it is not positively daft — any more than it can be confirmed. Were the painting not so famous and universally beguiling, we would have no difficulty in accepting it as yet another portrait from the Renaissance of a sitter unknown to us.

If we do not know who she was, what can we say about when she was painted? For a long time it seemed as if she would settle comfortably into a stylistic niche during the period of the *Battle of Anghiari*. However, recent analyses have made this appear less certain. Arguments for a later date take as their starting-point Antonio de' Beatis's statement in 1517 that the portrait was made 'at the instigation' of Guiliano de' Medici, who had been Leonardo's patron in Rome between 1513 and 1516. This evidence is not to be lightly brushed aside, and it is supported by the painting's technique of veiled glazes, which is demonstrably a characteristic of Leonardo's late style. The virtuoso use of this technique to portray actual veils as adornments to female beauty is a notable feature of the Louvre *St Anne* and apparently figured prominently in a lost painting of a veiled Pomona which he is reputed to have made for Francis I of France. Against the factors which favour a late date, the most powerful argument is the manifest influence which the portrait exercised on Raphael in Florence about 1506 and certainly before 1508; her pose is directly reflected in

Raphael's *Maddalena Doni* (Florence, Pitti); the setting of columns and low wall is replicated in the *Lady with the Unicorn* (Rome, Borghese); and both elements are recorded in his derivatively uninspired drawing of a lady in the Louvre. This points almost inescapably to the fact that the design of Leonardo's portrait was established during the Florentine period. Other aspects of its conception point in the same direction and we would be well advised to take careful account of these.

We have already noted the portrait's affinity in monumental design with the 'great lady' anatomy of *c.* 1508. This vision of the human figure first appeared in mature form in the anatomical studies associated with the battle-piece. If we want an architectural analogy for this round plenitude of shape we need look no further than the circular tower designs made for Piombino in 1504. The use of light, insistently directional yet softly generalizing, is precisely that recommended about 1504 in the second Madrid Manuscript. He twice advised the painter to avoid direct sunlight, preferring instead the positive but gentle light of high-walled streets, in which the shadows acquire borrowed radiance from light reflected off adjacent surfaces, so that faces are 'deprived integrally of every harsh boundary' in such a way as to 'appear full of grace from a distance' (25v and 71v). The breakdown of linearity, both in theory and practice, is more comprehensive than in the *Cecilia Gallerani* and the corresponding pre-scriptions in the Milanese notebooks.

However, the geological analogies, which we have found to play such a prominent part in the painting's effect, tend to associate it with the years immediately after he had ceased work on the *Battle*. The fragmentary discussions of geology in Manuscript L from about 1502 do not stand in anything like as close a relationship to the background as the sustained analyses of the earth's body in the Leicester Codex, which can be dated to the years after 1506. There is also, as will become apparent in Chapter V, good reason to associate certain of its optical qualities with the treatise 'On the Eye' which he composed in 1508.

There is one way to make sense of these conflicting strands of argument. This is to assume that the portrait as it now exists is a cumulative image developed over a number of years. According to this assumption, its design as a portrait of a Florentine lady in the *dolce stil nuovo* would have been laid down during his period of remarkable creativity in Florence between 1503 and 1506, reaching cartoon stage at least, and perhaps beginning its life as a painting on its fine-grained panel of white poplar. During the immediately succeeding years, at a time when he was speculating most intensively upon matters of physical geography, he would have underlined the universality of its imagery, generalizing his portrait of a specific lady into a meditation on the human and terrestrial bodies. The final step in bringing it to completion would have been taken when Giuliano expressed interest in acquiring it. This is to infer that the patron wished to possess the portrait simply as a beautiful picture by Leonardo

rather than as a portrait of a specific person. A few years later 'portraits' of beautiful women by Titian and Palma Vecchio were regarded in just this light. Giuliano's death in 1516 would have left the portrait in the artist's possession, and we can be reasonably sure that Leonardo took it with him to France, where it was seen by the Cardinal of Aragon's visiting party. At some point it entered the collection of Francis I and became one of the treasures in his Appartement des Bains at Fontainebleau. Although there are a worrying number of imponderables in this account, at least it does not conflict with the available clues in the way in which all the alternative hypotheses appear to do. Above all, such a prolonged gestation would be consistent with its deeply meditated and complex character.

The *Portrait of a Lady* would not be the only instance of an extended period of development for a single image. It would find a close parallel in his lost painting of *Leda and the Swan* (Plate 72), a work which is intimately associated with the portrait in more than just this. Indeed, the *Lady* and the *Leda* may be regarded as entirely complementary images of human life in the context of nature, the former evoking the similes of blood, flesh and bones in the bodies of man and the earth, while the latter resounds with analogies between the reproductive processes of the female body and the generative powers of the natural world. It is no coincidence that these two physiological themes, circulatory and reproductive, were central issues in his anatomical researches during the winter of 1507-8.

Leonardo's interest in *Leda* first emerges on a page of drawings containing a study for an Anghiari horse (W.12337), dateable to the first half of 1504. On this page are two small sketches of a kneeling woman in an elaborately twisted pose which are recognizable as preliminary stages in his design for a *Kneeling Leda*. The design is known in three closely related variants: a drawing at Chatsworth (Plate 73); a slightly less resolved study in the Boymans Museum, Rotterdam; and a mildly repellent painting by a follower (Munich, Alte Pinakothek) which omits the swan and shows Leda cradling one of the children in her right arm. To illustrate this pagan theme of Leda's union with the swan (Jupiter in one of his many copulatory disguises), Leonardo has aptly sought formal inspiration in the kneeling type of classical Venus. This was a period when his interest in antique art reached an unusually high level; it was the period of his Anghiari horses, based upon the Phaeton Sarcophagus, the Neptune drawing, the Hercules design and his literary description of the 'Site of Venus' on Cyprus (W. 12591).

As we would expect, the antique prototype has been utterly transformed in Leonardo's hands. The poised balance of the antique Venus has been superseded by a sense of immanent impulsion. The gyrations and torsions of Leda's *contrapposto* pose create an unstable pattern of unprecedented intricacy. That such a highly improbable posture has been rendered with a high degree of conviction is a tribute to the compelling vitality of his draughtsmanship. The hatching lines now curve compul-

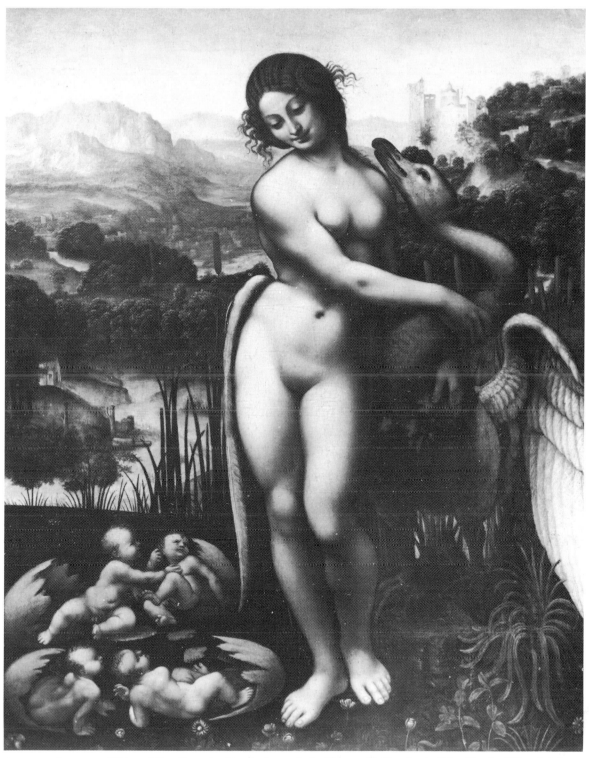

Pl.72 After Leonardo, *Leda and the Swan*, Collection of the Earl of Pembroke, Wilton House, Wiltshire

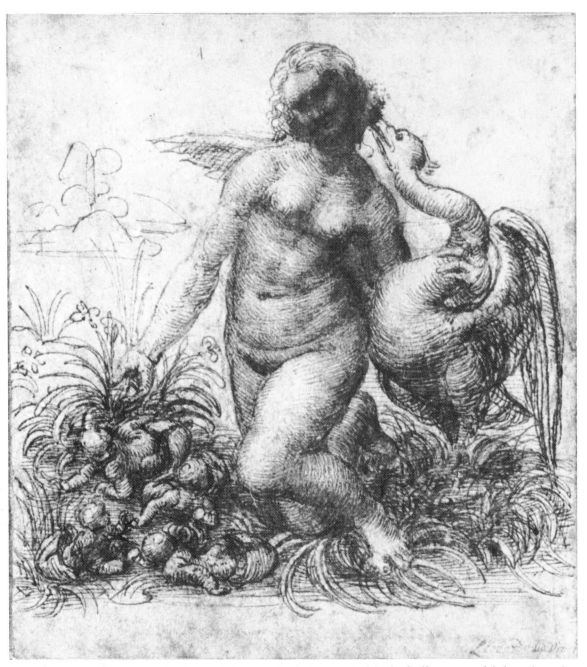

Pl.73 *Study for the Kneeling Leda* (*c.* 1506), black chalk, pen and ink and wash, Chatsworth, Devonshire Collection

sively *around* the individual forms, like the parallel gouges made by a sculptor's claw chisel. This technique, which he first used extensively for his Anghiari studies, marks a clear departure from the graded left-to-right hatching of his pre-1500 drawing style. The extreme manner in which the

new method is exploited in the Chatsworth and Rotterdam drawings suggests that they were drawn towards the end of his work on the *Battle*, that is to say about 1506. The four wriggling babies, Castor, Pollux, Helen and Clytemnestra, set up secondary vortices of impulsive motion as they emerge with precocious *contrapposti* from the two enormous eggs. The final component in this symphony of convoluted motion is provided by the swirling plants, whose inner surge of growth is vividly expressed by the spiral whorls of their leaves. How these plants would have been characterized in detail can be seen in the botanical studies at Windsor, particularly the one whose centre-piece is the Star of Bethlehem (*Ornithogalum umbellatum*, Plate 74).

Leonardo probably developed the *Kneeling Leda* no further than a cartoon or a highly finished drawing comparable to the *Neptune* for Antonio Segni. Instead, he turned to a standing pose in which the bodily torsions could be more mellifluously presented. The first sketches unequivocally connected with the standing *Leda* appear on a page which can be dated with some security to 1507-8 (W.12642), because it also contains an anatomical study from the centenarian series. The new pose, rhythmically suave where the kneeling posture had been overtly vivacious, is also a transmutation of a classical motif, probably as transmitted by Filippino Lippi. For the muse Erato in his *Allegory of Music* (Berlin, Dahlem Museum), Filippino adapted the pose of Lysippus' *Cupid with a Bow*, a Greek statue known to the Renaissance through Roman copies. Accompanied by a musical swan, which helps confirm her relevance for Leonardo's *Leda*, Erato stands in a pose essentially the same as Leonardo's figure with respect to the arms, torso, hips and legs. The one feature in which Leonardo has departed conspicuously from both Filippino and the classical prototype is the position of Leda's head, which he has inclined to the left in contradistinction to the motion of her arms. This small but crucial adjustment had turned a two-part *contrapposto* of considerable grace into a triple gyration around a clearly defined central axis. And where Filippino had overlaid the musical contours of his figure with an elaborate series of linear arabesques formed by fluttering drapery and spiralling ribbons, Leonardo has felt confident enough to allow the harmonic proportionality of his nude figure to stand unadorned: 'In narrative paintings never make so many ornaments on your figures...that they obscure the form and pose of such figures' (Madrid II, 25v).

The rhythms of the supporting elements in the painting were more restrained and subservient than in the designs for *Kneeling Leda*, but they were no less beautiful in their own right. Most beautiful of all was Leda's coiffure, studied in a remarkable series of drawings at Windsor (12515-8 and Plate 75). An elaborately plaited wig was set on her head in such a way as to allow a few curvy strands of her own hair to burst free at its lateral edges, and two apertures were left in the whorls at each side for some liberated waves to surge forth, like water from a mountain spring. The wig

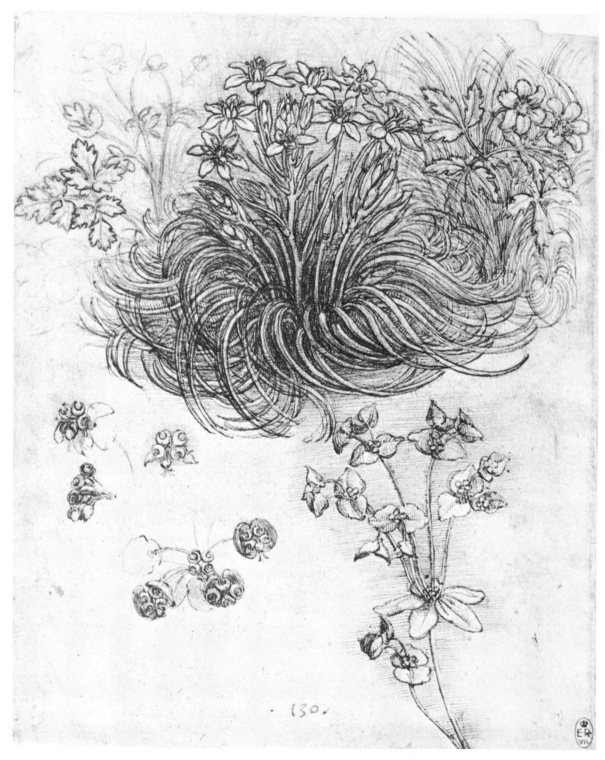

Pl.74 *Study of the Star of Bethlehem (Ornithogalum umbellatum) and Other Plants* (*c.* 1506), red chalk, pen and ink, Windsor, Royal Library (12424)

itself was a tightly regimented elaboration of these natural spirals. It is altogether characteristic of Leonardo's design procedures that he studied even the rear of the wig, which was not to appear in the painting.

We know, on the basis of a drawing by Raphael, that the essence of Leda's pose and the style of her coiffure were established before Leonardo's departure from Florence in 1508, but all the other evidence indicates that he did not make his definitive, painted version until considerably later. About 1514 he was still experimenting with the pose in a small sketch (C.A.156rb), and he probably continued to make minute adjustments to her rhythmic contours over a long period. And the poses of at least two of her babies in the final design were closely related to the lively figures of infants on the huge antique sculpture of *The Nile* which was discovered in Rome about 1512. The end product was a painting which went with him to France in 1516 and which seems to have perished there during the seventeenth century. A number of copies, of which the Wilton House version is probably as close as any to Leonardo's original, agree on the basic disposition of Leda, the swan and their progeny (though they are at serious variance in their landscapes). A comparison of the copies, preliminary drawings and Raphael's sketch show that the *contrapposto* of Leda's figure in the final version was subtly muted during the course of the painting's evolution: the turn of Leda's head was marginally softened; her left arm and shoulder were pulled slightly forward, reducing in prominence the naughty profile of her left nipple; while her right breast was squeezed more sensously against her right arm; the swan's enveloping wing no longer closely caressed her right leg down to her knee but hung vertically from mid-thigh level, thus modulating the bulgy curvature of her right hip; and the swan was transformed from white to 'black', with the result that the lecherous sinuosity of his neck stood in less stark contrast to the shaded left side of her body. These adjustments were small in formal terms, but they played vital roles in tuning the design to an exquisite pitch of musicality. Yet the copies suggest that Leda's beauty was not without a hint of strangeness. Her seductiveness was calculated with such infinite care that the end result was to distance Leonardo's svelte vision of womankind from our more ragged desires. There certainly was none of the warm sensuality with which Titian was to endow his naked women, nor the romantic magic of Giorgione's almost contemporary image of nude *Venus* (Dresden, Gemäldegalerie).

The *Leda* was an emphatically self-conscious painting, not least for the overt way in which Leonardo used it to express his reverence for the generative powers of nature. The supreme mystery of natural organisms was one of the major themes which arose from the centenarian series of drawings, and his studies of reproductive organs from this time possess a special kind of vital potency (e.g. W.19095r-v and 19098v). Leda's fruitful liaison with the swan symbolized the union of man and nature. The fecundity of their union was underlined by the flowering and seeding

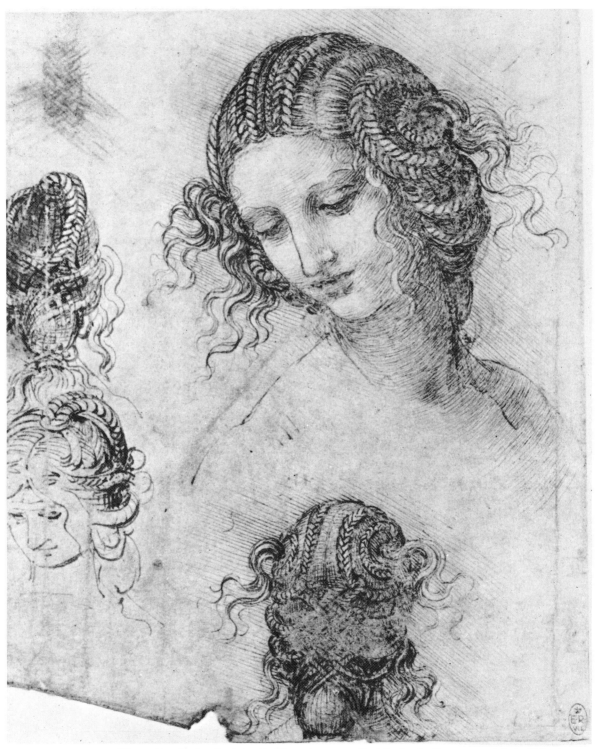

Pl.75 *Study for Leda's Coiffure* (*c.* 1507-8), black chalk, pen and ink, Windsor, Royal Library (12516)

plants, whose abundant fertility can be better appreciated in the related drawings at Windsor (12419-12430) than in the copies. The role of water in nourishing these generative powers was also made explicit. In the first version Leda was kneeling on obviously swampy ground — bulrushes figure prominently in the Rotterdam drawing — and in the Wilton house copy of the standing *Leda* the underlying dampness of the terrain is nicely apparent both from the foreground bulrushes and the middleground. We may well imagine that the distant landscape in Leonardo's own version would have extended this theme of moist lushness. There is an obvious contrast betweeen the rich deposits of fertile soil upon which the plants thrive in the *Leda* and the predominantly bare bones of primeval erosion in the *Portrait of a Lady*, but the fecundity of the former is ultimately dependent upon the inexorable processes of the latter. The *Leda* and the *Lady* express two sides of the microcosmic coin: the procreative powers of all living things; and the circulatory processes of 'vivification' which arise from natural flux.

These two paintings, both conceived during Leonardo's residence in Florence and brought to complex perfection during subsequent stages of his career, embrace a number of the themes which were to figure prominently in the final phase of his intellectual development. His late vision of the world was increasingly dominated by his reverence for the awesome intricacy of natural creation: the elaborate perfection of natural systems in their full complexity of organic design; the dynamic sense of natural processes in incessant motion; the complicated rule of mathematical order over the complex mechanisms of the natural world; and the elusive and illusive visual effects of optical perception. Many of the most striking effects in the *Portrait of a Lady* and the *Leda* belong with his late vision, and to this extent they span the periods covered by this and the following chapter.

V The Prime Mover

> If man's construction should appear to you
> to be of marvellous artifice, remember that
> it is nothing compared to the soul which
> inhabits such architecture, and truly, be it
> what it may, it is a divine thing (W.19001r).

While Leonardo had been working in Florence, the Milanese legal processes had been grinding their verbose way towards a settlement of the dispute concerning the *Madonna of the Rocks*. The way towards an agreement was opened by the arbitrators' report on 27 April 1506. And before the end of the next month the painter had arrived in Milan. Whether these two events were cause and effect, we have no way of knowing.

Charles d'Amboise, who was governing the city on Louis' behalf, was personally anxious to secure Leonardo's services for more than the three months the Florentine Signoria had authorized. Charles' request on 18 August for an extension to Leonardo's leave specifically mentioned a 'certain work which he has started', and in his reply of 16 December to Soderini's exasperated letter he referred to 'certain designs and architecture and other things pertaining to our situation' with which Leonardo was involved. The Governor added that Leonardo 'has provided satisfaction in such a manner that we do not only remain content with him but have unstinted admiration for him'. Whatever hopes the Signoria may have entertained of rapidly resecuring the painter's services on a permanent basis must have evaporated in January 1507 when Francesco Pandolfini, Florentine ambassador to Louis, reported the King as saying that he wanted 'certain small paintings of Our Lady and others, according to how my fancy [*fantasia*] takes me, and perhaps I will have him portray myself'. The King's desire for such paintings was occasioned by 'a small picture' which he had seen — surely the *Madonna with the Yarnwinder* owned by his secretary, Robertet. It was Robertet who was responsible for writing Louis' letter of 14 January requiring that the Signoria should permit Leonardo to stay until he 'makes the work which we intend him to do'. During the summer of 1507 Louis visited Italy, primarily to suppress a rebellion at Genoa, and on 24 May he grandly entered Milan. Leonardo had probably returned from a visit to Florence during the spring in time to greet the King. By July Louis was referring to the artist as 'our dear and good friend Leonardo da Vinci, our painter and engineer in ordinary'. In this capacity Leonardo received a salary on an annual basis from July to July (C.A.192ra-rb).

During the autumn of 1507, when he had returned to Florence to settle a lawsuit arising from his uncle's will, it was the turn of the French to request his speedy return 'to finish the work' which he was 'obliged to make'. Early in 1508 Leonardo dispatched Salai to Milan to explain that 'I am almost at the end of the litigation with my brothers and that I anticipate joining you this Easter and will carry with me the two panels on which are two Madonnas of different sizes which I have commenced for the most Christian King or for whosoever you wish' (C.A.372va). There is no concrete evidence as to which paintings he had begun — assuming that he was not making misleading claims — but there are three plausible candidates. The smallest and most likely is the *Madonna and Children at Play*, an energetic and pastoral reworking of the children and Virgin from the *Madonna of the Rocks*, known only through copies (e.g. Oxford, Ashmolean Museum). The other two are variations on the St Anne themes, the London 'cartoon' (Plate 62) and the Louvre *Madonna Child, St Anne and a Lamb* (Plate 61). The only surviving work which was definitely completed about this time was the second version of the *Madonna of the Rocks* (Plate 76). On 23 October 1508 a final payment of 100 litre to Ambrogio da Predis was ratified by Leonardo, following the receipt of a similar sum just over a year earlier. Stylistically, however, the second *Madonna of the Rocks* causes more problems than it solves.

In many ways the London picture is a markedly more mature work than the Louvre version (Plate 34). All the forms of the individual figures have gained a new amplitude and the architectural grandeur of the group as a whole has been enhanced by its perceptibly increased sense of scale within what is a fractionally smaller panel. The overly literal pointing gesture of the Angel has been eliminated and his glance has been turned inwards to add an extra dimension to the internal network of wordless communication. The light is even more insistently directional, blending all the details with the spatial substratum in a comprehensively unified manner. The formal changes are entirely consistent with his style at the time of the *Last Supper* (Plate 52), that is to say about 1497, and suggest that the groundwork for the painting was laid down at that time. But the arbitration document of 1506 makes it clear that the painting had not been finished by the time he left Milan. The painting for which final payment was made in 1508 cannot, therefore, be assigned to a single period. In this it resembles the *Leda*, the *Portrait of a Lady* and to some extent the Louvre *St Anne*, but the stylistic problems are even greater in this case. The added complication arises from the probability of studio participation.

Ambrogio da Predis was involved with the project from the first and he was still acting for Leonardo at the last. This documented involvement, together with what had been characterized as the 'dead' handling of certain details, has lead some critics to assign the final execution of the painting substantially to Ambrogio. However, authentic paintings by Ambrogio show what his style was really like — and it nowhere came

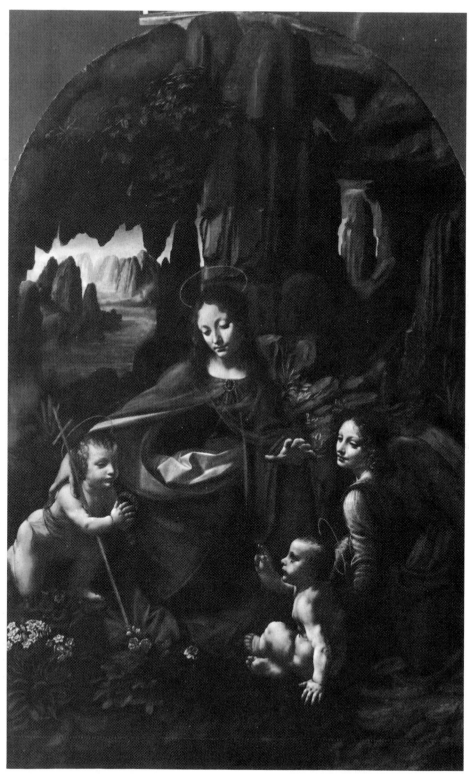

Pl.76 *Madonna of the Rocks* (*c.* 1495-1508), London, National Gallery

within striking range of the finest passages in the London painting. Leonardo's personal participation is unequivocally manifested in important and substantial areas of the picture. Look especially at the complex and analytically deliberate modulations of shaded contour within the Virgin's head; at the wonderful subtlety of the diaphanous band running from her right shoulder, across her breast and over her left arm; at the radiant refinement of the Angel's head and the electric vitality of his curls; and at the Angel's left sleeve, where the use of translucent glazes is exploited with ravishing delicacy. All these effects lie definitively outside Ambrogio's range, or that of any other known pupil. Moreover, the Angel's head and, to a lesser degree, that of the Virgin reveal the hand-print technique of blending paint which was Leonardo's personal signature. Against this must be set the waxily mechanical handling of other details, especially the foreground flowers, but even these may be Leonardo himself working at a lower key. I am inclined to recognize much of the painting as Leonardo's work from the late 1490s, while some foreground details, such as the Angel's head and draperies, can be assigned to his three-month leave of absence from Florence in 1506 and thereafter. If he did use an assistant or assistants, it was in genuinely subsidiary capacities. I believe that he largely fulfilled the demands of the 1506 settlement that the 'panel or picture on which is depicted the Virgin' should be finished 'in two years. . . by the hand of the said Master Leonardo'. What the authorities apparently did not realize was that the painting as handed over was still not completely finished in a number of inconspicuous respects: the Angel's left hand and Christ's back; Christ's right hand; and St John's right foot.

In addition to whatever paintings he may have completed after his return to Milan, we know from Charles's correspondence that he was engaged upon 'architecture'. The French Governor was a man of high cultural ambitions and aimed to revive in some measure the artistic fortunes of the Milanese court. He could not have signalled his intentions more clearly than by his patronage of Leonardo, and the artist for his part no doubt welcomed the opportunity to resume a comfortably salaried position in the city. We can reasonably assume that Leonardo resumed his practice of designing courtly delights — allegories, festive decorations, theatrical spectaculars, etc. — and although there is no documentation comparable to that from the Sforza era, a few such designs can be securely assigned to this period. One drawing at Windsor (Plate 77) displays a series of emblems, each surrounded by a cameo-like frame. The theme concerns the incineration of falsehood's waxy mask by truth's remorseless light: 'Dissimulation is frustrated in front of such a judge — deceit puts on a mask — nothing is obscure under sunlight — fire represents truth because it destroys all sophistry and lying, and the mask is for falsehood and lying.' By Leonardo's obscure standards this concept is notably lucid.

We can only speculate as to the nature of the '*architectura*' designed

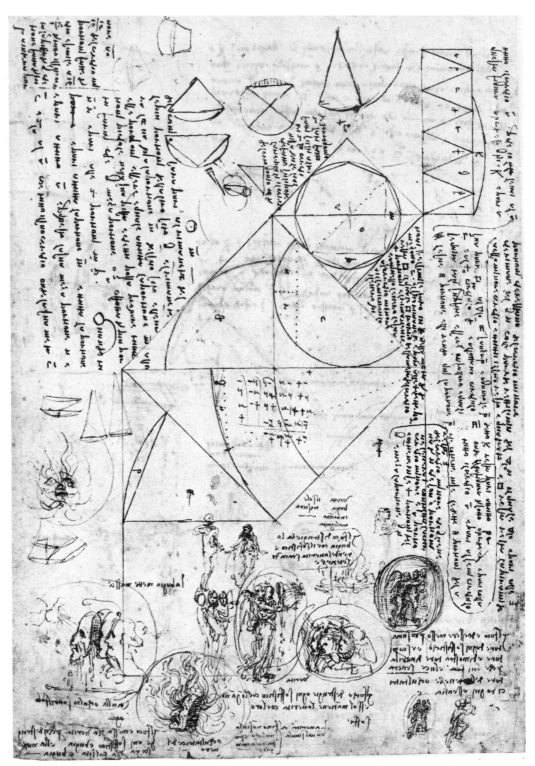

Pl.77 *Geometrical Studies of Squaring a Circle and Studies for an Allegory of Truth and Falsehood* (*c.* 1509), pen and ink, Windsor, Royal Library (12700v)

for Charles. The Governor's only remaining construction of note is the Oratory of S. Maria alla Fontana, an aisleless structure of modest dimensions, decorated externally with a pleasing arcade and flanked by two small courtyards. It is tempting to think that Leonardo played at least a consultant's role in the felicitous design of the ensemble, but there are no solid grounds for believing so. Among his architectural drawings from this time are rough sketches of a palace plan for the '*gran maestro*', which should probably be identified as relating to a project for the Governor's new residence. The drawings (e.g. C.A.231rb) show that Leonardo was thinking along the lines of the newly fashionable kind of colonnaded palace, like Poggio Reale at Naples, which utilized loggias to link the airy interiors with exterior terraces and gardens. But his patron died in 1511 and the palace does not appear to have made significant progress.

The only extensive series of designs from his second residence in Milan which can be indisputably related to a documented project concerns another equestrian monument, this time to glorify Giovanni Giacomo Trivulzio, a belligerent *condottiere* in the traditional mould of Renaissance captains. Trivulzio had begun his career under Sforza patronage, but had angrily left Milan in 1488 for rival service in Naples. When Charles VIII entered Naples in 1494 he became a French commander and subsequently played a significant military role in Ludovico's downfall. In his will, drafted in 1504, he authorized four thousand ducats for the erection of his own monument in S. Nazaro. Presented with an opportunity to redeem his earlier failure, Leonardo devoted considerable energies to designs for the new monument, and prepared a detailed cost estimate for the 'sepulchral memorial to Messer Giovanni Jacomo da Trevulzo' (C.A.179va). His estimate opens with the 'cost of labours and materials for the horse: one charger, life size with rider, will require for the cost of the metal — 500 ducats. . .'. There follows the price of thirty-one items, including models 'in clay and then in wax', supportive armatures and casting pit, the wages of labourers, marble for the architectural base, bronze capitals, a recumbent effigy of Trivulzio on his sarcophagus, and '8 figures around the base. . . at 25 ducats each'. The grand total, 3046 ducats, is well within the sum stipulated by the General.

None of the finished drawings which must have been submitted with the estimate have survived, but a number of preliminary sketches relate closely to the major items. Of these sketches, the illustrated example (Plate 78) exhibits the most balanced relationship of horse to base and gives the best indication of the 'stone figure of the deceased' lying on the 'slab of the tombstone'. The drawing also provides a slight indication on the left of one of the figures around the base. These figures, eight in number, were to take the form of captives tied to columns (Figure 65) in the manner of the 'slaves' which Michelangelo had been planning for the tomb of Julius II from 1505 onwards. No doubt they were intended to make appropriate references to Trivulzio's military conquests. As the drawing

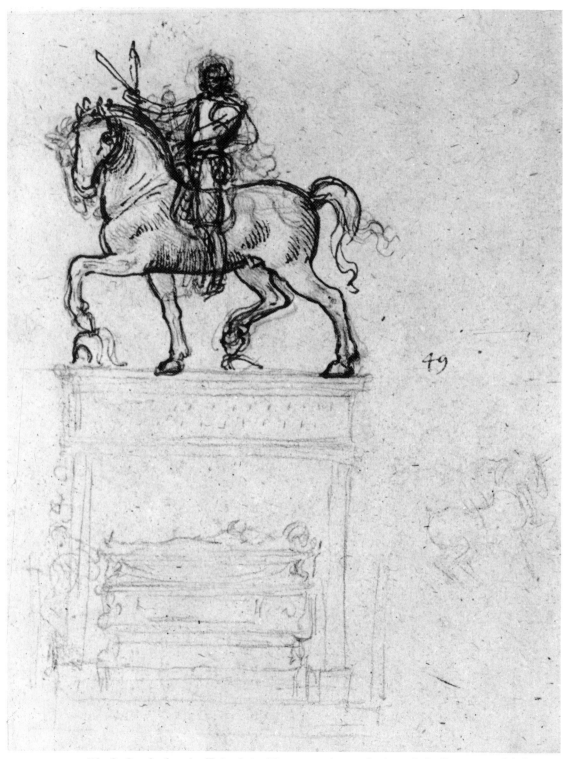

Pl.78 *Study for the Trivulzio Monument* (*c.* 1508–9), red chalk, pen and ink,
Windsor, Royal Library (12356r)

Fig.65 *Study for a 'Captive' for the Trivulzio Monument,* based on W.12355

progressed, the red chalk outlines of horse and rider were redefined and modified in ink. He turned the horse's and rider's heads towards the spectator, breaking the planar profile of the design, just as Verrocchio had vigorously done in the Colleoni monument. However, even this relatively well-organized sketch cannot be regarded as a definitive solution, and the other surviving drawings present a number of alternatives.

One of these revived Leonardo's old idea for a rearing horse. Some of the rearing schemes (W.12353 and 12355) probably precede the numerous walking versions, but, as ever reluctant to cast away an attractive invention, he returned to the former pose in his last thoughts of all (W.12354). Some distance of time separates his earliest and latest drawings for the monument. The earliest, together with the estimate, can be associated with his first resuming permanent residence in Milan in 1508, while the latter may have resulted from his reviving the project about 1511. It is not altogether surprising that work on Trivulzio's monument did not proceed while Charles d'Amboise was in supreme control of Milan — the ambitious *condottiere* and the official Governor were not on the best of terms — while after Charles' death in 1511 the historical circumstances in Milan became progessively less conducive to the completion of such a major work in bronze, even though Trivulzio was now in command of the city.

There is a remarkable element of reprise in all this — his return to Milan, the *Madonna of the Rocks,* his work at court and a frustrated project for an equestrian statue. This quality of reprise, as if his career were proceeding in a cyclical manner, was not simply limited to coincidences of historical circumstance. More profoundly, it involved a revisiting of what had been his major intellectual concerns during the 1490s: anatomy, geometry, dynamics, water researches, the geographical sciences, astronomy, optics and art theory. Many of these pursuits had of course continued to engage his attention in the intervening period, but there is real justification for regarding his intellectual development after 1508 as a comprehensive picking up of earlier threads across the whole range of his thought. We have already seen him picking up the anatomical thread during the winter of 1507-8, and on his return to Milan he continued to explore anatomical problems in a sustained manner, eventually achieving the finest results in any of his fields of scientific endeavour.

In the final phase of his thought, no less than during the 1490s, Leonardo's anatomical investigations played a central role in determining his attitude towards the formative principles of the universe. How could it be otherwise, given man's microcosmic properties? It would be wrong, however, to see his late anatomical work simply as an extension of his earlier ideas. Indeed, the tidy simplifications of his earlier demonstrations were replaced by a greater awareness of the awesomely complex perfections involved in natural design. 'Although human ingenuity makes various inventions, corresponding by means of various machines to the same end, it will never discover any inventions more beautiful, more appropriate or more direct than nature, because in her inventions nothing is lacking and nothing is superfluous' (W.19115r). It is no longer any good for the investigator to construct his own simplified demonstrations of human forms and functions: 'The abbreviators of works do injury to knowledge and to love, for love of anything is the offspring of knowledge, love being more fervent in proportion as knowledge is more certain, and this certainty springs from a thorough knowledge of all those parts which united compose the whole. . . Truly it is impatience, mother of folly, who praises brevity' (W.19084r). There are no short cuts in arriving at a proper understanding of the 'marvel of artifice' which is the human body. Every smallest detail has a function and must be rigorously explained in functional terms, as his notes on individual features of the body make abundantly clear.

His insistence that the anatomist pay due homage to organic complexity in all its details is best illustrated by a series of skeletal and myological demonstrations from 1510, which are quite different in character from anything which had preceded them — even from the relatively recent centenarian anatomies. The late demonstrations were part of a drive to bring his anatomical researches to a triumphant conclusion: 'This winter of 1510 I believe that I will expedite all this anatomy' (W.19016r). The 1510 series of foot demonstrations include some highly finished and resolved drawings (Plate 79), yet they exhibit almost none of the synthetic quality which had characterized definitive illustrations from earlier phases of his work. There is a new sense of actuality in his depictions; the illustrated drawing records the forms encountered at a particular stage of dissection, rendered with contrived neatness to be sure, but no longer artificially constructed according to predetermined conceptions of function.

Faced with the spatial complexity of anatomical forms he found that three or four part systems of 'architectural' surveying could no longer cope with all the details he wished to demonstrate. The obstinate asymmetry of the foot lead him to increase his survey to six views (W.19018r), while the formal complexity of the muscles in the arm, shoulder and upper thorax could only be embraced by a cinematographic sequence of eight views, of which four are shown here (Plate 80): 'If you wish to understand all the parts of an anatomized man, you turn either him or your eye through

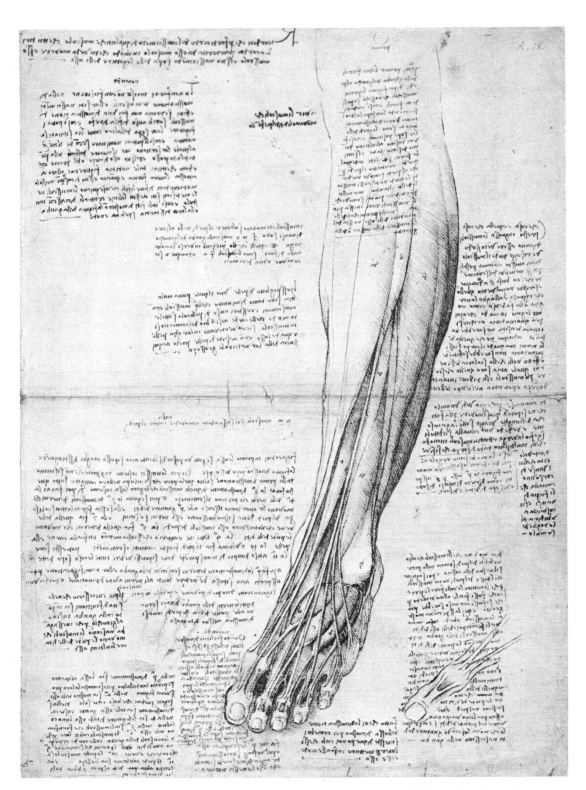

Pl.79 *Study of the Superficial Anatomy of the Foot and Lower Leg* (1510), pen and ink, Windsor, Royal Library (19017r)

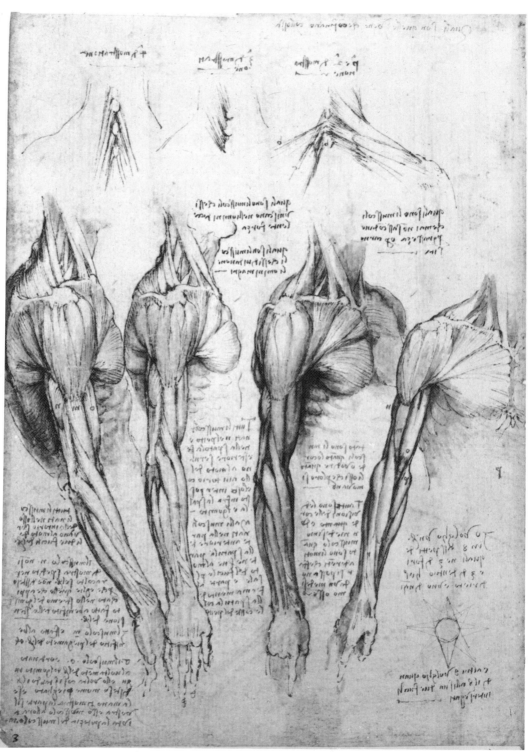

Pl.80 *Four Sequential Studies of the Superficial Anatomy of the Arm, Shoulder and Breast* (*c.* 1510-11), pen and ink and wash, Windsor, Royal Library (19008v)

all the various positions... turning him about and searching for the origins of each member' (W.19061r). The stellate diagram in the lower right hand corner illustrates his system in the optical terms of Pecham's visual pyramids (Figure 18). In the last resort his compulsive desire to leave no visual stone unturned led him outside even the eight-view system. In his demonstrations of the deeper muscles of the shoulder (Plate 81) he instinctively selected the most informative angle, changing the viewpoint and the arm's position regardless of their conformity to his geometrical system of surveying.

By the standards of the 'aesthetic' requirements which he expressed in relation to his centenarian illustrations, the shoulder dissections 'remain monstrous things from having their parts removed'. He has eschewed his attractive technique of magic transparency in favour of a more direct relationship with what the dissecting anatomist would encounter as he progressively removed the overlying forms. The ultimate stage was the pulling apart of the innermost components in a series of 'exploded' views, such as that of the foot and shin bones on the page of shoulder dissections: 'Show the bones separated and somewhat out of position so that it may be possible to distinguish better the shape of each bone by itself. And afterwards join them together in such a way that they do not diverge from the first demonstration except in the part which is concealed by their contact' (W.19018r). This brilliantly innovatory technique has become one of the standbys of modern technical illustration. In case even these apparently exhaustive techniques should still leave room for visual doubt, 'first make a demonstration with thinned muscles in the form of threads, and in this way you will be able to represent them above one another as nature has placed them' (W.19018r).

Such completeness of visual survey provided the ultimate grounds for his challenge to the writer: 'With what words, O writer, will you describe with similar perfection the entire configuration which the drawing here does?' (19071r); 'You who claim to demonstrate in words the shape of man from every aspect dismiss such an idea, because the more minutely you describe the more you will lead away from the thing described' (19013v). His own drawings 'will give a true knowledge of their shapes that neither the ancient masters nor the moderns would be able to give without an immense, tiresome and confusing amount of writing and time' (19007v). It should be noted in this context that traditional anatomical texts were generally unillustrated, and from Leonardo's point of view all too many of them were only available in the obscure tongue of Greek.

His demand that every nuance of form be rigorously respected arose from a changing emphasis in his scientific method, away from the loosely compositive approach of the 1490s and towards a rigorous empiricism which sought functional explanations for observed forms: 'Nature begins with the cause, and ends with the experience; we must follow the opposite course, that is beginning, as I said before, with experience and from this

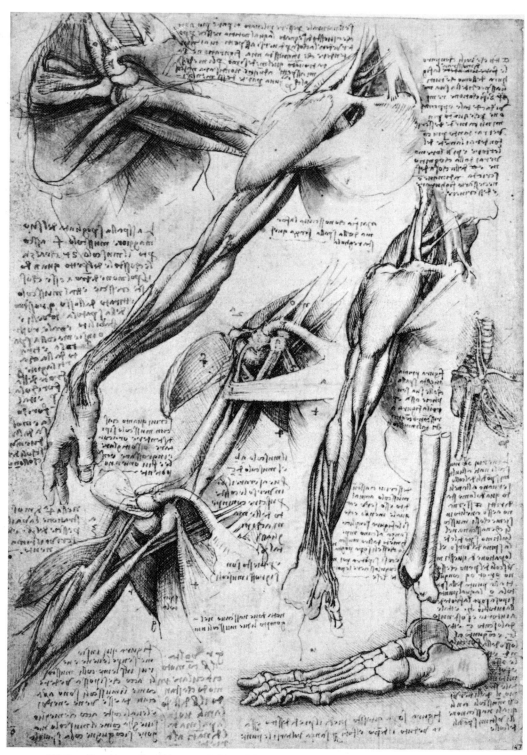

Pl.81 *Studies of a Dissected Shoulder, Bones of the Foot and Lower Leg, and Thoracic Musculature* (*c.* 1510), pen and ink and wash, Windsor, Royal Library (19013v)

investigate the reason' (E.55r); 'Things in the mind which have not passed through sense are vain and can produce no truth which is not condemned' (W.19070v). This contrasts with the view he expressed during the period of the centenarian dissection: 'Understand the cause and you will not need experiment' (C.A.147va). His method of argument in 1510 and therafter was invariably from form to function. Explanations of anatomical detail were commonly introduced by such remarks as 'this was ordained by nature so that. . . ', or 'nature does this because. . . ', or 'necessity has caused this in order that. . . '. A drawing to explain the action of a heart valve is accompanied by a homily to the effect that 'this the inventor made for the cause shown in the figure above, which reveals how the creator does not make anything superfluous or defective' (W.19074r). If nature (the inventor, the creator, god, necessity or whatever else he may call the formative agency) has made a shape, it must have a function. For instance, every variation in each bone must serve a purpose: 'It will be necessary for me to investigate the particular use of each protuberance on every bone' (W.19004r). In the face of such complex perfection he could not but 'praise the first builder of such a machine' (W.19014w).

This intense teleology proved the basis for his late empiricism in precisely the same way as it had in the writings of the foremost classical anatomist, Galen. Leonardo's great predecessor had exulted in 'the wonderful skill of the creator', and referred to his treatise *On the Function of Parts* as a 'sacred discourse which I am composing as a hymn of praise to our creator' (XIV,2,295 and III,1,174). Galen believed that 'Nature does nothing in vain. . . the artifice of nature is worked out in every part' (*Anatomical Procedures,* II, 2), and his own anatomical method was founded upon a desire to account functionally for all observed forms. There is good reason on purely anatomical grounds to think that Leonardo avidly studied *De usu partium* about 1510, and the closeness of his theoretical pronouncements to Galen's views strongly suggests that this was the case. A likely intermediary between himself and Galen, whose writings remained largely in Greek, was the Paduan and Pavian authority, Marcantonio della Torre (d. 1511). Leonardo's liaison with Marcantonio was mentioned by Paolo Giovio, and is probably confirmed by two references to a 'Marcantonio' in his notebooks at this time (C.A.20vb and W.19102v). If he admired Galen and his latter-day disciple for the intellectual precision of their method and for their grasp of anatomical detail, he would have found their traditional technique of verbal description to have been unbearably prolix — 'tiresome and confusing' to use his own words.

However, written accounts were not to be eliminated altogether in Leonardo's own system. 'It is necessary both to illustrate and to describe' (19013v) — to illustrate the actual forms in all their glorious detail and to describe their functioning in the context of universal laws. The texts accompanying illustrations certainly had an important role to play, providing it was the role for which words were best suited: 'If you wish to

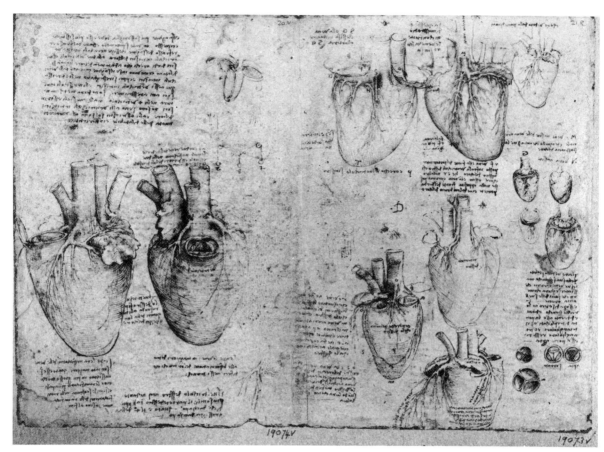

Pl.82 *Studies of the Heart (of an Ox or Bull?)* (1513-14), pen and ink, Windsor, Royal Library (19073v-4v)

demonstrate in words to the ears. . . speak of substantial or natural things and do not meddle in things pertaining to the eye' (19071r). In fact, the explanatory role of the texts became ever more intricate as the drawings became more visually elaborate, and his late pages of anatomical research contain increasingly sustained analyses of physiological functions — often at great length. Nowhere is this more evident than in his analysis of the heart's action, in which monumental yet detailed illustrations of organic form (Plate 82) are accompanied by complex textual accounts of haemodynamics.

The heart studies which he made during 1513-14 — one of the series is dated '9th of January 1513' (W.19077v) — represent the climax of his attempt to understand internal functions, and they provide an ideal standpoint from which to survey the complex unity of his late vision. The heart, in keeping with his vision of universal science, could only be understood in the light of dynamic law and mathematical 'necessity', and such an understanding would cast light upon all those sciences which relate to the body of the earth.

The 1513-14 series exhibit severe anatomical shortcomings. They were almost certainly based upon a bovine heart, and he clung to the Galenic idea that blood passed through invisible pores in the septum which separates the ventricles. But I am not concerned here so much with their anatomical inaccuracy as with their visual magnificence and physiological beauty. If we compare the synthetic regularity of branching in his earlier illustration of the respiratory system (Plate 69) with the organic irregularity of the blood vessels on the surface of the later hearts, we cannot but be struck by the difference in approach. The organic complexity of the later 'tree of the vessels' does not mean, however, that he has rejected the relationship between branching systems and dynamic law. Rather, he has become concerned to extend and develop his understanding of the way in which these laws are obeyed, attempting to account for the manifest variety of branching systems. Asymmetrical branches obeyed the law that 'The vessels are always larger internal to the bifurcation of their trunks' (i.e. nearer the line of the main axis); and 'The branches of the vessels are always larger in proportion to their origin from a larger trunk; that is from their principal ramification; the same continues in the ramifications up to the end' (W.19074v). These laws were distilled from numerous studies of plant and tree branching from this late period, such as those of the elm, walnut and elder which appear in Manuscript G. Having analysed actual examples he drew a series of conclusions: 'The beginning of the branch will always have the central line of its thickness taking its direction from the central line of plant' (G.14r); and 'Between one ramification and the next, if there are no other actual branches, the tree will be of uniform thickness ... because the whole sum of the humour which feeds the beginnings of this branch continues to feed it until it produces the next branch. And this nourishment of equal cause produces equal effect' (G.17r)

His consistent faith that there really were regular causes behind natural effects in all their abundant variety explains the apparent paradox that as his drawings became less mechanically simplified so he insisted more dogmatically that everything should be explained with mathematical precision: 'There is no certainty in sciences where one of the mathematical sciences cannot be applied or which are not associated with mathematics' (G.96v). Thus it was that he wrote on two of his pages of heart studies: 'He who debases the supreme certainty of mathematics feeds on confusion and can never silence the contradictions of the sophistical sciences' (W.19084r); and 'Let no one who is not a mathematician read my principles' (W.19118r). This latter statement paraphrases the injunction which Plato had placed above the door of his Academy and which Pacioli had quoted with approval in its Latin version: *Nemo huc geometrie expers ingrediatur* ('let no one who does not know geometry enter here'). None of this would have surprised medieval scientists of the Alhazen-Bacon-Pecham school. Indeed, practitioners of natural science could expect to be

called 'mathematicians' by their medieval contemporaries. What Leonardo personally achieved was to unite their revered mathematics with his uniquely complex vision of organic structure.

In one conspicuous detail of the heart, the cusped valve at the base of the pulmonary artery, he was able to realize his ambition to forge a mathematical science of anatomy. This valve, constructed from three semilunar cusps, prevents the blood expelled into the artery from re-entering the heart. It is shown in isolation in small sketches in the lower right hand corner of the illustrated page (Figure 66) and again in another page from the series (Figure 67). On the contraction of the heart, blood forced its way between the centre of the flexible cusps from beneath. The subsequent reflux of the blood in the vessel's neck filled the cusps, reclosing the aperture during the expansion of the ventricle. This neat little piece of natural engineering seemed to present a perfect illustration of 'necessity' in geometrical action. He explained that 'nature makes three valves not four because the pellicles which close such valves make greater angles being three in number' (W.19117v). A four-cusp system would be more prone to collapse at the centre, while a two-part system would not open so readily. It was during the reflux stage that the action of force in the three-part structure automatically revealed the geometrical formula of its design — a formula which is no less regular than a diagram of pure geometry (Figure 68). The valve was a living piece of stereometry in dynamic action.

Fig.66 *Pulmonary/Aortic Valve in Isolation*, based on W. 19073v

Fig.67 *Six Views of the Pulmonary/Aortic Valve in Isolation*, based on W.19079v

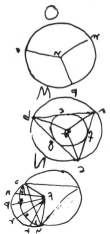

Fig.68 *Geometrical Analysis of the Pulmonary/Aortic Valve,* based on W.19116v

The striking resemblance between the configuration of the heart valve and a purely geometrical figure (Figure 69) is in one sense fortuitous, since the two diagrams serve different ends, but on a deeper level the resemblance is highly significant. The rules governing the latter ultimately provide the causes of the former's design. The geometrical diagram deals with the proportionalities of area which so obsessed him during the later phases of his career: 'The circle that touches the three angles of an equilateral triangle is triple the triangle which touches the three sides of the same triangle. The diameter of the largest circle made in the triangle is equal to two-thirds the axis of the same triangle' (G.7v). The opening of the heart valve was no less concerned with relationships of area to area, as the geometrical outlines of the cusps were transformed into different configurations. Thus the opening of the tricuspid valve (between the right atrium and ventricle) was illustrated as a study in geometrical areas (Figure 70), in precisely the same terms as Leonardo's geometrical studies. He knew that the pulmonary valve did not open in quite this regular manner, because its walls became floppily detensioned when blood was forced between them from below, but this did not mean that their operation in this phase was irregularly variable. Irregular and regular areas could exhibit precisely controlled equivalences, as he showed in his analyses of 'cut' and 'torn' circles (Figure 71).

Fig.69 *Geometrical Study of Circles and Triangles,* based on G.17v

Fig.70 *Geometrical Analysis of the Tricuspid Valve,* based on W.19074r

Fig.71 *Geometrical Studies of Incomplete Circles*, based on G.56r

His geometromaniac desire at this time to discover ever more intricate relationships of area between circles, triangles, squares, polygons, segments, sectors, falcated triangles and *lunulae* became an intellectual itch which he found impossible to scratch satisfactorily. Each new bout of scratching only served to stimulate fresh itches. Even the most devoted admirer of Leonardo must wonder if the whole matter had got rather out of hand (Plate 83). The importance of such constructions to him is testified by the way in which he tended to record their date of solution, as if they were events of unrivalled significance in his life: 'Having for a long time searched to square the angle to two equal curves. . . now in the year 1509 on the eve of the Calends of May [April 30] I have found the solution at the 22nd hour on Sunday' (W.19145). Referring to a diagram (Figure 72), he explained that since $A + B = C$, 'as is shown on the reverse of this page', the area of C would be equal to that of the triangle formed by $D + C$. Immediately below the diagram, beside the explanatory text, he characteristically began to work decorative variations on these kinds of falcated triangles, creating a repetitive pattern of interlocked units (Figure 73). Such patterns appear in profusion in his late manuscripts.

The most astonishing manifestation of the frantic inventiveness with which he pursued such matters is the neatly arranged series of 180 annotated diagrams on the illustrated sheet from the *Codice atlantico* (Plate 83). The annotations outline the relative proportions of the shaded and unshaded areas in relation to each other and to the whole. A particularly nice example from about the same time shows a series of unshaded *lunulae* which are 'equal in value to each other in area' and which together 'equal half that of the greatest circle' (Figure 74). There can be little doubt that his motivation in these studies was a complex compound of intellectual and aesthetic satisfactions. Even the intellectual aspects ultimately assumed the air of conundrums or games, rather than belonging to the mainstream of mathematical science. This quality is accurately reflected in the title under which he intended to group his geometrical puzzles about

Pl.83 *Geometrical Studies of Related Areas* (*c.* 1513), pen and ink, Milan, Biblioteca Ambrosiana (C.A. 167ra-b)

A = A
d = B
コ = C

ρ = D
D = E

Fig.72 *Study of the Area of a Curved Triangle (1509)*, based on W.19145

Fig.73 *Geometrical Rosette Pattern*, based on W.19145

Fig.74 *Geometrical Studies of Related Areas,* based on C.A.221vb

1514: 'As I have shown. . . various ways of squaring the circle. . . and have given the rules for proceeding to infinity, I now begin the book called *De ludo geometrico*' (C.A.45va). 'Ludo' in this sense is equivalent to 'diverting pursuit' or 'engrossing pastime'. His 'geometrical games' would have stood in much the same relationship to the sublime science of Euclid as a crossword puzzle stands in relation to the composition of poetry.

This playful dimension did not mean that geometry lost any of its profound significance for him. Indeed his reverence for the 'great abstraction and subtlety of mathematics' (to use Pacioli's phrase) was never greater than in the final years of his life. The more he studied Euclid, Archimedes and the other classical mathematicians, the greater became his admiration for their science. He vigorously defended them 'against some commentators who blame the ancient inventors from whom were born the grammars and the sciences and who set themselves up as knights against the deceased inventors' (F.27v). Nowhere was Leonardo more a classicist in the Renaissance sense than in his late geometry. Mathematics assumed a special validity of its own as a 'wholly mental' operation abstracted from material and instrumental concerns (F.59r). The dependence of natural science upon mathematics was no less close, but mathematics expressed truths which were not so much empirical as intellectually incontrovertible:

> The elements of mathematics, that is to say number and measure, termed arithmetic and geometry, discourse with supreme truth on discontinuous and continuous quantities. Here no one argues that twice three makes more or less than six, nor that a triangle has angles smaller than two right angles, but with eternal silence every dissension is destroyed, and in tranquillity these sciences are relished by their devotees (Urb.19v).

To my mind, it is no coincidence that the Plato of the *Timaeus* twice figures in Leonardo's debates in Manuscript F (27r and 59r). I am not suggesting that he belatedly became a Neoplatonist, but his attitude to the role of mathematics was increasingly coloured by philosophical traits which were certainly not primary characteristics of Aristotle's practice. The geometrical problems which continued to occupy him after his

departure from Florence were substantially those which had concerned him during the Anghiari period. And the character of his approach — what I have called the concrete quality of his geometrical vision — remained essentially constant throughout his late work. In squaring a spherical surface, for example, he began by dissecting it into eighths (Figure 75 no. 1), one of which was then inscribed with a series of parallels (no. 2). The next step involved straightening all but one of the curved sides 'with a movement on a level plane' (no.3). How he accomplished this 'movement' is not explained. The resulting quarter circle finally remained to be squared, applying the triangular 'unrolling' technique which he had earlier devised for squaring the whole circle (nos 4 and 5). Once again the key procedure in his method resembled a sculpturally manipulative process in which geometrical form assumed a special kind of physical reality.

Although he claimed to have resolved the classic problem of squaring the circle during his years in Florence, his late manuscripts contain repeated revisions and recapitulations of this problem. About 1508 he restated his belief that 'Archimedes has given the quadrature of a polygon, not of a circle. . . and I square the circle minus the smallest portion of it that the intellect can imagine, that is the smallest point possible' (W.12280r). His own 'method of the process to infinity' (C.A.45va), involving an approximation which was infinitely perfectible, was not new in principle, and a comparable procedure had been widely disseminated in medieval treatises. One diagram accompanying the Archimedes note (Figure 76) demonstrates his awareness that the 'unrolling' technique of about 1506 (see Figure 60) had ignored the curved segments at the bases of the triangles; but by multiplying the sides of his inscribed figure indefinitely he could reduce their significance to that of the 'smallest portion. . . that the intellect can imagine'. In the case of an inscribed figure with relatively few sides (such as the octagon in Plate 77) he persistently strove to find a rectilinear figure equal in area to the omitted portions. By the time of the composition of Manuscript G, that is to say from 1510 onwards, his increased knowledge of Archimedes' writings finally resulted in his acknowledging that it was 'Archimedes the Syracusan who found that the multiplication of half the diameter of the circle by half of its circumference made a rectilinear quadrilateral equal to the circle' (G.96r). And his late studies of stereometry paid repeated homage to the Syracusan's genius (Figure 77).

Archimedes' influence was both direct and indirect. Leonardo undoubtedly derived important ideas from those 'commentators' whom he professed to despise. His treatment of a spiral is a case in point. His construction of a spiral in Manuscript G (Figure 78) appears to be based on Oresme's *De configurationibus* (I,21), as are the definitions and theorems he quoted in Manuscript E:

> A helix is a single curved line, the curve of which is uniformly irregular
> and it goes revolving around a point at a distance uniformly irre-

Fig.76 *Study of the Triangular Technique of Squaring a Circle,* based on W.12280r

Fig.77 *Stereometric Studies of Archimedean Volumes,* based on G.61v (sphere within a cube), E.1v/G.62r (cone within a cylinder) and E.56r (pyramid within a cube)

Fig.75 *Technique for Squaring the Surface of a Sphere,* based on E.24v

gular. . . The movement of a hemisphere commenced by the circumference of its greatest circle ends in the middle of the hemisphere after having described a spiral course. This is proved by the second concerning compound impetus which says 'of compound impetus one part will be as much slower than the other as it is shorter'; and 'that will be shorter which is farther distant from the direct line of the movement made by its mover' (Figure 79).

This reference to impetus serves to remind us that the geometrical transformation of the actual forms in nature, such as the heart valves, took place in the context of mechanical law. As if to underline this point, the illustrated studies of the heart (Plate 82) are accompanied by a rough sketch of a pulley system (Figure 80). The purpose of the sketch is apparently to show the mechanical principle governing the ventricular valves: 'When the heart enlarges itself. . . [the papillary muscle] shortens,

drawing itself by means of its chords towards [the valve]. . . and is the cause of the shortening and opening of the heart' (W.19093r). The two lateral weights, U and V, correspond to the muscles of the ventricular wall which pull the valve shut as represented by the horizontal line between the pulleys. The subsequent contraction of the papillary muscle, represented by the central weight, P, causes the valve to open triangularly to a degree determined by the relative tensions in the system.

The three-cusp valves were less actively muscular in operation, but cleverly exploited the particular dynamic properties of the blood in turbulent motion. The key to their operation lay in the reaction of the surging blood to the flask-like neck of the pulmonary artery. As blood poured between the cusps it was progressively constricted by the vessel's neck (Figure 81). 'Its percussion is delivered against a resistant place' and deflected circularly by the curved wall. In keeping with the laws of medieval dynamics, the blood 'wants to maintain its impetus along the line of the beginning of its revolving motion' (W.19117v). The primary vortices — inexorably expending their impetus as they must — turned back into the cusps, swirling circularly within them and inflating them in such a way as to fill the pulmonary aperture. He typically provided the reader with cross-references to his books on dynamics, such as 'the 6th on the percussion of liquids' and 'the 4th on revolving motion'. The principles of revolving motion involved such matters as the spirally rolling hemisphere (see Figure 79).

Fig.78 *Construction of a Spiral*, based on G.54v

Fig.79 *Spiral Path of a Rolling Hemisphere*, based on E.34v

Fig.80 *Mechanical Analysis of the Operation of the Ventricular Valve*, based on W.19074v

U and V weights corresponding to the pull of the ventricular walls
P weight corresponding to the pull of the papillary muscle

Fig.81 *Vortices of Blood within the Neck of the Pulmonary Aorta*, based on W.19117v

Ultimately, the beguiling goal of his late anatomies — the marriage of organic complexity and mathematical certainty in the context of mechanical law — proved to be elusive for the most part. But this did nothing to shake his belief in the absolute necessity for such an approach towards the science of the human body, or indeed to any other science. With the more obviously mechanical systems invented by the human engineer the goal seemed rather more attainable: 'Mechanics is the paradise of the mechanical sciences, because with it one comes to the fruits of mathematics' (E.8v). A simple mechanical problem, such as that of balances, appeared to be an utterly obvious instance of applied mathematics, and this is precisely how he had earlier treated it (see Figure 33). But things were no longer quite as simple as this. What he came to realize was that the relationship between mathematical theory and practical realities was far from straightforward — even in the case of the simplest mechanical systems.

> The science of weights is led into error by its practice, and in many instances practice is not in harmony with this science nor is it possible to bring it into harmony: and this is caused by the axis of balances... which according to the ancient philosophers were placed by nature as poles of a mathematical line and in some cases as mathematical points, and these points and lines are devoid of substance, whereas practice makes them possessed of substance (C.A.93vb).

This argument relied upon his increased awareness of the distinction between incorporeal mathematics and material existence: 'There is an infinite difference between the mechanical point and the mathematical point, because the mechanical is visible and consequently has continuous

magnitude and everything continuous is infinitely divisible. The mathematical point on the other hand is invisible and without magnitude and where there is no magnitude there is no division' (C.A.200rb). Not only would the axes of an actual balance possess their own weight but this weight would not act uniformly as soon as the balance began to tilt. Using a diagram which exaggerated the material thickness of a balance arm for the sake of clarity (Figure 82), he explained that the difference between the 'mathematical centre' (s) and the 'centre of revolution' (f) of the balance arm (a b c d) would mean that 'the balance does not have all its natural weight on the centre of its revolution, but it has as much less weight as the upper arm slants' (E.58r). This progressively eccentric action of the weight around the pivot of the balance will clearly throw all the paper calculations out of true.

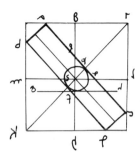

Fig.82 *Analysis of the Effects of a Balance Arm,* based on E.58r

In other aspects of mechanics we can witness a comparable intrusion of physical complications into his previously tidy world of causes and effects. His earlier law of conservation of impetus in bouncing (see Figure 26) was decisively refuted: 'The percussion of the incidence, made upon the dense object, diminishes in part the impetus united to this mobile object', as can be clearly demonstrated 'if you measure the movement. . . made without incidence and the movement produced by many bounds up and down' (F.75v). He also became more conscious of the frictional factors which consume impetus. Three types of friction were involved: 'simple', resulting from the dragging of one material against another; 'compound', caused by contact with two different surfaces; and 'irregular', produced by the edges and irregularities of the moving object. The resistant medium was a further factor which entered the equation more insistently in his late mechanics:

> The force of the mover ought to be always in proportion to the weight of the whole mobile object and to the resistance of the medium in which the weight moves. But one cannot deduce the law of this action unless one first gives the quantity of the condensing of the air when struck by any mobile object whatever; and the condensing will be of greater or lesser density according to the greater or lesser speed of the mobile object compressing it, as is seen in the flight of birds (E.28v).

We will find such physical complications arising again and again in his late science.

Leonardo's greater consciousness of the many natural resistances to force led him to qualify the Aristotelian ratios of power, time, distance and weight, the direct ratios we have earlier seen him adopting, criticizing and readopting. In Manuscript F, having reiterated the rules dealing with the consequence of halving the weight of a mobile object, he added the qualification that 'if a force move a body in a certain time over a certain distance, it is not necessary that this power move twice this weight in twice this time over twice [sic] the distance, because it might be that this force would not be sufficient to move the mobile object' (51v). Similarly, he acknowledged that half the force might not be able to move the original weight at all. In fact, these qualifications were precisely those made by Aristotle himself, qualifications which were generally overlooked in the late medieval demolitions of Aristotle's ratios and ultimately rendered irrelevant by the more sophisticated exponential formulae of Buridan. I suspect that this return to the authentic Aristotle owed as much to his incomplete knowledge (or understanding?) of late medieval dynamics as to any conscious desire to revive the 'true doctrines of the ancients' in a Rennaissance manner — although this latter motive would be consistent with the open classicism of his late mathematics.

The old Aristotelian problem of a projectile's continuing motion also persisted in bothering him, and the apparently discredited doctrine of antiperistasis obstinately refused to go away. 'The adversary. . . says that the impetus which moves the mobile object is in the air which surrounds it from the middle backwards' (G.85v). At first sight his late rejection of the 'adversary's' opinion appears to be such as to allow no room for his previous compromises. In accordance with his avowed method, he quoted 'experience' in framing his arguments. To answer the question as to 'whether the movement of the air is as swift as its mover', he cited the evidence which 'experience shows us when the horse runs along dusty roads': 'the air will never possess a swiftness equal to that of its mover, and this is shown to us by the movement of the dust...which follows the horse, for after having moved a short distance it turns back with an eddying motion and thereby consumes its impetus' (E.80r). He also studied the aerial motions behind moving objects by watching 'the atoms [of dust] which are found in the circular rays of the sun when they penetrate through some window into a dark place' (F.74), a reference which recalls the 'atomism' of Epicurus as expressed in Lucretius' *De rerum naturae.* However, there is no evidence that Leonardo ever seriously considered adopting the basic tenets of classical 'atomism', and the form of his analogy suggests that his actual source was Isidore of Seville's popular seventh-century encyclopedia, the *Etymologiae.* Isidore compared the atoms of Epicurus to 'those tiny dust particles which are visible in the rays of sun passing through a window' (13, ii, 1).

The result of Leonardo's investigations was an axiom which stated that 'impetus is that which under another name is termed derived movement. . . In no part of this derived movement will one ever find a velocity equal to that of the primary movement' (G.85v). It should, therefore, be axiomatic that the 'derived' motion of the air 'does not push the mobile object when it is separated from the power of its mover' (Leic.29v). In his most extended argument against antiperistasis he bombarded his 'adversary' with a fusilade of axioms: 'The reflection of anything is always of less power than its incidence'; 'No mobile object moves of itself unless its members exert force on other bodies outside it'; 'The potency of the mover is separated entirely from the mover and transferred to the body moved by it, and goes on to consume itself in the course of time in penetrating the air which is always compressed by the mobile object'; 'Every impression is preserved for a long time in the object on which it is impressed'; 'Every natural act is communicated from the agent to the object in the shortest possible time'; 'Never in the same time will the greater power be overcome by the lesser power'; and 'It is impossible that at one and the same time the mover should move the mobile object and the mobile object move its mover'. Having unleashed this fusilade, he triumphantly concluded that 'the mobile object does not move on account of the wave of air created by the impetus of the mover', adding a philosophical coda to the effect that 'It is impossible that anything of its own can be the cause of its own creation; and those things which are of themselves are eternal' (Leic.29v).

Although his reasoning pursued a characteristically meandering course, its gist is quite clear and corresponded in general terms to the medieval grounds for rejecting antiperistasis. However, a continuing role for the medium was not completely eliminated in Leonardo's theory. If the medium could not actually push harder than the original force, its motion could still facilitate the maintenance of the impetus. In one of his last thoughts on the matter he wrote, 'Impetus is the impression of local movement transmitted from the mover to the mobile object and maintained by the air or by the water as they move to prevent a vacuum' (C.A.168vb). Water and air act differently, however, 'because air is condensable to infinity and water is not'. The velocity of the air which rushed into the space behind the object was greater than that of the compressible air in front, and this encouraged the object's forward motion. Incompressible water necessarily moved at the same speed in front and behind, lending less assistance to impetus. To support this interpretation he could point to the demonstrably quicker death of an object's impetus in water than in air.

Armed with this knowledge of natural causes, the designer of boats could act accordingly:

> Three ships of uniform breadth, length and depth, when propelled by equal powers, will have different speeds of movement [Figure 83]; for the ship which presents its widest part in front is swifter, and it

resembles the shape of birds and fishes such as the mullet. And this ship opens with its sides and in front of it a great quantity of water which afterwards with its revolution presses against the last two-thirds of the ship. The ship *dc* does the opposite, and *fe* has a movement midway between the two above (G.50v).

Not surprisingly, an erroneous theory has erroneous implications in practice.

Fig.83 *Hydrodynamic Design of Boats and Fishes,* based on G.50v

Although Leonardo's late theory of motion was in the main equivalent to impetus mechanics, it thus retained substantial vestiges of classical Aristotlianism. Only rarely did he adopted an argument from the medieval texts in more or less unabridged form, but only when he did so can we identify his likely source. One of these instances is his analysis of compound motion in a projectile fired from a moving base. He opened his discussion with a consideration of the Ptolemaic problem of an arrow shot from a moving ship, first in the same direction as the ship's motion and then against it (G.54r). He then turned his attention to the related question of an arrow shot from the rotating earth. If an arrow is fired vertically upwards from the revolving world, why does it return to precisely the same place?

> The arrow shot from the centre of the earth to the highest point of the elements will ascend and descend by the same straight line, although the elements may be in rotation around the centre. The gravity which descends through the elements when they are in rotation always has its movement correspond to the direction of the line which extends from the commencing point of the movement to the centre of the world (G.54v). . . it comes about that a stone thrown from a tower does not strike the side of the tower before reaching the ground (G.55r).

The fall is vertical in relation to the revolving spheres of fire, air, water and earth, but relative to exterior space it can be seen to pursue a spiral path. A object which fell for twenty-four hours would make a complete revolution in a spiral judged from a static viewpoint (see Figure 78). His examples and analysis are those which Oresme adduced in favour of the earth's rotation. It is slightly disconcerting to find that Oresme,

having martialled an impressive array of evidence to indicate that the world revolved, did not consider the matter proven. However, the equivocation of Oresme's conclusion did not prevent the efficacy of his 'experimental' arguments from impressing Leonardo.

The subtle duality of a movement which was at once relatively vertical and absolutely spiral is typical of the complicated relativities which operated in natural science. Leonardo saw nature as weaving an infinite variety of elusive patterns on the basic warp and woof of mathematical perfection. Nowhere could nature's endless variations on geometrical themes be seen more marvellously than in the dynamics of water, above all in the configuration of vortices. As a foundation for his studies he outlined a basic classification of natural spirals, the first three of which were variations on the basic schema already illustrated in Figure 78. Altogether, there were 'four varieties, namely convex spiral, planar spiral, concave spiral and the fourth is the columnar spiral' (Figure 84). Each of these possessed its own dynamic properties and reacted to opposing forces in a different way. The peculiar form and efficacy of circulatory force in a vortex came from what he called 'a circumstance worthy of note'; 'The spiral or rotary movement of every liquid is so much the swifter as it is nearer the centre of its revolution', unlike a wheel in which the movement 'is so much slower as it nears the centre' (C.A.296vb). A related peculiarity was the way in which a rapid vortex tends to acquire a void at its centre: 'The lateral weight of the vortex-circulation is two-fold. . . and such duplication of weight firstly comes into being in the revolving movement of the water and secondly is created on the sides of this concavity, supporting itself there. . . It makes the concavity in the form of a pyramid and makes it so much the more swiftly as the pyramid is more pointed'(C.A.296vb). The 'concave spiral' in water thus prettily combined a pyramidal law of the type which had so delighted him in the 1490s with the revolving motion which is found so ubiquitously in his late science. This combination gave the vortex its uniquely concentrated force. The vortex was a natural power-drill, gouging remorselessly into underlying surfaces, sucking fragmented particles into its whirling mass and then projecting them into the surrounding space with violent impetus: 'It strikes and hollows out the bed in a sudden chasm, for, in addition to the force of the impact, there is joined the spiral quality made by the said revolution, by means of which those things disturbed by the impact are stirred up and carried away' (F.17v). This 'spiral quality' could have astonishing effects, both in remorseless power and geometrical regularity: 'Solid rock of Mugnone, hollowed out into the form of vases by the force of the water, is of such precision that it appears to be handiwork' (Figure 85).

If the 'concave spiral' was one of water's most characteristic configurations, it was only one of many. Impetus nowhere had more obviously geometrical consequences than in fluids, but nowhere was its action more subject to a tantalizing variety of intersecting variables. To outline the

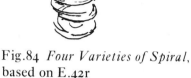

Fig.84 *Four Varieties of Spiral,* Fig.85 *Spiral Erosion of the Rock of Mugnone,*
based on E.42r based on B.L.29v

geometric theory of motion was one thing; to account for the actual configurations adopted by water was very much another. Leonardo's notebooks leave no doubt that he spent many hours contemplating water in motion, either in naturally occurring situations or in circumstances he had himself set up to produce particular kinds of flow. One obvious problem was actually seeing the motions in a transparent medium. To do so he suggested adding to the currents tiny particles such as grass seeds or staining one of two colliding water sources with dye. When he was able to observe the motion in the necessary detail its awesome complexities impressed themselves upon him to an ever greater degree: 'Running water has within itself an infinite number of movements which are greater or lesser than its principal course. This is proved by [watching] the things supported within two streams of water which are the same weight as the water.' The revealed motions of such things were 'sometimes swift, sometimes slow, and sometimes turning to the right and sometimes to the left, at one instant upwards and at another downwards, turning over and back on itself, now in one direction and now in another, obeying all the forces that have power to move it, and in the struggles perpetrated by the mobile forces always as the booty of the victor' (G.93r).

The 'infinite number' of geometrical permutations in moving water by no means persuaded Leonardo to abandon his quest to encompass them within his understanding. Manuscript F, 'begun in Milan on 12th September 1508' (1r), contains page after page dedicated to such matters and comparable discussions feature prominently in the Leicester Codex, probably composed partly in Florence and partly in Milan.

It is not hard to understand the aesthetic qualities which drew him 'to investigate the many beautiful movements which result from the penetration of one element into another' (F.34v). And a number of his analyses

are undeniably impressive pieces of writing. But the total effect of his writings on water is to my mind rather discouraging. An excessive accumulation of descriptive details all but obliterates a framework of dynamic law which could be adequately stated in a fraction of the space. When he proudly informed the reader that 'in these eight pages there are seven hundred and thirty conclusions on water' (Leic. 26v), we may feel that the boundary between dedication and obsession has been overstepped, just as it had been in his most repetitive pages of geometrical variations (Plate 83). We cannot but be grateful, however, that his obsession resulted in one of his most miraculous drawings, illustrated in Plate 84.

The two studies at the top of the page belong to an extensive series dedicated to the turbulent effects of interruption in a fast flow. Sometimes obstructions were placed laterally at the margins of the stream, creating between them a brilliant interlace of curvilinear percussions (e.g. F.89r). In other drawings, as here, rudder-like obstructions cut viciously into the flow at different depths and at different angles with an incredible variety of results. Here the water rushes onwards in a series of gurgling spirals and sweeping curves, like twisted pennants blown in a fierce wind. And the parallels with the natural movement of hair, which we have noticed before, are particularly apparent in the horse's-mane pattern in the second demonstration. The main drawing on the page is less hair-like and more floral in nature, resembling a bouquet of aquatic blossoms, the translucent equivalent of the *Star of Bethlehem* (see Plate 74). It is the most complete of all his water drawings. It is to his hydrodynamics what the 'great lady' anatomy is to his science of the human body, that is to say, a composite study in which causes and effects from many separate analyses are fused together in an astonishing synthesis. A set of drawings in Manuscript F and at Windsor (especially 12661-2) represent preliminary stages in this synthesis, as the components of turbulent water and submerged air unfold at first separately and then in conjunction. He explained that there were three factors to be taken into account: the primary motion of the falling column of water; the secondary motion of the accidentally submerged air; and the reflex motion of the main mass of water in the pool. The vortex patterns of water alone were intricate enough, but the admixture of air bubbles contributed additional complications: 'Of the eddies in water, all those which begin at the surface are filled with air; those which have their origin within the water are filled with water and these are more lasting because water within water has no weight' (C.A.42ra). In the drawing we can see the deeper eddies of 'water within water' happily pursuing their revolving impetuses to uninterrupted conclusions, while those mixed with the bubbles are thrust violently upwards to the surface, where they 'speedily perish' in exploding rosettes.

Leonardo took special pleasure in the behaviour and form of the bubbles:

The air which is submerged together with the water. . . returns to the

air, penetrating the water in sinuous motions, changing its substance into a great number of shapes. . .When the air enclosed within the water has arrived at the surface it immediately forms the figure of a hemisphere, and this is enclosed within an extremely thin film of water. This occurs of necessity because water always has cohesion in itself. . . and this air having reached the opening of the surface of the water and not finding there any weight of water to press it upwards, raises its head through the surface of the water with as great a weight of water joined to it as the said tenacity can support; and it stops there in a perfect circle as the base of a hemisphere, which has the said perfection because its surface has been uniformly expanded by the uniform power of the air.

The bubble settles as the impetus of its emergence is expended, and 'because the part of the water with which this air is clothed is heavier where it is more perpendicular to the centre of the circle which forms the base of the hemisphere. . . it lowers itself more' at the top of its curve, in accordance with the rule 'that part of a thing supported at its extremities is so much weaker as it is more distant from its foundation'. This less than hemispherical profile is structurally unstable, and it eventually 'breaks. . . in the third part of its curve; this is proved with the arches of walls, and therefore I will not treat of it in these notes, but will place it in the book where it is necessary' (Leic. 25r). We have seen many such analogies between the worlds of the natural and human engineer, but none is more delightful than this analysis of an air-bubble's fragile architecture.

Such considerations of hydrodynamic turbulence, 'infinite' though they were, only comprised the first of fifteen projected sections in an extensive treatise on water in all its aspects:

> Book 1 of water in itself; book 2 of the sea; book 3 of underground channels [vene]; book 4 of rivers; book 5 of the nature of the depths; book 6 of the objects [obstructions etc.]; book 7 of gravels; book 8 of the surface of water; book 9 of the things which move in it; book 10 of the means of renovating rivers; book 11 of conduits; book 12 of canals; book 13 of machines turned by water; book 14 of how to make water ascend; book 15 of things which are consumed by water (Leic. 15v).

Needless to say neither this exhaustive treatise nor the alternative schemes outlined elsewhere in his late manuscripts were brought to conclusion, and the surviving notebooks do not contain any single 'book' which can be regarded as complete. However, some of the pages in the Leicester Codex, containing large blocks of continuous text and neatly disposed illustrations in the margins can be taken to indicate the kind of work he had in mind. The pattern of his projected treatise is clear from the headings; it was to progress from 'pure' hydrodynamics, through the geographical study of the earth's irrigation, to questions of hydraulic engineering, military and civil. He intended to explain, for example, 'how

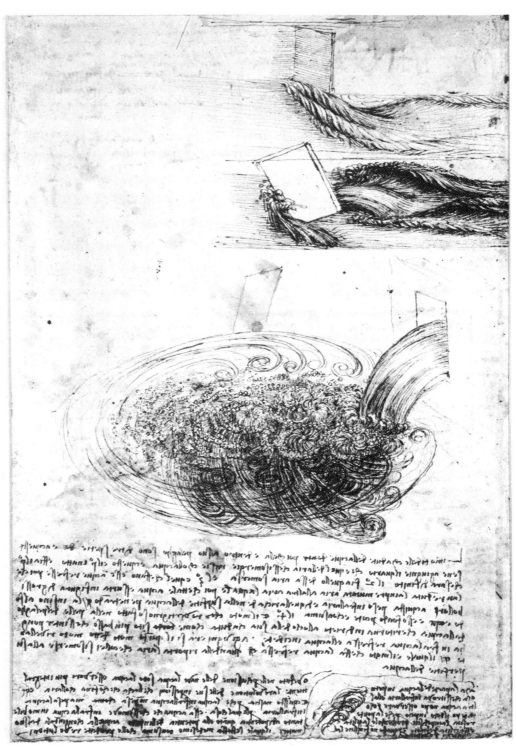

Pl.84 *Studies of Hydrodynamic Turbulence* (*c.* 1508-9), pen and ink, Windsor, Royal Library (12660v)

a river may be diverted by a few stones if one understands the line of its current' (Leic.27v), using the corkscrew vortices to work on man's behalf, in contrast to the labour-intensive efforts of the Florentines to divert the Arno. The power which could be placed in man's control was immense. It was a power which promised untold benefits but also threatened untold harm in the wrong hands. One of his inventions, which enabled men to swim under water, he hesitated to 'divulge, on account of the evil nature of those men' who might put it to destructive use in sinking boats (Leic.22v).

Over one-quarter of his treatise was to be devoted to the geography of water. This topic occupies the greater part of the Leicester Manuscript, a codex composed from thirty-six large folios which contain sustained discussions of a type paralleled only in his late discussions of the heart and less consistently in his *paragone*. In these extended debates he was taking up questions which had provided considerable bones of contention in classical and medieval science. An impressive roll-call of classical authorities contributed to his education in physical geography. Heading the list was Aristotle, whose *De caelo et mundo* and *Meteorologica* were well known to him; a section from the latter concerning the Sea of Azov, the Black Sea and the Mediterranean was extensively paraphrased in the Leicester Codex (31v). The work of Aristotle's successor, 'Theophrastus, on the ebb and the flow and on vortices and on water' is also mentioned in the same manuscript (16v). Pliny's encyclopaedic *Natural History* was a favourite source, and he was well aware of the important geographical texts by Ptolemy and Strabo. Of the subsequent Arabians, he certainly encountered Avicenna and Averroes, although largely through intermediaries in the medieval West. In medieval Europe itself the debates centred upon Aristotle's writings, particularly *De caelo et mundo* which was the subject of important commentaries by Albertus Magnus, Buridan and Albert of Saxony among others. On the inside of the front cover of Manuscript F, as part of a list which includes Aristotle's *Meteorologica* and 'Archimedes on the centre of gravity', Leonardo included 'Albertuccio' [Albert of Saxony] and 'Albertus [Magnus] de celo e mundo'. To this already extensive collection of sources we can add Ristoro d'Arezzo's *Della composizione del mondo,* already encountered as a source for the microcosmic analogy, and Pietro d'Abano's *Conciliator differentiarum philosophorum et precipue medicorum,* which includes a section 'on the ebb and flow of the sea' (W.19092v). There probably is no other field in which Leonardo's knowledge of classical and medieval sources was so extensive.

The inevitable foundation for his studies was the configuration of the four elements, fire enclosing air enclosing water enclosing earth. Plato, as Pacioli recorded in *De divina proportione,* had conceived a scheme in which the elements corresponded to the shape of the geometric bodies — cube for the earth, icosahedron for water, octahedron for air and pyramid for fire. Leonardo made a rough and somewhat inaccurate sketch of this system (Figure 86) and surprisingly took the trouble to defend it 'against those

Fig.86 *The Platonic Configuration of the Elements and the True Configuration*, based on F.27r

Fig.87 *Cross Section of the Earth with the Sphere of Water*, based on Leic.31r

who deny the opinion of Plato, who say that if the elements clothe one another in the shapes given by Plato they would cause a vacuum between one and the other'. He argued that the fluidity of water, air and fire would ensure that the intervening spaces were filled. However, as he immediately proceeded to point out, Plato was also in error, because in reality the flexible elements automatically adopted spherical configurations around their centre of gravity (Figure 87). He supported his opinion with a nice observation:

> A drop of dew with its perfect curvature affords us an opportunity to consider. . . how the watery sphere contains within itself the body of the earth without the destruction of its sphericity of surface. If you take a cube of lead the size of a grain of millet, and by means of a very fine thread attached to it you submerge it in this drop, you will perceive that the drop will not lose any of its original roundness, although it has been increased by an amount equal to the size of the cube which has been shut within it (F.62v).

If we extend this analogy by imagining the extreme corners of a larger cube jutting through the boundaries of the watery sphere, we have a situation analogous to those portions of the earth which project above the waters. Elsewhere Leonardo himself used the image of a pyramid within the watery sphere to make precisely this point (Figure 88).

The situation was not, however, as stable as these analogies might suggest. Not only was the shape of the earth irregular, but its composition

Fig.88 *Diagram of a Pyramid Partially Surrounded by a Sphere of Water*, based on Leic.35v

was not uniform. Its substance was of variable density and it contained within itself asymmetrical cavities full of mobile water, steam and air. Though the total system of the world — the earth enclosed by its elemental spheres — possessed a single centre of gravity, this centre did not correspond to the centre of the uneven earth's magnitude (Leic.35v). Returning to the geometrical analogy, he explained that 'If the centre of gravity of a pyramid is placed at the centre of the earth, the pyramid will change its centre of gravity if it is subsequently covered in part by the sphere of the water' (F.69v). This degree of disjunction between the two centres was not constant, because cycles of erosion and accretion on the earth continually altered the asymmetrical balance. Waters from the highest regions descended to the lower, carrying with them eroded soil. These waters naturally congregrated on the side of the earth which was predominantly lower and largely covered by water, making this side progressively heavier. The consequence was that the higher, lighter regions were thrust even further from the centre of gravity: 'The earth of our hemisphere became raised up more than it was before as by degrees it became lightened by the flow of water away from it through the Straits of Gibraltar; and it was raised so much the more because the weight of the water which flowed away from it was added to that of the earth which was turned to the other hemisphere' (Leic.8v). Eventually the Mediterranean will 'reveal its bed to the air and the only water-course remaining will be a very great river' (Leic.20r).

This analysis of the earth's shifting balance was substantially based upon Buridan's *Questions on Aristotle's 'On the Heavens and Earth'*. Buridan's explanations were adopted by Albert of Saxony, who almost certainly provided Leonardo's direct source. If it should seem that the ultimate consequence of their theory would be that the high ground must always become higher, Buridan explained that 'parts are constantly removed from it [by erosion] and carried in the opposite direction'. Leonardo believed that the earth's unstable and apparently irregular configuration was in fact governed by a constant relationship in volume between the projecting and submerged parts:

> I consider that the highest mountain there is on the earth is as far above the surface of the sphere of the water as the greatest depth of the sea is below the surface of the sea. It follows therefore that if one were to fill up the part wanting in the sea with the excess of earth, the earth would remain entirely spherical and covered by the sphere of water (Leic.35v).

The natural processes of elevation and depression, adding and taking away, were therefore performing continuous cycles of 'transformation' in a manner precisely analogous to his geometrical transformations of one shape into another of equal volume.

These gradual, inexorable and ultimately immense transformations of land mass provided, to Leonardo's way of thinking, a far better

explanation for fossilized sea creatures on high land than the Biblical Deluge. He had long been fascinated by the layered strata of shells revealed by the erosion of mountains and cliffs. In his first thoughts on the matter he wrote that on account of 'the two layers of shells it is necessary to say that the earth was indignantly submerged under the sea and made the first layer, and the deluge made the second' (B.L.156v, written about 1481). By the time he came to compile the Leicester Codex he had completely eliminated the Deluge as an 'efficient cause' of high fossils. The properties of the Biblical Deluge and the observed facts were irreconcilable in a number of ways: if the Deluge had been the agent, there should be records of sea creatures at the very top of mountains; the Deluge would not have caused the layered distribution of shells in strata at particular levels; the successive strata indicate 'more than one great inundation'; the relatively short duration of the Deluge would not have allowed time for the slow cockle to have moved so far from the sea; the retreat of the Deluge should have stranded sea creatures in the high lakes; and it could not be argued that the fossils were dead animals washed there by the Deluge, because the strata contain evidence that the creatures were alive (Leic.8v-9v). Those who expressed contrary ideas merely showed their 'silliness and stupidity', as did that 'other sect of ignoramuses who declared that nature or the heavens had created them by celestial influences' (Leic.10r).

One of his discussions of the fossil record contains a particularly nice and revealing story: 'In the mountains of Parma and Piacenza multitudes of shells and corals filled with worm holes may still be seen adhering to the rocks, and when I was working on the great horse at Milan a large sack of these . . . was brought to my workshop by some peasants and among them there were many which were still in their original condition' (Leic.9v). The peasants obviously knew that Maestro Leonardo was interested in such things and presumably anticipated that he would reward their efforts in a suitable manner.

That geographical flux had occurred, was occurring and would continue to occur was demonstrable. But what caused the movement of the waters in and around the body of the earth? In relation to the tides he asked 'whether the flow and ebb are occasioned by the moon and sun or by the breathing of the terrestrial machine' (Leic.17v). He was unable to reconcile the former possibility with the observed facts and he therefore sought an explanation within the breathing body of the earth itself. The world was envisaged as criss-crossed by circulatory systems of channels (see Figure 87): 'Here it is imagined that the earth is sectioned through the middle, showing the altitudes of the sea and earth; the veins arise from the beds of the seas [Figure 89] and intersect the world and ascend to the mountains and travel back again to the rivers and return to the sea' (Leic.31r). Mountain springs were explained by analogy with 'the blood of animals which is always transported from the sea of the heart to the summit of their

Fig.89 *Subterranean Water Course Arising from the Bed of a Lake*, based on G.48r

heads, and when one ruptures a vein, as when a vein is ruptured in the nose, it will be seen that all the blood from below is raised to the height of the ruptured vein' (Leic.21v). A suitable analogy from the world of plants was the way in which sap oozed from the top of a severed vine (B.L.233v). This explanation had appeared in basically the same form during the 1490s (e.g. A.55v-56v, H.77r and 101v) and continued to appear regularly before 1510 (e.g. B.L.58v-9r and 233r and Leic.21v). This concept of water as 'the vital humour of the arid earth' (B.L.236v) was not unfamiliar, and Leonardo undoubtedly knew Pliny's version: 'Water penetrates the earth everywhere, inside, outside, above, along connecting veins running in all directions and breaking through to the highest mountain summits, where it gushes as in siphons, driven by the pneuma and forced out by the weight of the earth.' Leonardo set his Plinian theory in opposition to those who contended that the surface of the oceans rise at their centres 'higher than the highest parts of the mountains' thus producing the head of water necessary to activate the mountain springs (A.56r and 58v). This 'common opinion, which is contrary to the truth', had been formulated by Averroes and was widely repeated during the Middle Ages.

About 1508, however, doubts began to enter his mind as to whether mountain springs were caused by a circulatory process analogous to blood in animals and sap in plants: 'You who have discovered such an invention must necessarily return to the study of natural things, for you will be found lacking in cognate knowledge, and of this you will have made great provision by the property of the friar of which you have come into

possession' (F.72r-v). The 'property of the friar' should probably be identified as one of the items listed on the cover of the same manuscript: 'Albertus *De caelo et mundo*, from Fra Bernardino.' As he restudied the analogies, certain discrepancies became apparent. Whereas the veins of man narrow with age, as the centenarian dissection had revealed, 'the concavities of the hollows of the veins of the earth are enlarged by the prolonged and continuous passage of water' (F.1r). Even more fundamentally, he realized that 'the origin of the sea is contrary to the origin of the blood, because the sea receives into itself all the rivers which are only caused by the water vapours raised into the air', while the 'sea of blood' arises within the veins (W.19003r). This unsettling realization, which came to him about 1510, forced him to seek a different explanation for the gushing of water from high springs. He considered the possibility, as suggested by Pliny, that the rivers running down the sides of mountains create an effect analogous to that of a siphon, but concluded that 'this cannot be, because the siphon requires a fall deeper than the surface of the sea, which is impossible' (G.70r). He now considered that 'the oceanic sea cannot penetrate from the bases to the summits of the mountains ... but only ascends as far as the dryness of the mountain attracts it' (G.70r). There is something heroic in this rejection of a theory which he had cherished for so many years. cherished for so many years.

Where did this leave the macrocosm? It was literally left without a heart. The analogy has been deprived of its life-blood. Leonardo did not spell out these consequences, but he was unquestionably aware of them. What happened in his thought after 1510 was that the picturesque analogy which he had held so dear was replaced by a less simplified system in which all the various bodies of nature in all their infinite variety were perfectly created to perform their infinitely varied functions in the shared context of universal law. It was in this shared context that the unity of man and the earth resided. The most fundamental causes were common to all things, but only when analogous functions were to be performed would analogous effects be made by formative nature. Each case had to be proved on its individual merits, because the analogies could no longer be taken as read. There were no There were no intellectual short cuts in the exploration of form and function in the bodies of man and the earth.

Only when man had achieved a perfectly detailed understanding could he hope to exploit natural causes and effects to the full. In his efforts to manipulate turbulent water, Leonardo must have envied the fish, with its instinctive command of hydrodynamics. And the motion of air was every bit as complex as that of water: 'In order to give the true science of the motion of birds through the air it is necessary first to give the science of the winds, which will be proved by means of the motion of water within itself' (E.54r). 'Write of swimming under water and you will have the flight of the bird through the air' (C.A.214rd). In Manuscript E, composed in 1513-14 and the last of his surviving notebooks, he took the already

complex analyses on the 1505 treatise 'On the Flight of Birds' an intricate stage further, reaching a point equivalent to his late hydrodynamics and geometry. One example will suffice to show the characteristic way in which his intricate expositions of particulars is laced with axioms of a general nature:

> The curve which is created in the extreme parts of the wings when these wings strike and press upon the air which is condensed beneath them has the effect of greatly increasing the bird's power of flight, for in addition. . . they compress the adjacent lateral air, by the 4th of the 2nd which states that 'every violence seeks to undo itself on the very lines of the movement which has produced it', and by the 7th 'every straightness which is bent by force has the lines of its power converging on the centre of a complete circle formed by the curve commenced by the extremity of this wing' (E.47v).

The accompanying diagram (Figure 90) shows the 'bent straightness' of the compressed air and the 'lines of power converging' on one of the wing tips.

Fig.90 *Compression Waves below a Bird's Wings*, based on E.47v

Although the turbulent powers of nature could be judiciously exploited by bird and man alike, all too often the elemental forces ran out of control, occasioning prodigies of nature before which man and the animals were powerless. During this period he keenly collected records of such prodigies, either on the basis of his own experiences or from hearsay. Into the latter category come his account of a terrible earthquake which temporarily swallowed the 'sea of Satalia near Rhodes' in 1489 (Leic.10v), and probably also his record of a forest which sank into an abyss in Savoy, accompanied by the effusion of a great flood four miles away (Leic.11v). On his own behalf he observed a 'cloud shaped like a huge mountain' over Milan which caused a 'stupendous storm of wind' (Leic.28r), and a 'hollow column of air' which excavated considerable quantities of stones, sand and seaweed. His description of a tornado gives a good idea of the tone of these accounts: 'I have seen motions of air so furious that they have gathered up and mingled in their course the largest trees of the forests and whole roofs of great palaces, and this same fury made a hollow opening with its vortex motion and excavated a gravel pit and transported gravel, sand and water more than half a mile through the air' (F.37v).

Leonardo's fascination with the terrestrial machine running turbulently amok reached its astonishing climax in a series of literary and visual images from the period of Manuscript E, that is to say about 1514,

or perhaps a little later. Under the heading 'The Deluge and its demonstration in painting', he composed an extended description of considerable power. It begins,

> Let the dark and gloomy air be shown battered by the rush of contrary and convoluted winds, mixed with the weight of the incessant rain and bearing hither and thither numberless branches rent from trees and mingled with numberless leaves. . . The ruins of mountains may be seen, already scoured by the racing of the rivers, collapsing above these rivers and blocking the valleys; the pent up rivers burst forth and inundate many lands and their inhabitants. . . (W.12665v).

A short excerpt, which is all that is possible here, does scant justice to the cumulative force of Leonardo's description. Any reader who wishes to savour his compulsive and compelling evocation of nature's power is recommended to read the complete account; it is conveniently available in all the standard anthologies.

The description's visual counterpart is the set of 'Deluge Drawings' at Windsor, sixteen in all, of which eight form a coherent group from the same period as his description (12377-8, 12380 and 12382-6). They are predominantly drawn in grainy swirls of sombre black chalk (Plate 85), but one has been given a disturbing degree of definition by pen-work in brown and yellowish inks (Plate 86). Near the top of the inked drawing, almost obscured by the murky effusions, he has written: 'Of clouds — make the degrees of rain falling at different distances of different obscurities, and the greater obscurity will be nearer the middle of its thickness.' The cool, distancing tone of this memorandum, as it drily records the optical effects of falling rain, is far from exceptional in the notes associated with the Deluge drawings. A page containing violently apocalyptic scribbles of a 'Last Judgment' and related cataclysms carries a note which carefully analyses the optical effects of illuminating a storm cloud from different directions (W.12388). His stirring description of the Milanese storm cloud is preceded by a meteorological analysis of wind formation, in which he concluded that 'it is necessary for a great quantity of air to rush together in order to create a cloud, and since it cannot leave a vacuum the air rushes in to fill up with itself the space left by the air first condensed and then transformed into a dense cloud' (Leic.28r). And most notable of all, the 'description of the deluge' on the *recto* of the Windsor sheet is couched in terms of the hydrodynamic laws with which we are already familiar:

> The swollen waters gyrate within the lake which contains them, and with eddying vortices percussively strike diverse objects, and leap into the air with muddy spume, and then falling back and making rebounds in the air with the percussed water. And the circular waves which fly from the place of percussion march with transverse impetus against the motion of other circular waves which move in opposition to them, and after making their percussion they leap up into the air without being separated from their bases...If the waves encounter various objects,

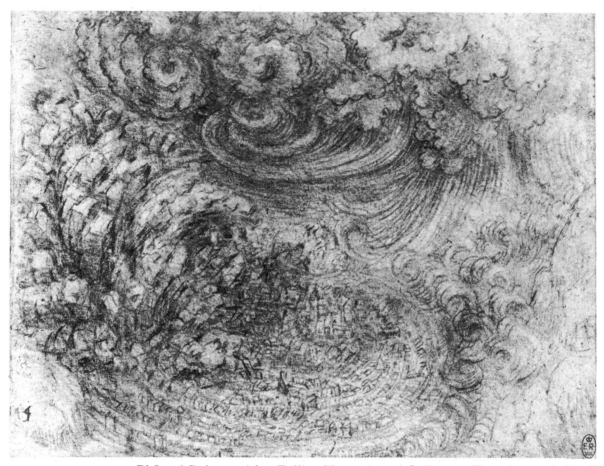

Pl.85 *A Deluge, with a Falling Mountain and Collapsing Town* (*c.* 1515), black chalk, Windsor, Royal Library (12378)

then they return in direct opposition to the blowing of the other winds, observing the same increase in curvature which they would have originally acquired in the observation of their principal motion (12665r).

As the description proceeds, so it is typically interspersed with axioms: 'The angle of reflection will equal the angle of incidence'; and 'The revolution of water in its parts will be so much faster as they are closer to the centre'.

These are extraordinarily intellectual means towards what we may irresistibly feel to be furiously expressive ends. If the balance in the formalized drawing is tilted away from expression and towards an analytical goal, akin to his water researches, the predominant tone of the series is inescapably menacing in the darkest possible manner. The percussive vortices of his dynamic theory have acquired terrifyingly emotional dimensions. They are the ultimate manifestations of his earlier

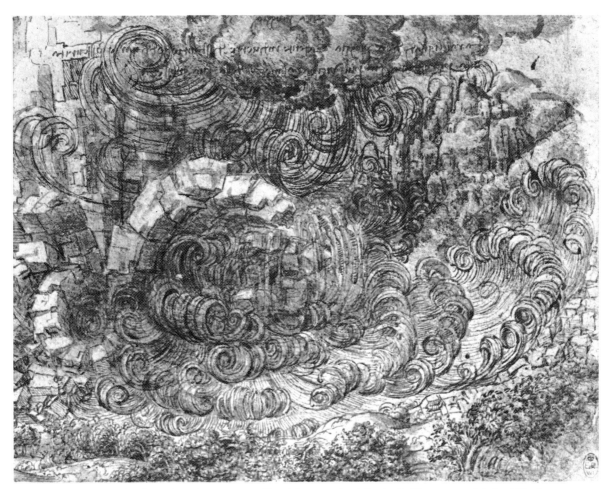

Pl.86 *A Deluge, Formalized* (*c.* 1515), black chalk, pen and ink, Windsor, Royal Library (12380)

trembling before 'the awful ruin, the inconceivable and pitiless havoc wrought by the deluges of ravening rivers, against which no human resource can avail' (C.A.108vb). Human victims seldom figure in the Deluge drawings (12376 is an exception), because the scale of the cataclysms is such as to render man obviously and disturbingly irrelevant. The fragile township in Plate 85, which is clawed to pieces by whirling torrents before its final immolation by the collapsing mountain, is a clear indication of man's helplessness in the face of elemental flux. We can only pity the human race in its vunerability:

> O how many might be seen closing their eyes with their hands to block out the immense rumbles made in the lowering air by the fury of the winds mingled with rain, the thunder of the heavens and the fury of the thunderbolts; others, finding it is not enough to shut their eyes, laid their hands one over the other to cover them more closely so as not to

> see the cruel slaughter made on the human species by the wrath of god.
> O how many lamentations and how many flung themselves from the
> rocks in terror! (W.12665v).

The hideous giant who ravaged the world in his letter to Benedetto Dei has
been replaced by the forces of nature herself. And in becoming more
credible the agent of destruction has become all the more terrifying.

His attribution of this orgy of destructive violence to the 'wrath of
God' highlights a question which may have already occurred to the reader:
do Leonardo's prescriptions and representations relate to the Biblical
Deluge? Or do they deal with entirely independent phenomena? There is
no conclusive evidence either way. The first thing to say is that his
arguments against attributing fossils to the Deluge cannot be taken to
mean that he rejected the truth of the Biblical narrative. He did not
suggest that the Biblical Deluge had not occurred but argued that it was
not itself responsible for some of the effects with which it was often
credited. It may be significant that his late prescriptions refer to '*the*
deluge', while he had previously described the depiction of '*a* tempest'
('*una fortuna*', Ash.II, 21r), '*a* gale' ('*uno vento*', B.L.169r), '*a* downpour'
('*una pioggia*', B.L.169r) and '*a* night scene' ('*una notte*', Ash.II, 18v). The
written account on the *verso* of the Windsor sheet (12665v), which
emphasizes the human aspects of the tragedy — 'others, throwing
themselves on their knees, commended themselves to God' — is closest in
spirit to the Deluge as normally represented. Indeed the description as a
whole reads like a critique of Michelangelo's meteorologically sterile
version on the Sistine ceiling. The brilliant strengths in figure-work and
almost hilarious weakness of atmospherics in Michelangelo's *Deluge* may
well have provided the stimulus for Leonardo's alternative visions.

A reference in Manuscript G to 'the depiction of the deluge' suggests
that the Biblical Deluge was not the only one in his mind: 'Neptune will be
seen in the midst of the waters with his trident, and let Aeolus and his
winds be seen, enmeshing the floating and uprooted trees in the immense
waves' (6v). This is recognizable as the *Quos Ego*, the incident from the
first book of Virgil's *Aeneid* in which Neptune calmed the storm generated
by Juno against the sea-born Trojans. The *Quos Ego* had probably already
provided the subject of his *Neptune* drawing for Antonio Segni. Certain
details of the victims' plight in the literary description (and in the drawing
on W.12376) also strongly recall the famous description of a deluge in
Ovid's *Metamorphoses*, a copy of which Leonardo owned. The Renaissance
itself provided a number of accounts comparable to the prodigies de-
scribed by Leonardo. Historians, chroniclers and diarists such as
Giovanni Villani, Giovanni Rucellai, Luca Landucci and Niccolò
Machiavelli recorded meteorological disasters with an assiduity which
reflected more than a common curiosity in natural phenomena. The
Renaissance and antique authors shared, in one way or another, a belief
that prodigies of nature 'meant something', that they were occasioned by

an external power to provide a lesson for mankind in general or for a particular segment of mankind. The classical deluges of Virgil and Ovid overtly served such a purpose, as of course did the Biblical exemplar. Conceptions of the *deus ex machina* ranged from the gods of classical antiquity and Christianity to the more abstract *fortuna* of Machiavelli, but in every case there was a power at work outside the actual physical processes involved.

I do not believe that Leonardo deviated from this habit of mind. In one of the earliest Deluge drawings Ovidian wind gods are specifically depicted (W.12376), and his later elimination of such visible 'causes' does nothing to weaken the impression that some extraordinary agent is involved. Indeed, the basically Aristotelian dynamics which he adopted presupposed that motion could only be given to an inert body by an external agent, since rest was the natural state. Even if particular objects, such as the gravel tossed hither and thither in a tornado, were set in motion by obviously physical causes, these causes themselves required explanation — and so on. The inescapable consequence of any series of causal explanations was the need for an ultimate cause — the 'unmoved mover' of Aristotelian cosmology. The 'unmoved mover' was manifested in the *primum mobile* ('prime mover'), the outermost sphere of the physical universe and the initiator of universal motion. The 'prime mover' was the metaphorical hand which stirred the elements in the universal bucket into revolving motion and simultaneously constrained everything to obey its laws: 'O admirable justice of thine, prime mover; you have not willed that any force should lack the order or quality of its necessary effects' (A.24r). As we will see, Leonardo was not interested in defining the agent which motivated the 'prime mover' itself, because he considered this ultimate agent to be indefinable, but its existence was an inescapable consequence of his dynamic theory — the theory which achieved its ultimate expression in his Deluge drawings.

The sphere of the *primum mobile* takes us to the outermost limits of the finite universe. Between the *primum mobile* and the earth's elemental spheres were the eight or more encircling spheres of the planets and fixed stars. Given his taste for universal mathematics in general and dynamic geometry in particular, we might expect Leonardo to have devoted considerable attention to astronomy. He was well aware of the Ptolemaic tradition with its sophisticated exposition of planetary motions and he undoubtedly held mathematical astronomy in high regard, in contrast to his disdain for predictive astrology. Among the items in his Madrid booklist (II, 2v) we find: Ptolemy's *Cosmography;* a work by the Arabian Astronomer, Albumasar; a *Sphera mundi,* either Sacrobosco's Ptolemaic treatise or Goro Dati's *La Spera;* and a book on the quadrant. He also mentioned a number of other astronomical sources, including Cleomedes (C.A.141v) and the inevitable Aristotle, together with Aristotle's medieval commentators. But his own astronomical writings were almost entirely

limited to questions arising from the visual perception of the heavenly bodies, so that his astronomy may not unfairly be described as the handmaiden of his optics: 'There is no part of astronomy [*astrologia*] that is not a function of visual lines and perspective' (Urb.7v). He was almost exclusively concerned with questions of the bodies' physical appearance rather than with making measured observations of their behaviour. Perhaps he considered that Ptolemy and his commentators had done almost all there was to do in computing planetary motions and dimensions: 'Make a discourse on the size of many stars, following the authors' (F.56r).

The matter which concerned Leonardo most keenly was the transmission of light from one planetary body to another, and particularly the optical properties of the moon. He consistently argued that 'the moon is not luminous in itself' (e.g. A.64r and B.L.94v), because 'it does not shine without the sun'. The moon acts like a 'spherical mirror' (B.L.28r), reflecting the sun's rays earthwards. But it is not a uniform mirror since its surface is marked with irregular patches, and it does not exhibit a shiny highlight like a polished ball. One explanation which 'has found favour with many philosophers, and above all with Aristotle' was that 'the moon is composed of areas of lesser and greater transparency as if one part had the qualities of alabaster and another the quality of crystal or glass' (F.84v). He almost certainly picked up this idea from Albert of Saxony's *Quaestiones de caelo et mundo* (II,24). His own opinion was that the moon resembled the earth in as much as it was surrounded by three elemental spheres — hence the observed 'haloes around the moon' (C.A.349v) — and that it reflected light unevenly from the interrupted surface of its watery sphere. The surface was broken both by the intrusion of land and by the waves in the lunar seas: 'The skin or surface of water which comprises the sea of the moon. . . is always ruffled, little or much, more or less, and this roughness is the cause of the proliferation of the innumerable images of the sun which are reflected in the ridges and concavities and sides and fronts of the innumerable waves.' These 'innumerable images' fuse together on their journey earthwards to produce the patchy radiance. 'This could not be if the sphere of water which in great part invests the moon was of uniform sphericity, because then the image of the sun would be single in each eye and its reflection would be distinct and its shining highlight would always be circular as is clearly taught us by the gold balls placed on the tops of high buildings' (B.L.94v). The principle of multiple radiance from a corrugated surface (Figure 91) was repeatedly stressed by Leonardo in relation to the moon, and it undoubtedly featured prominently in his discussion with 'Maestro Andrea da Imola' (probably Andrea Cattaneo) who falsely contended that 'The solar rays reflected in the body of a convex mirror are scattered and consumed after a short distance' (Leic.1v).

If the moon was essentially like the earth, the reverse must also apply: 'If you were on the moon or on a star, our earth would appear to you to

make the same effect as does the moon' (F.93r). Thus the 'slight glimmer' visible even in the dark portions of the moon arose from the reflection of light from the seas of our globe (Leic.2r). The natural conclusion was that 'The earth is a star much like the moon' (F.56r), a conclusion which has much in common with Cusanus' view that the earth was not essentially different in nature from the other planets. The planets and the world were, for Leonardo, reflective balls of variegated earth and water, borrowing radiance from the marvellous sun:

> There is not to be seen in the universe a body of greater magnitude and power than the sun; and its light illuminates all the celestial bodies distributed through the universe; and the life forces [*anime*] descend from it, because the heat which is in living animals comes from life forces and no other heat is there in the universe as will be shown in the 4th book. And certainly those who have chosen to adore men as gods, such as Jove, Saturn, Mars and company, have made a grievous error, seeing that even if man were as large as our world he would appear similar to the smallest star which appears as a spot in the universe, and also seeing that men are mortal, putrid and corruptible in their sepulchres. *La Spera* and Marullus [a Byzantine poet] and many others praise the sun (F.4v).

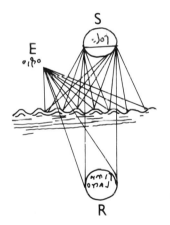

Fig.91 *Analysis of the Sun's Reflection from Waves in Water*, based on B.L.27r

E eye
S sun
R single image compared to the multiple radiance from the ruffled surface

This paean in praise of the sun and sober assessment of the earth's position cannot be used to claim Leonardo as an ancestor of Copernicus. Nowhere did Leonardo dethrone the world from its astronomical position at the centre of the universal orbits. All his astronomical analyses and accompanying diagrams show that he was committed to the geocentric theory which had dominated classical and medieval cosmology.

His tendency to discuss astronomy largely in terms of visual perception was a natural consequence of his increasingly sophisticated attitude towards the relationship between observation and knowledge. His science during the 1490s had been founded upon an assumption that the eye really saw what was there, transmitting accurate images to the intellect

via the *sensus communis*. Even his early awareness of the way in which the refractive properties of the atmosphere complicated our perception of the sun's size (A.64r) had done nothing to unsettle his belief in the eye's essentially straightforward relationship with the visible world. By 1508 he had begun to realize how complicated the situation really was. Not only were all kinds of external distortions involved, but the eye itself even contributed some of the features which we attribute to the objects: 'The order of proving how the earth is a star: first define the eye; then show how the twinkling of a star arises in the eye. . . and how the rays of the stars originate in the eye' (F.25v). This realization of the eye's propensity for deception had profound consequences. It destroyed the tidy identification between seeing and knowing which had characterized his earliest essays in natural science.

This disturbance was not merely a matter of the odd illusion here, the occasional deception there; it involved the very heart of the visual process, the pyramidal mechanism of perspective perception which he had adopted from Alberti and woven so neatly into the universal fabric of pyramidal laws (see Figures 17 and 20). In Manuscript D, a short treatise 'On the Eye' almost certainly composed in 1508, he repeatedly insisted that in the eye 'the visual power is not reduced to a point as the painter-perspectivists would like to believe' (D.10v, 3v, 4v, 6v and also F.28r, 31r and 36r). He now believed that the visual power *(virtù visiva)* existed in a surface within the eye. This idea signalled the transformation of his perspective theory from that of a 'painter-perspectivist' into that of a successor to Alhazen, Witelo, Bacon and Pecham. All the medieval authorities agreed that 'vision takes place by the arrangment of the image on the glacial humour exactly corresponding to the object outside' (Pecham, I, 37). The elaborate system of concentric and eccentric spheres in the medieval eye was dedicated to the refraction of the rays 'away from the perpendicular' in such a way as to form a concise and orderly image at the interface of the glacial and vitreous humours.

In Manuscript D Leonardo asserted that the truth of the matter will be 'demonstrated by experience and the conclusion drawn by necessity' (1v) — a clear statement of the rigorous method he attempted to apply in all his late science. He relied upon three main 'experiences' to prove his point that 'every part of the pupil possesses the *virtù visiva*' (4v). The first involved placing a very thin object, such as a needle or a straw, close to the eye. He found that 'the thing in front of the eye which is smaller than the pupil will not interrupt in the eye any other distant object and although it is dense it has the effect of a transparent thing' (6v). This he explained by reference to a diagram (Figure 92), which shows that the object r will not prevent rays from any part of the distant object ht from impinging upon some part of the visual power across the crystalline sphere at qa. His second 'experience' showed 'how the eye does not know the edge of any body' (10v), particularly a very adjacent one. The edge of an object cp

(Figure 93) will be seen by the visual power *ab* at different positions relative to the background *nm*, resulting in a blurred perception of the edge. The centre of the visual power provided the strongest image along the line *rf*, but the secondary images at *e*, *g*, *d* and *h* will prevent an absolutely precise contour from being observed. His third demonstration relied upon a delightful illusion which can be easily confirmed by the reader. A small hole is made in a card *rs* (Figure 94), which is positioned about 17 cm from the eye. A needle *gl* is then moved across the eye so closely as to 'touch the points of the eyelids'. The image of the needle will appear to move across the aperture in a direction contrary to its actual motion and will appear to be situated on the far side of the card (4v). His explanation involved the principle that light rays passing through a small aperture will be inverted, as recorded in a number of the medieval texts. Thus the needle in moving downwards from *k* to *h* actually interrupted rays from progressively higher points on the background. He had set up a situation in which he could legitimately claim to have drawn a line across the surface of the *virtù visiva*.

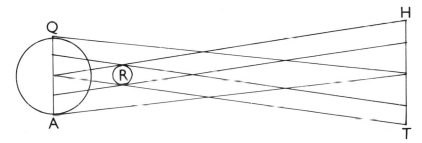

Fig.92 *Optical Demonstration of the 'Transparency' of a Small Object close to the Eye*, based on D.6v

Q-A effective width of the visual power in the crystalline humour of the eye
R small object
H-T background

In case the reader should be thinking that the perceptual surface envisaged by Leonardo is akin to the modern theory of vision, involving the receptive retina, it should be said that his conception of the eye's internal optics remained very remote from Kepler's fundamental explanation of the lens focusing images on the rear wall of an optical chamber. To account for the way in which the rays arrived at the perceptual surface, Leonardo devised an elaborate system of intersections in which the rays twice crossed within the refractory spheres (Figure 95). This double intersection was to his mind necessitated by the inversion of the rays after they have passed through the aperture of the pupil. He was not prepared to believe that the eye could operate with an inverted image,

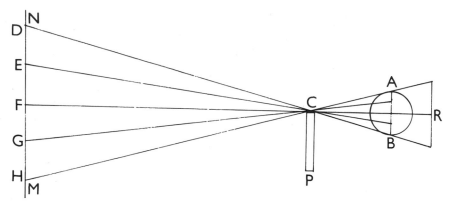

Fig.93 *Optical Demonstration of the Blurred Edge Effect of an Object close to the Eye*, based on D.10v

N-M background
D, E, F, G, H points on the background
C-P object
A-B effective width of the visual power in the crystalline humour of the eye
R-F visual axis

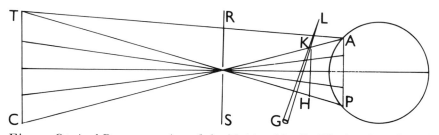

Fig.94 *Optical Demonstration of the Moving Needle Illusion*, based on D.2v

T-C background
R-S card with small aperture
L-G needle
K-H path of needle
A-P effective width of the visual power in the crystalline humour of the eye

so he used the crystalline sphere to effect the necessary re-inversion. The alternative configurations of rays with which he experimented in Manuscript D exhibit a rather arbitrary quality and reflect his lack of accurate knowledge of the eye's internal structures. In this respect he was no better equipped than his medieval predecessors. Where he deviated most sharply from the earlier authorities — as in his inversion of the rays in the pupil — he did so on a speculative basis, using his knowledge of apertures, glass spheres and mirrors to devise hypothetical systems which

could produce the desired effects. This was, of course, a contravention of his proclaimed method of working rigorously from observed form to physiological function, but in the case of the eye the necessary anatomical information remained highly elusive.

The intersection of rays through an aperture, which provided a cornerstone for the optical systems in Manuscript D, occasioned a characteristic hymn in praise of nature's astonishing subtely:

> O marvellous necessity. . . O mighty process. Here the figures, here the colours, here all the images of the parts of the universe are reduced to a point; and what point is so marvellous? O marvellous, O stupendous necessity. You constrain by your laws all effects to participate in their causes in the briefest possible way. These are miracles. . . Forms already vanished, infused in so small a space, it can regenerate and reconstitute by its dilation (C.A.345va).

Like Alhazen and Bacon before him, he used the *camera obscura* effect of light through a pinhole aperture to show that images from separate sources remained discrete even after passing through the tiniest point, that is to say through the smallest *punto naturale* (Figure 96)

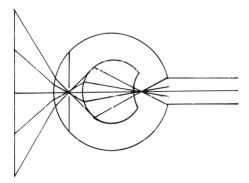

Fig.95 *Double Intersection of the Rays within the Eye*, based on D.10v

His experiments with apertures, glass balls filled with water, lenses and mirrors occupied a considerable amount of time during the latter part of his career. This is not surprising, since rays of light dance to a geometrical tune in a more readily controlled manner than vortices in water and air. His patron in Rome after 1513, Giuliano de' Medici, appears to have sponsored his optical inventions. Leonardo took a German artificer 'who makes mirrors' into his studio to assist in 'a work for *Il Magnifico* [Giuliano]' (C.A.247vb). However, Giovanni Tedesco, the mirror maker, gave him nothing but trouble, and in 1515 Leonardo wrote to Giuliano, who was visiting Bologna, to complain that the 'German deceiver' was using the opportunity to feather his own nest rather than serving Giuliano and himself (C.A.247vb, 283ra, 182vc and 92rb). He accused the German, in collusion with a companion, of intending to plagiarize his own ideas,

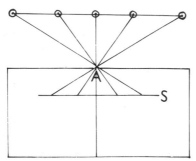

Fig.96 *Diagram of the 'Camera Obscura' Phenomenon*, based on D.8r

A aperture through which passes light from five separate sources
S screen within a darkened chamber which receives the images of the lights in reverse configuration

Fig.97 *Analysis of the Reflection of Rays in a Parallel Beam striking a Concave Mirror*, based on B.L.87v

and the malicious companion even 'hindered me in anatomy, denoucing it before the Pope' (C.A.182vc).

The device which he suspected the conspirators of wishing to 'make public' for their own benefit was what he called a *sagoma*, a novel framework for manufacturing parabolic mirrors. His interest in such mirrors appears to have been rekindled aboout 1508 by his close study of medieval optics, and a scrics of diagrams in the Arundel Codex are based upon Witelo's treatise (Figure 97). He had also devoted a good deal of energy in Manuscript F and elsewhere to the so-called 'problem of Alhazen' - how 'to find the angle of reflection' of rays from a curved mirror

(C.A.185vb) – and eventually devised an ingenious instrument for its solution (B.L.70v and C.A.108va). Such questions possessed a more than theoretical interest, in that the focused rays of a concave mirror produced an enormous concentration of heat. Archimedes had used the burning power of parabolic mirrors in the defence of Syracuse, as Leonardo almost certainly knew, and the device for *Il Magnifico* may well have been a burning mirror for military use. Giuliano was, after all, in charge of the Papal forces. Leonardo also mentioned the possibility of using such mirrors 'to boil each cauldron in a dyeing works; and with this a pool can be warmed, because there will always be boiled water' (C.A.371va).

It is a measure of his intellectual integrity that he allowed his late optical studies to disturb the attractively tidy assumptions which he had adopted as a 'painter-perspectivist'. This was no less heroic in its own way than his disruption of the microcosmic analogy. Not only was the painter's pyramid of perspective deprived of its physical existence but the image within the eye was complicated by all kinds of illusions in the external world. Additionally, he came to realize that 'perspective made by art' on a flat surface was itself subject to the distortions of 'perspective made by nature' (E.16v).

Even during the 1490s he was aware of certain optical complications which did not fall within the scope of the painter's system, and he had begun to consider the possibility that the pyramid did not correspond in reality to the eye's actual optics (C.A.250va). But the crucial doubts concerning 'painter's perspective' only fully emerged during the later period. The painter's system was logical enough within itself, and certainly worked tolerably well in certain circumstances, but there were many reasons why it did not correspond in reality to our perception of the outside world. For instance, the refraction of light rays at the eye's surface has the effect of creating a wider visual angle than that adopted by 'the perspectivist who believes that the visual rays come straight into the eye'; hence 'the eye judges the size of an object as being larger than that which is shown in the painter's perspective' (D.2r). And in looking at an object strung out across the field of vision, such as a wall perpendicular to our line of sight (Figure 98a), there will actually be a lateral recession towards the distant ends of the wall: 'Such parallel sides will display themselves in a hexagonal figure, that is with six sides and six angles (Figure 98b), and in reality will not show itself to have four angles and four sides. In Albertian perspective such an object would be portrayed with its sides parallel to the rectangular boundaries of the picture. To these angular problems of apparent size and lateral recession can be added the serious complication that 'the eye does not know the edge of any body' (D.10v), as we have already noticed. This is not to take into account the problems of binocular vision (seeing with both eyes simultaneously), nor such matters as optical illusions and the earth's curvature.

 A B

Fig.98 *Lateral Recession of a Wide Object Perpendicular to the Line of Sight,* based on E.4r

A as normally portrayed, although the ends of a wall are actually more distant from the eye than the wall's central point (the arc corresponds to a line equidistant from the eye)
B as rendered in bilateral recession

For someone who had believed so emphatically in the accuracy of painting's portrayal of the visible world, these realizations cannot have been altogether easy to face. How did Leonardo as a painter face them in theory and practice?

As far as 'painter's perspective' was concerned he still believed that it provided a generally effective system for depicting in two dimension the relative sizes of objects, and he appears to have reconciled himself to mimimizing the effects of its limitations. His experiments with anamorphic representations, which combined artificial and natural perspective to make 'compound perspective', were more in the nature of visual curiosities than serious attempts to circumvent the short-comings of the standard technique. His late attitude to painter's perspective of the orthodox kind cannot be judged so much from what he said about it after 1508 but from the fact that he said very little about it at all. Although he still acknowledged that it was the 'guide and gateway' of the painter's science (G.8r), and referred to it as 'a most subtle invention of mathematics' (Urb.27v, L´A.17), he certainly was not disposed to conduct the kind of extended expositions of linear perspective which had featured so prominently in his Milanese notebooks. His late manuscripts, or at least those which are known to us, show that he tended to place his priorities elsewhere when he attempted to evoke nature's appearance in the medium of painting.

From 1508 onwards he was engrossed in studying the infinite variables of the visible world, its illusions, ambiguities, deceptions and fleeting subtleties — all of which disrupted the linear stability of artificial perspective. His later notes are full of beguiling and brilliant observations as he strove to pin down the elusive butterfly of natural appearances. Looking at revolving objects such as a spinning wheel and 'whirling fire-brand' he saw that 'although they move on the one spot, they do not. . . reveal themselves as they are in reality' but leave a continuously blurred image of their parts (G.35r). This is the kind of effect which Velasquez was to exploit almost one-and-a-half centuries later in his *Spinners* (Madrid, Museo del Prado). Another nice example is his description of the apparent lightening of tone on a tree's windward side, which 'occurs because

the wind exposes the underside of the leaves, which are invariably much paler than their right sides' (B.L.113v). He intensively studied variations of light and shade on the same object and on objects of different surface textures, attempting to show how a moving viewpoint and variations in the light source will effect the relationship between 'light' and 'lustre' on each form. We have already seen one of the consequences of such studies in his analysis of the moon's radiance. In judging the intensity of such reflected lights 'the eye will often be deceived', because equal intensities will appear to be more or less potent according to the relative brightness of adjacent surfaces (G.12v). Effects of distance were of special concern, not only on account of the atmospheric properties of mists and 'vapours', but because the eye's discrimination becomes confused over long distances and will be unable to discern the true extremities of objects: 'Every object. . . will at a distance appear to be spherical' (G.26v). The apparent fusion of two adjacent light sources when viewed from a distance was duly noted and anatomized (F.35v-6r).

Above all, Leonardo realized that any illuminated object 'is never seen entirely in its true colour' (Urb.193r, L'A.21). This arises from the myriad variations produced by the colour of the impinging light and coloured reflections from adjacent objects. We have already seen such effects figuring exquisitely as early as the first *Madonna of the Rocks*. In his late writings he became increasingly insistent that true local colour is never seen in the natural world. He recorded seeing 'reddish' lights accompanied by 'greenish' shadows and noted 'bluish' shadows in a white object (Urb.75r, L A.20). Wet streets, he observed, produced 'yellowish' reflections in people's flesh tones (Urb.207v, L A.47). The nineteenth-century techniques of Delacroix and the Impressionists do not seem all that far away.

Leonardo found that trees provided particularly rewarding subjects for studying 'apparent' colour and form in relation to their 'actual' properties. In other words, he was concerned to differentiate what was actually 'seen' in a given situation from what was independently 'known' about the objects in question. His observations ranged from detailed effects of tone and colour on individual leaves to the generalizing effects of distance. Each leaf was affected by four tonal factors, 'that is to say, shadow, lightness, luminous highlight and transparency', any combination of all four being apparent in a leaf at any one time. For example, 'a leaf of concave surface seen in reverse from underneath sometimes is seen half shaded and half transparent'. Each leaf will also borrow colour from the illuminating light, from the 'blueness' of the atmosphere and from the enhancing greeness of adjacent leaves (G.3r). The upper side of a leaf will appear to partake more of atmospheric blueness 'to the extent that it is more foreshortened' (G.2v), although the effect will be less prominent in yellowish leaves (G.28v). The dappled shadows in a bunch of leaves will further complicate the tonal patterns, camouflaging their individual shapes (G.4v).

This is not to say that the painter should delineate every leaf according to these rules. The overall effect of the whole tree must be taken into account. 'Remember, O painter, that the varieties of light and shade in the same species of tree will be relative to the rarity and density of the branching' (E.18v). And at a distance the detailed 'accidents' of light and shade become mingled into a single, predominant effect (G.24r). 'The airy perforations through the body of trees and gaps between the trees. . . will not be shown to the eyes at a considerable distance, because where the whole can only be discerned with effort, it is difficult to recognize the parts, in that they make a confused mixture which partakes more of that which predominates' (G.25v). A page of tree drawings at Windsor shows these subtle effects in all their beauty. On one side he has portrayed the fuzzy flicker of light and shade in a distant copse of birches, while on the other he has isolated a single tree (Plate 87), below which he has written a note on the effects of light and shade in relation to density of branching and background tone. The darker foliage below and to the left is characterized by a softly quivering blurr, while the middle portions display more clearly defined bunches of foliage modelled in *chiaroscuro*. The most highlit areas to the upper right display a translucent radiance indefinite in shape. It is a study of which Constable might have been justifiably proud three hundred years later.

Every element in the natural world would be subject to comparable variables, according to the light conditions prevailing at the time. Mountainscapes, townscapes, clouds, mists and smoke will present an infinite spectrum of appearances at different times of day and at different seasons of the year. In addition to the variety of optical effects, there was also the astonishing variety of structural forms in nature: 'You imitator of nature, be careful to attend to the variety of configurations of things' (Urb.104r, L'A.36). Different species of tree will exhibit great diversity in their methods of branching. Naturally, he searched for the rules which made sense of the diversity: in the cherry and fir tree 'the top of the outermost shoots form a pyramid from the middle upwards; and the walnut and the oak from the middle will make a hemisphere' (G.51r). And behind the apparent randomness of leaf distribution lay general laws: 'Nature has placed the leaves of the latest shoots of many plants so the the sixth is always above the first and follows successively in this manner' (G.16v). As in his anatomies, the full variety must be observed before it is explained.

One of Leonardo's overriding concerns was that the painter should be 'universal' in the range of his subjects, portraying not only male figures but also 'women, children, dogs, horses, buildings, fields and hills' (Urb.61r, L'A.32). And in portraying human figures he must give credence to their full variety of forms and gestures: 'Differentiate between the action of humans according to their age and worth, and vary them according to type, that is male types and those of women' (Urb.115v, L'A.33).

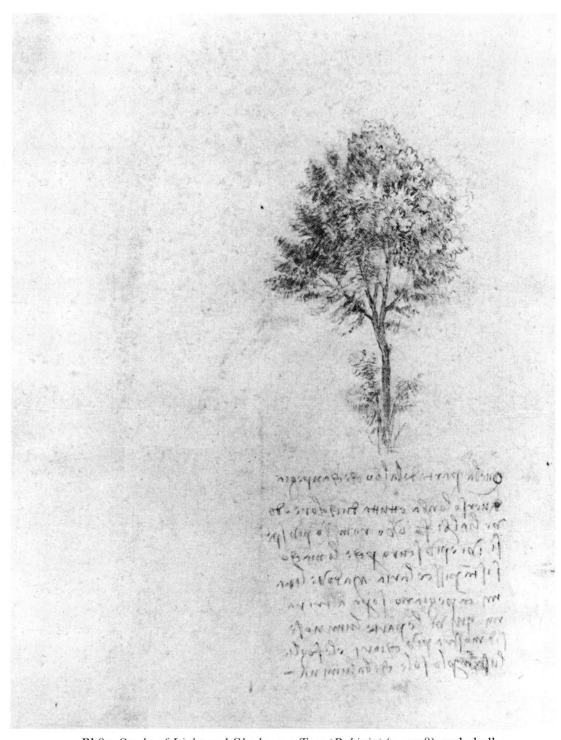

Pl.87 *Study of Light and Shade on a Tree (Robinia)* (*c.* 1508), red chalk, Windsor, Royal Library (12431v)

The painter must display 'variety in his figures if the men are not all to appear brothers etc.' (E.79v). Leonardo considered that every painter possessed an inherent tendency to make all his figures look alike, and, even worse, like the painter himself. This defect was as natural as it was pernicious:

> And know that you must fight your utmost against the vice, since it is a shortcoming which is born in company with judgement, because the soul, mistress of your body, is that which makes your individual judgement; and she naturally delights in works similar to that which she made in the composition of your body. And from this it arises that there is not so ugly a women that she does not find a lover — unless she is monstrous (Urb.44v-5r, L'A.28).

The innate shortcomings of each man's individual judgment, arising from those of his formative soul, must be overcome by a diligent study of human proportions 'to see in what part his own person varies, much or little, from that said to be praiseworthy'. The notion that 'every painter paints himself' was not an uncommon idea in the Renaissance. From Leonardo's point of view it threatened precisely the kind of purely internal creativity — 'beginning and ending in the mind' — which he so despised. Nature must always be the external point of reference.

In searching to rectify the deviant 'sameness' which characterized his figures, the artist should not resort solely to a single norm of proportional beauty: 'The measurements of parts and their thicknesses vary greatly in nature, and you should vary them yourself' in your paintings (Urb.104r-v, L'A.36). The painter should recognize that each type of figure possessed an appropriate system of proportional relationships within itself. The strong, for example, would be characterized by a quite different kind of harmonic structure from the graceful. Even the beautiful would be various in appearance: 'Beauty of face may be of equal fineness in different persons, but it is never in the same form' (Urb.51v, L'A.44). Above all, the painter should seek what is appropriate in each instance. He should obey the classical law of decorum (appropriateness) in narrative paintings, as laid down by Alberti and others: decorum in figure type and physiognomy; decorum in movement, gesture and expression; decorum in costume and colours. If the painting called for old women, for instance, they should not be shown with the muscles of a vigorous youth (Urb.107v, L'A.50).

Leonardo's injunctions would have only been worth making if they related to transgressions apparent in actual works of art. There is little difficulty in finding culprits in the matter of making figures look 'like brothers'. Perugino comes most readily to mind, but there is hardly a painter of the Renaissance who does not transgress this rule, including Leonardo himself. If this were not so, the historian's task of stylistic attribution would be even more difficult than it already is. However, there is one artist who could be seen to embody, almost without exception, all the faults upon which Leonardo dwelt in his late writings. That artist was

his unfriendly rival, Michelangelo. The figures on the Sistine ceiling, to
which Leonardo cannot but have reacted when he moved to Rome in
1513–14, all tended to come from the same Herculean mould, whether
Adam and Eve, or Jonah and the aged Cumaean Sybil. Furthermore,
Michelangelo's concentration on the human figure negated the 'univer-
sality' upon which Leonardo set such store. The *Deluge* on the Sistine
ceiling, a subject which demanded so much in terms of atmospherics, was
limited to the portrayal of figures in a sterile and ill-organized setting of
inadequately described earth, water and air. In almost every instance the
musculature of the individual figures was pronounced to a considerable
degree, whether the characters were young or old, women or men, actively
straining or passively resting, in direct contradiction to the law of mus-
cular decorum (Urb.116v, L'A.14). It was with real feeling that Leonardo
wrote,

> O, anatomical painter, beware that the overly strong indication of the
> bones, tendons and muscles does not cause you to become a wooden
> painter, with your wish that all your nudes should display their feel-
> ings. Therefore, wishing to rectify this, observe in what manner the
> muscles in old or lean persons cover or clothe the bones, and in
> addition to this note the rule concerning the same muscles filling the
> spaces interposed between them, and which are the muscles that never
> lose their appearance in any amount of fatness, and which are the
> muscles which lose the signs of their terminations with the least
> plumpness (E.19v-20r).

Elsewhere he explained that the skin between two muscles did not dip
sharply inwards in a 'V', nor did it make an extended curve, but produced a
pronounced concavity of a mellifluous kind (Figure 99).

Fig.99 *Demonstration of the Relationship between the Skin and Underlying
Muscles*, based on G.26r

A an excessively sharp indentation between the muscles
B an overly protracted curve
C the true contour, with the thickness of the skin taken into account

The challenge of Michelangelo's work in Florence and Rome may also
have encouraged Leonardo to resume his *paragone*. The younger artist's
steadfast belief in the superior virtues of sculpture could not have stood
more sharply in contrast to Leonardo's attitudes. The most damning
indictment of sculpture, from Leonardo's point of view, was its failure to

embody all those subtle complexities of space, light, colour and atmosphere which bulked so large in his prescriptions for artistic excellence. For its modelling in light and shade sculpture was dependent upon the good graces of nature, while the painter possessed autonomous control of light within his own creation. Nor could the sculptor even claim that his art was superior in its description of three-dimensionality; if the sculptor argued that in making one figure he must simultaneously control an 'infinite number' of configurations in space 'on account of the infinite contours which possess continuous quantities', the painter would reply that his picture can use infinitely subtle gradations of tone to display all the nuances of form which are visible in a figure at any other time (Urb.26v-7r). This ability to depict each and every detail in a three-dimensional form also provided, as we have seen, the essence of his challenge to the writer on anatomical matters (W.19013v and 19071r).

The way in which the painter could capture the mellifluous transitions of tone across a 'continuous quantity' greatly exercised his attention at this time. At one point he meticulously outlined a 'laboratory' technique for controlling the tonal gradations of the paints he was mixing (Urb.137v-8v, L°A.40). It is not surprising to find that he turned back to the impressively detailed observations on light and shade which he had recorded during the 1490s (see Figure 22), and some of his analyses in Manuscript C were repeated in Manuscript E without significant revision. No other aspect of his Milanese researches had stood the test of time so well. Where he progressed beyond Manuscript C was in his greater attention to qualities of transparency and ambiguous translucency — the kind of considerations we have already encountered in his tree studies. These the sculptor could not hope to rival, because sculpture 'cannot form luminous and transparent bodies, like veiled figures which display the naked body under veils covering them, nor make tiny pebbles of diverse colours beneath the surface of transparent waters' (Urb.25r-v, L°A.29).

Many of the observations on the scope of painting inevitably and properly call to mind the actual products of Leonardo's own hand. A masterpiece of veiled painting has already occupied our attention. I refer of course to the *Portrait of a Lady* (Plate 71). And, on a more detailed level, variegated 'pebbles of diverse colours' are prettily apparent between the feet of St Anne in the Louvre painting (Plate 61) — not perhaps in a reproduction but certainly in the original, for a sharp-eyed observer. The time has come for us to see how the paintings made during this last phase of his career relate to his writings on art, and indeed to his late vision of the world as a whole.

The reader may be forgiven an inward groan when he learns yet again that we simply do not know with any certainty what Leonardo painted during this period, that is to say, after the delivery of the second *Madonna of the Rocks* in the autumn of 1508. I have suggested that the *Portrait of a Lady* continued to take shape after his departure from Florence and that

his *Leda* was probably not painted in its final form until about 1514. But neither of these works owes its origins to the post-Florentine period. The only surviving painting which appears to have been entirely designed and conceived after 1508 is the half-length *St John the Baptist* (Plate 88). There is at least a thin thread of evidence for assigning its design to the spring of 1509. On a page in the *Codice atlantico* (179ra) a pupil timidly outlined a pointing hand which is recognizably close to that in the painting. On top of the pupil's chalk drawing Leonardo himself added pen and ink sketches of geometry with accompanying notes. This page can be recognized as belonging to a series which includes C.A.82ra, to which it was once joined, and C.A.359ra, which is dated 3 May 1509. This evidence does not guarantee that the painting was made about this time, but taken together with the work's optical qualities it does help support a dating of 1509-10.

The *St John* is the most dramatic expression of Leonardo's desire to create relief in paintings through the use of *chiaroscuro*. Relief, as he consistently emphasized, was a product of the optical relationship between an object and its background: 'A very fundamental part of painting is the background of the painted objects' (G.23v). A background of different tone could totally transform the effect of a figure. At one point he asserted that 'things will demonstrate much more relief with an illuminated background than with a dark one'; because the most strongly shaded portions of a figure will not be discerned against a dark background and will not therefore appear to detach themselves from it. 'From a distance nothing will appear other than the illuminated parts' (Urb.136v, L'A.26). On the other hand he was well aware of the efficacy of tonal contrast: 'White with black or black with white will appear more potent, one by the other, and thus adjacent opposites will always display themselves more perfectly' (Urb.75v, L'A.27). 'If your figure is light set it on a dark background' (Urb.136r, L'A.30). Although its present murky condition does nothing to help us gauge Leonardo's intentions, there are clear signs that he retained just enough secondary light in the shaded portions of St John's body to maintain the crucial separation from the background. As in the moon, even the dark areas of his figure retain a 'slight glimmer' of reflected radiance.

The extreme softness with which the tonal transitions are handled from one facial contour to another reflects his intense interest in the veiling qualities of atmosphere, while the little touches of light in the hair serve to differentiate the radiance of lustrous waves from the diffused glow of pliant flesh. But what are we to make of the sharp and unsubtle silhouettes of the pointing finger and his other bodily contours? They manifestly contradict his finding in Manuscript D that 'the eye does not know the edge of any body'. He specifically informed the painter that the boundary which one coloured form makes with another is 'an imperceptible thing even close at hand' (Urb.153v-4r, L'A.16). It is right that the nearest contours ('*li primi*') should be more apparent than those further away ('*cose seconde*'), in accordance with atmospheric perspective, but this

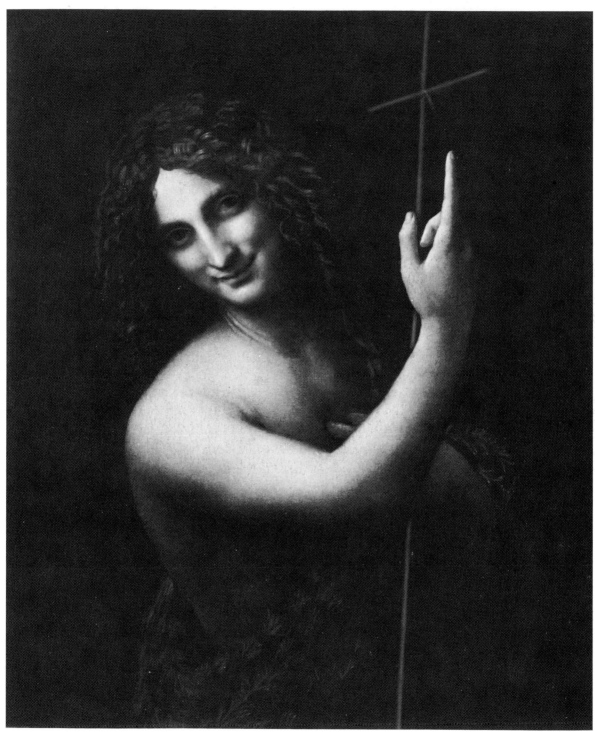

Pl.88 *St John the Baptist* (*c.* 1509), Paris, Louvre

effect has been exaggerated in the painting to a painful degree — exaggerated I believe by crude overpainting by someone who wished to rescue the fading outlines of Leonardo's figure from the ever-darkening depths of the panel. Where the overpainting has wreaked least havoc — in the cheeks, nose and mouth — the tonal effects are still meltingly subtle yet structurally firm.

In one sense the painting is about light, a light which is both optical and expressive, just as the vortices of his deluges had delivered their emotion in a scientifically designed vehicle. No one has ever denied that the *St John* conveys a remarkable impression of emotional involvement, but the nature of that involvement has been variously interpreted — and often not to Leonardo's credit. At worst it has been characterized as the effusion of an aging homosexual. Perhaps in one sense it is, but if this is all it is, it would have no more value than an obscene graffito. The 'psychological' interpretation is, to my mind, a supreme irrelevance when it comes to understanding in historical terms why the image of the saint crystallized in the form it did. I can see no reason why this painting, alone of all his works, should not be a highly considered product of his customarily complex reciprocation between form and content.

It can be shown that the *St John* arose from one of his typically fluid processes of association between different subjects and related forms. His conception of a single, pointing figure, displayed from the waist or slightly below, originated in Florence about 1506-8 in the form of the *Angel of the Annunciation.* This composition is known in a pupil's drawing corrected by the master (W.12328r) and in painted variants, of which the best is probably a studio version (Basel, Öffentliche Kunstsammlung). The Angel's head, torso and left arm are in essentially the same position as those of St John, while the Angel's right arm, bent sharply at the elbow, points vertically upwards rather than forming an arc across his body. The tilt and slight turn shared by the necks of both figures beautifully illustrate his description of the effects caused by bending the 'joints of the bodily parts': 'Notice how the flesh increases on one side and decreases on the other' so that it is 'wrinkled on the side opposite to that which is stretched' (Urb.107r, L'A.26 and Urb.121v-2r, L'A.14). The particular motions of the head and neck in the paintings is 'called compound, and occurs when twisting is added to bending, as happens when the ear is inclined towards one of his shoulders and the face is turned towards the same side' (Urb.107r, L'A.26). The potentially infinite permutations of this 'compound' rotation comprise a 'continuous quantity', a property which is greatly enhanced in the *St John* by the curvaceous continuity of his right arm. The development of *St John* from the *Angel* is, however, not merely a question of formal manipulation. It is also deeply concerned with meaning.

The portrayal on separate panels of the *Angel* and *Virgin Annunciate* was not uncommon in altarpiece design, and Antonello da Messina had

already daringly shown the seated Virgin from the front as if we were standing in the position of the Angel. Leonardo's concept is even more radical than Antonello's, in that we are the privileged recipients of the Angel's divine message, his annunciation of Christ's forthcoming birth. The Angel's pointing gesture could not make a more explicit reference to the heavenly paternity of the baby which Mary was to bear. Such gestures had become something of a trademark in Leonardo's paintings and were invariably used to denote a sense of spiritual insight on behalf of the figure in question, either in general terms of divine providence or in knowing anticipation of a specific event such as the Baptism or Crucifixion. A late drawing of the seated *St John* (formerly Varese, Museo del Sacro Monte) depicts the saint pointing with studied deliberation at his reed cross in an appropriately prophetic manner. The painted *St John* is no less explicitly prophetic. His gesture is a visual restatement of his words 'There is one who cometh after me', and we are left in no doubt as to the celestial origins of his successor.

Can we credit such a spiritual approach in an artist who has generally been regarded as of dubious orthodoxy in Christian terms, if not an actual atheist? It is true that Leonardo had no patience with the dafter talk of spirits nor with those practitioners of necromancy who claimed to be able to summon up metaphysical powers (W.19047v-8v), but this is not to say that he saw the universe as operating independently of divine guidance. To be sure, all effects and their immediate causes in nature could be rigorously explained in physical terms without recourse to divine powers, but it was the very perfection with which causes and effects fitted together which proclaimed the existence of a supreme creator. This creative power, the ultimate 'cause of the causes', lay beyond rational comprehension: 'Water percussed by water makes circles around the point of percussion; as over longer distances the voice in the air; and even longer in the fire; and longer still the mind in the universe; but because it [the mind] is finite it does not extend to infinity' (H.67r). This 'mysterious speculation', as it has been called (and misinterpreted) is based on his reading of Albertus Magnus, and means that the mind can extend its understanding to all the causes and effects in the physical spheres of the observable universe, but outside this nothing is rationally knowable to finite intelligence. This attitude made good sense in relation to the most common of the medieval cosmological systems, in which the outermost sphere of the physical universe, the *primum mobile*, was itself surrounded by the infinitely extended presence of an ineffable divinity. Leonardo did not on his own behalf intend 'to write or give information of those things of which the human mind is incapable and which cannot be proved by an instance of nature' (W.19084r). Accordingly, he left matters pertaining to 'the definition of the soul. . . to the minds of friars, fathers of the people, who by inspiration possess the secrets. I let be the sacred writings, for they are the supreme truth' (W.19115r). I do not sense any irony in this praise of the 'sacred

writings', any more than I think the *St John* was intended to mock Christian belief.

In the *St John* Leonardo has intuitively placed his art in the service of an ultimately mysterious end, namely the evocation of 'otherness' — of something remote from our normal comprehension. John is one who 'by inspiration possesses the secrets', as his knowing smile suggests. There was no sense in which Leonardo's science could or should have expressed such matters, but the suggestive magic of artistic creation could imply the existence of a 'supreme truth', the nature of which 'cannot be proved by any instance of nature'.

The sheer concentration with which Leonardo has spelt out St John's spiritual message — focusing relentlessly on the saint's expression and gesture — militated against his exploiting anything like the full range of visual effects recommended in his late notebooks. The optical game of hide-and-seek is well enough described in relation to a single figure, but there are none of the supporting effects which featured so prominently in his prescriptions for good painting. For such effects we have to look at the other surviving painting from this period, the Louvre *St Anne* (Plate 61).

We have already noticed the attractively variegated pebbles between St Anne's feet — a small detail, certainly, but one which is deeply symptomatic of Leonardo's approach to the ravishing variety of natural phenomena and which embodies in microcosm his approach to the picture as a whole. The twisted veins of coloured minerals within the pebbles create an effect which he strove to reproduce on his own account in artificial preparations he called '*mistioni*'. He made a series of 'small pipes in the manner of goosequills' which were gathered together into a bundle, moistened and pressed. 'If you press them flat they will give one effect; if you press them into a rectangle they will give you another; and similarly if you press them into a triangle. . . And if in the transparent part exposed to the sun you make with a small stylus a mixture of different colours. . . you can make very beautiful patterns and various small stains with contours like those in agate' (F.55v). The geometrical techniques of squeezing transformed the patterns visible at the ends of the tubes into complex configurations of compressed curves (Figure 100). The results not only recalled geological features but also 'the mesentery of an animal' (K.115v). The scintillation of his '*mistioni*' when 'exposed to the sun' paralleled a whole range of coloristic effects produced by nature: the rainbow (W.19076r and 19150r); the 'very beautiful colours generated' by birds' feathers 'in their diverse movements'; in 'antique glass found underground'; 'in stagnant waters'; in 'oil spread on water'; in 'the surface of diamond or beryl'; and 'in many other circumstances which I will forgo because these are enough for my purpose here' (W.19150r). Such coloristic phenomena had earlier been enthusiastically recorded by Roger Bacon, as Leonardo was certainly aware.

The Louvre picture as a whole was intended to be a hymn in praise of

Fig.100 *Linear Pattern produced by 'Mistioni',* based on F.95v

nature's visual magic. I say 'intended' because the ravages of time have disrupted its precious unity. Most disturbing is the pale flatness of the Virgin's blue skirt, the result of ultramarine sickness (long-term breakdown of the pigment) rather than an indication that Leonardo had not finished painting this area. To this major tonal disruption have been added a number of other off-key notes: the brown darkening of the foreground shadows; the loss of definition in the shadows of St Anne's skirt; and the heavy blotchiness of the tree, which exhibits almost none of the sparkling translucencies which we might expect. Also, it is no longer clear if the disturbingly sharp fall in ground level at the front of the picture was intended to denote the edge of a rocky pool, as is likely, or a stratified cliff. However, the incomparable magic in the better preserved areas still succeeds in transcending these limitations to a remarkable degree. The garment around the Virgin's arm, shoulder and waist somehow combine the independent life of his water studies with the description of the bodily form in the manner of antique 'wet-style' drapery. The looping spirals of diaphanous material around her arm marvellously imply the convexity of the inner, invisible surface as well as amplifying the roundness of the visible side. A rose reflection from the garment on her shoulder beautifully mingles in the shadow of her neck with a blue-green radiance from her skirt. The wriggling worms of wiry wool in the lamb's coat result in broken effects of light and shade in the half-tones of the animal's body, while in the more fully illuminated parts the many reflected lights merge to create patches of almost solid brightness. By contrast, the more open curls of Christ's hair react in a more translucent manner, with a certain proportion of the reflected light coming from the underlying skin. And, most remarkable of all is the distant landscape, a fitting climax to the series of mountainscapes which had begun in the early *Annunciation* (Plate 9). Forms of indescribable delicacy float into our vision through veils of mobile vapour. A suggestion of glimmer on the hidden horizon gently provokes golden echoes in the pale azure contours of the mountains. And on the left a broad cascade spills from a raised valley, creating a bubbly fringe in the horizontal lake below. The more distant mountain layers dissolve progressively in distinctness and diminish in apparent height towards the left (and by implication towards the right) to produce a sense of bilateral recession similar to that outlined in Manuscript E (see Figure 96). They also carry a

suggestion of the curvature of the earth's crust. It is this curvature which explains the 'inclined' lake in the upper right of the *Portrait of a Lady* (Plate 71). Although similar in some respects, the landscapes in the *St Anne* and the *Portrait* do not appear to have been painted at quite the same time. The landscape behind the lady is less developed in technique. In particular it has little of the 'water-colour' translucency so strikingly apparent in the *St Anne*, and it must surely be the earlier of the two.

Some clue as to when the *St Anne* landscape was painted can be gleaned from a series of drawings at Windsor. A fixed point is provided by a drawing dated 1511 (12416), which is part of a coherent group (12410-16). The mountainscapes on three of these (12410, 12411 and 12414) appear to correspond to an intermediate stage between the two painted landscapes. Also at Windsor are two rockscapes even closer in style to the *St Anne* (12396-7). The rockscapes exhibit marked affinities with the Deluge drawings and may be as late as 1514. This suggests a date for the *St Anne* landscape of about 1513-14, contemporary with Manuscript E, while the *Portrait's* mountainscape would have originated about 1508-10, during the period when Leonardo was completing the Leicester Codex.

Such stylistic indicators provide our only grounds for dating the *St Anne*. We do not know for whom it was painted. It may have been the larger of 'the two Madonnas of different sizes' which he had begun for Louis XII before Easter 1508, but I am inclined to think that the London cartoon (Plate 62) is a more likely candidate. In style the cartoon and its preparatory drawing (Plate 63) appear to originate from about this time. I suspect that the classic sculpturality of the cartoon's figure group stands at the climax of his Florentine work, and may directly reflect his involvement with Rustici during the autumn, winter and spring of 1507-8. That he had a panel of specific dimensions in mind from the first is suggested by the measured scales visible along the lower and right hand edges of the framing lines drawn around the main sketch in the preliminary drawing. The scaling appears to be calculated according to the ratio 1 : 10, allowing for the fact that the cartoon has been trimmed at the top and down both sides. There is no record of Leonardo himself having begun to paint the panel, but echoes of the Madonna and Child in paintings by followers suggest that their poses were carried to a higher degree of realization than is apparent in the London version.

The painting and the cartoon are astonishingly different solutions to a problem which in most other hands would have produced but one kind of answer. The cartoon is all solidity, soft solidity but none the less solid for all its veiled subtlety. Its parts lock together like tongue-and-grooved joinery. Apparent instabilities are resolved as if by architectural statics. By contrast, the painting is all motion, flowing in diagonal curves along the hypotenuse of the figure group. Its forms are predominantly slippery and sinuous. I am not at all sure that we can legitimately call one solution more 'advanced' than the other. We have already seen that the ancestor of the

Louvre composition was the 1501 cartoon described by Fra Pietro da Novellara, and it has been suggested more hypothetically that the 'Vasari version' provided the basis for the London drawings. In any case, the London cartoon almost certainly intervened between the 1501 composition and its later reworking in the Louvre painting. I really do not think that we are dealing with a linear development in which 'good' is succeeded by 'better'. The cartoon and painting present alternative solutions, capable of validly existing side-by-side in Leonardo's mind, perhaps during the course of a number of years.

As always the formal variations are inseparable from his manipulation of content. The emotional ebb and flow of dynamic symbolism in the painting has already been outlined in Fra Pietro's sensitive description. The cartoon contains emotional relationships of no less intensity, but the pulse is perceptibly slowed by the horizontal and vertical accents, and the resonances are less elastically stretched from one corner of the group to another. Within the cartoon are two echoing relationships, separate yet complementary. In contrast to the painting, Christ exudes precocious authority and awareness, reassuring his sombre young companion that matters are willed to be as the Father and Son would wish. St Anne, with the knowing smile and gesture of the painted *St John*, provides similar intimations of divine will for the Virgin, should it be necessary. The presence of St John in the cartoon has led some commentators to suppose that 'St Anne' is not, so to speak, St Anne but St Elizabeth, the mother of John. The narrative would thus become an illustration of the apocryphal meeting in the wilderness, related in type to the *Madonna of the Rocks*. Given the fluidity of Leonardo's creative methods, such as transformation in content is not impossible. However, the second lady's role in the cartoon is no different from when she is certainly St Anne — she provides physical and spiritual support for Mary in each instance — and it is more reasonable to identify her as the Virgin's mother.

The *St Anne* painting, the *Portrait of a Lady*, the *Leda*, the Deluge drawings, late anatomies and Manuscript E have carried us outside the chronological limits of Leonardo's second period in Milan, which ended on 24 September 1513 when he left the city with his pupils, Francesco Melzi, Salai, Lorenzo and Il Fanfoia (E.1r). He had remained in Lombardy for over a year after the reinstatement of Massimiliano Sforza as ruler of Milan in July 1512 by Swiss soldiers in alliance with the Pope. The initial attacks of the Swiss in December 1511 had been repulsed by the French — Leonardo made a drawing of a huge fire started by the Swiss at the 'place called Dexe [Desio]' (W.12416) — but the French position in Milan had become impossibly precarious. On 19 September 1513, having lost control of the city, they eventually abandoned even the *Castello*, their last stronghold in Milan. It may have been the conclusive nature of the *Castello's* surrender that finally persuaded Leonardo to leave. During his last two years in Lombardy he seems to have spent a considerable amount

of time at the Villa Melzi at Vapprio d'Adda. Giovanni Francesco Melzi, unusually well bred and educated for a *garzone*, had entered the studio as a teenager at some time before 1510. Leonardo was obviously a welcome guest in the family's extensive villa on the banks of the Adda. He drew up plans for the villa's enlargement about 1513 (W. 19077v, 19107v, C.A.61rb, 395rb etc.), and he drew some splendidly vivacious studies of the nearby Adda canal and ferry (W. 12398-400). Melzi, for his part, became a not unaccomplished painter in a Leonardesque vein and, more importantly, became Leonardo's literary executor. After the master's death Melzi did his utmost to ensure the preservation of the precious notebooks, and was almost certainly responsible for the compilation of the invaluable Codex Urbinas, the *Treatise on Painting.*

After visiting Florence, where the Medici were enjoying their newly restored status as rulers of the city, Leonardo and his companions proceeded to Rome, where the first Medici Pope, Leo X, now occupied the Papal throne. On 1 December 1513 rooms were being prepared for Leonardo's use in the Belvedere of the Vatican Palace. Leonardo's first reference to his residence in 'the Belvedere in the studio assigned to me by Il Magnifico' dates from 7 July 1514 (C.A.90va). The 'Magnifico', Giuliano de' Medici, has left little mark on the history of his times, but he appears to have been a generous and sympathetic patron, providing Leonardo with support in his technical as well as artistic work. While based in Rome the artist travelled widely. During 1514 he visited Civitavecchia in the spring, Parma and S. Angelo in the autumn, probably serving Giuliano as a military adviser. Early in 1515 he appears to have spent some time in Florence, drawing up plans for an extensive remodelling of the area around the Medici palace and church of S. Lorenzo (C.A.315rb). He was probably also involved in designing costumes (e.g. W. 12575-7) and temporary structures for the festivals which the Medici used as public proclamations of their *virtù* (e.g. C.A.3rb-vb).

In retaining power the Medici were heavily dependent upon an alliance with France, which was reinforced in February 1515 by the marriage of Giuliano to Philiberta of Savoy. Giuliano's wife was the aunt of Francis I, who had become the French king following the death of Louis on 1 January 1515. It was in this atmosphere of Francophilia that Leonardo was asked to design a mechanical lion which the Florentines used to greet the French king on his entry to Lyons on 12 July 1515. The lion was described as advancing a few menacing steps towards Francis before opening its breast to display an abundance of *fleur-de-lys*, the flower happily symbolic of both the French monarchy and the Florentine state. It is also possible that Leonardo accompanied Leo X to Bologna to meet the King in December 1515. In any event, Francis was certainly aware of the artist's talents. Within six months of Giuliano's death in March 1516, Leonardo travelled to France to enter the King's service. The last record of his presence in Rome comes from August of that year (C.A.172vb).

During the last years of his life, as 'premier peinctre et ingenieur et architecte du Roy', Leonardo appears to have led a graciously privileged existence in the Palace of Cloux at Amboise. It was there that he wrote his last surviving note to carry a date — 'on 24 June, day of St John, 1518, at Amboise in the Palace of Cloux' (C.A.249rb) — a note appended to a characteristically obsessional page of geometrical conundrums. And it was there that he was visited by the Cardinal of Aragon's party on 10 October 1517, as recorded by Antonio de' Beatis. Antonio reported that a manual infirmity prevented Leonardo from painting 'with his former finesse', but his fertility as a designer was in no way impaired. He was as active as ever in devising projects and inventing delights for courtly consumption. Waterworks figured prominently among these, both for delight and utility. Most spectacular was the system of canalization planned in connection with the project for a great palace at Romorantin on the banks of the Saudre. Leonardo's scheme for the new residence and its environs can be reconstructed from a series of sketches (see especially C.A.76vb, 217vb and 294vb). A complex network of canals, including a basin for aquatic tournaments, and formal gardens with fountains were to provide a splendid setting for the new royal palace. The residence itself was projected as a rectangular structure articulated with classical motifs and punctuated by round towers — a fusion of Renaissance motifs and the French chateau tradition. Although work may have begun, Francis subsequently turned his attention to Chambord, and Leonardo's ideas were never to be realized. Or we should say, more correctly, that they were never realized by Leonardo himself. Echoes of his designs continued to reverberate in subsequent chateau design throughout the century.

One reason for the abandonment of Romorantin was the infirmity and eventual death of its designer. On 23 April 1519 Leonardo made his will, providing for his burial in the church of St Florentin at Amboise and distributing his possessions between members of his faithful household. 'Messer Francesco da Melzo, noble of Milan, in remuneration of services and favours done in the past' was to receive 'each and every book which the Testator owns at present and other instruments and images pertaining to his art and profession as a painter'. On 2 May Leonardo died, and Melzi wrote to Leonardo's half-brother, Ser Giuliano di Ser Piero da Vinci, movingly expressing his sorrow: 'It would be impossible for me to be able to express the grief under which I have fallen, and as long as the elements of my body remain conjoined I will be possessed of perpetual sadness.'

Although Leonardo died in voluntary exile from his own land, there is no reason to think that he died unacknowledged or unnoticed. Although the picturesque anecdote of his expiring in the arms of Francis is no more than a false legend, the King certainly did not fail to appreciate that his 'painter, engineer and architect' was someone quite exceptional — and not just as an artist. Benvenuto Cellini, the Florentine goldsmith and sculptor later employed by the King, reported that

King Francis, being enamoured to an extraordinary degree of Leonardo's great talents, took such pleasure in hearing him talk that he would only on a few days of the year deprive himself of his company... I cannot resist repeating the words which I heard the King say about him, in the presence of the Cardinal of Ferrara and the Cardinal of Lorraine and the King of Navarre; he said that he did not believe that a man had ever been born who knew as much as Leonardo, not only in the spheres of painting, sculpture and architecture, but that he was also a very great philosopher.

During the centuries following Leonardo's death his legacy has inevitably become dispersed and in part lost. Our responsibility, as heirs to this precious legacy, is to draw together the dispersed and disorderly fragments, creating some kind of synthesis in order to make as good a sense of the whole as the vagaries of survival have permitted. In attempting to do this in a single volume, I should like to think that I have borne in mind Leonardo's own disparagement of those who oversimplify for the sake of easy understanding. I have already quoted this disparagement once, but it is worth repeating. 'The abbreviators of works do injury to knowledge and to love, for love of anything is the offspring of knowledge, love being more fervent in proportion as knowledge is more certain, and this certainty springs from a thorough knowledge of all the parts which compose the whole' (W.19048r). The rich diversity of parts in his heritage must be respected, but, as I have attempted to show, the diversity is not chaotic, and I fervently believe that it is the duty of any Leonardo scholar, no matter how small a detail he may be considering, never to lose sight of the whole. As Leonardo himself wrote about 1508, in connection with his anatomical studies: 'You will draw accurate outlines' around the dissected area 'so that the shape of the limb which you describe will not remain a monstrous thing from having its parts taken away. Additionally there follows a greater knowledge of the whole, because after the part is removed you will still see the true shape overall' (W.19027r and 19035r).

Bibliography

Although this necessarily selective list has been compiled specifically to acknowledge the sources which have played the most prominent roles in the preparation of this book, I hope it will also serve the needs of anyone who wishes to pursue further investigations. To this end I have drawn attention to those recent works which provide further bibliographical information.

The bibliography is classified in sections corresponding to the divisions of the text. Within the first section I have included all those sources and authors mentioned in the preface. Within the sections relating to each chapter, the sources are arranged in an order corresponding to the sequence of subjects in the text. Reference to previously cited literature is by number.

Preface

Leonardo's writings in facsimile and transcription

MSS. A. to M.:
> *Les Manuscrits de Léonard de Vinci. Manuscrit A. (etc.)*, ed. C. Ravaisson-Mollien, 6 vols, Paris, 1881-91.
> MSS. A. and B.: *I Manoscritti e i Disegni di Leonardo da Vinci*, Reale Commissione Vinciana, Rome, 1938 and 1941. MSS. A.-D. are also available in the more recent French eds by A. Corbeau and N. De Toni.

Ash. I and II:
> ed. Ravaisson-Mollien as above.

B.L.:
> *I Manoscritti e i Disegni di Leonardo da Vinci, Il Codice Arundel* 263 Reale Commissione Vinciana, 4 vols, Rome, 1923-30.

C.A.:
> *Il Codice Atlantico di Leonardo da Vinci nella Biblioteca Ambrosiana di Milano*, Reale Accademia dei Lincei, transcribed by G. Piumati, 35 vols, Milan, 1894-1904 (I have continued to refer to the folio nos of this ed. in order to permit ready concordance with the existing anthologies and literature). Also the more recent facsimile, following restoration etc., *Il Codice Atlantico di Leonardo da Vinci*, 12 vols, Florence, 1973-5; with transcriptions and concordance by A. Marinoni, *Il Codice Atlantico della Biblioteca Ambrosiana di Milano, transrizione diplomatica e critica*, Florence, 1975-.

Forster I, II and III:
> *I Manoscritti e i Disegni di Leonardo da Vinci. Il Codice Forster I (etc.)*, Reale Commissione Vinciana, 5 vols, Rome 1930-6.

Leic.:

> *Il Codice di Leonardo da Vinci della Biblioteca di Lord Leicester in Holkham Hall*, ed. G. Calvi, Reale Instituto Lombardo di Scienze e Lettere, Milan, 1909.

Madrid I and II:

> *The Manuscripts of Leonardo da Vinci ... at the Biblioteca Nacional of Madrid*, ed. L. Reti, 5 vols, New York, 1974.

Triv.:

> *Il Codice di Leonardo da Vinci della Biblioteca del Principe Trivulzio in Milano*, ed. L. Beltrami, Milan, 1891. Also *Il Codice Trivulziano*, ed. N. de Toni, Milan, 1939.

Turin:

> *I manoscritti di Leonardo da Vinci. Codice sul volo degli uccelli e varie altre materie*, ed. T. Sabachnikoff, G. Piumati and C. Ravaisson-Mollien, Paris 1893. And *I fogli mancanti al codice di Leonardo da Vinci nella Biblioteca Reale di Torino*, ed. E. Carusi, Rome, 1926.

Urb.:

> *Treatise On Painting (Codex Urbinas Latinus 1270) by Leonardo da Vinci*, ed. A.P. McMahon, 2 vols, Princeton, 1956 (with classified bibliography).

W.:

> *I manoscritti di Leonardo da Vinci della Reale Biblioteca di Windsor. Dell' Anatomia, Fogli A*, ed. Sabachnikoff and Piumati, Paris, 1898.
> *I manoscritti di Leonardo da Vinci della Reale Biblioteca di Windsor. Dell'Anatomia, Fogli B*, ed. T. Sabachnikoff and G. Piumati, Turin, 1901 (see also no. 249).
> *Leonardo da Vinci, Quaderni d'Anatomia (I-IV)*, ed. O. Vangensten, A. Fonahn and H. Hopstock, 6 vols, Christiana, 1911-16.

For the editions and history of the MSS. see:

(1) A. Marinoni, 'I manoscritti di Leonardo da Vinci e le loro edizioni', *Leonardo: Saggi e ricerche*, Rome, 1954, pp. 231-73.
(2) C. Pedretti, *Leonardo da Vinci On Painting: A Lost Book (Libro A)*, London, 1965, pp. 252-9.

Anthologies of Leonardo's writings

(3) *The Literary Works of Leonardo da Vinci*, ed. J.P. Richter, 3rd ed., 2 vols, London and New York, 1970; with *Commentary* by C. Pedretti, 2 vols, Oxford, 1977, containing extensive bibliographical references and an updating of Richter's history of the MSS. Also *Selections from the Notebooks of Leonardo da Vinci*, ed. I. Richter, Oxford, 1977.
(4) *The Notebooks of Leonardo da Vinci*, ed. E. MacCurdy, 2 vols, London, 1938.
(5) *Scritti scelti di Leonardo da Vinci*, ed. A.M. Brizio, Turin, 1952.
(6) *Leonardo da Vinci. Scritti letterari*, ed. A. Marinoni, rev. ed., Milan, 1974.

Works cited in the Preface

(7) L. Beltrami, *Documenti e Memorie riguardanti la Vita e le Opere di Leonardo da Vinci*, Milan, 1919.

(8) G. Calvi, *I Manoscritti di Leonardo da Vinci dal punto di vista cronologico, storico e biografico*, Bologna, 1925.

(9) K. Clark, *Leonardo da Vinci. An Account of his Development as an Artist*, rev. ed., Harmondsworth, 1967.

(10) K. Clark, *The Drawings of Leonardo da Vinci in the Collection of Her Majesty the Queen at Windsor Castle*, 2nd ed. with C. Pedretti, 3 vols, London and New York, 1968 (see also no. 249).

(11) P. Duhem, *Etudes sur Léonard de Vinci, ceux qu'il a lus e ceux qui l'ont lu*, 3 vols, Paris, 1906-13.

(12) P. Giovio, *Leonardi Vincii Vita* (*c.* 1527) in Richter (no. 4), I, pp. 2-3, the earliest biography.

(13) E. Gombrich, 'The Form of Movement in Water and Air', *Leonardo's Legacy*, ed. C. O'Malley, Berkeley and Los Angeles, 1969, pp. 131-204.

(14) L. Heydenreich, *Leonardo da Vinci*, 2 vols, New York and Basel, 1954, with classified bibliography.

(15) E. MacCurdy, *The Mind of Leonardo da Vinci*, London, Toronto and New York, 1932.

(16) F. Malaguzzi-Valeri, *La Corte di Ludovico il Moro*, 3 vols, Milan, 1913, 1917 and 1923.

(17) E. Müntz, *Léonard de Vinci, l'artiste, le penseur, le savant*, 2 vols, Paris, 1899.

(18) C. O'Malley and J. Saunders, *Leonardo da Vinci on the Human Body*, New York, 1952.

(19) G. Poggi (ed.), *Leonardo da Vinci: la 'Vita' di Giorgio Vasari nuovamente commentata e illustrata con 200 tavole*, Florence, 1919.

(20) A. Popham, *The Drawings of Leonardo da Vinci*, London, 1946.

(21) G. Séailles, *Léonard de Vinci, l'artiste et le savant*, Paris, 1892.

(22) E. Solmi, *Leonardo (1452-1519)*, Florence, 1900; and 'Le Fonti dei manoscritti di Leonardo da Vinci', *Giornale storico della Letteratura Italiana* (suppl. 10-11), Turin, 1908 and 1911, pp. 312-27.

(23) G. Vasari, *Life of Leonardo da Vinci* (1550 and 1568) in Beltrami (no. 7) and Poggi (no. 19); also *The Life of Leonardo da Vinci by Giorgio Vasari*, trs. H. Horne, London, 1903.

(24) P. Valéry, *Introduction à la methode de Léonard de Vinci*, in *Nouvelle Revue*, 15 August 1895, and *Nouvelle Revue Francaise*, Paris, 1919.

(25) V. Zubov, *Leonardo da Vinci*, trs. D. Kraus, Cambridge (Mass.), 1968.

Chapter I

Space, perspective and optics (pages 24-36)

(26) Cennino Ccnnini, *Il Libro dell'Arte*, ed. D. Thompson, New Haven, 1932, and trs. Thompson, 1933.

(27) J. White, *The Birth and Rebirth of Pictorial Space*, 2nd ed., London, 1967.

(28) A. Manetti(?), *The Life of Brunelleschi*, ed. H. Saalman and trs. C. Enggass, Pennsylvania and London, 1970.

(29) M. Kemp, 'Science, non-science and nonsense: the interpretation of Brunelleschi's perspective', *Art History*, I, 1978, pp. 134-61.

(30) H. Janson, 'Ground Plan and Elevation of Masaccio's *Trinity* Fresco', *Essays in the History of Art presented to Rudolf Wittkower*, London, 1967, pp. 83-8.

(31) *Leon Battista Alberti 'On Painting' and 'On Sculpture'*, ed. and trs. C. Grayson, London, 1972.

(32) D. Lindberg, *Theories of Vision from Al-Kindi to Kepler*, Chicago, 1976, with extensive bibliographical material.

(33) L. Ghiberti, *I Commentarii*, ed. J. von Schlosser, *Lorenzo Ghibertis Denwürdigkeiten*, Berlin, 1912.

Antiquity, Humanist revivals, etc. (pages 36-7)

(34) Vitruvius, *The Ten Books on Architecture*, trs. M. Morgan, Cambridge (Mass.), 1914 and New York, 1960; also White (no. 27), pp. 250-6.

(35) L. Ciapponi, 'Il "De Architectura" di Vitruvio nel primo umanesimo', *Italia Medioevale e Umanistica*, III, 1960, pp. 59-99.

(36) *The Elder Pliny's Chapters on the History of Art* (trs. from the *Natural History*), Sellers, Jex-Blake, London, 1896.

(37) M. Baxandall, *Giotto and the Orators*, Oxford, 1971, for fine analyses of humanist attitudes to artists.

(38) G. Vasari, *Le Vite...*, ed. G. Milanesi, 9 vols, Florence, 1906.

(39) L. Bruni, *Le Vite di Dante e di Petrarca*, ed. H. Baron, *Leonardo Bruni Aretino*, Leipzig, 1928.

Verrocchio and early Leonardo (pages 40-90)

(40) G. Passavant, *Verrocchio*, London, 1969.

(41) C. Seymour Jnr, *The Sculpture of Verrocchio*, London, 1971.

(42) J. Walker, 'Ginevra de'Benci by Leonardo da Vinci', *Report and Studies in the History of Art*, National Gallery of Art, Washington, 1967, pp. 1-38.

(43) T. Brachert, 'A Distinctive Aspect in the Painting Technique of the Ginevra de'Benci and of Leonardo's other Early Works', *Report and Studies in the History of Art*, National Gallery of Art, Washington, 1969, pp. 85-104.

(44) F. Albertini, *Memoriale di molte statue et picture ...* (1510), in Beltrami (no. 7), for the reference to 'an Angel by Leonardo Vinci' in S. Salvi — either in the *Baptism* or a separate picture (ch. IV).

(45) J.G.P. Hills, *Leonardo's Adoration of the Magi and its Antecedants*, M.A. Report, University of London, 1971, for a review of the documents and iconographical suggestions.

(46) R. Hatfield, *Botticelli's Uffizi "Adoration"*, Princeton, 1976, for an illuminating account of the Compagnia de' Magi and somewhat overelaborate analysis of content.

(47) G. Rucellai, *Zibaldone Quaresimale* (1457-), ed. A Perosa, *Studies of the Warburg Institute*, London, 1960, p. 76.

(48) E. Fahy is to publish a full analysis of the content and style of Verrocchio's *'Ruskin Madonna'* in a booklet for the National Gallery of Scotland, Edinburgh.

(49) *The Unknown Leonardo,* ed. L. Reti, London, 1974, for articles by B. Dibner, S. Bedini and L. Reti on Leonardo's technical works, with further references; also Reti and Dibner in *L's Legacy* (no. 13).

(50) R. Stites, *The Sublimations of Leonardo da Vinci with a Translation of the Codex Trivulzianus,* Washington, 1970, for useful details of Leonardo's early technical drawings, within an otherwise misguided book.

(51) R. Valturio, *De re militari,* Verona, Joannes Nicolai de Verona, 1472; and trs. P. Ramusio, Verona, Boninus de Boninis, 1483.

(52) F. Prager and G. Scaglia, *Brunelleschi. Studies of his Technology and Inventions,* Cambridge (Mass.), 1970.

(53) F. de Giorgio, *Trattati de architettura civile e militare,* ed. C. Maltese and L. Maltese Degrassi, 2 vols, Milan, 1967.

Chapter II

Madonna of the Rocks (pages 93-9)

(54) H. Glasser, *Artists' Contracts in the Early Renaissance,* Ph.D. thesis, Columbia University, 1965 (University Microfilms, 68-5649), in which the documentation of the Madonna is transcribed and, to my mind, misinterpreted. The new documents for the 1508 commission for the copy have been discovered in the Archivio di Stato in Milan (notary Marco Formenti) by G. Sironi. In the summaries available to me in May 1980, the documents appear to complicate the problem of the two versions rather than resolving it (see also no. 252).

(55) C. Gould, *Leonardo. The Artist and Non-Artist,* London, 1975, pp. 75-90, for a considered review of the documentation.

(56) M. Levi d'Ancona, *The Iconography of the Immaculate Conception in the Middle Ages and Early Renaissance,* New York, 1957.

(57) M. Aronberg Lavin, 'Giovannino Battista: A Study in Renaissance Religious Symbolism', *Art Bulletin,* XXXVII, 1955, pp. 85-101.

(58) D. Robertson Jnr, 'In Foraminibus Petrae. A Note on Leonardo's "Virgin of the Rocks"', *Renaissance News,* VII, 1954, pp. 92-5.

(59) J. Shearman, 'Leonardo's Colour and Chiaroscuro', *Zeitschrift für Kunstgeschichte,* XXV, 1962, pp. 13-47.

(60) 'Anonimo Gaddiano', Antonio Billi and Vasari in Beltrami (no. 7) and Horne (no. 23), for the gift to Maximilian.

Milan and the Sforza Court (pages 93-102)

(61) Malaguzzi-Valeri (no. 16).

(62) *Storia di Milano,* Fondazione Treccani, Milan, 1953-66.

(63) C. Ady, *A History of Milan under the Sforza,* London, 1907, still the only survey of its kind in English. The most recent Italian survey is C. Santoro, *Gli Sforza,* Milan 1968.

(64) *Milano e Laghi* in the 'Guida d'Italia' series (Touring Club Italiano), 8th ed., Milan, 1967, for a comprehensive guide to the monuments of Milan.

Leonardo's literary education, writing, etc. (pages 102-6)

(65) A. Marinoni, *Gli appunti grammaticali e lessicale di Leonardo da Vinci*, 2 vols, Milan 1944 and 1952; and Marinoni's related studies cited in *Scritti letterari* (no. 6), p. 8.

(66) E. Garin, 'Il problema delle fonti del pensiero di Leonardo', *La coltura filosofica del Rinascimento*, Florence, 1961, pp. 388-401.

(67) Solmi, 'Fonti' (no. 22).

(68) H. Baron, *The Crisis of the Early Italian Renaissance*, rev. ed., Princeton, 1966, pp. 420-3, for Buonaccorso da Montemagno the Ygr.

Architecture (pages 107-13)

(69) *Leon Battista Alberti. L'Architettura*, ed. G. Orlandi and P. Portoghesi, 2 vols, Milan, 1966. The old Leoni translation (1755 and reprinted London, 1955) requires complete revision.

(70) Filarete's *Treatise on Architecture*, facsimile and trs. J. Spencer, 2 vols, New Haven, 1965.

(71) Francesco di Giorgio (no. 53).

(72) R. Wittkower, *Architectural Principles in the Age of Humanism*, rev. ed., London, 1962.

(73) S. Lang, 'Leonardo's Architectural Designs and the Sforza Manusoleum', *Journal of the Warburg and Courtauld Institutes*, XXXI, 1968, pp. 218-33.

(74) C. Pedretti, *Leonardo da Vinci. The Royal Palace at Romorantin*, Cambridge (Mass.), 1972, with extensive bibliographical references for all phases of Leonardo's career as an architect.

Microcosm, proportions, etc. (pages 114-19)

(75) R. Allers, 'Microcosmus', *Traditio*, II, 1944, p. 241ff.

(76) L. Barkan, *Nature's Work of Art*, New Haven and London, 1975, esp. ch. I, for a recent survey of microcosmic theories.

(77) Luca Pacioli, *De divina proportione*, Venice, Paganinum de Paganinis, 1509; and ed. C. Winterberg, Vienna, 1889.

(78) Wittkower (no. 72).

(79) W. Lotz, 'Eine Deinokratesdarstellung des Francesco di Giorgio', *Mitteilungen der Kunsthistorisches Institut in Florenz*, V, 1940, pp. 428-33.

(80) Ristoro d'Arezzo, *La Composizione del Mondo*, ed. E Narducci, Rome, 1859, I, 20.

(81) Zubov (no. 25), pp. 122-3.

Machines, flight, etc. (pages 119-24)

(82) L. Reti and B. Dibner in *Leonardo's Legacy* (no. 13).
(83) L. Reti and S. Bedini in *The Unknown Leonardo* (no. 49).
(84) I. Hart, *The Mechanical Investigations of Leonardo da Vinci*, 2nd ed. with foreword by E. Moody, Berkeley, Los Angeles, Cambridge and London, 1963.

Anatomy, physiology, etc. (pages 124-8 and 135-8)

(85) O'Malley and Saunders (no. 18) (see also no. 249).
(86) S. Esche, *Leonardo da Vinci. Das anatomische Werke*, Basel, 1954.
(87) K. Keele, 'Leonardo da Vinci's Research on the Central Nervous System', *Atti del Simposio Internationale di Storia della neurologia*, Varenna, 1961, pp. 12-30.
(88) M. Kemp, 'Il concetto dell'anima in Leonardo's Early Skull Studies', *Journal of the Warburg and Courtauld Institutes*, XXXIV, 1971, pp. 115-34, revised in my 'From "Mimesis" to "Fantasia"', *Viator*, VIII, 1977, pp. 361-2 and 379-81, with further references.
(89) R. Bacon, *Opus Majus*, ed. J. Bridges, 3 vols, Oxford, 1897 and London, 1900.

Optics (pages 128-34)

(90) Lindberg (no. 32).
(91) J. Pecham, *Perspectiva Communis*, ed. and trs. D. Lindberg, *John Pecham and the Science of Optics*, Madison, Wisconsin, 1970.
(92) Alberti (no. 31).
(93) M. Kemp, 'Leonardo and the Visual Pyramid', *Journal of the Warburg and Courtauld Institutes*, XL, 1977, pp. 128-49.

Dynamics and statics (pages 138-47)

(94) E. Grant, *Physical Science in the Middle Ages*, London, 1971 and Cambridge, 1977, for a succinct introduction and useful 'bibliographical essay'.
(95) A. Crombie, *Medieval and Early Modern Science*, 2 vols, New York, 1959.
(96) M. Clagett, *The Science of Mechanics in the Middle Ages*, Madison, Wisconsin, 1959.
(97) E. Moody and M. Clagett, *The Medieval Science of Weights*, Madison, Wisconsin, 1952.
(98) Duhem (no. 11).
(99) Gombrich (no. 13).
(100) Hart and Moody (no. 84).
(101) N. Oresme, *De proportionibus proportionum and Ad pauca respicientes*, ed. and trs. E. Grant, Madison, Wisconsin, 1966.

Luca Pacioli, mathematics, etc. (pages 146-50)

(102) P. Rose, *The Italian Renaissance of Mathematics*, Geneva, 1975.

(103) Pacioli (no. 77). Also the facsimile ed. of the MS. in the Ambrosiana (the Galeazzo Sanseverino version), *Fontes Ambrosiani, XXXI*, ed. G. Biggiogero and F. Riva, Milan, 1966; and the Ludovican MS. in the Bibliothèque Publique et Universitaire de Genève, MS. Langues Etrangères 210.

(104) P. Speziali, 'Léonard da Vinci et la "Divina Proportione" de Luca Pacioli', *Bibliothèque d'Humanisme et Renaissance*, XV, 1953, pp. 295-305.

Chapter III

Court art, humour, fantasy, etc. (pages 152-7 and 159-65)

(105) Malaguzzi-Valeri (no. 16).

(106) P. Barolsky, *Infinite Jest. Wit and Humour in Italian Renaissance Art*, Missouri, 1978, the only survey of its kind, though sadly inadequate in a number of areas, including grotesques.

(107) Kemp, 'Mimesis to Fantasia' for attitudes to 'fantasy' (no. 88).

(108) A. Marinoni, *I Rebus di Leonardo da Vinci, raccolti e interpretati*, Florence, 1951.

Physiognomics (pages 158-9)

(109) M. Scot, *Liber phisionomiae*, Venice, Jacobus de Tivizzano, 1477, and ed. L. Thorndyke, London, 1965.

(110) R. Bacon, *Secretum secretorum*, ed. R. Steele, *Opera hactenus inedita Rogeri Baconi*, V, Oxford, 1920.

(111) M. Savonarola, *Speculum phisionomiae*, Paris, Bibliothèque Nationale, MS. lat. 7357(1442?).

(112) P. Meller, 'Physiognomic Theory in Renaissance Heroic Portraits', *Acts of the XXth International Congress of the History of Art*, vol. II, Princeton, 1963, pp. 53-69.

(113) E. Gombrich, 'Leonardo da Vinci's Method of Analysis and Permutation: the Grotesque Heads', *The Heritage of Apelles*, London, 1976, pp. 57-75.

Mathematical 'games' (pages 163-4)

(114) L. Pacioli, *De viribus quantitas*, Bologna, Biblioteca dell' Universita, MS.250. An edition is being prepared by P. Rose.

(115) C. Pedretti, 'Il "De viribus quantitas" di Luca Pacioli', *Studi Vinciani*, Geneva, 1957, pp. 43-53.

Theatrical designs and music (pages 166-70)

(116) K. Steinitz, 'Leonardo Architetto Teatrale e Organizzatore di Feste' *IX Lettura Vinciana* (Milan, 1969), Florence, 1970.

(117) C. Pedretti, 'Dessins d'une scène, exécutés par Léonard de Vinci pour Charles d'Amboise (1506-7)', *Le lieu Théâtral à la Renaissance*, Paris,

1964, pp. 27-34, for a late date for the 'Pluto's Paradise' design.

(118) E. Motta, 'Musici alla Corte degli Sforza', *Archivio Storico Lombardo*, 2 ser., XIV, 1887, pp. 29-64 and 514ff.

(119) E. Winternitz in *The Unknown Leonardo* (no. 49), with further references to Leonardo's musical activities.

Vigevano (pages 171-4)

(120) E. Solmi, 'Leonardo da Vinci nel Castello e nella Sforzesca di Vigevano', *Viglevanum*, 1911, pp. 149ff.

(121) V. Berghoef, 'Les origines de la Place Ducale a Vigevano', *Palladio*, XIV, 1964, pp. 165-78.

(122) V. Carnevalli, *La Sforzesca*, Vigevano, 1952.

Engineering (pages 174-7)

(123) Dibner in *Leonardo's Legacy* (no. 13) and in *The Unknown Leonardo* (no. 49) for automation and military designs.

(124) Reti and C. Zammattio in *The Unknown Leonardo* (no. 49) for mechanical and hydraulic engineering.

Early accounts of Leonardo's personality etc. (pages 177-80)

(125) M. Bandello, *Le Novelle*, ed. F. Picco, Milan, 1973, part I, dedication to Novella LVIII.

(126) G. Giraldi, *Discorsi intorno al comporre dei romanzi, delle commedie e delle tragedie* (1554) in Richter (no. 3), I, pp. 28-9.

(127) Vasari (no. 23).

(128) Giovio (no. 12).

(129) Beltrami (no. 7) for other early sources.

(130) E. Möller 'Wie sah Leonardo aus?', *Belvedere*, IX, 1926, pp. 29-46.

Sala delle Asse (pages 181-9)

(131) L. Beltrami, 'La Sala delle Asse nel Castello di Milano', *Rassegna d'Arte*, 1902, pp. 65ff.

(132) Biblioteca Trivulziana, MS. 2168, a compendium of Visconti-Sforza *imprese*, illustrates an arboreal *divisa*, 'Per zentilezza', in which a youth is pulling down the branch of a tree (fol. 34v).

(133) A Luzio and R. Renier, 'Il lusso di Isabella d'Este', *Nuova Antologia*, 4 ser., LXVII, 1896, p. 462, for the *fantasia dei vinci*.

(134) Malaguzzi-Valeri (no. 16), I, 'La Vita Privata', 1913, p. 432, for the *pallio*.

(135) Alberti (no. 69), and Vitruvius (no. 34).

S. Maria delle Grazie and the Last Supper (pages 189-99)

(136) C. Pedretti, 'The Sforza Sepulchre', *Gazette des Beaux Arts*, LXXXIX, 1977, pp. 121-31.

(137) L. Steinberg, 'Leonardo's Last Supper', *Art Quarterly*, XXXVI, 1973, pp. 297-410, with a comprehensive review of the literature, but guilty on its own account of interpretative overkill.
(138) L. Heydenreich, *Leonardo: the Last Supper*, London, 1974.
(139) Alberti (no. 31).
(140) T. Brachert, 'A Musical Canon of Proportion in Leonardo's *Last Supper*', *Art Bulletin*, LIII, 1971, pp. 461-6.

Portraits (pages 199-202)

(141) J. Pope-Hennessy, *The Portrait in the Renaissance*, London and New York, 1966.
(142) C.A. 167v contains the three epigrams on Lucrezia's portrait: Richter (no. 3) II, p. 387, s. 1560.
(143) Beltrami (no. 7) for Cecilia's and Isabella's letters.
(144) F. Calvi, *Famiglie Notabili Milanesi*, Milan, 1884, vol. II, for the Gallerani.
(145) K. Kwiatkowski, 'La Dame à l'Hermine de Léonard de Vinci' *Museum National de Varsovie*, Warsaw, 1955.
(146) Richter (no. 3), I, p.77n., for Bellincioni's sonnet on Cecilia's portrait.

Sforza Monument (pages 207-8 and 211-12)

(147) V. Bush, 'Leonardo's Sforza Monument and Cinquecento Sculpture', *Arte Lombarda*, I., 1978, pp. 47-68.
(148) J. Pope-Hennessy, *Italian Renaissance Sculpture*, 2nd ed., London and New York, 1971, pp. 52-9 and fig. 87 (Pollaiuolo). (See also No. 250.)
(149) M. Brugnoli in *The Unknown Leonardo* (no. 49).
(150) Pedretti, *Commentary* (no. 3), II, p. 1ff., esp. p. 10, n. 1-2.
(151) P. Grierson, 'Ercole d'Este and Leonardo da Vinci's Equestrian Statue of Francesco Sforza', *Italian Studies*, XIV, 1959, pp. 40-8.

Chapter IV

(152) Beltrami (no. 7) for the documents on which the chronology is founded. New evidence from the Madrid MSS. is conveniently available in Pedretti, *Commentary* (no. 3), II, pp. 318-20.

Madonna of the Yarnwinder and St Annes (pages 215-16 and 219-27)

(153) Beltrami (no. 7) for the Novellara letters. The most commonly consulted translation in L. Goldscheider, *Leonardo da Vinci*, London, 1959, is significantly inaccurate.
(154) J. Wasserman, 'A Re-discovered Cartoon by Leonardo da Vinci', *Burlington Magazine*, CXII, 1970, pp. 194-210, for arguments in favour of the 'Vasari version'.
(155) J. Wasserman, 'Michelangelo's Virgin and Child with St Anne at Oxford', *Burlington Magazine*, CXI, 1969, pp. 122-31; and 'The Dating and Patronage of Leonardo's Burlington House Cartoon', *Art Bulletin*,

LIII, 1971, pp. 312-25, for advocacy of an early date for the National Gallery cartoon.

(156) C. Pedretti, 'The Burlington House Cartoon', *Burlington Magazine*, CX, 1968, pp. 22-8, for a later dating.

(157) F. Canuti, *Il Perugino*, 2 vols, Siena, 1931, for the documents relating to the SS. Annunziata altarpiece.

Cesare Borgia and Jacopo Appiani and the canals (pages 227-34)

(158) M. Mallett, *The Borgias*, London, 1971, esp. chs 8-10.

(159) Heydenreich (no. 14), pp. 84-9.

(160) J. Gadol, *Leon Battista Alberti. Universal Man of the Early Renaissance*, Chicago and London, 1969, pp. 157-95, for cartographic methods, with references to eds of Alberti's writings.

(161) Pedretti, *Commentary* (no. 3), II, pp. 177-9, for a sixteenth-century account of the Pisa project.

(162) Zammattio in *The Unknown Leonardo* (no. 49), pp. 194-5, for a map of Leonardo's Arno canal.

(163) Heydenreich in *The Unknown Leonardo* (no. 49), for the Arno projects and Piombino works.

The Republic, the Council Hall and the Battle of Anghiari (pages 234-47)

(164) J. Wilde, 'The Hall of the Great Council of Florence', *Journal of the Warburg and Courtauld Institutes*, VII, 1944, pp. 65-81, with extensive references to the documentation.

(165) Beltrami (no. 7) for documents relating to the *Battle;* and D. Chambers, *Patrons and Artists in the Italian Renaissance*, London, 1970, pp. 85-8, for translations of Sansovino's contract and Leonardo's revised agreement.

(166) C. Seymour Jnr, *Michelangelo's David. A Search for Identity*, Pittsburgh, 1967.

(167) L. Ettlinger, 'Hercules Florentinus', *Mitteilungen des Kunsthistorischen Instituts in Florenz*, XVI, 1972, pp. 119-42.

(168) Cennini (no. 26), LXXII, for *tempera a secco*.

(169) Vasari (no. 38), translated in *Vasari on Technique*, trs. L. Maclehose, London 1907 and New York 1960, VIII, 22.

(170) C. Pedretti, *Leonardo. A Study in Chronology and Style*, London, 1973, pp. 81-96, for valuable information re. the hall, and eccentric interpretations of the copies.

(171) E. Gombrich, 'Leonardo's Methods of Working out Compositions', *Norm and Form*, London, 1966, pp. 58-63.

(172) H. Hibbard. *Michelangelo*. London, 1975, p. 74f. for a succinct account of Michelangelo's *Battle of Cascina*.

(173) Poggio Bracciolini, *Historia Florentina*, trs. J. Poggio, Venice, Jacobus Rubeus, 1476.

(174) N. Machiavelli, *Istorie Fiorentine*, trs. W. Marriott, London, 1909 and 1976, for a lively account of Piccino's activities, albeit with a distorted

account of the casualties in the battle (actually about 50 dead and 800 wounded).

(175) F. Gilbert, 'Florentine Political Assumptions in the Period of Savonarola and Soderini', *Journal of the Warburg and Courtauld Institutes*, XX, 1957, pp. 187-214.

(176) K. Suter, 'The Earliest Copy of the Battle of Anghiari', *Burlington Magazine*, LV, 1929, for an unusual identification of the Florentines as the soldiers on the left.

(177) P. Schubring, *Cassoni*, Leipzig-Berlin, 1932, no. XVIII.

(178) G. Neufeld, 'Leonardo da Vinci's Battle of Anghiari: a generic reconstruction', *Art Bulletin*, XXXI, 1949, pp. 170-83, for the least improbable of all the many attempts to reconstruct Leonardo's scheme for the whole wall.

Madrid booklist and mathematics (pages 247-55)

(179) Pedretti, *Commentary* (no. 3), II, pp. 355-68, for a thorough review of the booklist, with references to the important work on the identifications by Reti and Maccagni.

(180) R. Marcolongo, *Studi Vinciani. Memorie sulla geometrica e sulla meccanica di Leonardo da Vinci*, Naples, 1937; and *Leonardo da Vinci, artista, scienzato*, Milan, 1950.

(182) A. Marinoni, 'Leonardo ed Euclide', *Scritti* (no. 5), pp. 258-67.

(182) Pacioli (no. 77).

(183) L. Pacioli, *Summa de Arithmetica, Geometria, Proportioni et Proportionalità*, Venice, Paganinus de Paganinis, 1494.

(184) A. Marinoni, 'L'aritmetica di Leonardo', *Periodico de Matematiche*, Dec. 1968, p. 557ff.; and 'La teorica dei numeri frazionari nei manoscritti vinciani. Leonardo e Luca Pacioli', *Raccolta Vinciana*, XX, 1964, pp. 111-96.

(185) L. Valla, *De expetendis et fugiendis rebus opus...*, ed. Ioannes Petrus Valla, Venice, in aedibus Aldi, 1501.

(186) N. Cusanus, *De tranformationibus geometricis*, Corte Maggiore, 1502.

(187) *Tetragonismus id est circuli quadrata per Campanum ...*, ed. P. Gauricus, Venice, Ioan. Bapt. Sessa, 1503.

(188) M. Clagett, 'Leonardo da Vinci and the Medieval Archimedes', *Physis*, XI, 1969, pp. 100-51; and *Archimedes in the Middle Ages*, Madison, Wisconsin, 1964.

Bird flight and anatomy (pages 255-63)

(189) Hart (no. 84), for a translation of the Turin Codex.

(190) O'Malley and Saunders (no. 18).

(191) M. Kemp, 'Dissection and Divinity in Leonardo's Late Anatomies', *Journal of the Warburg and Courtauld Institutes*, XXXV, 1972, pp. 200-25.

(192) *The Fasciculo di Medicina, Venice, 1493*, trs. and intro. C. Singer, Florence, 1925, for Mundinus.

'Mona Lisa' and Leda (pages 263-77)

(193) Pope-Hennessy (no. 141).
(194) K. Clark, 'Mona Lisa', *Burlington Magazine*, CXV, 1973, pp. 144-50.
(195) M. Hours, 'Etude analytique des tableaux de Léonard de Vinci au laboratoire du Musée du Louvre', *Leonardo: Saggi e ricerche*, Rome, 1952.
(196) K. Keele, 'The Genesis of the Mona Lisa', *Journal of the History of Medicine and Allied Sciences*, XIV, 1959, pp. 136-59.
(197) Dante Alighieri, *Il Convivio*, ed. Busnelli and Vandelli, Florence, 1953.
(198) Antonio de Beatis, *Relazione del viaggio del cardinale Luigi Aragona* (1517-18), ed. L. Pastor, *Die Riese des Kardinals Luigi d'Aragona*, Freigburg, 1905; and Beltrami (no. 7)(see also no. 255).
(199) Pedretti (no. 170), pp. 132-9, for arguments in favour of a late dating for the portrait.
(200) R. McMullen, *Mona Lisa. The Picture and the Myth*, Boston, 1975, for the later legends and history.
(201) Clark (no. 9), ch. 6, and Heydenreich, pls 68 and 73 for the Ledas.
(202) K. Clark, 'Leonardo and the Antique', *Leonardo's Legacy* (no. 13).
(203) E. Panofsky, *Renaissance and Renascences in Western Art*, Upsala, 1965, figs 150-1, for Filippino's *Erato* and the *Cupid*.
(204) The evidence relating to the *Nile* is now available in A. Smart and M. Kemp, 'Leonardo's *Leda:* Roman Sources and New Chronology', *Art History*, III, 1980, pp. 160-71.

Chapter V

Return to Milan etc. (pages 278-85)

(205) Glasser (no. 54) for the *Madonna of the Rocks* documentation.
(206) Beltrami (no. 7) for the Letters from the Signoria, the French authorities and Louis XII; supplemented by B. Hochstetler Meyer, 'Louis XII, Leonardo and the *Burlington House Cartoor*', *Gazette des Beaux Arts*, LXXXVI, 1975, pp. 105-9.
(207) Pedretti (no. 74), pp. 41-52, for Charles' palace.
(208) Clark (no. 10), pp. xxxviii-xli, for the Trivulzio monument.

Anatomy and physiology (pages 285-95 and 300-2)

(209) O'Malley and Saunders (no. 18).
(210) Kemp (no. 191).
(211) Galen, *Anatomical Proceedures*, ed. C. Singer, Oxford, 1965.
(212) Galen, *De usu partium*, ed. and trs. M. May, New York, 1968.
(213) K. Keele, *Leonardo da Vinci on the Movement of the Heart and Blood*, London, 1952.
(214) Pacioli (no. 77), ed. 1889, p. 39, for Plato's motto.

Mathematics (pages 296-300)

(215) A. Marinoni, 'Leonardo, Luca Pacioli e il "De ludo geometrico"', *Atti e Memorie dell'Accademia Petrarca di Lettere, Arti e Scienze di Arezzo*, XL (new ser. 1970-2), Arezzo, 1974.

(216) Clagett (no. 188).

Dynamics and hydrodynamics (pages 302-10)

(217) Zubov (no. 25), pp. 188-9.

(218) Gombrich (no. 13), underrating the complexity of Leonardo's position in relation to the medieval authorities and Aristotle.

(219) N. Oresme, *Tractatus de configurationibus qualitatum et motuum*, ed. and trs. M. Clagett, *Nicole Oresme and the Medieval Geometry of Qualities and Motions*, Madison, Wisconsin, 1968.

(220) N. Oresme, *Tractatus de commensurabilitate vel incommensurabilitate motuum celi*, ed. and trs. E. Grant, *Nicole Oresme and his Kinematics of Circular Motion*, Madison, Wisconsin, 1971.

Geography, geology, meteorology and astronomy (pages 312-25)

(221) M. Baratta, *Leonardo da Vinci ed i problemi della terra*, Turin, 1903.

(222) Zubov (no. 25), pp. 190-5 and 226-51 for geological problems.

(223) Albert of Saxony, *Quaestiones in Aristotelis libros de caelo et mundo*, Pavia, Antonius Carcanus, 1481.

(224) Clark (no. 10) for the Deluge drawings and related studies.

(225) J. Gantner, *Leonardos Visionen von der Sintflut und von Untergang der Welt*, Bern, 1958.

(226) Pedretti (no. 170), pp. 10-24, for the historical context of the Deluge drawings.

(227) Zubov (no. 25), pp. 145-54, for Leonardo's astronomy.

Optics (pages 325-32)

(228) Kemp (no. 93).

(229) D. Strong, *Leonardo da Vinci on the Eye*, Ph.D. thesis, University of California, Los Angeles, 1968, University Microfilms 246.

(230) J. Ackerman, 'Leonardo's Eye', *Journal of the Warburg and Courtauld Institutes*, XII, 1978, pp. 108-46.

(231) Lindberg (no. 32).

(232) C. Pedretti, 'Leonardo on Curvilinear Perspective', *Bibliothèque d'humanisme et Renaissance*, XXV, 1963, pp. 69-87.

(233) C. Pedretti, 'The problem of Alhazen', *Gazette des Beaux Arts*, LXXVI, 1970, pp. 312-14.

(234) A.M. Brizio, 'Razzi incidenti e razzi refressi', *II Lettura Vinciana* (Milan, 1963), Florence 1964.

Late theory, St John and St Annes (pages 333-46)

(235) Pedretti (no. 2) for all Libro A references, and for the chronology of

the Codex Urbinas.

(236) M. Kemp. '*Ogni dipintore dipinge se:* a Neoplatonic echo in Leonardo's art theory?', *Cultural Aspects of the Italian Renaisance: Essays in Honour of P.O. Kristeller,* ed. C. Clough, Manchester, 1976, pp. 311-33.

(237) Pedretti (no. 170), fig. 168, for the sketch of St John's hand.

(238) M. Hours, 'A propos de l'examen au laboratoire de "la Vierge aux Rochers" et du "Saint Jean-Baptiste" de Léonard', *Raccolta Vinciana,* XIX, Milan, 1962, pp. 126-8.

(239) Gould (no. 55), pp. 122-4 and pl. 62, for the *Angel.*

(240) Pedretti (no. 170), fig. 65, for the seated *St John* drawing.

(241) Gould (no. 55) for arguments in favour of the 1507-8 dating for the London cartoon. See also Pedretti (no. 156); and A. Popham and P. Pouncey, *Italian Drawings in the Department of Prints and Drawings in the British Museum. The XIVth and XVth Centuries,* 2 vols, London, 1950.

(242) A. Ottino della Casa, *L'opera completa di Leonardo pittore,* intro. M. Pomilio, Milan, 1967, no. 35, for variants of the Louvre *St Anne.*

(243) A Shug, 'Zur Ikonographie von Leonardos Londoner Karton', *Pantheon,* XXVI, 1968, pp. 452-5, and XXVII, 1969, pp. 24-35, for the St Anne-St Elizabeth problem.

Late architecture and last years in France (pages 348-9)

(244) Antonio de Beatis (no. 198)

(245) Pedretti (no.74), for the Villa Melzi and Romorantin.

(246) C. Pedretti, 'Leonardo's Last Drawings', *Italian Quarterly,* Los Angeles, III, 11, pp. 42-57; and 'Leonardo da Vinci: Manuscripts and drawings of the French period, 1517-18', *Gazette des Beaux Arts,* LXXVI, 1970, pp. 285-318.

(247) B. Cellini, *Della Architettura,* in *La Letteratura Italiana,* XXVII, Milan and Naples, n.d., p.1111.

(248) Richter (no. 3), II, pp. 388-91, for Leonardo's will.

Addenda
(publications which became available after the completion of the text)

(249) *Leonardo da Vinci. Corpus of Anatomical Studies in the Collection of Her Majesty the Queen at Windsor Castle,* ed. C. Pedretti and K. Keele, New York, 1979.

(250) L. Ettlinger, *Antonio and Piero Pollaiuolo,* Oxford, 1978.

(251) J.G.P. Hills, 'Leonardo and Flemish Painting', *The Burlington Magazine,* CXXII, 1980, pp. 609-15.

(252) *Corriere d'Informazione,* Milan, 13 May 1980, for a report on the new documents for the *Virgin of the Rocks* (made available to me by Allan Braham and Cecil Gould).

(253) W. Welliver, 'Symbolic Meaning in Leonardo's and Raphael's Painted Architecture', *Art Quarterly* (new series) II, 1, Winter 1979, pp. 37-66.

(254) B. Morley, 'The Plant Illustrations of Leonardo da Vinci', *The Burlington Magazine*, CXXI, 1979, pp. 553-60.

(255) D.A. Brown and K. Oberhuber, '*Monna Vanna* and *Fornarina*: Leonardo and Raphael in Rome', *Essays Presented for Myron P. Gilmore*, ed. S. Bertelli and G. Ramakus, vol. II, 1978, pp. 26-86, for a useful account of the 'nude *Mona Lisa*' and less convincing conclusions regarding the '*Mona Lisa*' herself.

(256) M. Kemp, '*Navis Ecclesiae:* an Ambrosian Metaphor in Leonardo's Allegory of the Nautical Wolf and Imperious Eagle', *Bibliothèque d'Humanisme et Renaissance* (forthcoming).

Index

The index was compiled by Margaret Walker.
All works are by Leonardo unless otherwise indicated. Throughout, the letter 'L'
is used to denote Leonardo. Works by others are listed under the name of the artist
or writer.

Abano, Pietro d': *Conciliator differentiarum philosophorum et precipue medicorum*, 312
Abbaco, Benedetto del, 86
Acoustics, 106, 124, 131–2, 135, 177, 342, fig. 19
Adoration of the Magi, 66–9, 72–8, 85, 92, 96, 203, 213, 219, 247, pls. 24–7
Adoration of the Shepherds, studies, 68, 74
Aerodynamics, 122–3, 139, 255–6, 317–18, 318, 319, 329 fig. 90; *see also* Dynamics
Aesop: *Fables*, 154, 155
Agnolo, Baccio d', 221, 226, 234
Aides-mémoires, *see* Memoranda
Albert of Saxony, 142, 253, 314; *Quaestiones de caelo et mundo*, 312, 324
Alberti, Leon Battista, 32, 35, 37, 40, 44, 72, 74, 106, 108, 109, 110, 114, 129–30, 162, 164, 188, 190, 194, 196, 228, 326, 331, figs. 4–5, 17; *Apologhi*, 155; *De familia*, 104, *Descriptio urbis Romae*, 228; *Ludi mathematici*, 164, 228; *On Painting*, 32–3; *On Statuary*, 114
Albertinelli, Mariotto, 40
Albertini, Francesco, 218
Albertus Magnus, 104, 125, 140, 342; *Commentary on De caelo et mundo*, 312, 317; *Secrets*, 104

Albumasar, 323
Alexander VI, Pope, 216, 228
Alfonso of Aragon, King of Naples, 211
Alhazen, 33, 35, 130, 293, 326, 329, 331; *Opticae thesaurus*, 129
Alighieri, Dante, *see* Dante
Aliprando, Vincento, 105
Alkindi, 105
All'antica, *see* Classical antiquity
Allegory, *see* Symbolism
Amadeo, Giovanni Antonio, 102, 107
Amboise, Charles d', 217, 278, 281, 283, 285
Amboise: Palace of Cloux, 268, 248; —, *S. Florentin*, 348
Anatomists, artists as, 37–9, 125
Anatomy, 37–8, 39, 43–4, 63, 107, 119, 122, 124, 125, 129, 137, 205, 269, 270, 273, 257–8, 260–1, 285–6, 289, 291–2, 302, 330, 334, 346, 349; *see also* individual parts of the body; *On the Human Body*
Andrea da Imola, *see* Cattaneo, Andrea
Angel(s), 42–3, 48, 58, 60, 341; see also *Angel of the Annunciation*
Angel of the Annunciation (lost work), 218, 341, 342
Anghiari, Battle of, 235–6, 243, 256–7; see also *Battle of Anghiari*
Anne, St., 226, 235; *see also* Fra Bartolomeo; Madonna, Child and

St. Anne compositions

Annunciation, 48–9, 49, 54, 60, 61, 120, 344, pl. 9

Annunciation (play), 168

Antiperistasis, *see* Dynamics

Antiquario, Jacopo, 101

Antonello da Messina, 266, 341–2

Antonio, Maestro, 105

Apelles, 36, 37, 52, 148, 179, 205; *Calumny* (lost work), 162

Aphorisms, 106, 156; *see also* Pictographs

Appiani, Jacopo IV, 217, 232, 234

Aquilea, Patriarch of, 246

Aquinas, St. Thomas, 106, 140

Aragon, Alfonso of, *see* Alfonso of Aragon

Aragon, Cardinal of, 268, 270, 348

Aragon, Isabella of, *see* Isabella of Aragon

Araldo, Francesco, 86

Archimedes, 145, 179, 254, 298, 299, 312, 331; *De mensura circuli* (*On the Measurement of Circles*), 248, 253; *On the Equilibrium of Planes*, 254, 256; *On the Square and the Cylinder*, 254

Architecture, 88, 106, 107, 108, 109–10, 113–17, 122, 124, 146, 149, 188, 205, 215, 216, 228, 230, 247, 267, 269, 278, 281, 283, 310, 347, 348, 349; *figs.* 6–11, 51–2; pls. 35–7; *see also* Fortifications; Perspective; Statics

Arezzo, Ristoro d', 119; *Della composizione del mondo*, 104, 312

Arezzo, 265

Argiropolo, Giovanni, 86

Ariosto, Ludovico: *Orlando Furioso*, 153

Aristotle, 91, 104, 106, 125, 128, 139, 142, 148, 158, 161, 298, 304, 306, 323, 324; *De Anima* (*On the Soul*), 125, 128; *Physics*, 140; *De caelo et Mundo* (*On the Heavens and Earth*), 140, 312, 314; *Posterior Analytics*, 105

Arithmetic, 39, 248, 250, 298, figs. 55–6; pl. 53; *see also* Liberal Arts; Proportion, Musical

Arm, anatomy of the, pl. 80

Arno, R., 216–17, 231–2, 258, 263, 265, 312

Art: L's books on, *see* Library; — history, 24, 36; —theory, 26, 32, 285, *see also* individual media; *Paragone*

Artists, status of, 39, 103, 211; *see also* Anatomists, artists as; Engineers, artists as; Intellectuals, artists as; *Paragone*

Arundel ms., *see* London, British Library

Ascoli, Cecco d': *Acerba*, 104, 154

Ashburnham mss., *see* Paris, Institut de France

Astrology, 39, 153, 154, 158, 323

Astronomy, 86, 285, 323–5, 326; *see also* Liberal Arts

Athens, Duke of, *see* Brienne, Walter of

Augustine, St., 128

Avalos, Costanza d', 268

Averroes, 127, 312, 316

Avicenna, 125, 312

Bacon, Roger, 33, 35, 125, 128, 293, 326, 329, 343; *Opus majus*, 35, 129, 250; *Secretum secretorum*, 158

Balances, *see* Statics

Ballistics, 106, 142, 143–4, 176; figs. 26, 28; *see also* Dynamics; Fortifications

Bandello, Matteo, 180, 200

Baptism of Christ (Verrocchio and L), 58, 60–1, 84, pl. 17

Bari, Duke of, *see* Sforza, Ludovico; Sforza, Sforza

Basilica of Maxentius (Temple of Peace), 72, 73

Bats, flight of, 122, 256

Battagio, Giovanni, 174

Battle of Anghiari, 217, 218, 234, 236–40, 242–7, 256, 257, 268, 269, 270, 272, 273, 299; pls. 65–8; *see also* Anghiari, Battle of

Beatis, Antonio de', 268, 348

Beatrice (Dante's), 268

'*Belle Ferronière*', 199, 202

Bellincioni, Bernardo, 101, 152, 153, 156, 167, 201; *Paradiso*, 152, 167–8; *Timone*, 153

Bellini, Giovanni, 52–3, 200

Bells, 230

Benci, Amerigo de', 49

Benci, Ginevra de': portrait of, 49, 60, 61, pl. 10; —, family background, 49, 51

Benedetto del Abbaco, *see* Abbaco, Benedetto del

Bentivoglio Monument, 203

Bertoldo di Giovanni, 91

Bestiary, 104, 155, 158, 171, 201

Biagio, Rafaello d'Antonio di, 238

Bible, L's, 104

Billi, Antonio, 238

Birds, flight of, 122–4, 255–6, 303, 317–8, figs. 14, 90

Boccaccio, 106, 156; *Decamerone*, 156

Boethius, 148

Boiardo, Matteo Maria, 153

Bologna, 230, 347; *see also* Bentivoglio Monument

Bombardieri, Giovanni, 105

Bona di Savoia, Duchess of Milan, 99, 184, 187

Books, L's, *see* Library

Borgia, Cesare, Duke of Valentinois, 216, 217, 227–8, 230, 231, 233, 234, 254, 265

Borgo San Sepolchro, 246, 254

Borgognone, Ambrogio, 102

Boso, Gian Francesco, 43

Botany, 42, 44, 46, 48, 258, 260, 273, 277, 293, 309, 316, fig. 64, pls. 8, 74; *see also* Symbolism; Trees

Botticelli, Sandro, 214, 218; *Adoration of the Magi*, 68, 75; *Calumny*, 162; posthumous portrait of *Giuliano de' Medici*, 155

Botticini, Francesco, 42

Bracciolini, Poggio, 36; *Facetie*, 156; *History of Florence*, 243

Bradwardine, Thomas, 140, 142

Brain, physiology of the, 125–7, 135, figs. 15–16; *See also* Neurology

Bramante, Donato, 107, 153, 174, 187, 188, 190, 230, 265, fig. 51

Bramantino (Bartolomeo Suardi), 102

Brienne, Walter of, Duke of Athens, 226, 243

Briosco, Benedetto, 102

Bruges, 46

Brunelleschi, Filippo, 26–9, 31–2, 40, 88, 89, 109, 110, 113, 120, 168, figs. 1–2

Bruni, Leonardo, 39

Buonarrotti, Michelangelo, *see* Michelangelo

Buridan, Jean, 139, 140–1, 143, 144, 304, 312; *Questions on Aristotle's On the Heavens and Earth*, 314

Busti, Bernardino de', 94

Butinone, Bernardino, 102

Calco, Tristano, 167, 245

Calvo of the Alberti, 86

Campanus, Johannes, 150

Canals, *see* Hydraulic Engineering

Caponi, Stefano, 102

Caradosso Foppa, 102

Carbone, Lodovico: *Cento trenta novelle*, 156

Cardano, Fazio, 102, 105

Caricatures, *see* Grotesques

Cartography, 228–30, 232, pl. 64

Cascina, Battle of, 235–6, 243; *see also* Michelangelo: *Battle of Cascina*

Castellazzo (Vigevano), Sforza farm at, 171

Casting, 61, 205–7, fig. 49, pl. 59

Casts, life, 38, 43

Caterina (L's mother), 23

Cattaneo, Andrea (Andrea da Imola), 324

Cavalca, Pietro, 94

Cellini, Benvenuto, 348-9

Celsus, Cornelius, 104, 106; *De medicina*, 107

Cennini, Cennino, 24, 38, 237

Cesena, 228, 230

Charles VIII, King of France, 185, 211, 212, 213, 216, 237, 283

Chiaroscuro, 78, 96-8, 134, 194, 201, 267, 333-4, 338, 339, 341, 343, fig. 22, p. 87; *see also* Light; *Paragone*

Christianity, 33, 109, 128, 323, 342, 343

Christus, Petrus, 49

Cieperello, (Ser) Benedetto, 86

Cimabue, 24

Circulatory system, *see* Heart and circulatory system

City designs, *see* Urban planning

Civitavecchia, 347

Clark, Kenneth, 44

Classical antiquity, 26, 31, 35-7, 39, 88, 91, 100, 106, 152, 203-4, 205, 207, 214, 244, 270-3, 323

Classical science, 33, 83-5, 89, 103, 104, 107, 119, 129, 130, 135, 145, 298, 312

Cleomedes, 323

Cloux, Palace of, *see* Amboise

Codex Urbinas, *see* Rome, Vatican

Codice atlantico, see Milan, *Biblioteca Ambrosiana*

Colour theory, *see Chiaroscuro*?

Compagnia de' Magi, 68, 75

Company of Painters, *see* Company of St. Luke of Florence

Company of St. Luke of Florence, 23, 40, 51, 92, 217

Conceits, *see* Symbolism

Concetto dell' anima see Motions of the mind

Confraternity of the Immaculate Conception, 93-4, 96, 99, 278

Contrapposto, 227, 270, 272, 273, 275

Copernicus, Nicholas, 325

Correggio, Niccolò da, 101, 153, 187; *Mopsa e Daphne*, 153; *Innamoramento de Orlando*, 153

Cossa, Francesco del, 156

Creative method, 68-9, 72, 90, 223, 240; *see also* Drawing style

Credi, Lorenzo di, 42

Crivelli, Lucrezia, (lost) portrait of, 199

Cronaca, Il, 234

Ctesibius, 170

Curio, 168

Cusanus, Nicholas, 325; *De transformationibus geometricis*, 250-1

Dante Alighieri, 33, 39, 104, 106, 162, 189, 210, 267-8; *Convivio*, 104, 106, 162, 267; *Divina Commedia*, 104, 162; *Paradiso, Il*, 33

Dati, Goro: *La Spera*, 323, 325

De ludo geometrico, 298

Decorum, 29, 334, 336-7

Dei, Benedetto, 159, 162, 322

Della Robbia, Luca, *see* Robbia

Della Torre, Marcantonio, *see* Torre

Deluge, 315, 319-23, 341, 345, pls. 85-6; *see also* Prodigies of nature

Desiderio da Settignano, 54

Desio, drawing of fire at, 346

Devices, heraldic, *see* Symbolism

Dialectic, *see* Liberal Arts, 39, 103, 211

Dissection, *see* Anatomy

Dolcebuono, Giovan Giacomo, 107, 174

Domenico di Michelino, 86

Donatello, 32, 37, 204; *Equestrian monument to Erasmo da Narni (Gattamelata)*, 202, 205

Donati, Manno, 243

Donatus: *Grammatica*, 103

Doodles, 42, 44, 53, 81, 87-8, 90, 248; *see also* Memoranda

Drawing style, 52, 270, 272–3; revolutionary 'brainstorm' technique, 54, 56–7, 78, 227, 240, pls. 15–16; see also *Paragone*

Dynamics, 89, 119, 120, 122, 124, 137, 138, 139–43, 144, 146, 148, 150, 160, 256, 285, 303, 304–6, 323, 341, figs. 25, 31, 79; see also Aerodynamics; Ballistics; Brain, anatomy and physiology of the; Elements of Machines; Excavations; Flux; Fortifications; Gravity; Heart, anatomy and physiology of the; Hydrodynamics; Movement; Neurology; Statics

Earthquakes, see Prodigies of nature

Elements, the four, 114, 117, 138, 138–9, 140, 155, 306, 312–13, 314, fig. 86; see also Geography

Elements of Machines, 119–20, 256, figs. 12–13, pl. 41

Elizabeth, St., 346

Emblems, see Symbolism

Embryology, see Reproductive system

Empiricism, 103, 105, 106–7, 128, 143–4, 148, 150, 179, 230, 232, 257, 289, 291, 304, 307, 308, 325, 326–7, 329; see also Observation; Optics; Perceptions, sensory; Scientific method

Engineering, 42, 61, 84, 88, 89, 90, 174, 247, 278, 348; see also Casting; Engineers, artists as; Hydraulic engineering; Industrial engineering; Mechanical engineering; Military engineering; Naval engineering

Engineers, artists as, 88–9, 102, 174

Epicurus, 304

Epiphany, see *Adoration of the Magi*

Equilibrium, see Statics

Este, Alfonso d', 152, 215

Este, Beatrice d', Duchess of Milan, 101, 152, 153, 171, 181, 185, 190, 199, 207, 211; see also Symbolism

Este, d', Court of, 91, 101, 152, 153, 156, 167, 169

Este, Ercole, d', 211, 212

Este, Isabella, d', Marchioness of Mantua, 101, 153, 171, 187, 207, 215–16, 217, 218, 219, 268, 226, 227, 268

Este, Medialuso, d', 164

Euclid, 102, 145, 148, 150, 190, 250, 298; *Elements*, 150, 248; *Euclid volgare*, 248

Eutocus, 250

Excavations, 232–3, 234, 248

Experience, see Empiricism

Experiments, see Empiricism

Eyck, Jan van, 49, 60, 201

Eye, anatomy and physiology of the, 35, 128–9, 130, 131, 155, 328, 329, figs. 15–16; —, as window of the soul, 267; see also Optics; Sight

Fables, 52, 93, 154–5, 156, 158, 188

Facetie, 156, 157, 159; see also Fables

Faculty psychology, see Brain, anatomy and physiology of the

Fancelli, Luca, 231

Fanfoia, Il, 346

Fantasia: exercise of, 160–2, 211; location in brain of, see Brain, anatomy and physiology of the; products of, see Fables; *Facetie*; Fantastic descriptions; Grotesques; *Last Supper*; Milan: *Castello Sforzesco, Sala delle Asse*; Prophecies; Symbolism

Fantastic descriptions and compositions, 159–60, 161, 162

Ferrara, Cardinal of, 349

Ferrara, Giacomo Andrea da, 36, 105

Ferrara, War of, 100

Festa di San Giovanni, 72, 74

Festival design, see Stage design

Ficino, Marsilio, 91, 128

Filarete, Antonio, 100, 108, 110, 161, 164

Filelfo, Francesco, 101
Fior di Virtù, 154, 155, 156
Fioravante di Domenico, 42, 44, 53, 79
Floods, *see* Prodigies of nature
Florence, 91–2, 99, 100, 103, 106, 125, 128, 149, 152, 169, 202, 211, 213–14, 215, 216, 217, 218, 221, 227, 231, 232, 234, 247, 258, 265, 269, 299, 308, 337, 338, 341, 345, 347; see also *Battle of Anghiari*; Leonardo; —, *Baptistery* (*S. Giovanni*), 26, 35, 40, 109, 257, figs. 1–2; —, *Cathedral* (*S.M. del Fiore*), 26, 40, 80, 89, fig. 1; —, *Palazzo della Signoria* (*Palazzo Vecchio*), 26, 214, 226, 238; *Chapel of St. Bernard*, 53, 92; *Sala del Consiglio Maggiore*, 214, 217, 218, 226, 234–36, 237, 238, 244, 245, 247, 257, fig. 54; —, *Palazzo Medici*, 347; —, *Palazzo Vecchio*, *see Palazzo della Signoria*; —, *Piazza della Signoria*, 26; —, *S.S. Annunziata*, 221; —, *S. Felice*, 168; —, *S. Francesco al Monte* (*S. Salvatore*), 215; —, *S. Giovanni*, *see* Baptistery; —, *S. Lorenzo*, 110, 347; —, *S. Maria degli Angeli*, 88, 109; —,*S. Maria del Fiore*, *see Cathedral*; —, *S. Maria Novella*, 32, 75; *Sala del Papa*, 217, 236; —, *S. Maria Nuova*, 46, 212, 216, 247, 257; —, *S. Salvatore*, see *S. Francesco al Monte*; —, *S. Salvi*, 218; —, *S. Spirito*, 88, 109
Florentine government, 26, 53, 92, 213–14, 217, 226, 231, 234, 235, 236, 237, 243–4, 245, 246, 248, 268, 278; *see also* Symbolism
Flowers, *see* Botany
Flux, 52, 117–18, 261, 263, 277, 314–15, 321
Flying machine, 122–4, 137, 256, 257, fig. 14
Fontainebleau, 270
Foot, *see* Leg

Foppa, Caradosso, *see* Caradosso Foppa
Foppa, Vincenzo, 102
Force, *see* Dynamics
Fornovo, Battle of, 185, 211
Forster Mss, *see* London, Victoria and Albert Museum
Fortifications, 82, 100, 105, 216, 228, 229, 230, 233–4, 248, 269, figs. 50, 53, pl. 30
Fra Bartolomeo, 218; *St. Anne Altarpiece*, 226, 236
Fra Bernardino, 317
Francesco d'Antonio (L's uncle), 81, 279
Francesco di Giorgio Martini, 88–9, 102, 107, 108, 109, 110, 115, 117, 161, 203
Francis I, King of France, 268, 270, 347, 348, 349
Fregoso, Antonio, 101
Frezzi, Federigo: *Quadrerigio*, 104, 154

Gaffuri, Ambrogio de', 93
Gaffurio, Franchino, 101, 169–70; *De Harmonia*, 110, fig. 9, *Theorica musicae*, 169
Galen, 129, 258–9, 291, 293; *Anatomical Procedures*, 291; *De usu partium* (*On the Function of Parts*), 291
Gallerani, Cecilia, portrait of, 199–210, 202, 215, 266, 269, pl. 56
Gauricus, Pomponius, 248
Gentile da Fabriano, 44; *Adoration of the Magi*, 68
Geographical description, L's imaginary, 159
Geography, 285, 310, 312, 313–17, figs. 87, 89
Geology, 98–9, 261, 263, 265, 269, 313–16, 322, 343, fig. 85
Geometry, 39, 86, 90, 120, 133, 144, 148–50, 190, 198, 215, 248, 250–5, 256, 285, 293, 296–8, 307, 309, 313,

314, 318, 323, 339, 343, 348, figs. 21, 31, 39–42, 57–62, 71–4, 76–9, 84, 86–8, pls. 33, 53, 77, 83; *see also* Anatomy; Architecture; Heart, anatomy and physiology of the; Hydrodynamics; Liberal Arts; Light; Microcosm and macrocosm; Military engineering; Optics; Perspective

Ghiberti, Lorenzo, 32, 35–6, *Commentaries*, 35, 36, 39

Ghirlandaio, Domenico, 42, 44, 213

Giocondo, Francesco di Bartolomeo di Zanobi del, 268

Giorgione: *Venus*, 275

Giotto, 24–6, 36, 37, 44, 266; *Christ before the High Priest* 24–6, 190, pl. 1; *Navicella*, 190

Giovio, Paolo, 167, 207, 291

Giraldi, Giovanbattista, 180

Girolamo da Fegline, 42

Giuliano (Ser) di Ser Piero da Vinci, 348

Goes, Hugo van der, 48; *Portinari Altarpiece*, 46

Gonzaga Court, 91, 92, 101

Gonzaga family, 101, 152

Gonzaga, Francesco, Marquis of Mantua, 211, 215

Gozzoli, Benozzo, 74

Grammar, *see* Liberal Arts

Grapes, transportation of, 230

Gravity: centres of, 254, 255, 314; —, laws of, 132, 143, fig. 21

Grotesques, 156–8, 159, pl. 42

Guild of St. Luke, *see* Company of St. Luke of Florence

Guiscardi, Mariolo de', 205

Haemodynamics, *see* Heart, anatomy and physiology of the

Hair, 60, 265, 273, 275, 309, pl 75; *see also* Verrocchio

Hand print technique, 52, 281

Hands, studies of, 76, pl. 27

Harmonics, *see* Proportion, musical

Head(s), 42–3, 44, 46, 53–4, 60, 63, 65, 91, 157, 240, 266, 273, 275, pls. 5–7, 12, 21, 54, 67, 75; *see also* Grotesques; Physiognomy; Verrocchio

Heart and circulatory system, Anatomy and physiology of the, 257–8, 260, 261, 291, 292–3, 294–5, 300–1, 312, figs. 63–4, 66–8, 70, 80–1, pls. 70, 82; *see also* Microcosm and macrocosm; *Portrait of a Lady on a Balcony*

Herbert, George, 91, 117

Hercules and the Nemean Lion, 218, 226, 270

Heron of Alexandria, 170, 179

Holkham Hall (Norfolk), Library of Lord Leicester, mss. in, 172, 258, 261, 265, 269, 305, 308, 309–10, 312, 314, 315–16, 316, 318, 319, 324, 325, 345

Horses, 63, 205, 247, figs. 48–9, pls. 20, 58; see also *Adoration of the Magi*, *Battle of Anghiari*; Sforza, Francesco monument; Trivulzio monument

Human body, *see* Anatomy; Dynamics; Medicine; *On the Human Body*; Physiology; Proportion

Humanism, 23, 32, 36, 91, 209

Humours, *see* Temperaments

Hydraulic engineering, 43, 79, 83–4, 86, 105, 117, 170, 171–2, 179, 215, 216–17, 230, 231–2, 250, 310, 312, 347, 348, pls. 31, 40; *see also* Textile machinery

Hydrodynamics, 90, 131–2, 139, 140, 142, 229, 258, 265, 285, 305, 307–10, 311–12, 317, 318, 329, 343, figs. 19, 27–9, 83, pls. 84–5; *see also* Deluge; Water

Iconography, *see* Symbolism

Imagination, *see* Fantasia

Imola, map of, 228–30, pl. 64

Impetus theory, *see* Dynamics

Imprese, see Symbolism

Industrial engineering, 174–5, pl. 45;
 see also Hydraulic engineering
Insulis, Alanus de, 114
Intellectuals, artists as, 39–40
Invention, artistic, *see* Fantasia
Inventory, *see* List(s)
Isabella of Aragon, Princess of Naples,
 Duchess of Milan, 152, 167–8, 211
Isidore of Seville: *Etymologiae*, 304

Jean de Paris, *see* Perréal, Jean
Jerome, St., 42
John the Baptist, St., 63, 68, 94, 96,
 226, 245, 346, pl. 19; see also *Festa
 di S. Giovanni*; *Madonna, Child, St.
 Anne and St. John compositions*; *St.
 John the Baptist*
Jordanus of Nemore, 139; *De
 ponderibus*, 145
Joseph, St., 69, 72, 77
Jottings, *see* Doodles
Julius II, Pope, tomb of, 283

Kepler, Johannes, 327
Kimon, 36
Kindi, Al, *see* Alkindi
Knots, 42, 44, 187; *see also* Verrocchio

Lady in Profile, 202
Lady with the Ermine, see Gallerani,
 Cecilia
Landino, Cristoforo, 106
Landscape(s): backgrounds, 48, 52, 60,
 84, 263, 265, 269, 277, 344–5:
 drawings, 51–2, 60, 229, 345, pl. 11
Landucci, Luca, 322
Language, 106, 142; *see also*
 Vernacular, literature in the
Lascaris, Constantino, 101
Last Supper, 25, 37, 68, 79, 85, 120,
 148, 180, 189, 190–2, 194–9, 199,
 211, 237, 267, 279, fig. 47; pls. 25,
 52–4; *see also* Milan, *S. Maria delle
 Grazie*
Laura (Petrarch's), 106, 267, 268

Laurana, Luciano, 230
Leda and the Swan, 218, 270, 275, 277,
 279, 339, 346: copies after L, 275, pl.
 72; *Kneeling Leda*, 270, 272–3, 277,
 pl. 73; *Standing Leda*, 273, 275, 277,
 pl. 75
Leg, anatomy of the, 286, pls. 79, 81
Leicester Ms., *see* Holkham Hall
Leo X, Pope, 180, 347
Leonardo da Vinci: Florentine heritage
 of, 23–90; form of name, 23; birth
 and family background, 23; on
 history of Florentine art, 24; as equal
 of the ancients, 37; intellectual
 proclivities, 39–40; early education,
 40; apprenticeship and influence of
 Verrocchio, 40, 42–4, 48, 49, 51, 54,
 58, 60–3, 65–6; difficulties with
 Latin, 40, 84, 103–4; homosexuality,
 42, 341; life studies, 44; devotion to
 world of nature, 44, 52, 177; 343–4,
 see also nature; left handed, 63;
 difficulties in fulfilling obligations,
 etc, 53, 68, 92, 93–4, 99, 180–1, 199,
 214, 223, 237, 238; dislike of war, 74,
 177, pl. 47; to Milan, 1482, 78, 91,
 see also below, First Milanese period; ?
 lawsuit over Uncle's inheritance, 81,
 218, 279; literary exercises, 86–7, 98–
 9, 159, 164, 270, 319–22, *see also*
 Doodles, Fables; *Facetie*; Fantastic?
 descriptions; Prophecies; Texts; ?
 literary works owned by L, *see*
 Library; personality, 86–8, 162, 177,
 179; self education, 89, 102–6, 150,
 248; first Milanese period, 91–212;
 vineyard of, 92, 172; as musician,
 131, 149, 169; shares lodgings with
 Pacioli, 149, 216; vegetarian, 177;
 physical appearance, 177; generosity,
 179; working methods, 158–9, 180,
 see also drawing style; love of
 solitude, 179, active mind, 180,
 business agreement with Louis XII,
 212; bank account, 212, 216, 257; in

Florence, 1500–2, 213, 214, 215–16; influence on other artists, 213, 218–19, in Mantua, winter, 1499–1500, 215; in Venice, March, 1500, 215; in Urbino, summer, 1502, 216, 227–31, 265; in Florence, 1503–6, 216–17, *see also Battle of Anghiari*; in Piombino, 1504, 217; in Milan, 1506–7, 217, 238, 247, 257; in Florence, March, 1507, 218, 257; in Milan, May, 1507, 218; in Florence, August, 1507–8, 218, 257, 277; leaves Florence, 1508, 275, 299; in Milan, Sept., 1508, 218, 308; numerous projects for paintings, 1500–8, 218; offered *S.S. Annunziata* commission by Filippino Lippi, 221; biography by Vasari, 221–2; in Rome, February, 1503(?), 230–1; rival to Michelangelo, 237, 337; on committee to decide location of *David*, 237; picks up threads of earlier interests, 257, 285; to France, 1516, 270, 275, 347–8; in employment of French rulers of Milan, 278, 281; dislike of abbreviation, 286, 349; peasants bring fossils to, 315; accuses Giovanni Tedesco of plagiarism, 329–30; and religion, 342, 343; in Rome, 347; visits Florence, 1515, 347; failing health, 348; will, 348, legacy, 349
Library (ies): of L, 104, 129, 154, 156, 158, 160, 247, 257, 310–17, 322, 323;—used by L, 104–5, 230, 254
Libro A, *see* Rome, Vatican
Light, 32–3, 35, 90, 98, 131, 132, 134, 201–2, 269, 279, 324–6, 329, 333, figs. 23, 96; see also *Chiaroscuro*; Mirrors; Optical illusions; Optics; Perspective
Light and shade, theories of, see *Chiaroscuro*
Limbourg, Pol de, 77
Linguistics, *see* Language

Lion, mechanical, 347
Lippi, Filippino, 53, 68, 213, 214, 221, 223, 226, 234, 236, 273; *Adoration of the Magi*, 68, 213; *Allegory of Music*, 273
Lippi, Fra Filippo, 48; *Adoration of the Magi*, 68, 72, 74, pl. 23
List(s): of works, 38, 42–3, 49, 53, 79, 92;—, of L's books, 247
Llanos, Ferrando de, 238
London, British Library, ms. (Arundel) in, 98–9, 159, 167, 168, 179, 215, 248, 250, 254, 257, 315, 316, 322, 324, 330, 331, 333
—, Victoria and Albert Museum, mss. in, 116, 128, 139, 146, 150, 155, 170, 205, 250, 251, 252
Lorenzetti, brothers, 36
Lorenzo (pupil of L), 346
Lorraine, Cardinal of, 349
Louis XII, King of France (formerly Duc d' Orléans), 211, 212, 216, 217, 228, 237, 257, 278, 345, 347
Lucca, Siege of, 88
Lucretius: *De rerum naturae*, 304
Luini, Bernardino: *Young Christ*, 218
Lyons, 347
Lysippus: *Cupid with a Bow*, 273

Machiavelli, Niccolò, 216, 217, 227, 228, 230, 231, 237, 240, 243, 322, 323
Macrocosm, *see* Microcosm and macrocosm
Madonna(s); unidentified paintings of, in 1482 inventory, 43, 53, 54, 79; —*and Child with a Cat*, drawings, 53, 54, 56–7, 78, pls. 15–16; — *and Child with the Infant St. John*, drawings, 53; —*with the Vase of Flowers*, 53, 54, 61, pl. 13; — *Benois*, 53, 54, 57, pl. 14; study of head of, (Paris) relating to *Madonna Litta*, 53–4, 60, pl. 12; — *and Child*, study on page with *Last Supper* sketch, pl.

25; — *Litta* (Hermitage, after L), 54; sketches of the, 78; — *of the Rocks*, 181, 194, 201, 278, 279, 285, 346; Louvre version; 94, 96-9, 279, 333, pl. 34, London, National Gallery version; 94, 99, 279, 338, pl. 76, *see also Confraternity of the Immaculate Conception*; — (?), undertaken for Matthias Corvinus, 210; —, *Child, St. Anne and a Lamb* (cartoon described as unfinished by Fra Pietro), 215, 220, 223, 226, 227, 346; — *with the Yarnwinder*, 218, 221, 227, 278, described by Fra Pietro, 216; narrative qualities in, 219; version, (Coll. Duke of Buccleuch and Queensberry), 219, pl. 60; —, *Child and St. Anne*, project, 218; —, *with the Infants Christ and St. John*, project, 218; —, *Child, St. Anne and a Lamb* (Louvre), 221, 223, 268, 279, 338, 343-6, pl. 61; —, *Child, St. Anne and St. John* (cartoon described by Vasari), 221, 223, 226, 227, 346; —, *Child, St. Anne*(?), *and St. John*, cartoon (London, National Gallery), 223, 345, 346, pl. 62, studies, 223, 227, 279, 345, 346, pl. 63; — unidentified, cited by L in autumn, 1507, intended for Louis XII, 279, 345; — *and Children at Play* (lost work, known through copies), 279; *see also* Symbolism; *Virgin Annunciate* (*general*)

Madonna del Monte, Sanctuary of the (nr. Varese), 186

Madrid, Biblioteca Nacional, mss. in, 120, 144, 168, 170, 206, 207, 213, 232, 233, 247, 238, 248, 250, 251, 254, 255, 273, 323, 343

Maino, Giacomo del, 93

Manetti, Antonio, 26

Manetti, Gianozzo, 115

Manganello, Il (Anon.), 104

Mantegazza, brothers, 102, 202

Mantegna, Andrea, 92, 162; *St. Zeno Altarpiece*, 74, 92

Mantua, Marchioness of, *see* Este, Isaballa d')

Mantua, Marquis of, *see* Gonzaga, Federigo)

Mantua, 169, 215; *Palazzo Ducale*, 181

Manuscripts: Milanese, 89, 103, 104, 122, 269, 332; see also Holkham?, Hall; London, British Library; London, Victoria and Albert ? Museum; Madrid, Biblioteca? Nacional; Milan, Biblioteca ? Ambrosiana; Milan, Castello ? Sforzesco, Biblioteca Trivulziana; ? Paris, Institut de France; Rome, ? Vatican; Turin, Biblioteca Reale; ? Windsor, Royal Library ?

Marcus Aurelius?, equestrian monument to, 203, 205

Marius (in Sallust's *Bellum Iugurthinum*), 102-3

Marliani, family, 101-2, 105, 139

Marmocchi, Carlo, 86

Martelli, Piero di Braccio, 257

Martini, Simone, 36-7

Marullus, 325

Mary Magdalene, project, 218

Masaccio, 24, 29, 31-2, 37, 44, 97, 266; *Trinity with the Virgin, St. John and Donors*, 29-32, 194, 196, fig. 3, pl. 2

Masolino, 32

Mathematics, 73, 105, 129, 132-4, 146, 150, 163-4, 216, 227, 247-8, 250, 253, 277, 293-4, 296, 298, 302-3, 307, 323, 332; *see also* Architecture, Arithmetic; Dynamics; Geometry; Heart, anatomy and physiology of the; 'Necessity'; Proportion, Musical; Statics

Matthias Corvinus, King of Hungary, 210

Maximilian, Emperor of Germany, 99, 152-3, 184, 185, 207, 212

Mechanical engineering, 79-82, 84-6,

88, 89, 107, 119-20, 122, 124, 170, 174, 256, 302-3, 347, figs. 12, 13, pls. 5, 25, 27-9, 32-3, 41; *see also* Dynamics; Excavations; Flying machine; Fortifications; Heart, anatomy and physiology of the; Hydraulic engineering; Stage design; Statics

Mechanics, *see* Mechanical enginering

Medical science, *see* Medicine

Medici Bank, 105; in Bruges, 46; in Milan, 100

Medici, Cosimo (*Pater Patriae*), de', 110

Medici family, 40, 51, 61, 68, 75, 91-2, 106, 128, 202, 211, 213, 214, 226, 234, 347

(Medici, Giuliano de', 155, 266)

Medici, Giuliano de', Duke of Nemours (*Il Magnifico*), 268, 269, 270, 329, 331, 347)

Medici, Lorenzo de' (*Il Magnifico*), 39, 49, 91, 152, 203, 214

Medici, Villa (Careggi), 61; Ficino's Academy at, 91

Medicine, 39, 101-2, 104, 107-8, 125

Melzi, Giovanni Francesco, 346, 347, 348

Melzi, Villa (Vapprio d'Adda), 347

Memoranda, 40, 86, 89, 105, 119, 129, 140, 159, 174, 199, 238, 247; *see also* List(s)

Merula, Giorgio, 101

Meteorological: instrument, 85-6, pl. 25; allegory, 155; phenomena, 238, 318-19

Michelangelo, 213, 218-19, 226, 283, 336-7; *Bacchus*, 213; *Battle of Cascina*, 234, 236, 237, 243; *see also Cascina, Battle of; David*, 226, 237; *Deluge*, 322, 337; (*Pieta*, 213; *see also Paragone*)

Michiel, Marcantonio, 101

Microcosm and macrocosm, 114-19, 127, 162, 229, 261, 263, 277, 286,

312, 315-17, 331

Migliorotti, Atalante, 43, 60, 91, 169

Milan, 42, 66, 78, 79, 84, 86, 89, 90, 91, 100, 211-12, 216, 217, 228, 231, 232, 257, 278, 279, 281, 283, 285, 308, 346, 348; (see also *Battle of Anghiari*; Leonardo; Sforza Court;) *Biblioteca Ambrosiana*, ms. (*Codice atlantico*) in, 24, 25, 29, 38, 43, 52, 79, 83, 84, 85, 86-7, 88, 89, 90, 92, 102, 103, 104, 105, 107, 122, 123, 125, 129, 130, 134-5, 138, 139, 140, 151, 156, 159, 160, 162, 163, 168, 170, 172, 177, 180, 187, 188, 191, 201, 202, 204, 212, 215, 232, 233, 237-8, 240, 248, 253, 254, 255, 275, 278, 279, 283, 291, 296, 298, 299, 302, 303, 305, 307, 309, 317, 321, 323, 324, 329, 331, 339, 347, 348; —, *Castello Sforzesco*, 153, 163, 187, 212, 347, pl. 54, *see also* Sforza Court; *Biblioteca Trivulziana*, ms. in, 103, 104, 106, 107, 128, 153, 170, 173, 179, 267; *Sala delle Asse*, 181-2, 184-9, 199, 211, 212, fig. 44, pls. 48-51; *Saletta Negra*, 181-2; —, Cathedral, 100-1, 160, 207; *tiburio*, 107, 108, 109, 113, 123, 174, pl. 35; —, *Corte Vecchia*, 123, 180; —, *Lazzaretto*, 101; —, *Ospedale Maggiore*, 1001, 101; —, *S. Ambrogio*, 188; Library, 105; —, *S. Eustorgio: Portinari* Chapel, 100; —, *S. Francesco Grande*, 93, 94; —, *S. Lorenzo*, 109; —, *S. Maria alla Fontana*: Oratory, 283; —, *S. Maria delle Grazie*, 180, 181, 189-90, pl. 55, see also *Last Supper*

Milan, Duchess of, *see* Bona di Savoia; Este, Beatrice d'; Isabella of Aragon

Milan, Duke of, *see* Sforza, Francesco I; Sforza, Galeazzo Maria; Sforza, Gian Galeazzo; Sforza, Ludovico; Visconti, Filippo Maria

Military engineering, 78-82, 88, 89, 93,

100, 124, 174, 175, 176-7, 215, 217, 227, 230, 232-4, 312, 347, pls. 46-7; *see also* Ballistics; Fortifications; Hydraulic engineering; Mirrors

Mirrors, 26, 328, 329, 330-1

Mistioni, 343, fig. 100

Mona Lisa, *see Portrait of a Lady on a Balcony*

Monsters, *see* Fantastic descriptions

Monte Ceceri (Fiesole), 256

Monte Oliveto, Convent of (near Florence), 48

Montefeltro, Federigo da, Duke of Urbino, 265, 266

Montefeltro, Guidobaldo, Duke of Urbino, 149, 254, 265

Montefeltro, family, 101, 230

Montemagno, Bonacorso da, the Younger; *Dispute Concerning Nobility*, 102-3

Montorfano, Giovanni Donato, 102; *Calvary*, 190, 199

Moral precepts, 106

Motion, *see* Movement

'Motions of the mind', 37, 190-1, 227, 267

Movement, 90; five natures of, 134-5; *see also* Dynamics; Flux

Multiple viewpoint, 63, 65, 80, 110, 149, 286, 289, figs. 39-40, pls. 21, 80-1

Mundinus, 125, 136

Muscles, *see* Myology

Music, 39, 91, 101, 124, 131, 169-70; *see also* Liberal Arts; Proportion, Musical

Musician, portrait of a, 202

Myology, 286, 337, fig. 99, pl. 81

Myron, 37, 148; *Discobolus*, 36

Naples, 283; Court at, 91; *Poggio Reale*, 283

Naples, King of, *see* Alfonso of Aragon

Naples, Princess of, *see* Isabella of Aragon

Natural philosophy, 86, 89, 101-5, 179, 247, 293, pl. 33, *see also* Optics

Nature, 24, 25, 36-7, 44, 46, 84-5, 89, 90, 98, 103, 154, 277, 286, 291, 317, 329, 334, 336, 342, 343; *see also* Anatomy, Botany, Flux; Leonardo; Mathematics; Microcosm and macrocosm; Perspective; Physiology

Naval engineering, 43, 79

Navarre, King of, 349

'Necessity', 150-1, 291, 292, 294, 329; *see also* Mathematics

Neck and shoulders, *see* Neurology

Nemours, Duke of, *see* Medici, Giuliano de'

Neoplatonism, 91, 106, 128, 298

Neptune, drawing, 218, 270, 273, 322

Netherlandish art, 44, 46, 48, 49, 52, 60, 61, 97, 213

Neurology, 135-6, 191, 258, fig. 24

Newton, Sir Isaac, 144

Niccolini, Luigi di Bernardo, 51

Notebooks, *see* Manuscripts

Novellara, Fra Pietro da, 215-16, 219, 227, 247, 346

Observation, 105, 129, 143, 144, 154, 180, 230, 257, 325, 333-4; *see also* Empiricism; Optics

Oil painting technique, 48, 49, 52, 60, 237-8; *see also* Hand print technique

On Conduits, 258

On the Eye, 269, 326

On the Flight of Birds, 255-6, 318; *See also* Birds, flight of

On the Human Body, 119, 124, 125, 131, 137, 158

On Transformation, 251, 255, 256

On Water, 258, 310

Opthalmology, *see* Optics

Optics, 32-4, 35, 39, 89, 98, 106, 129-31, 132, 135, 194, 277, 285, 289, 319, 324-32, figs. 4, 17-18, 20, 91-8; see also *Chiaroscuro*; Eye, anatomy of the; Light; Mirrors; Optical illusions

Optical illusions, 35, 326, 332–3; see also *Chiaroscuro*; Optics; Perspective
Oresme, Nicole, 140, 142, 143, 306–7; *De configurationibus*, 299
Orleans, Duc d', *see* Louis XII
Ovid, 160, 323; *Letters*, 104, *Metamorphoses*, 87, 159, 322
Pacioli, Luca, 37, 100, 101, 115, 146, 148–9, 164, 209, 216, 227, 228, 248, 293, 298; *De divina proportione*, 148–9, 198, 248, 312; *De viribus quantitatis*, 148, 164; *Summa de arithmetica, geometria, proportione et proportionalità*, 148, 248
Padua, 24–6, 127, pl. 1; *see also* Donatello
Padua, Bishop of, 254
Painting, 36, 37, 79, 96, 103, 148, 158, 162, 177, 179, 190, 192, 194, 219, 227, 240, 245, 247, 266, 269, 334, 336–7, 349; *see also Paragone*; Portraits
Palladio, Andrea, 113
Palma, Jacopo, *Il Vecchio*, 270
Palmieri, Matteo: *Della vita civile*, 104
Pandolfini, Francesco, 278
Papal Court, patronage at, 91
Parables, *see* Fables
Paragone debate, 49, 148, 207, 209–11, 289, 291, 312, 337–8; *see also* Artists, status of
Paris, Institut de France, mss. in: A, 117–18, 119, 129, 131, 138, 139, 140, 142, 144, 145, 196, 258, 316, 323, 324, 326, 338; Ash, 97, 103, 109, 130, 132–3, 133–4, 137, 139, 158, 159, 161, 162, 179, 190, 191, 195, 201, 209, 210, 240, 246, 253, 322; B, 88, 109, 117, 122, 123, 144, 170, 172, 176, 190, 256; C, 97, 105, 140, 201, 202, 203, 338; D, 326, 328, 329, 331, 339; E, 291, 299–300, 302, 304, 317–18, 318–19, 331, 334, 336, 337, 338, 344, 345, 346; F, 143, 298, 303, 304, 307, 308, 309, 312, 313, 314, 316–17,

317, 318, 324, 324–5, 326, 330, 333; G, 40, 253, 293, 295, 299, 304, 305, 306, 308, 317, 322, 332, 333, 333–4, 334, 339; H, 103, 117, 138, 155, 156, 164, 165, 171, 201, 316; I, 142, 144, 150, 160, 163, 170, 198; K, 105, 248, 250, 254, 343; L, 142, 143, 144, 212, 228, 230, 234, 248, 250, 254, 269; M, 142, 143, 149, 150, 198
Parma, 315, 347
Parrhasios, 148
Patronage, 91–2, 214, 269–70; *see also* Medici, Giuliano de', Duke of Nemours; Portraits; Sforza Court
Patterns, 296. fig. 73; *see also* Knots
Pavia, 100, 101, 102, 104, 105, 115, 129, 153, 190; —, *S. Maria in Pertica*, 109, fig. 6; *see also* Regisole
Pecham, John, 33, 35, 151, 202, 289, 293, 326; *Perspectiva communis*, 35, 102, 129, 130
Pecorara, La (Vigevano), Sforza farm at, 171
Pelacani, Biagio, 139; *De ponderibus*, 145
Perception, optical, *see* Optics
Perception, sensory, 106, 124, 125, 127–8, 291; *see also* Brain, physiology of the; Empiricism; Movement; Neurology; *Paragone*
Perotti, Nicolai: *Rudimenta grammatices*, 103
Perréal, Jean, 237
Perspectiva, see Optics
Perspective, 24–9, 31, 32, 35–6, 39, 40, 43, 48, 73–4, 77, 89, 103, 120, 129, 131, 132–3, 149, 326, 331–2, figs. 1–3, 47, pls. 1–2, 26; — of colour, 98, 133; see also *Chiaroscuro*; — of disappearance, 98, 133; see also Chiaroscuro
Perugino, Pietro, 42, 213, 223, 336
Pesaro, 228, 230
Petrarch, 37, 106, 267
Pheidias, 36, 148, 179, 180

Philiberta of Savoy, 347

Philoponus, 250

Philosophy, 39, 91, 106, 162, 349

Physiognomy, 44, 75-6, 90, 124, 158-9, 160, 240, 242, 266-7, 336; *see also* 'Motions of the mind'

Piacenza, 315

Physiology, 37, 107, 229, 257-8, 260-1, 263, 270, 277, 286, 291-2, 315-17, pl. 70; *see also* individual parts of the body; *Leda and the Swan*; *On the Human Body*; *Portrait of a Lady on a Balcony*

Piccino, Niccolo, 243, 244, 245

Pico della Mirandola, Giovanni: *De ente et uno*, 128

Pictographs, 163

Piero(Ser) da Vinci, 23, 67, 75, 81, 221

Piero della Francesca, 43, 97; *Montefeltro dyptych*, 265, 266

Piombino, 217, 228, 230, 233, 234, 237, 247, 248, 269

Pisa, 88, 216, 231, 232, 236

Pisanello, 44, 74

Pisano, family, 36

Pistoia, 232, 265

Plato, 128, 130, 148, 293, 312-13; *Timaeus*, 114, 298; *see also* Neoplatonism

Pliny the Elder, 36, 37, 52, 168, 316, 317; *Natural History*, 36, 154, 155, 312

Plutarch, 117; *De gloria Atheniensium*, 209

Poetry, 37, 39, 104; see also *Paragone*

Poggio Reale, *see* Naples

Pointing gesture, 341, 342, 343, 346

Poliziano, Angelo, 156; *Orpheus*, 169

Pollaiuolo, Antonio, 37-8, 39, 52, 202, 203; *Battle of the Nude Men*, 37, pl. 3

Pollaiuolo, brothers, 42

Polycleitos, 148

Portinari, Benedetto, 105

Portinari, Tommaso, 46

Portrait of a Lady (Milan: Ambrosiana), 199

Portrait of a Lady on a Balcony (*Mona Lisa*), 218, 263, 265, 266-70, 277, 279, 338, 345, 346, pl. 71

Portraits, 42-3, 49, 50, 93, 181, 199, 201, 215-16, 269-70; see also *Belle Ferronière*; Benci, Ginevra de'; Crivelli, Lucrezia; Este, Isabella d'; Gallerani, Cecilia; *Lady in Profile*; *Musician*; *Portrait of a Lady on a Balcony*; Sforza family; Sforza, Francesco, monument

Prato, 232, 265

Praxiteles, 36, 37, 148

Predis, Ambrogio da, 93, 94, 102, 279, 281

Predis, Evangelista da, 93, 102

Prime mover, 140, 150, 323, 342; *see also* Deluge; Dynamics

Prodigies of nature, 318, 322-3; *see also* Deluge

Prophecies, 162-3, 177

Proportion, 32, 37, 42, 44, 103, 113-14, 115-17, 124, 146, 188, 205, 336, figs. 5, 11; *see also* Mathematics; Proportion, musical; Statics

Proportion, musical, 110-11, 114, 124, 133, 124, 146, 170, 196, 198, 205, 250, figs. 9, 47

Protogenes, 52

Pseudo-Bonaventura, 68

Psychology, *see* Brain, physiology of the

Ptolemy, 48, 306, 213, 323, 324; *Cosmography*, 114, 261, 323

Pucci, Antonio: *Historia della Reina d'Oriente*, 160

Pulci, Luigi: *Morgante*, 160; *Vocaboli latini*, 106

Puns, 23, 49, 106, 164, 165-6, 187, 200; *see also* Symbolism

Pyramid: visual, *see* Optics; —al laws, *see* Geometry

Pythagoras, 39, 114, 148, 159

Rainstorms, optical effects of, 319
Ramusio, Paolo, 104
Raphael, 218, 239, 243, 246, 268–9, 275; *Lady with the Unicorn*, 269; *Maddalena Doni*, 269
Regisole, 203–4
Religion, books on, owned by L, 247
Reproductive system, anatomy and physiology of the, 124, 125, 136, 258, 261, 270 Pl. 70; see also *Leda and the Swan*
Resolutio and compositio, see Scientific method
Respiratory system, anatomy and physiology of the, 258, 261, 293, pls. 69–70
Rhetoric, *see* Liberal Arts
Riddles, *see* Prophecies
Rimini, 228, 230, 250
Robbia, Luca della, 32
Robertet, Florimond, 216, 219, 221, 278
Romano, Gian Cristoforo, 102, 168
Rome, 228, 231, 268, 275, 329, 337, 347; , *Vatican*, mss. in: *Codex Urbinas*, 40, 78, 97, 102, 126, 128, 129, 133, 154, 158, 161–2, 162, 179, 210, 210–11, 240, 254, 263, 298, 324, 332, 333, 334, 336, 337, 338, 339, 341, 347; *Libro A*, 332, 333, 334, 336, 337, 338, 339, 341
Romorantin, Palace project, 348
Rosate, Ambrogio Varese da, 154
Rosselli, Cosimo, 42
Rubens, Sir Peter Paul, 239, 245, pl. 65
Rucellai, Giovanni, 72, 322
Rustici, Gian Francesco, 257, 345; *St. John Preaching*, 257

Sacchetti, Franco: *Novelle*, 156
Sacrobosco, 323
St. John the Baptist, 339, 341, 342, 343, 346, pl. 88
St. Luke, Company of, *see* Company of St. Luke of Florence

Sala delle Asse, see Milan: Castello Sforzesco
Salai, 179, 279, 346
Sallust, 156; *Bellum Iugurthinum*, 102–3, 156
Salvator Mundi, 218, 228
S. Angelo, 347
San Donato a Scopeto, Monastery of (outside Florence), 67
S. Nazaro, 283
Sangallo, Antonio da, the Elder, 234
Sanseverino, Galeazzo, 100, 148, 167, 171, 205
Sanseverino, Giovan Francesco, 168
Sansovino, Andrea, 234, 236
Sarto, Andrea del, 218
Savonarola, Girolamo, 213, 214, 234
Savonarola, Michele, 158
Scot, Michael: *Liber phisionomiae?* 158
Scientific method, 89, 124–5, 137, 151, 161, 286, 289, 291, 329; *see also* Empiricism
Sculpture, 36, 61, 63, 79, 266, 349; *see also* Paragone; Sforza Francesco monument; Trivulzio monument; Verrocchio
Sebastian, St., "eight pictures of," 42
Segni, Antonio, 218, 158, 273, 322
Sforza, Anna, 152
Sforza, Battista, Duchess of Urbino,? 265, 266
Sforza, Bianca Maria, 99, 152–3, 184, 207
Sforza Court, 91, 92–3, 101, 102, 104, 152–70 *passim*, 174, 199, 209, 214, 281; *see also* Symbolism; Vigevano
Sforza, Ercole (later Massimiliano), *see* Sforza, Massimiliano
Sforza, family, 100, 110, 152, 171, 199, 212, 283, pl. 36; *see also* Symbolism
Sforza, Francesco, Duke of Milan, 42, 100, 101, 164, 171
Sforza, Francesco (son of Ludovico), 153
Sforza, Francesco, monument to, 37,

63, 149, 180, 202–7, 211, 212, 240, 315, figs. 48–9, pl. 58

Sforza, Galeazzo Maria, Duke of Milan, 99, 152, 169, 184, 185, 202

Sforza, Gian Galeazzo, Duke of Milan, 99, 153, 165, 167, 171

Sforza, Ludovico (*Il Moro*), Duke of Bari, later Duke of Milan, 61, 78–9, 83, 84, 88, 92–3, 99–100, 101, 103, 148, 149, 152, 153, 154, 170–4, 179, 181, 184–5, 189–90, 199, 202, 203, 211–12, 234, 283; *see also* Sforza Court; Symbolism

Sforza, Massimiliano (Ercole), 103, 153, 346

Sforza, Sforza, Duke of Bari, 99

Sforzesca, La (Vigevano), 171, 172, 181

Shadows, see *Chiaroscuro*

Shoulder, anatomy of neck and, pl. 81; —s, *see* Neurology

Siena, 230

Sight, 126, 128, 209; *see also* Eye, anatomy and physiology of the; Optics

Signoria, see Florentine Government

Sillacio, Niccolo, 104

Simonides, 37, 209

Simplicius, 250

Sixtus, IV, Pope, 94

Skull drawings, 113, 116, 125, 126, figs. 15–16, pl. 37

Smell, sense of, 250

Soderini, Piero, *Gonfaloniere*, 238, 244, 245, 248

Solari, Cristoforo, 190

Solari, family, 102

Solari, Guiniforte, 190

Soldo, Giovanni del, 248

Soul, the human, 106, 125, 127–8, 158, 267, 278, 336, 342; *see also* Nature

Stage design, 93, 131–2, 152, 153, 166–9, 171, 347, fig. 43

Statics, 89, 106, 120, 138–9, 144–6, 148, 232, 302, 303, 304, figs. 32–8, 82; *see also* Gravity, centres of

Stereometry, *see* Geometry

Strabo, 312

Studio Pisano, 248

Suardi, Bartolomeo, *see* Bramantino

Subsidence, *see* Prodigies of nature

Symbolism, Allegory and Iconography: of the Madonna, 44, 46, 54, 72–3, 77–8, 94, 96, 219; —, of trees, 77–8, 96, 186, 187–9, fig. 46, pl. 44; —, botanical, 96; —, architectural, 115; —, of Sforza family, 152, 153–4, 164–6, 173, 184–7, figs. 45–6, pls. 43, 48–51; —, of Florentine Republic, 226, 228, 234–6; —, for French rulers of Milan, 281, pl. 77; *see also* Anne, St.; Fables; John, St.; Microcosm and macrocosms; Puns; Stage design

Taccone, Baldassare, 168; *Danaë*, 153, 168

Tedesco, Giovanni, 329–30

Temperaments, the four, 114, 124, 158

Temple of Peace, *see* Basilica of Maxentius

Terminology, *see* Language

Textile: industry, 83, 174; — machinery, 174–5, pl. 45

Texts, explanatory, 165, 291–2

Theatre design, *see* Stage design

Theology, 33, 35, 39, 106

Theon of Alexandria, 250

Theophrastus, 312

Three dimensional viewpoint, *see* Multiple viewpoint

Three Kings, The (play), 75

Time, 86–7, 134, 250, 265, 304; — and motion studies, 248

Titian, 270, 275

Tonal modelling, see *Chiaroscuro*

Topography, 263; *see also* Cartography

Torre, Marcantonio della, 291

Toscanelli, Paolo, 86

Toviglia, Villa (Florence), drawing of, 215

Treatise on Painting, 347; *see also Codex Urbinas*
Treatise on Water, 119
Trees, studies of, 333-4, 338, pl. 87; *see also* Botany; Symbolism
Très Riches Heures du Duc de Berry, Les, 77
Trivulzio, Giovanni Giacomo, 283; —, monument to, 283, 285, fig. 65, pl. 78
Trivulzio ms., *see* Milan, Castello Sforzesco, Biblioteca Trivulziana
Turin, Biblioteca Reale, ms. in, 176, 255, 256

Uccello, Paolo, 43
uccello, *see* Flying machine
Urban planning, 117, 122, 172-4, 229, pls. 39-40, 44
Urbino, Duchess of, *see* Sforza, Battista
Urbino, Duke of, *see* Montefeltro, Federigo da; Montefeltro, Guidobaldo da
Urbino, 216, 227, 228; — *Palazzo Ducale*, 181, 230; *Capella del Perdono*, 230, fig. 51; *staircase*, 230, fig. 52
Urino-genital system, physiology of the, *see* Reproductive system, anatomy and physiology of the

Valentinois, Duke of, *see* Borgia, Cesare
Valla, Giorgio: *De expetendis et fugiendibus rebus*, 248, 250-1
Valturio, Roberto, 176; *De re militari*, 83-4, 104, 106, 107
Van Eyck, Jan, *see* Eyck, Jan van
Van der Goes, Hugo *see* Goes, Hugo van der
Vanishing point, *see* Perspective
Vasari, Giorgio, 37-8, 60, 63, 221, 223, 226, 236, 238, 240, 268, 346
Venice, 52, 202
Vernacular, literature in the, 104, 105,
129, 154, 169-70, 248
Verona, *Church of St. Zeno*, 92
Verrocchio, Andrea del, 23, 37, 38-9, 40, 42-4, 48, 49, 51, 54, 56, 60-3, 65-6, 76, 89, 91, 110, 156, 201, 204, 214; *Alexander and Darius* (lost reliefs), 44; *Baptism of Christ*, 58, 60-1, 84, pl. 17; *Bartolomeo Colleone*, 202, 205, 285; *Battle of the Nude Gods* (lost cartoon), 39; bust of *Giuliano de' Medici*, 266; *Lady Holding Flowers*, 49; *Madonna in Front of a Ruined Basilica*; 40, 73, pl. 4; *Putto with a Dolphin*, 61, pl. 18; *Study of a Lady's Head with Elaborate Coiffure*, 46, 54, pl. 7
Vigevano, 170-4, 181, 190; —, *S. Antonio*, 172; —, *Castello Sforzesco*, 172, 173, pl. 44; —, *Piazza Ducale*, 172-3, 186, pl. 44; —, *Cathedral*, 172
Villani, Giovanni, 322; *Chronicle*, 265
Vinci, 23, 52
Virgil, 323; *Aeneid*, 323
Virgin, *see* Madonna
Virgin Annunciate (general), 341-2
Visconti, Bernabo, equestrian monument to, 202
Visconti, family, 100, 152, 165, 172, 202, 243
Visconti, Filippo Maria, *Duke of Milan*, 171, 184
Visconti, Gaspare, 101, 153; *De Paolo e Daria amanti*, 153
Visconti, Valentina, 212
Vision, science of, *see* Optics
Visual pyramid, *see* Optics
Vitolone, *see* Witelo
Vitruvian Man, 115, pl. 38
Vitruvius: *Ten Books*, 35, 36, 39, 105, 117, 131-2, 170, 176, 188, 253; *see also* Vitruvian Man
Volterra, Bishop of, 216
Vortices, *see* Hydrodynamics

War: of Ferrara, 100; — against Pisa, 231

Water, 60, 142, 150, 230, 277, 324–5, figs. 42, 91; *see also* Deluge; Geography; Hydraulic engineering; Hydrodynamics

Weaponry, *see* Military engineering

Wheels, 230

Window frames, 230

Windsor Castle, Royal Library, ms. in 114, 124, 126, 127, 135, 136, 158, 163, 191, 205, 219, 228, 232, 240, 257, 258, 260, 261, 263, 270, 273, 275, 278, 281, 285, 286, 289, 291, 292, 293, 294, 296, 299, 301, 312, 317, 319, 320–1, 322, 323, 341, 342, 343, 346, 347, 349

Witelo, 33, 35, 105, 129, 130, 202, 326; *Opticae libri decem*, 129, 330

Workshops, organization of, 40 *see also* Verrocchio

Young Christ (lost work), 215, 218

Zacchia, Lorenzo, 239

Zenale, Bernardino, 102

Zeuxis, 36, 148